Game Audio Implementation

Game Audio Implementation offers a unique practical approach to learning all about game audio. If you've always wanted to hear your sound or music in a real game then this is the book for you. Each chapter is accompanied by its own game level where you can see the techniques and theories in action before working through over 70 exercises to develop your own demo level. Taking you all the way from first principles to complex interactive systems in the industry standard Unreal Engine©, you'll gain the skills to implement your sound and music along with a deep transferable knowledge of the principles you can apply across a range of other game development tools.

The accompanying website (www.gameaudioimplementation.com) includes:

- 12 downloadable demonstration games;
- A unique exercise level for you to develop for your portfolio;
- An up-to-date online bibliography with further reading for each chapter;
- A free sound library with hundreds of game sound effects.

Richard Stevens leads the Masters in Sound and Music for Interactive Games program at Leeds Beckett University, and promotes the games audio education and research through international conference talks, publications, panels, and workshops.

Dave Raybould is Senior Lecturer at Leeds Beckett University where he teaches games audio, sound design, and synthesis. In his time off he likes to relax by being chased and bitten by police dogs.

The Book

Game Audio Implementation offers a unique practical approach to learning all about game audio.

If you've always wanted to hear your sound or music in a real game then this is the book for you. Each chapter is accompanied by its own game level where you can see the techniques and theories in action before working through over 70 exercises to develop your own demo level.

Taking you all the way from first principles to complex interactive systems in the industry standard Unreal Engine, you'll gain the skills to implement your sound and music along with a deep transferable knowledge of principles you can apply across a range of other game development tools.

Subscribe
Email us to be kept up to date with new releases, etc...

News
The book is released

The accompanying website (www.gameaudioimplementation.com) includes:

- 12 downloadable demonstration games
- A unique exercise level for you to develop for your portfolio
- An up-to-date online bibliography with further reading for each chapter
- A free sound library with hundreds of game SFX

CREDITS

Graphics and Level Design
Epic Games free marketplace assets used throughout—thanks!

Chris Forde: Level Design and Assets
Chapter 00 Shooter, Chapter 05 Offices, Chapter 06 Dialogue, and Chapter 07 Urban warfare
http://cjforde.tumblr.com

Nick Campbell: Level Design and Assets
Chapter 01 Jungle, Chapter 08 Space ship, Chapter 12 Music platformer systems and layout (assets from Epic Games), and additional assets—urban warfare sculpture and area locations blueprint

 Nick Campbell graduated from Leeds Met (now Beckett) University in 2014 with a BSc (Hons) in music technology, where he specialized in game audio. Nick has since been furthering his passion for games by working for a variety of clients as a self-taught 3D artist and level designer. A catalog of Nick's previous work can be found on his portfolio website along with all his current projects.
www.nickcampbellportfolio.com

Matt McIntosh: Level Design and Assets
Chapter 03 and Chapter 10 Racer
Matt McIntosh has worked on titles such as *Sega All-stars Racing, Virtua Tennis 2009, Dirt 2, Sega Superstars Tennis, New International Track and Field*, and *Driver 76*. He is now working at Leeds Beckett University as a senior lecturer for the game design course, and he specializes in asset creation. His industry experience and his passion for 3D enable him to not only create characters, environments, vehicles, props, and animations, but also deliver modules of content on those topics to his students as well.

 You can find his 3D portfolio at http://mat-art.cgsociety.org. As Matt is keen to develop his own games in the future using Unreal 4, he is keeping a blog of his progress of model production as he gets used to the engine. His blog can be found at http://matts-gameworks.tumblr.com.

Sounds
Andrew Quinn (http://www.aquinn.co.uk)
Joe Thom (http://www.sonicinnovations.co.uk)
Naila Burney Arango (http://burnis.co)
Benny Reibel
Paul Ratcliff

Music
Evangelous Chouvardas—Dialogue level, Desert, Offices
Danny McDermott—Racer level
Mickey Flora—Shooter Level

QUICK REFERENCE/TIPS

Finding assets: Use the Content Browser, filter by type, and search by name.

Finding [Actors] in the level: Use the World Outliner panel to search by name or type.

Finding in-game [Actors] in the Level Blueprint: Right-click on the actor in the Viewport and use /Level/Find in Level Blueprint.

Finding assets referred to in blueprints: Use Ctrl + B to fi nd and select in the Content Browser. Ctrl + F: Find in Level Blueprint.

Ctrl + E: Edit asset

F2: Rename asset

Blueprint and Sound Cue Graphs

RMB Click, hold and drag: Move the graph

Mouse Wheel: Zoom in / out

LMB Click on node: Select node

LMB Click, hold and drag in empty space: Marquee selection

LMB Click on selected node(s), hold and drag: Move Selected item(s)

RMB click in empty space: Open the ➡Graph Action Menu

LMB Click on node pin, hold and drag out to empty space: Open the ➡ Graph Action Menu

LMB click on node pin, hold and drag out to other pin: Make new connections

Ctrl + LMB click on node pin with existing connection, hold and drag top new node pin: Move an existing connection.

Alt + LMB click on node pin to break connections.

Double-click on a wire to insert a reroute node (for keeping things tidy).

Game Audio Implementation

A Practical Guide Using the Unreal Engine

Richard Stevens and Dave Raybould

LONDON AND NEW YORK

First published 2016 by Focal Press

Published 2016 by Routledge
2 Park Square, Milton Park, Abingdon, Oxon OX14 4RN
52 Vanderbilt Avenue, New York, NY 10017

Routledge is an imprint of the Taylor & Francis Group, an informa business

Copyright © 2016 Taylor & Francis.

Library of Congress Cataloging-in-Publication Data
Stevens, Richard, 1971–
 Game audio implementation : a practical guide using the unreal engine / Richard Stevens and Dave Raybould.
 pages cm
1. Sound—Recording and reproducing—Digital techniques. 2. Computer games—Programming. I. Raybould, Dave. II. Title.

 TK7881.4.S75 2015
 794.8'165—dc23
 2015010904

ISBN: 978-1-138-77724-8 (pbk)

Typeset in Myriad Pro
by Apex CoVantage, LLC

Contents

Acknowledgements xv
Introduction xvi
Approaches to the Book xviii

00 Loading Sequence: Quick Start 1

Setting up the Demo Projects 1
Navigation of the Game World 2
 Version Control and Auto-saves 3
 Looking and Moving 4
 Views 4
 Bookmarks 5
 Moving/Looking 6
 In-game Actors: Finding and Changing Your First Sound 6
Navigating the Assets and the Content Browser 7
 Filtering Results 8
Navigating the Game System: Blueprints 10
Preparing Assets for Import 11
 Editing 12
 Sample Rates and File Formats 12
 Looping 13
Importing Assets 16
 Folder Structures and Naming Conventions 17
Conclusion 20

01 Sound Part A: Ambience and Environment 23

Introduction 23
Ambience 24

Contents

Types of Sound 25
Area Loops 26
Source Loops 31
Filter over Distance 32
Area Loops and Source Loops: Attention to Detail 33
Sound Cues 35
Adding Sounds to Sound Cues 36
Source One-shots 37
Polyphonic or Overlapping One-shots 40
Player-oriented One-shots 41
One-shots: Sourcing and Masking 44
Embedding Source Sounds into Game Actor Blueprints 44
Ambience Recap: An Artist's Approach 46
Occlusion Issues 46
Triggers and Switching Ambience 46
Reverb 51
Triggering Sounds with Key or Controller Input 53
Trigger Use Events 53
Conclusion 56

02 Sound Part B: Procedural Sound Design 59

Introduction 59
Sample Rates and Audio Compression 62
Sample Rates Revisited 62
Audio File Compression 64
Sequenced Variation 65
Time-based Variation 66
Asynchronous Loops 66
Random Time: Blocks 68
Random Time: Fragments 69
Controlling Random Events: Clusters of Activity 70
Concatenation 71
Concatenation for Variation in Loops 72
Layered Concatenation 75
Concatenation for a Chain of Events 76
Concatenate Sample Rates 78
Multiple Start Points 80
Layered Variation 81
Simple Random Combinations 83

Random Combinations with Individualized Pitch and Delays ... 84
Deconstructing a Sound for Procedural Use ... 85
Scalability ... 88
Modulation/Modifiers for Variation ... 90
Pitch ... 90
Reuse Sounds for Different Sized Sources ... 90
Transformative Reuse ... 91
Pitch Envelopes ... 92
Volume ... 96
One-shot Volume Envelopes ... 96
Looping Volume Envelopes ... 98
Oscillation ... 100
Wavetables ... 103
Parameterization = Interactivity ... 106
Swapping out Sounds with -Branch- ... 106
Parameters to Pitch with <Set Pitch Multiplier> ... 110
Parameter-based Crossfades with -Crossfade by Param- ... 112
Using User-defined Curves ... 116
Monitoring Memory and Level Streaming Approaches ... 121
Asset Checking ... 121
Memory Checking ... 122
Level Streaming ... 123
Sound Streaming ... 126
Conclusion ... 126

03 **Music Part A: Quick Start** ... **129**

Introduction ... 129
Interactive Music Principles ... 130
Playlists ... 133
Level Music, Loops, and Decay Tails ... 135
Decay Tails ... 136
Loop with Integrated Decay ... 136
Play Then Loop ... 137
Looping Manually ... 139
Stingers/Ornamental Forms ... 141
Simple Parallel Forms ... 143
Simple Transitional Forms ... 144
Conclusion ... 146

04 Music Part B: Basics and Parallel Forms **149**

Introduction 149
Music Basics 149
 Source Music 149
 One-shots 150
 Music for Timed Events 152
 Ornamental Forms/Stingers 154
Parallel Forms 156
 Switching or Fading Layers (Parallel Forms for Orientation) 157
 Using Variables to Determine Volume (Parallel Forms for Proximity) 159
 Linear Variables to Volume 160
 Curves to Volume 164
 Mix Automation for Parallel Layers 166
Conclusion 171

05 Music Part C: Transitional Forms **173**

Introduction 173
Clunky Transitions 173
 Nasty 173
 Crossfades (and When to Use Them) 175
 Masking Transitions 177
Musical Transitions 178
 Working with Chunks: Measure-based Transitions 181
 Decay Tails Revisited 182
 Controlling a Switch 183
 Transitioning on Measure in Longer Pieces 185
 Pre-syncs or Ramps 187
 Aligned Transitions 190
 Putting It Together 193
A Musical Conclusion 194

06 Dialogue **197**

Introduction 197
Randomization 198
 Better than Random? Randomize without Replacement 200
Dialogue for Advice 201
 Timed Help Advice 201
 Triggered Advice 202

Dialogue Interrupts 204
 Bad/Better/Better-er 204
Conditions and Dialogue Choices 208
 Simple Conditions and Dialogue Choices 208
 Counts to Dialogue Choices 210
 Tracking Multiple Actions or Inventory for Dialogue Choice 212
 Conditions to Sound Cue Branching Choices 216
Branching Dialogue 217
Characters, Contexts, and Dialogue Choices 221
Localization or Localisation? 224
Conclusion 225

07 Making It Real 227

Introduction 227
Sound Propagation 227
 Reverb: Advanced 227
 Nested Reverbs and Prioritization 229
 Reverb: Prebake 233
 Spatialization 233
 Sound Source Types 234
 Directional and Diffuse Sources 238
 Distance Attenuation and Detail over Distance 240
 Filter over Distance 244
 Detail over Distance 245
 Occlusion, Obstruction, and Exclusions 246
 Occlusion 246
 Ambient Zones 250
 Prioritization of Zones 252
 Obstructions and Exclusions 253
 Dynamic Occlusion 254
Moving Objects and Moving Sounds 256
 Sounds That Move 256
 Moving Sound Sources with Matinee 257
 Creating Movement 258
 Moving Objects That Make Sound 260
 Rotating Doors 260
 Open/Opening Loops 262
 Matinee Events for Mechanical Systems 263
 Matinee Sound Track 265

Physics 266
 Speed of Sound 266
 Doppler 267
 Doppler: Faking It 268
 Collisions 269
 Simple Object Collisions 269
 Velocity to Collision Sounds 271
 Sliding, Rolling, and Scraping 274
 Physics-based Collisions: Cascading Physics 276
Prioritization: Number of Voices Control 278
Animations 279
 Footsteps 01: Anim Notifies 280
 Footsteps 02: Surfaces 281
 Footsteps 03: Creep/Walk/Run 285
 Footsteps 04: Foley or Weapon Carrying Layers 287
 Footsteps 05: Other Notes 288
Cameras and Cutscenes 289
Cameras and the Listener 292
 Separating the Camera and Listener Position 296
Conclusion 299

08 Making It Good **301**

Introduction 301
Mixing 302
 General Mixing Principles 302
 Reference Levels 305
 Sound Classes and Sound Mixes: The Unreal Engine Mixing System 305
 Sound Class Properties 306
The Roles and Functions of Game Audio 309
 The I.N.F.O.R.M. Model 310
 Instruction 310
 Sound Mix: Triggered Ducking 310
 Sound Mix: Triggered EQ 312
 Passive/Automatic Mix Changes 314
 Sound Mix: Base Sound Mix and Mix Modifiers 317
 Notification 320
 Character State 321
 NPC State 321

Object State		322
Game State		323
Feedback		323
Pickups		323
HUD Interactions		324
Orientation		326
Navigate		326
Attract		327
Repel		327
Rhythm-action		327
Mechanic		327
Recall/Learn		328
Decoy		328
Mask		330
Testing the Mix		331
Conclusion: Audio Concepting		332
09	**Advanced: Weapons**	**335**
Introduction		335
System		336
One-shot, Retriggered, or Loop?		338
One-shot		338
Retriggered		340
Retriggered with Tail		342
Loop with Tail		343
Looping Beam Weapons		344
Projectiles		345
Feedback		347
Environment and Distance Elements		348
Environment Layers		348
Distance Layers		350
Bullets		352
Impacts		352
Casings		354
Whizzbys		355
Conclusion		356

10	**Advanced: Vehicles**	**359**
	Introduction	359
	Simple Velocity to Pitch	359
	Crossfading Elements	361
	Pitch Curves for Automatic Gears	364
	Smooth Operator	365
	Surface/Tire Layers	366
	Skids	368
	Additional Elements	369
	Engage/Disengage	369
	Turbo Dump	370
	Impact and Damage Layer	371
	Wind Layer	371
	Engine Load/Stress Layer	372
	Car Body Movement or Suspension Layer	373
	Vehicle Cameras	373
	Conclusion	373
11	**Advanced: Sports Dialogue and Crowds**	**375**
	Introduction	375
	Crowd Systems	375
	Randomized Crowd	376
	Crowd Excitement Levels	376
	Commentary	378
	Color Commentary	379
	Concatenated Dialogue for Play-by-play Commentary	380
	Considerations for Concatenated Dialogue	385
	Dialogue Queues	385
	Conclusion	388
12	**Advanced: Music**	**391**
	Introduction	391
	Harmonically and Rhythmically Aware Stingers	391
	Harmonically Appropriate Stingers	391
	Rhythmically-synched Stingers	393
	Sequenced Melodies	395
	Play for Proximity	395
	Chained Melodic Pickups	395

Algorithmic or Procedural Forms 396
 Generative Combinations 397
 Granular Note-level Sequences 399
 Using Random Seeds 400
Rhythm-action 403
 Graphically Led 404
 Call and Response 406
Conclusion 408

Conclusion 409
Appendix A: Core Concepts 410
 Key and Gamepad Inputs 410
 Events and Triggers 411
 Manipulating Actors 414
 Referencing In-game Actors within Blueprints 415
 Variables, Parameters, Numbers, and Arrays 416
 Transforming and Constraining Variables and Parameters 420
 Reading through Curves 421
 Evaluating Variables and Parameters 423
 Routing Decisions and Events 424
 Custom Events 426
 Controlling Audio Components 427
 Sound Cue Nodes 430
 Console Commands 433
 Others 435
 Matinee 435
 Attaching Actors to other Actors 436
 Timeline 437
 Audio Finished 437
 Timer 438
Appendix B: Blueprint Primer 439
 Navigating, Creating and Connecting 439
 Events and the Programming Paradigm 439
 Compiling Blueprints 441
 Actor Blueprints 442
 Structures 443
 The Graph Action Menu 443
 Creating Nodes between Existing Connections 445
 Finding Things in Blueprints 445

Communicating between Blueprints 445
 Casting 445
Event Dispatcher 447
Getting References to Spawned Actors 448
Appendix C: Testing, Troubleshooting, and Good Practice 449
 Watching Blueprints 449
 Print String 450
Auto-Save Recovery 451
Organizing and Commenting 452
Working in Separate Audio-only Levels 453
Tips for Slow Running 456
Index 458

Acknowledgements

Thanks to our colleagues and students at Leeds Beckett University and to Chris Forde, Nick Campbell, Evangelous Chouvardas, Matt McIntosh, Ben Minto, Andrew Quinn, Joe Thom, Naila Burney Arango, Andreas Hamm, Dan Reynolds, Benny Reibel, Sean Connelly, Caitlin Murphy, Paul Ratcliff and the rest of the team at Focal Press for their contributions and input.

Audio editing screenshots taken in REAPER from Çockos Incorporated and Adobe Audition from Adobe Systems Software Ltd. Screenshots made using ShareX, and a vast amount of things to do organized with help from Trello.

A huge thanks to our respective families for their immense patience, to Frank and Gwen for providing some much needed diversion, and to the game audio community for being an inspiring, helpful, and supportive bunch of people. #gameaudio

Introduction

Making a modern game is a process of intense collaboration, and we hope to provide you with the tools and knowledge to make an important contribution to that process. Although you might be an audio specialist, the sound, music, and dialogue in the game are only going to be as good as the systems that trigger them or feed them with gameplay information. This is why we will take you not only deep into the audio, but will also help you to understand the game systems behind it.

This book is driven by two beliefs. The first is that people learn best about game audio by implementing audio in real games. The second is that the greater the integration we can have between the game designers and the audio designers, the greater the opportunities for audio as part of the gameplay experience.

Middleware solutions such as WWise, FMod, and others can provide great tools, and we would encourage you to learn these as well, but we want you to get experience working in real game scenarios and to be able to be proactive, not just reactive. You don't want to be waiting around for a designer or programmer to implement something that, with a little knowledge, you could do in 30 seconds. Having this knowledge about the systems behind the audio will allow you to have real control, to be more involved in the game's production, to be able to build prototypes for your ideas, and to influence the game's development through a shared common toolset that everyone can understand and relate to. The Unreal Engine is behind many of today's biggest games and provides us with this opportunity.

Game audio is not about learning a piece of software, since software changes all the time, and as you move from company to company, you'll always need to learn new tools as most games use internal or proprietary systems for their audio. The concepts and theory you'll learn here are transferable to any game audio engine or middleware that you might come across, and the visual scripting paradigm you'll become familiar with is a fundamental part of almost all modern game development tools.

The approach we've taken will allow you to gain real hands-on experience developing audio within a commercial game engine while also equipping you with the skills and knowledge to apply this learning in the future to other game engines and platforms you may encounter. By understanding the means of production, you won't just be the passive provider of assets but will understand the game design process, allowing you to get involved, to experiment, and to innovate.

We hope you find this book useful.

Richard and Dave

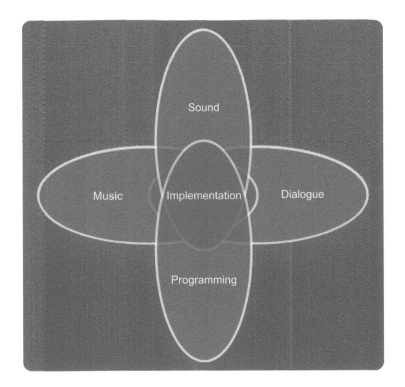

Approaches to the Book

This is a practical hands-on book since most people learn best through doing. It is not for cozying up in front of the fire and reading, but to have by your side as you sit at your computer producing and implementing audio in real games. In any system there are usually multiple ways in which you can achieve the same results, some of which may be 'better' than others. We have chosen the methods for the book on the basis of demonstrating the principles in as straightforward a way as possible. Making a game is a complex process. Although in some places there are a few steep learning curves, approach it with patience and a methodical attitude, and you will have lots of fun!

Let us say straight away that we expect very few people to complete the whole book! Take what you need and then use it as a reference to return to as and when you need it. If you are focused on learning about a specific aspect or role, then use the chart below as a guide to which sections might be of most interest to you.

	Basic All Rounder	Advanced All Rounder	Sound Designer Basics	Sound Designer Advanced	Composer Basics	Composer Advanced
00 Loading Sequence	☐	☐	☐		☐	☐
01 Sound A	☐	☐	☐	☐		
02 Sound B	☐	☐	☐	☐		
03 Music A					☐	☐
04 Music B						☐
05 Music C						☐
06 Dialogue		☐	☐	☐		
07 Real		☐		☐		
08 Good		☐		☐		
09 Advanced: Weapons		☐		☐		
10 Advanced: Vehicles		☐		☐		
11 Advanced: Sports Dialogue		☐		☐		
12 Advanced: Music		☐				☐

There are 12 different game levels to download and play around with, one for each chapter or section of the book (visit www.gameaudioimplementation.com). There are lots of different games here in all

types of genres, so you should get a wide experience. As you start each chapter, you should download the relevant chapter project. We explain things in as much detail as we have room to do in the book, but for a full understanding of the systems, you'll want to open up the demonstration levels and take a deeper look. We'd recommend downloading and printing out the 'Locations Guide' document from the website which gives a quick overview of techniques and where you can find them in the demo levels.

Each technique in the book is accompanied by an exercise. You should also download the exercise level, which is one big map that you will gradually populate as you work. By the end of the book, you will have a complete game that you can use as your own demo project. Follow through the exercise instructions, but also look back at the description of our demo systems for further guidance. We have also included screenshots of the systems for each completed exercise as a separate download on the website, so you can take a peek if you get really stuck. And don't forget to check the FAQ on the website.

The Unreal Engine is constantly updated, so things change and occasionally break! We will check regularly and update the demo levels when required, and we will highlight the recommended Unreal Engine version on the download page. Don't forget to also look at the Unreal Engine website and the News and Learn tabs of the Epic Launcher for lots of additional tutorials on various aspects of the program that might come in handy.

Sound designers Andrew Quinn and Joe Thom have also put together a fantastic resource of sound effects on the site for you to download and use. These can be found on the Sound Library page of the website.

Health warning: Although you are going to be building lots of systems yourself, it's always worth getting your programmer/engineer to take a look as well in terms of optimization.

The Formatting of the Book

We have tried to format the book so that things are as clear as possible and you can quickly find the things you need. This may appear a little bewildering at first, but hopefully it will all soon start to make sense!

Project:

Level:

These are the projects you should download, and maps or levels you should open for each chapter. We are going to be using the terms map and level interchangeably.

Area_01

This indicates a particular area of the demo level map or exercise level. You can find these in game by searching in the ➡ World Outliner. Each area is indicated in level by an in-game icon that bears the *Area* name.

They are usually also accompanied by (Bookmark #) to indicate the shortcut key you can use to jump straight to this area of the game in the editor.

"Blueprint Section"

These are sections of the Blueprint where we have added a comment box to help your find them.

➡ Interface Panels

The interface of the Unreal Editor is comprised of many ➡ Panels that allow you to access different things. This icon indicates that we are talking about one of these.

[Actors], [Blueprint], and the [Level Blueprint]

These are either in-game [Actors] you can find in the game world itself or [Blueprints], which are systems where you can control game events and variables. The [Level Blueprint] is a special Blueprint where you can design the main gameplay systems.

<Blueprint Nodes>

These are the individual functions that you string together in Blueprints to create gameplay.

{Assets}

These are game assets that can be found in the ➡ **Content Browser** (with the exception of Blueprints).

-Sound Cue Nodes-

These are nodes that are specific to Sound Cues.

Variables and Menu Options

These are, well, variables and menu options.

Loading Sequence: Quick Start 00

Summary : Opening projects and maps, bookmarks, looking and moving around in the game environment, finding in-game Actors and swapping out their sounds using the Content Browser

Project : DemoCh00Shooter01 **Level :** Shooter01

Setting up the Demo Projects

Summary : Getting started with the tutorial projects

Install UE4 from www.unrealengine.com.

Now go to www.gameaudioimplementation.com and firstly download and install the GABInstaller files, following the instructions on the website. This contains files that are needed for the demo and exercise levels. As you start each chapter you'll also want to download and install the appropriate chapter demo levels, so for this chapter download DemoCh00Shooter01 and follow the instructions for installing this to your working folder. Your working folder will be:

PC: C:\Users\UserName\Documents\Unreal Projects
Mac: /Users/UserName/Documents/Unreal Projects/

You should always work with your project folder stored at this location, not an external drive or anywhere else. When you need to switch computer (from work to home, etc.) just copy your project folder and put it in the same location and all the references should remain intact.

The GABInstaller also puts some other files that we'll be referring to later on in the Engine Folder:

PC: C:\Program Files\Epic Games\Engine Version
Mac: /Users/Shared/Epic Games/Engine Version

Navigation of the Game World

Summary : The Level Editor interface, version control, bookmarks, moving around, in-game Actors

From the Epic Games launcher:

PC: Start Menu/Epic Games Launcher
Mac: Applications folder\Epic Games Launcher

Choose Library/DemoCh00Shooter01.

If you can't see it in the library, you may need to relaunch Unreal or check that you've put the project in the correct place.

Once the project is opened, you'll see the main level editor workspace. From the File menu, choose Open Level and select the level called Shooter01.

Now play the map by clicking on the very appropriately named Play icon on the top toolbar.

Shoot some stuff using the arrow keys to move your ship and spacebar to fire. You can toggle a full screen view using F11 (or Mac Function + F11). Press the Esc key to return to the level editor window.

Version Control and Auto-saves

It's good to mess around and try things, so we'd encourage you to start playing around with the game itself as soon as possible—just make sure it's easy to get back to a working version first. Let's start by saving your own new version of the level. That way you can always easily go back to the original.

If you find yourself working on a commercial game you'll have to quickly get used to the idea of version control. Obviously in a multimillion-dollar business, you can't rely on the "I think Johnny had a copy of it on his pen drive" approach to file management. Version control software such as SVN or Perforce provides a networked system for backing up and tracking changes of all the game and development data, but even if you're working by yourself or in a small team, it is no less important to get into good habits so you don't lose hours of work.

Incremental File Naming

Don't call your map "MyLevel" and then keep saving your work over the previous version. If something goes wrong or this file becomes corrupt, you'll have nothing, and those hot salty tears of regret won't help. Every time you save a level (which should be often) use the date and an incremented file name:

MyMap_2021_12_25_V001

Fifteen minutes later...

MyMap_2021_12_25_V002

You'll notice that we're using Year_Month_Date_, as this makes it easy to sort by filename to see a historical record of your versions in order of date. Do the same with your audio files and DAW sessions. Adopting this approach means that when it all goes horribly wrong, you've only lost 15 minutes of work, not 15 hours. You'll also notice that we've used underscores (_) instead of spaces. You should get into the habit of doing this with all your files when working in game development, including your audio files. The general rule is that game development software doesn't like spaces!

Backup

Once a day back up your work to several locations. As well as using different hard drives, this includes different physical locations. Offices or homes do occasionally burn down or get flooded, so keep a copy in more than one place. This may seem like an impossibly dull way to start your adventures into game audio—and it is, but you'll thank us later!

Auto-saves

As you can get absorbed in work and forget to save regularly, the Unreal Engine has an auto-save feature. The default setting is to auto-save your maps and content every 10 minutes, but you can change these settings via the Edit/Editor Preferences/Loading & Saving menu.

The auto-save files are saved here:

PC: C:\Users\UserName\Documents\Unreal Projects\Project Name\Saved\Autosaves
Mac: /Users/UserName/Documents/Unreal Projects/Project Name/Saved/Autosaves

If the worst does happen, then you can copy the auto-saved map back into your project maps folder:

Project Name\Content\Maps (see also Appendix C/Testing, Troubleshooting, and Good Practice/ Auto-Save Recovery)

Although this can be useful in an emergency, we would not advise relying on this too much, so get into the habit of making your own regular saves.

Looking and Moving

If you haven't used a game editor before, simply navigating your way around is probably going to be one of the steepest learning curves.

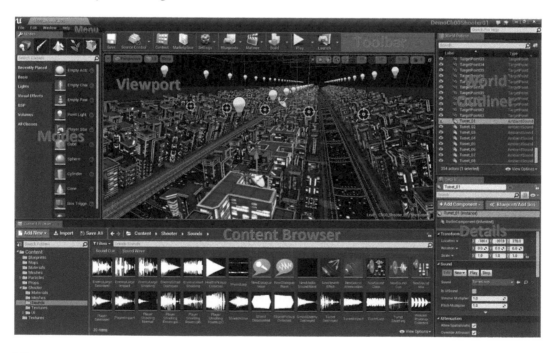

Views

The interface is set up as a number of ➡ Panels and the whole area is drag-and-drop configurable to suit your working habits. You can select which panels are visible from the Window menu (and if you make a mess of things, you can use the Window/Layout/Reset Layout option).

Menu: This area has the File/Open, Edit, Window, and Help menus.

Toolbar: This area has Play and Build and open Blueprints and settings.

- ➡ **Modes:** This panel has five sub-tabs: Place, Paint, Landscape, Foliage, and Geometry. We will be mostly using Place to find Actors that we can drag and drop into our level.
- ➡ **Viewport:** This is where we see the game level itself.
- ➡ **World Outliner:** We can search this to find Actors located in the game world.
- ➡ **Details:** This shows us the settings for the currently selected Actor.
- ➡ **Content Browser:** This is where all of our game assets are viewed.

Note that each ➡ **Panel** has an icon, and it's worth getting to know some of these in order to more quickly locate the ➡ **Panel** you are after when you have multiple panels opened as separate Tabs. You can use Ctrl + Tab to quickly switch between open tabs.

In the ➡ **Viewport** panel, there are a few options for changing the views that may come in handy in the future.

Try some of these now. For instance, try changing (1) to a top-down view (Alt + J). Now look at the level in wireframe mode (2) (Alt + 2). Also try changing from lit mode to unlit. This isn't as pretty but makes the editor run a lot smoother! We'll be spending most of our time in perspective view (Alt + G) and lit mode (Alt + 4), so return to these settings for now.

If at this point you are getting frustrated because Unreal seems to be running slowly, then look ahead to Appendix C: Testing, Troubleshooting, and Good Practice/Tips for Slow Running. The other thing you'll want to try is muting and unmuting the Real Time Audio from the Settings/Real Time Audio menu. For now you should hear the game music, which you may want to mute again so it doesn't drive you crazy. You'll want to use this Real Time Audio a lot when auditioning ambient sounds.

Bookmarks

In this first map, we've put some basic navigation points. Click the mouse in the ➡ **Viewport** window to make sure it's selected and then try jumping between these points by pressing keyboard keys 1, 2, 3, and 4. You can override these or create your own by pressing Ctrl + a number key (e.g., Ctrl + 1) to set them up. It's a real time saver to set up these kinds of geographical bookmarks when working on your own levels. For now press 1 to return to the first bookmark.

Moving/Looking

Most level editors use a combination of mouse buttons to enable you (or what is sometimes referred to as the camera) to move around the X/Y/Z axis in the 3D space. Some (like Unreal) also allow you to use first person shooter type keys for navigation. Hold your right mouse button (RMB) down, and try using the following keys to move around:

W/S (forward/back along the X-/Y-axis)

A/D (left/right along the X-/Y-axis)

E/Q (up/down along the Z-axis)

Now try holding your left mouse button (LMB) and moving the mouse, using the mouse wheel and holding both mouse buttons together to start seeing how you can also use these to navigate in different ways.

LMB (left mouse button): Rotate camera left/right and move forward/back

RMB (right mouse button): Mouse look

LMB + RMB: Move left/right and move up/down

Mouse Wheel: Move forward/back

In-game Actors: Finding and Changing Your First Sound

As you fly around the level, you'll notice lots of icons that are not visible when you actually play the game. These are called [Actors], and you can press G to toggle their visibility in the editor. You can of course move around the level to find and select any [Actor] you're looking for, but it's often quicker to use the ➡World Outliner that is usually found in the top right-hand corner of the editor window.

Go to the ➡World Outliner now and find [AmbientSound01] either by scrolling through the list or by typing the name in the search box (this is usually quicker).

This is an [Ambient Sound], an Actor which is typically used to place sound at specific locations in the game. In this case, however, it is playing a stereo music file and so is not actually spatialized.

Double-click on [AmbientSound01] in the list or press F with it selected to focus on it. This will shift your Viewport to look at the Actor. Now look at the ➡Details panel, and you can see the sound that's currently attached to this Actor, {Musicloop}. Selecting a distant Actor in the ➡Viewport and pressing F is also very useful for quickly navigating your way around.

Try selecting a different sound from the drop-down menu, {MusicLoop_Alt} for instance, and then play the game again (Alt + P). You've just implemented your first game audio—easy!

You can add sounds to [Ambient Sound] Actors by using this drop-down list (which lists all suitable assets in your project folder) but another method we'll be using a lot is via the ➡Content Browser.

Navigating the Assets and the Content Browser

Summary : Browsing for assets, folder structures, searching, and filtering results

When you create a new project, a set of folders is generated.

These are where your assets for the project are stored, and you access them through the ➡Content Browser.

PC: C:\Users\UserName\Documents\Unreal Projects\
Mac: /Users/UserName/Documents/Unreal Projects/

The ➡Content Browser is also where you can create new assets of different types via the Add New menu.

Filtering Results

Looking at the ➡Content Browser you can see the project folder structure is replicated down the left-hand side. As you select a folder, the file path is shown along the top, and you can also use this to navigate the folders.

You can search through these folders in the same way you would in your computer's Finder/Explorer, but there are a number of utilities that you can use that will make your searching and navigation a lot faster. After selecting the parent folder Content, use the Filters drop-down menu to choose to see only the files of type: Sounds/Sound Wave. You will now see only the Sound Waves, and you will see all of them for the entire project, including any subfolders. Having made a filter selection, this becomes a button underneath the Filters menu that you can then switch on/off when required.

In the top box, you can start typing the name of a wave you are looking for (e.g. TurretShooting) and it will again filter your results by name. A combination of typing the name in the search box and filtering by type means it's very quick to find the asset you are after.

The View Options menu in the bottom right-hand side of the ➡Content Browser also allows you to see your assets in a list or in columns—which provides some useful additional information we'll be looking at later.

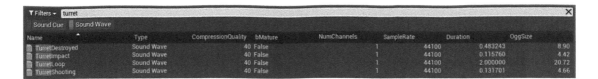

Let's use the ➡Content Browser now to find a sound to swap out for the turrets in the game.

Use the Sound Wave filter and search for "Turret" to find the {TurretLoop_Alt} sound asset. Click on this to select it.

Now in the ➡World Outliner, search for the ambient sound [Turret_01]. With this selected you can now use its ➡Details panel to click on the arrow alongside the Sound row to assign the item you have selected in the ➡Content Browser to this [Ambient Sound].

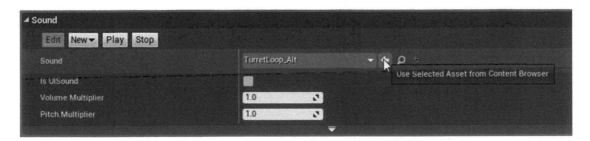

This idea of selecting an asset in the ➡Content Browser and then using the arrow key to assign it to an [Actor] is a key technique in the Unreal Engine. The magnifying glass icon next to it is equally useful, as this will find and focus on the currently assigned asset in the ➡Content Browser.

Play the game again (Play icon in the ➡Toolbar), and you should now hear that the first turret has a new sound. (Ordinarily we might combine the Turret graphics and the Turret sound into a re-usable Blueprint—we'll be looking at this in the next Chapter.)

There are 9 other turrets that need changing, but this need not be laborious. If you select multiple Actors at the same time, you can access and change their ➡Details simultaneously. Use the ➡World Outliner again to find "Turret_", and you should see the other 9 Actors. Select them all then assign the sound using the arrow button as you did before (make sure your asset is still selected in the ➡Content Browser).

We've looked at using the ➡World Outliner to find Actors placed in our game, and the ➡Content Browser to find assets. The rest of the sounds for this level are controlled deeper within the system of the game, so we will now plunge straight away into the wonderful world of Blueprints.

Navigating the Game System: Blueprints

Summary : Blueprints, navigating Blueprints, and swapping out assets in Blueprints

Blueprints are Unreal's node-based visual scripting system used for creating gameplay. To put it another way, there are a bunch of boxes (nodes) that do certain things, and we create gameplay by stringing them together in different ways! There is more on Blueprints in Appendix B: Blueprint Primer.

Open the [Level Blueprint] by selecting Blueprints/Open Level Blueprint from the top ➡Toolbar.

You will be presented with the Blueprint ➡Event Graph. This will look pretty intimidating at first but move around the screen by holding down the RMB (right mouse button) to grab and drag the screen and the middle mouse wheel to zoom. (See Appendix B: Blueprint Primer/Navigating, Creating and Connecting for more.)

Find the section labeled "Turrets—Stop AmbientSounds".

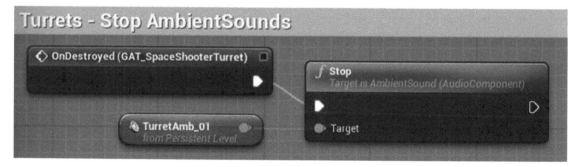

Here's a simple example where the Blueprint is set up to stop the appropriate [Ambient Sound] in the level if the player shoots and destroys the turret. We'll go more into Blueprints as we work our way through the book, but for the moment we just need to open and navigate around them in order to find and swap out the other sounds in the game.

Use the search box in the [Level Blueprint] (Ctrl + F) to search for ShieldActive, then double-click on the result. This will find it and focus the view on a node called <Play Sound Attached> in the

Shield Logic section of the Blueprint. This triggers and stops the ShieldActive sound that plays when you get a shield pickup in the game.

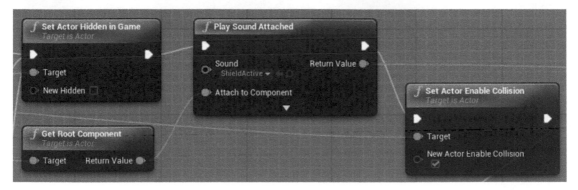

You'll see that this node <Play Sound Attached> has the familiar arrow and magnifying glass icons for assigning a sound from the ➡Content Browser and finding sounds in the ➡Content Browser. You can swap out the ShieldActive sound by selecting your chosen asset in the ➡Content Browser (e.g., {ShieldActive_Alt}) and clicking the arrow to assign it. While you're here, if you look a little to the right in the ➡Event Graph, you'll see the <Play Sound Attached> node used for the shield deactivated sound (when the shield runs out). You can swap this out for an alternative sound in the same way (e.g., {ShieldDeactivated_Alt}).

That's all good fun, but by now we expect you're itching to bring in some of your own sounds—read on!

Preparing Assets for Import

Summary : Editing, bit depth, sample rate, and looping considerations prior to sound file importing

Before you can implement your own sounds in the game, you'll want to make sure that they are nicely edited and in the correct format. This will save you a lot of headaches later on, and it's worth getting into best practices from the start. If you're already happy with the need to edit the sounds well, use appropriate sample rates, and how to loop sounds nicely, then you can jump right ahead to Importing Assets below if you like, but it's probably worth having a quick recap anyway.

Editing

Sound and music editing takes place outside of the Unreal Engine in your preferred DAW. We're fans of REAPER since it's cheap (always important!) and has a number of features that are good for batch processing audio files, something particularly useful for game audio.

So you've got a nice sound, let's say for traditions sake it's a beep, and you're about to import it into your game.

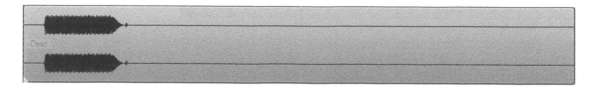

As we'll explore in Chapter 02, a key challenge in audio for games is that your audio needs to fit onto a gaming platform's memory or within various download restrictions. The first thing you'll want to do is edit it nicely, since the silent parts of a sound file actually take up exactly the same amount of memory per second as the parts with sound!

Before editing: *Beep_01_32_96* = 746kB,

After editing: *Beep_01_32_96_Edited* = 113kB

Sample Rates and File Formats

Next you'll want to consider the sample rate and bit depth of your sound. You may have recorded it at 96kHz and 32bits for the best fidelity of information when manipulating the audio, but for playback Unreal will only accept files of 16bit format, and 96kHz is unnecessary.

Stereo 32bit, 96 kHz: *Beep_01_32_96_Edited* = 113kB

Stereo 16bit, 44.1kHz: *Beep_01_16_44_Edited* = 26kB

What about if we took it down to 22kHz—does it really make a difference? Depending on the frequency content of this file, it may indeed make a significant difference to the sound. Use your ears (and the Nyquist-Shannon theorem) to decide. In the case of our *Beep*, it still sounds fine. If you have amazing quality files for all your basics, you may find yourself needing to compromise on important

stuff later on (especially if you're working on a downloadable or mobile game where file size is particularly limited).

```
Stereo 16bit, 44.1kHz: Beep_01_16_44_Edited = 26kB

Stereo 16bit, 22kHz: Beep_01_16_22_Edited = 14kB
```

Lastly we know that this *Beep* will actually be played from a specific spatialized location in the game, so we don't actually need or want a stereo file.

```
Stereo 16bit, 22kHz: Beep_01_16_22_Edited = 14kB

Mono 16bit, 22kHz: Beep_01_16_22_Edited_Mono = 7kB
```

So we've made the sound more than 100 times smaller, and in-game it will sound exactly the same.

File Importing Checklist

Filename without spaces in it?	✔
16-bit?	✔
Appropriate sample rate?	✔
Mono?	✔

Exercise 00_01: Preparing Assets for Import

In the folder below, we've provided you with some audio files.

PC: C:\Users\UserName\Documents\Unreal Projects\DemoCh00Shooter01\Prep
Mac: /Users/UserName/Documents/Unreal Projects/DemoCh00Shooter01/Prep

1 Using the advice offered above regarding editing, bit depth, and sample rates, see how small you can make them without significantly affecting their sound quality.

Looping

To swap out the shield sound and music for your own, you'll need to edit these so that they loop well. Getting a nice loop can be tricky. Unless you get lucky, your initial selection from a sound will probably loop around with some kind of audible click. We'll look in more detail at issues around looping music in Chapter 03, but for the moment we will look at some basic looping concepts.

Usually when creating a loop, you're either after something that definitely sounds repetitive, like a mechanical or electronic sound, or you want something that sounds seamless so it doesn't feel like a loop at all. The key to both loopy loops and invisible loops is to combine careful listening with a close look at the waveform of the sound itself. If you want a more seamless tone, then your first aim is to find a part of the file that is fairly constant. If there is too much change or any characteristic sounds are popping out, then as it loops around these will become rhythmic and predictable, giving it a looping feel that we want to avoid in this case. For both kinds of loop, you want to find a start and end point where there isn't too much of a jump in volume—this is what causes clicks. After making your selection, it's often a good idea to look away from the screen when previewing your loops so you can concentrate on hearing whether it feels loopy or clicky and not be distracted by the waveform view.

For your shields you might want to start with an electronic alarm sound and find a section of it to loop for when the ships shields are on.

You may get lucky and your initial selection may sound fine, in which case just trim/crop the sound and export, and you're done! More likely you'll find that every time it loops around you have an audible click.

This is because there's a very sudden change in volume when it jumps from the end of the file back to the start. You can see this from the zoomed in waveforms below.

End of loop:

Start of loop:

Zero Crossings

The answer to this jump in volume is to find the nearest zero crossing points (see your DAW manual for how to do this) so that both the start and end of your loop will be on the zero line—hence no jump in volume, hence no click!

Mono files are a lot easier to loop nicely since with a stereo file you're looking for the coincidence of the left and right channel both having a zero crossing at the same point—which is very rare and may not be at the point where you want to loop.

Fades

Simply starting and ending your loop at zero crossing points won't always work, so another trick to try is to zoom right into the waveform and create a very short fade in at the start and short fade out at the end. Again, this helps to ease any rapid changes in volume that can cause clicks. If you experiment with different length fades, then you can often create fades that are quick enough not to be audible but still get rid of the click.

Split and Crossfade

If you're getting nowhere with the zero crossings or short fades, then you could try the following: Find a zero crossing point around the center of your file, and split your file at this point.

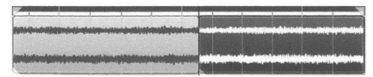

Now drag the final section to be in front of the first section, and create a little overlap. In some DAWs this will automatically create a crossfade where they overlap, but in others you'll need to do it manually. We know that our split point was at a zero crossing, and now our split point has been moved to the very start and at the very end of the file, so in theory it should loop well, and the middle section shouldn't click, as we've created a crossfade to ease the transition.

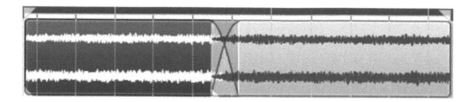

Note for some platforms your loops will need to be working in sample lengths that are divisible by a given number of samples (e.g., multiples of 64 or 28). Most tools that convert the audio for the platform will handle this automatically, but if your loop is working perfectly in your editor but not in game, it may be worth investigating this with your programmer. Looping MP3s can be particularly problematic, but there are some tools to help—See the Further Reading section of the website.

Exercise 00_02: Looping

In the folder below we've provided you with some audio files.

PC: C:\Users\UserName\Documents\Unreal Projects\DemoCh00Shooter01\Loops
Mac: /Users/UserName/Documents/Unreal Projects/DemoCh00Shooter01/Loops

1 Try some of the techniques outlined above to find some nice looping sections that you can import for your own turret sounds in a moment.

Importing Assets

Summary : Browsing for assets, folder structures, searching and filtering results

So after all that prep, we're finally ready to import our sounds. How tricky is this going to be? Not at all! Just drag and drop your sound files into a folder in the ➡ Content Browser (if you really want to, you can also use the Import button in the ➡ Content Browser).

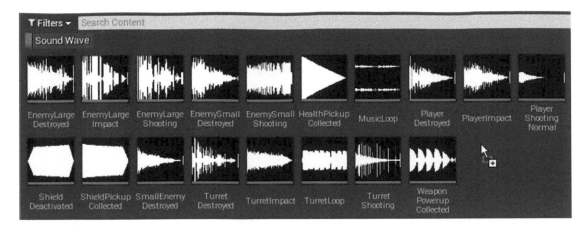

You can often drag and drop into the ➡Content Browser directly from your DAW browser, which is very useful! Should you want to swap out assets at a later stage you can also right click and *Reimport*—which is very useful too!

Folder Structures and Naming Conventions

Before you get too carried away with adding loads of sound and music files to your project, it's worth taking a moment to think about how you're going to organize them. Considering that the average game contains many thousands of audio assets, a little thought and planning now will prevent problems later on.

Useful folder structures are a good start, as illustrated in the following example:

➡Content Browser

Game/Audio folder:

SFX
```
Generic (used in multiple levels)
Level_01 (Specific to level 01)
Level_02 (Specific to level 02)
```

Music
```
Generic (used in multiple levels)
Level_01 (Specific to level 01)
Level_02 (Specific to level 02)
```

Dialogue
```
Generic (used in multiple levels)
Level_01 (Specific to level 01)
Level_02 (Specific to level 02)
```

17

You also need to think about your file names, even if you're not working in a team (where an established naming convention is essential). It's unlikely you'll remember what Grt_Brd_Crash_Tk12_va.wav actually is in one month's time. Many platforms have a limit on the number of characters you can have in a filename, so you'll need to come up with a list of meaningful abbreviations. Here are some examples:

```
Ambience:
        Location: Jungle/Desert/Mountains
                Type: Loop/OneShot,
                        Source: Birds/Insect/Animal
                        Specific: BU01

AmJuLoBiBu01.wav = Ambience Jungle Loop Birds Budgies 01

Foley:
        Character: Player/Squad/Fairies
                Type: Footsteps/Cloth/Equipment
                Surface: NA/Wood/Metal/Concrete

FoFaFoWo01.wav = Foley Fairies Footsteps Wood 01

Magic:
        Character: Player/Sage/Wizard Good/Wizard Bad
                Type: OneShot/Looped
                        Spell type: Fire/Ice/Donut

MaWBLoFi01.wav = Magic Wizard Bad Looped Fire 01

UI, Vehicle, VO (Type: Barks/Cinematic/Scripted), Weapon, etc.
```

You might also want to indicate in the filename whether the asset is Mono (**_Mo**), Stereo (**_St**), or Multichannel (**_Mt**).

How you choose to do this will depend of the type of game you're working on. If you have loads of vehicles for example, then this aspect will need some more definitions. Even a clumsy naming convention that people stick to is far better than no naming convention at all.

Exercise 00_03: MyShooter

Replace all the sounds in the game with your own original assets. Have fun and be brilliant, original, or brilliantly original!

1 Import your sounds and music (either by using the Import button in the ➡ **Content Browser** or by dragging and dropping the wavs into a folder in the ➡ **Content Browser**) then find the following references to sounds and replace them with your own.

2 Ambient Sounds

These are in the game as [Ambient Sound] Actors, so find them using the ➡World Outliner.
Select the [Ambient Sound], then swap out the sound in the ➡Details panel. Remember to select the asset you want in the ➡Content Browser then use the arrow in the ➡Details panel to assign it to the [Ambient Sound].

Music (loop): [AmbientSound01]
Turrets (loop): [Turret_01] (and others up to 10)
Don't forget that if you want your sounds to loop, you need to double-click on the Sound Wave to open the ➡Generic Asset Editor and check the Looping option.

3 Level Blueprint

Open the [Level Blueprint] using the Blueprints icon in the ➡Toolbar to see the ➡Event Graph, and then search (Ctrl + F) to find the relevant sound nodes (a search for "attached" will find the <Play Sound Attached> nodes).

ShieldActive—<Play Sound Attached>
ShieldDeactivated—<Play Sound Attached>

4 Actor Blueprints

Find these Actor Blueprints by selecting the Blueprints folder in the ➡Content Browser, and then double-click to open the Blueprints and search (Ctrl + F) to find the sound nodes.
For example, open the Blueprint from the ➡Content Browser: [GAB_SpaceShooterPawn]
Then find and replace:
Player ship shooting—
Search "playershootingnormal" then replace the reference in the <Play Sound At Location> node.
Impacts on player ship—
Search "playerimpact" then replace the reference in the <Play Sound At Location> node.
Player ship destroyed—
Search "playerdestroyed" then replace the reference in the <Play Sound At Location> node.

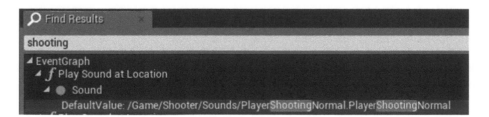

5 Below is a list of the rest of the sounds:

Blueprint Name	Sound Function	Sound Name
GAB_SpaceShooterEnemy_Large	Large enemy shooting	EnemyLargeShooting
	Large enemy impact	EnemyLargeImpact
	Large enemy destroyed	EnemylargeDestroyed
GAB_SpaceShooterEnemy_Small	Small enemies shooting	EnemySmallShooting
	Small enemies destroyed	EnemySmallDestroyed
GAB_SpaceShooterTurret	Turret shooting	TurretShooting
	Turret impact	TurretImpact
	Turret destroyed	TurretDestroyed
GAB_SpaceshooterHealth	Health pickup	HeathPickupCollected
GAB_SpaceShooterShieldPickup	Shield pickup	ShieldPickupCollected
GAB_SpaceShooterAmmo01	Ammo 01 pickup	WeaponPowerupCollected
GAB_SpaceShooterAmmo02	Ammo 02 pickup	WeaponPowerupCollected
GAB_SpaceShooterAmmo03	Ammo 03 pickup	WeaponPowerupCollected

Conclusion

We've covered quite a lot in this section, but it means you've come a long way and now know how to navigate your way around the interface and the game world, as well as how to import assets and add them to existing objects (whether in-game [Ambient Sounds] or in Blueprint <Nodes>).

For further reading there is a wealth of material out there about UE4. The documentation on the Unreal Engine website is a good place to start, along with their video tutorials. Visit www. unrealengine.com.

Recap:

After working through this chapter you should now be able to:

• Prepare assets through editing (including editing for loops if required) and modifying bit depth and sample rates;

- Import assets by dragging and dropping audio files from your Explorer or Finder window into the ➡Content Browser;
- Find assets by using filter by type and search by name in the ➡Content Browser;
- Find in-game [Actors] by using the ➡World Outliner panel to search by name or type;
- Assign assets to [Ambient Sound] Actors and Blueprint nodes.

Sound Part A: Ambience and Environment

01

Summary : Ambience with Ambient Sound Actors, attenuation shapes and falloff distance, spatialization, filter over distance, area loops, source loops, source one-shots, player-oriented one-shots, Sound Cues, audio volumes for reverb, triggers and triggered sounds, embedding sounds into Blueprint Actors

Project : DemoCh01Jungle01 **Level :** Jungle01

You can skip between the different locations in game using the keys 1–9.

Introduction

Summary : Playing the game

Download, install, then open the Project: DemoCh01Jungle01 and the Level: Jungle01.

Play the map.

If you're not used to this kind of first person shooter environment, then practice using the mouse to look around and the W, A, S, and D keys to move around (don't forget if you hold down the RMB you can also move around in similar fashion within the editor). Press the Esc key to return to the editor window.

Now press the Bookmark keys 1–9 to have a look at the different areas in the environment. Explore the level and get a feel for how the sounds are working. Remember you can also hear the Ambient Sounds in edit mode by enabling Real Time Audio from the Settings menu on the ➡Toolbar.

To be able to jump in and play the game from any starting position, the easiest thing to do is to change the play settings (the drop down menu next to the Play icon on the ➡Toolbar) to Spawn player at/Current Camera Location. You can also right-click anywhere on the floor surface and choose Play from Here, but this can be a little unreliable.

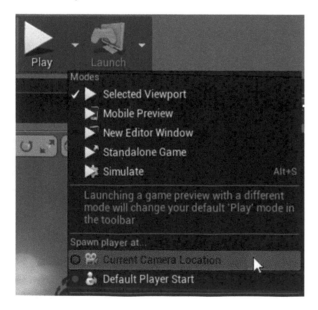

Ambience

Summary : Ambient Sound Actors, attenuation shapes and falloff distance, area loops, source loops, source one-shots, player-oriented one-shots

The background ambience to your level forms the crucial foundations on which everything else sits. The attention to detail required for really immersive ambience is one thing that's sometimes overlooked by people starting in game audio. In this section we'll be looking at how to implement both the background environmental sounds and sonic landmarks of your map.

Exercise 01_01: Listening Exercise

1. Sit quiet and still for one minute. Write down everything you hear.
2. Now think about how you might begin to group these sounds by their characteristics. You'll find that they tend to be either constant/looping sounds (usually from some kind of mechanical or electronic source) or one-shots (usually instigated by some sort of human or natural agent). You might end up with something like this.

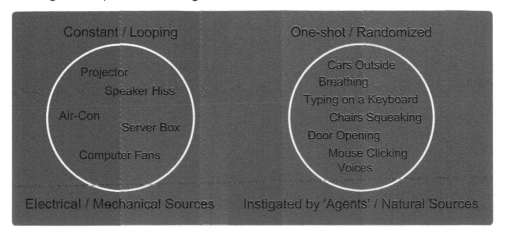

3. Reflect on how you might need to implement these in-game in different ways and the amount of detail there is in even the simplest audio environment.

Types of Sound

Ambient Sounds tend to be implemented in the following ways:

Area Loops—These are typically long loops (2–3 minutes) that cover particular sections of the environment. These can sometimes include both background sounds and occasional one-shots, or be shorter loops with just a background area or room tone. Although they sometimes have spatial sounds within them (typically being stereo or quad files), they play back directly to the players ears and don't pan around as you move.

Source Loops—These are shorter looping sounds that come from specific spatialized sources in the game (typically 4–10 seconds of mechanical/electrical sources that naturally have looping characteristics) and so are spatialized in the game world.

Source One-shots—These are the occasional one-off spatialized sounds that occur at randomized intervals to give the impression of life and activity in the level. The source could be a specifically located one or an imaginary one.

Player-oriented Sounds (POS)—These are similar to source one-shots but come from imaginary sources that we don't necessarily actually see and are always located relative to the player's position in the game world.

Area Loops

From their experience in the real world, people expect there to be sound of some sort everywhere they go in a game. Even a bare empty room will feel weird with no sound. Acting as a useful indicator of location, these area loops or room tones not only make an environment feel more real, but can also be used to set the mood of a particular place. Games that use streaming off the disk (discussed in Chapter 02) often use long ambient loops as an efficient way of populating an area with sound. Although not strictly natural since these loops lack the randomization of reality, they can work well if they are long enough and combined with other elements.

It might seem strange that these are not spatialized (in other words, they don't come from a specific location in the game world), but sounds do tend to become more diffuse (less defined in their direction) the further away you are, so this doesn't feel entirely unconvincing. It is certainly better than the whole environment whipping/panning around you as you move. In most modern games, these would be multichannel, but given that we're just getting started, we'll stick to stereo for now and cover how to import multichannel ambiences in Chapter 08.

Attenuation

Press the 1 key to jump to the *Cave 01* area (Bookmark 1). In front of you, there is a loudspeaker icon representing an [Ambient Sound] Actor of the type that you have already come across in Chapter 00.

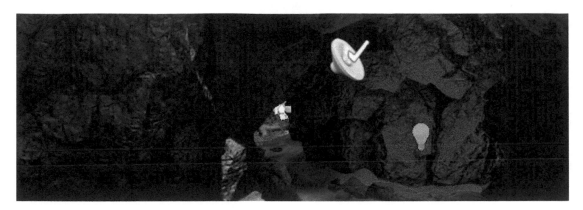

By selecting the icon, you can see the sound used in the ➡Details panel and the Attenuation settings (expand the *Attenuation Overrides* drop down) that control the size of the area over which we'll hear it. In this instance we're using a Box shape. The sound is at its maximum volume when the player is inside the interior box, then the sound drops away to zero at the exterior box. The numbers in the Extents settings refer to the Unreal Unit measurement of distance where 1 UU (Unreal Unit) is equal to 1cm. In order to see the sound attenuation curves more clearly and avoid confusion, you can switch off the Volumes/Lightmass Importance from the Show menu of the ➡Viewport.

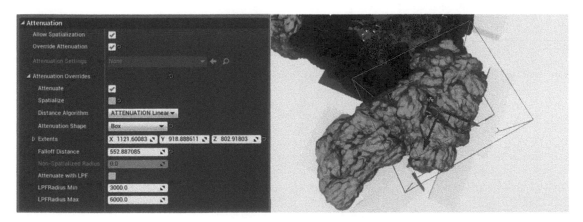

Using the magnifying glass icon next to the Sound reference in the ➡Details panel will find the sound in the ➡Content Browser ({Cave_Loop_01}). Double-click the Sound Wave to open its ➡Generic Editor panel, and you can see it is set to be a looping sound.

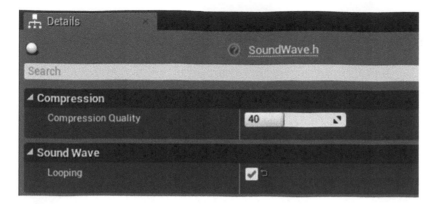

Look back at the ➡Details panel of the [Ambient Sound], and you can see that the Override Attenuation box is checked. This means that we are controlling the attenuation locally, and you can see we've set it not to Spatialize.

Press 2 to jump to Bookmark 2 then use the ➡World Outliner to find and select (Ctrl + Click to multiple select) the following area loops for this part of the game level:

[Cave_01_Loop] (Main cave)

[Cave_01b_Loop] (Smaller cave off the main cave)

[Jungle_Loop] (The Jungle area you emerge into)

Note how we've used different attenuation shapes that are appropriate for the areas we're trying to cover.

These all follow the same principle that the sound is at its maximum volume within the inner shape then falls off towards the outer limits. Each shape uses different names for their inner areas as you can see from the illustrations below. The cone shape has a slightly more specific usage that we'll be looking at in more detail in Chapter 07.

Sphere: Max Volume inside Radius, then falling off to Falloff Distance.

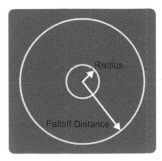

Box: Max Volume inside Extents, then falling off to Falloff Distance.

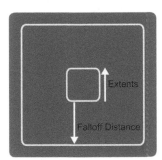

Capsule: Max Volume inside capsule as defined by Half Height and Radius, then falling off to Falloff Distance.

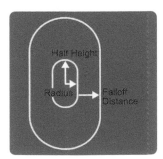

Cone: Max Volume inside inner cone as defined by Cone Radius and Cone Angle, then falling off to cone defined by Falloff Distance and Falloff Angle. Cone Offset allows us to offset the start of the cone back from the location of the Ambient Sound Actor.

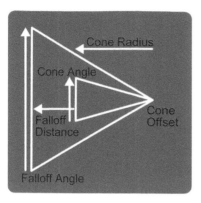

Exercise 01_02: Area Loops

Download and install the Exercise_Project from the website. In this exercise we are going to add area loops to the *Cave 01* and *Oasis* areas of the exercise level using Ambient Sounds for area loops.

[Ambient Sound], attenuation shapes and falloff distance, spatialization, hiding/showing items in the level, volume multiplier

1 Open Project: Exercise_Project, Level: Exercise_A
2 You can see that there are two main areas to the first section of this map, *Cave 01* (Bookmark 1), and *Oasis* (Bookmark 2). Using the sounds provided in the folder below (or your own), add background area loops to encapsulate each of the two environments.
 PC: C:\Users\UserName\Documents\Unreal Projects\Exercise_Project\Exercise_Assets\01_02_CaveToneandJungleLoops
 Mac: /Users/UserName/Documents/Unreal Projects/Exercise_Project/Exercise_Assets/01_02_CaveToneandJungleLoops
3 If you find the level is slow or unresponsive, then see the following section for some tips on getting it to run more smoothly-Appendix C: Testing, Troubleshooting, and Good Practice/Tips for Slow Running.
4 When you've imported the sounds (drag and drop into a folder in the ➡ **Content Browser**), you will need to set each one to be looping. You do this by double-clicking on the {**Sound Wave**} asset to open the ➡ **Generic Asset** Panel and ticking the Looping box in the Sound Wave section. (You also can select multiple {**Sound Waves**} at once—right-click them and choose Edit to edit all their properties at once.)

5 Add an [Ambient Sound] Actor to the level. You can do this in several ways.

 a. Drag and drop your desired {Sound Wave} asset from the ➡Content Browser into the game world.

 b. With your asset selected in the ➡Content Browser, right-click in the game world and select Place Actor/Selection.

 c. In the ➡Modes panel (top left) type "sound" in the Search Classes box, then drag and drop the [Ambient Sound] Actor into the level. You'll then need to assign a sound to it.

6 As you add each [Ambient Sound], give them meaningful names by editing their ➡Details panel.

7 Position your [Ambient Sound]s by clicking and dragging on the red/green/blue arrows to move them. These arrows represent the Translate Widget (moving widget). For more see Appendix A: Core Concepts/Manipulating Actors.

8 For each [Ambient Sound] tick the Override Attenuation setting, and set the Allow Spatialization to off. Choose an appropriate Attenuation Shape (a box and a sphere would probably work best for these areas), set the Extents (or Radius or Capsule height) of the inner area and the Falloff Distance. Move and rotate as required to cover each area.

9 When you are setting your shape properties for the Ambient Sounds, you might sometimes want to see things more clearly in the level. If you select anything in the level and press H, this temporarily hides the selected object and can allow you to see and place things more accurately. To reset and show everything again press Ctrl + H.

10 Use a variety of attenuation shapes and falloff distances to produce smooth transitions between each area and ensure there are no holes.

11 As you go, and again at the end, adjust each Ambient Sound's Volume Multiplier until you are happy with the relative volume of the sounds in each area.

Note that while volume settings in most DAWs are scaled to take account of the logarithmic nature of sound perception, unfortunately volume settings in the Unreal Engine are not. This causes volume multipliers, particularly at the lower end, to feel slightly unpredictable. This is why we often use curves to control volume—see Appendix A: Core Concepts/Transforming and Constraining Variables and Parameters/Reading through Curves.

Source Loops

For area loops the attenuation settings are about creating a smooth transition between one area and the next. Source loop sounds have a specific point of origin in the game—they are coming from a particular source object, so in this case the attenuation settings are about trying to recreate the realistic drop in volume over distance.

Inside the second large cave (*Cave 02*, Bookmark 3), you can see that the ambience is now created with a general background area loop together with several source loops.

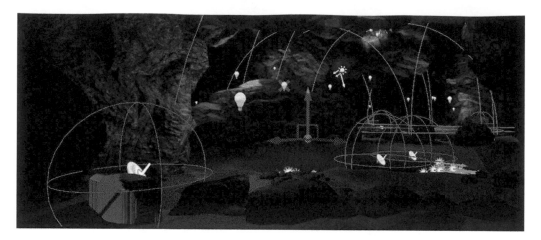

This time these Ambient Sound Actors are spatialized and located in much more specific areas around their source objects. If you look at the ➡Details panel for the Ambient Sound located by the yellow box on the left as you enter the cave ([Generator]), you can see that the attenuation is controlled locally (Override Attenuation) and that the sphere attenuation shape is now spatialized (Allow Spatialization). Unlike the area loops, you will hear these pan from left to right (or in surround) as you move around.

Filter over Distance

Sound travelling in air also changes in frequency content depending on the humidity and temperature. While this is rather tricky to calculate accurately, we can fake something like this by applying a low-pass filter over distance in addition to attenuating the volume.

If you look at the two areas where we have water dripping through the roof of the cave ([Water_Stream_01] and [Water_Stream_02]), you can see that these Ambient Sounds have the Attenuate with LPF option enabled. The LPFRadius Min is the distance at which no filtering is applied, and LPFRadius Max is where the maximum filtering is applied.

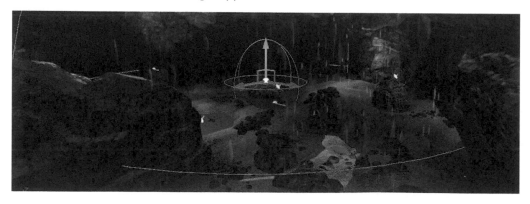

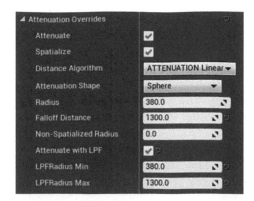

There are a variety of other aspects regarding how the sound attenuates that you have control over, such as the curve by which it attenuates (Distance Algorithm) and the region in which the sound becomes spatialized (Non-Spatialized Radius). Feel free to play around with these, but we'll be coming back to them in more detail in Chapter 07.

Area Loops and Source Loops: Attention to Detail

Although the implementation of ambient loops may appear relatively easy, don't make the mistake of thinking that it is simple. Creating a convincing and detailed environment is a huge creative challenge, and is so important to setting the mood and tone of your game. The next area serves as an illustration of the kind of attention to detail you should be thinking about.

As it is raining in *Jungle: Area 02* (Bookmark 4), we have a stereo area loop for the background, but we also need source loops for the specific sound of rain falling on different objects within the area. For example in the small patch around the hut we need:

The rain on the metal roof of the hut
Rain on the wooden crates outside the hut

Rain on the metal barrels outside the hut

Rain in the leaves of the trees (which will of course sound different from the general rain on the grass)

Using the ➡ **World Outliner** search for and select the sounds starting with Jungle02 to see these more clearly. Each one of these needs to be carefully considered in regard to its Inner Area Size and Falloff Distance, whether to apply the low-pass filter, and whether to Spatialize the sound or simply attenuate over distance.

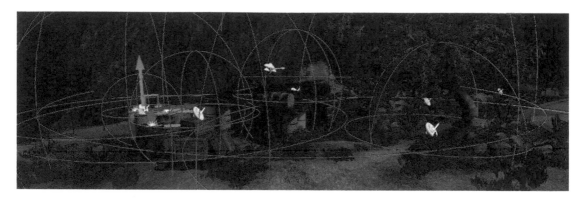

Exercise 01_03: Source Loops

In this exercise we will be adding source loops to the *Cave 01* area of the exercise level using Ambient Sound Actors.

Low-pass filter over distance, previewing attenuation shapes in-game

1 Open your exercise level.

2 You should have completed the area loops for the initial areas during Exercise 01_02, and now you need to add source loops to some of the objects in the level. Focus on *Cave 01* (Bookmark 1) to begin with.

3 You can use some of the sounds provided in the exercise folder or import your own. If importing, do not forget to set them as looping wave files by editing the Looping option in their ➡ Details panel (double-click a Sound Wave to open this).

4 As in Exercise 01_02 create Ambient Sound Actors in the level (the easiest way is simply to drag and drop your {Sound Wave}s into the level) and move them to the required position using the red, green, or blue arrows. This time tick the Allow Spatialization box in the Ambient Sound's ➡ Details panel. Then Override Attenuation and set up their attenuation settings. Since these are specific sound sources, these will typically be much smaller and more localized than the area loops.

5 For some sounds you might also want to add some low-pass filter attenuation by ticking this option and choosing appropriate LPFRadius Min and Max settings (typically to match the inner and falloff settings of your shape).

6 As well as previewing your source loops as you move around the game in the Viewport (Settings/Real Time Audio), you may want to actually see the attenuation shapes in the game as you play it. If you edit your Sound Waves ➡ Generic Asset Editor to enable Debug, you can call up the Console while playing the game (¬ or Tab key, depending on your keyboard language settings), then type "Stat Sounds-Debug". "Stat Sounds Off" turns this off. You'll then see their attenuation setting in the game represented in blue shapes when the Ambient Sounds are active. As well as being useful, this also looks pretty cool—which is always important! For more on Console commands, see Appendix A: Core Concepts/Console Commands.

7 Go back over all your sounds in the level and adjust their Volume Multiplier and Attenuation settings until you are satisfied.

Sound Cues

In the next section we are going to be using Sound Cues (indicated in the text by {Sound Cue Name}), so we'll spend a moment to look at what these are. Rather than simply playing back one .wav or Sound Wave file, most game editors will have a more abstracted layer for sound events so that you are in fact triggering a system that contains multiple .wav files. Sometimes called a sound event or sound object, in the Unreal Engine these systems take place within a Sound Cue. We will be talking about this idea again in more depth in Chapter 02.

In the ➡ Content Browser double-click on the {Thunder} Sound Cue. This will open the ➡ Sound Cue Editor.

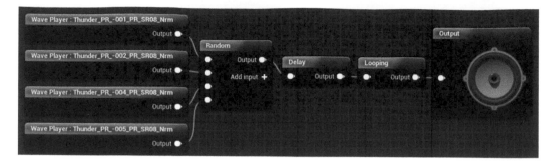

You should see a panel to the right that displays the ➡Palette of objects or -Nodes- available for you to build your systems with, and to the left a ➡Details panel where you have access to their settings. Try pressing Play from the top toolbar of the ➡Sound Cue Editor. You should hear a thunder sound. You may have to wait a while, as this Sound Cue has a -Delay- node in it. If you select one of the -Wave Players- and click on Play Node from the top toolbar, you'll hear it immediately since now we're choosing to play that specific node rather than the whole cue. (You can also preview the cue up to the selected node by double clicking on it.)

Navigating in Sound Cues (and Blueprints)
LMB—Click to select, click and hold to drag

RMB—Click and hold to move the screen around

Ctrl + LMB—Click to select and deselect multiple items

Shift + LMB—Drag to marquee select (this allows you to draw a rectangle and will select the items within it)

Click and drag wires between pins to connect up the systems, Alt + click to delete connections, and Ctrl + click to move an existing connection to another pin. (See also the Quick Reference/Tips page at the back of the book.).

In addition to the systems you can build within them, another advantage of using Sound Cues is that you can reuse them in a number of locations in your level, and any changes you need to make need only be made on the Sound Cue itself rather than hunting around the level to make changes on multiple [Ambient Sound]s.

Sound Cue Nodes

We'll be using Sound Cues a great deal throughout the book and will go into each node's function as we go, but for the moment a description of each of the nodes available in the Sound Cue and their function can be found in Appendix A: Core Concepts/Sound Cue Nodes.

Adding Sounds to Sound Cues

The simplest way to add your sounds to a Sound Cue is to drag and drop the {Sound Waves} from the ➡Content Browser into the ➡Sound Cue Editor graph; however, this is not always the fastest method.

If you first select your {Sound Waves} in the ➡ Content Browser then right-click in the ➡ Sound Cue Editor, you'll see that you have the option to add the waves prelinked to a particular -Node-. For example you might have 10 waves that you want to play back randomly. If you use this method, they'll all appear in the Sound Cue already linked up to a -Random- node rather than having to link them up individually.

This is the right-click menu in the ➡ Sound Cue Editor when waves are selected in the ➡ Content Browser:

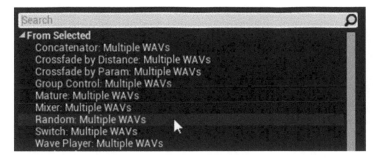

When you are working in the ➡ Sound Cue Editor, you can sync the ➡ Content Browser to select the cue you are working on by pressing Ctrl + B. To find the specific Sound Wave in the browser, right-click on it in the Viewport and choose Sync to Browser.

Source One-shots

As we saw in the listening exercise, the real world is typically made up of a combination of loops and one-shots. One thing that will stop a game environment from feeling immersive and natural is any repetition of a series or sequence of sounds, as these immediately jump out as being artificial. Imagine this scenario in the real world: A dog barks a few times, then a car door slams, somebody shouts, and a helicopter flies overhead. If any of those sounds were to repeat but actually sounded pretty much the same (i.e., the same sample), then it might be unusual but you'd probably accept it. If they happened again but with exactly the same timing in exactly the same order then it would feel incredibly odd. To break this up, we need a system that will allow us to play back a random choice of sounds at random times.

Sometimes our one-shots are associated with actual objects or agents in the game, but very often they are there to create the impression of a world much more real and alive than it actually is. In the perfect game, there would be no such thing as one-shots like this because the environmental ambience would be comprised of hundreds of individual agents going around, doing their thing, and making the occasional noise—like in the real world. Given that most companies don't want to bankrupt themselves by developing assets for every possible object that might be in a world, it's our job to fake it by creating the impression that these things are there, even when they are not necessarily visible. So there might be imaginary birds in the trees, imaginary traffic just out of sight, and imaginary police cars in the distance.

Find the [Thunder] Ambient Sound in the level that references the {Thunder} Sound Cue you just looked at (using the ➡World Outliner panel search). Select it, press F to focus, and you'll see that it is in the *Jungle: Area 02* (Bookmark 4). Using the ➡Details panel and the looking glass icon, locate the Sound Cue {Thunder} again in the ➡Content Browser, and double-click it to open the ➡Sound Cue editor if it is not still open.

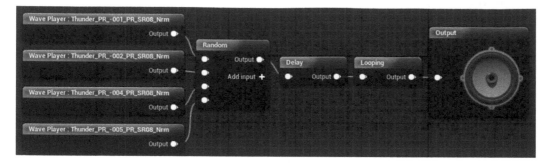

If you select the -Delay- node and look at the ➡Details panel, you can see that its settings are Delay Min = 8 and Delay Max = 20. So the system starts, and a random time count between 8 and 20 seconds is chosen. When that time is reached, a random choice is made to play one of the Sound Waves attached to the -Random- node. When that sound has finished playing, the -Looping- node restarts the system and chooses a new delay time, so we get a random delay between a random choice of sounds.

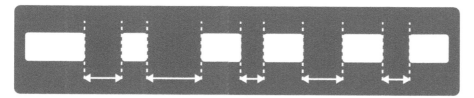

In the first part of the *Temple Clearing 01* (Bookmark 5), there are 4 more examples of the source one-shot using the Sound Cues: {Creature_01}, {Creature_02}, {Creature_03}, and some {Frogs}.

When you look at these Sound Cues in the ➡ Sound Cue Editor, you'll note that they have an additional node: the -Modulator-.

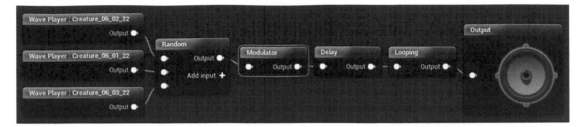

This is very useful for increasing variety in your one-shots, as it allows you to randomize both the volume and pitch of the sounds between Min and Max settings. Another thing to note is that you can alter the Weights within the -Random- node to make sounds more or less likely to be chosen, so if you want one of your sounds to be chosen more rarely than the others, set its Weight to be lower than the others (see more discussion of randomization in Chapter 06).

Exercise 01_04: Source One-shots

In this exercise you will add source one-shots to the *Oasis* area of your exercise level using Sound Cues that are referenced by Ambient Sound Actors.

{Sound Cue}, -Looping-, -Delay-, -Random-

1 You should have completed the area loops and source loops for the *Cave 01* area and *Oasis* during Exercises 01_02 and 01_03, so now we will add some randomized source one-shots like the ones above to bring some more life to the *Oasis* area (Bookmark 2).
2 Import your sounds or some of the provided exercise sounds.
3 Create a new Sound Cue. Click Add New in the ➡ Content Browser and choose Sounds / Sound Cue. Give it an appropriate name and double-click it to open the ➡ Sound Cue Editor.
4 Drag and drop your Sound Waves into the ➡ Sound Cue Editor Viewport.
5 Create a -Looping- node in the ➡ Sound Cue Editor by either right-clicking and selecting it from the menu or by dragging and dropping this node from the ➡ Palette of nodes on the right-hand side. Now do the same to create a -Delay- node and a -Random- node.
6 Connect your sounds to the -Random- node, creating additional inputs (Add Input on the -Random- node) as necessary.
7 Attach these nodes in the following order from left to right: -Random- to -Delay- to -Looping- to -Output-.
8 Set the Delay Min and Delay Max in the ➡ Details panel of the -Delay- node (select the node to see this). This sets the random time in seconds between the playback of a random sound selected by the -Random- node.

9 After auditioning the cue in the ➡Sound Cue Editor, drag and drop your new Sound Cue
 into the level to create an [Ambient Sound], and set this up with the usual attenuation details
 (Shape, Extents, Falloff Distance, and LPF settings).

10 Add several of these to your exercise level, and don't forget that you can set these up more
 quickly by adding multiple sounds already pre-connected to a -Random- node. Do this by
 selecting multiple Sound Wave files in the ➡Content Browser then using the right-click menu
 in the ➡Sound Cue Editor.

Polyphonic or Overlapping One-shots

Despite having random delays, you may have noticed some of your one-shot elements still may feel
a little artificial or even have a looping feel to them—why is that? One of the problems with a looping
delay that is implemented within a Sound Cue is that the -Delay- only actually starts once the first
sound has finished playing (i.e., the delay is the time between sounds), so you'll never get overlapping
sounds—in other words, it is a monophonic (one voice) system. If you're using short delays on sounds
of a similar length, then this can start to sound a bit loopy.

To create a system that has random delays between the start of sounds and allows them to be
retriggered with overlap (a multiple voice or polyphonic system), we need to allow for simultaneous
sounds by using a -Mixer-.

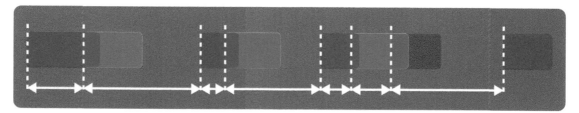

Again in the *Temple Clearing 01* area (Bookmark 5) over by the river is the Ambient Sound
[Loons_01] that references the Sound Cue {Loons_01}. Here you can see that we've set up two
looping delay systems. They will both randomly choose one of the Sound Waves but at different
times, and since they are then connected to a -Mixer- node, you will be able to hear both sources
play should they happen to overlap.

We've demonstrated source one-shots that are associated with specific locations in the game, but
these sources could equally be imaginary ones. Combining these kinds of randomized one-shots
with area loops in a single Sound Cue for an area is another approach you could take if the spatialized
aspects were less of a priority in your game.

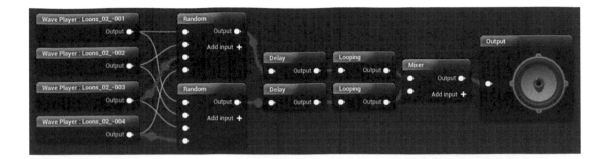

Exercise 01_05: Overlapping One-shots

In this exercise you will add some overlapping source one-shots to the oasis area of your exercise level.

-Mixer-

1 Go back to some of the randomized one-shot Sound Cues you created for Exercise 01_04 and adapt them to be able to play overlapping sounds.
2 Add a -**Mixer**- to your Sound Cue and feed your existing -**Looping**- /-**Delay**- system into it.
3 Now create a second -**Looping**- /-**Delay**- system (either referencing the same sounds or a new set) and feed these into a second input on the -**Mixer**- (created using Add Input on the -**Mixer**- node.)
4 Play the game and revel in the polyphonic joy.

Player-oriented One-shots

What's the sound of one hand clapping in a forest when there is nobody there to hear? Well, we don't know either, but having meticulously placed hundreds of one-shot sounds in the level to represent things that often aren't actually there or visible, you might ask yourself if there's a quicker alternative. After all there is little point in having the one-shots there if the player is not close enough to actually hear them. Player-oriented one-shots fulfill the purpose of representing these things in the world that you want there but can't see, and ensure that the player will always hear them since they are actually oriented around the player's location.

This functionality doesn't actually exist natively in the Unreal Engine, so we have cooked up a Macro, or a reusable Blueprint system, for you. This is imaginatively entitled the <GAB_Player_Oriented_One_Shot>, and this is what is generating the kookaburra and fly sounds in the area immediately in front of the temple (*Temple Clearing02*, Bookmark 6). This macro is installed when you installed the levels in the following directory:

PC: C:\Program Files\Epic Games\Engine Version\Engine\Content\GAB_Resources.
Mac: /Users/Shared/Epic Games/Engine Version/Engine/Content/GAB_Resources

Open up the [Level Blueprint] from the Blueprints icon on the ➡Toolbar and find the Player Oriented Sounds section.

We have placed a [Trigger] in the game level on the bridge, since we only want these sounds to come on when the player has crossed into the final area. The [Trigger] outputs an event when the player overlaps with it and then the <Sequence> node triggers our two Blueprint macro systems.

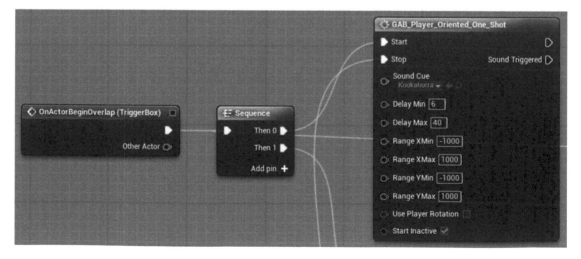

The XY values range from negative to positive, negative being behind (X) and to the left (Y), and positive being in front (X) and to the right (Y) relative to the game world axis. The XY values of the <GAB_Player_Oriented_One_Shot> represent potential distance ranges for the sound from the player in the XY plane of the game world axis. If you want the sound to originate from all directions you'll want to use both positive and negative values. Play this area (starting prior to the bridge), and you should hear these sounds being randomly spawned around you (this is particularly effective with 5.1 surround). Note that in the case of the kookaburra, for example, this can potentially spawn up to 1,000 units away, so we have made sure that our sound has an attenuation falloff of greater than this otherwise when it does play we might not hear it.

By default this does not take the player's rotation into account (the way they are facing), but if you specifically want sounds to always spawn in front or behind the player (or to the side), you can check the Use Player Rotation Boolean. By setting the X value to negative, for example, you can fix the sounds to always appear behind the player—spooky!

Exercise 01_06: Player-oriented One-shots

In this exercise we will be adding POS (Player-oriented sounds) to the *Oasis* area of your level. This is your first Blueprint system, so be brave! (Read the first part of **Appendix B: Blueprint primer** before starting this exercise)

<GAB_Player_Oriented_One_Shot>, [Trigger], <OnActorBeginOverlap Event>

1 Create a Sound Cue in the same way that you did the source one-shot (i.e., with a -**Looping**-, -**Delay**- node that picks a -**Random**- sound).
2 In the level create a [**Trigger**] as you enter the *Oasis* area (Bookmark 2). Search for "Trigger" in the ➡**Modes** panel and drag and drop the [**Trigger**] into your level. The easiest way to resize a Trigger is to use the widgets. Use the Spacebar to cycle through move/rotate/scale widgets (see Appendix A: Core Concepts/Manipulating Actors for more on widgets).
3 With your [**Trigger**] selected in the ➡**Viewport**, right-click in the [**Level Blueprint**] and Add Event for Trigger—/Collision/OnActorBeginOverlap.
4 Create a <GAB_Player_Oriented_One_Shot> node in your Blueprint by right-clicking and searching for this item in the ➡**Graph Action Menu** (you may need to turn off the Context Sensitive option).
5 Connect this up (LMB click and drag out) to the <OnActorBeginOverlap> event you just created to Start the <GAB_Player_Oriented_One_Shot> when the player walks through this [**Trigger**]. You may also want to add another [**Trigger**] on the exit of the Oasis to Stop it when you leave the area.
6 Check the Use Player Rotation option, set the Delay Min and Max to how frequently you want the sound played, and set the Range YMin and YMax to the distance left and right you want it away from the player. Remember that with rotation active, negative numbers will be to the left, and positive to the right.

7 Set the Range XMin and XMax to be negative so that the sounds spawn behind the player.

8 Check the Attenuation settings of your Sound Cue (in the ➡Details panel of the -Output-node) to make sure that when the sound spawns you will still be able to hear it (i.e., the Falloff Distance is greater than your X/Y settings).

9 You can watch your Blueprints in action on a second screen as you play, and even free up the mouse to go and move them around by holding Shift and pressing F1. See Appendix C: Testing, Troubleshooting, and Good practice/Watching Blueprints.

One-shots: Sourcing and Masking

Although randomized one-shot sounds are ideal for generating variety and life in your ambient environments, it can be tricky to source the sounds in the first place. Typically these sounds exist alongside others in the real world, so when you try to edit them out as individualized elements, you get all the background noise as well. Although you should always aim to get sounds that are as clean and isolated as possible, one can get a little obsessive about this when editing one-shots in isolation. Don't forget that the one-shots will likely be played against a background of both area loops and source loops. Often the frequencies in these background elements can help mask some of the noisiness on your one-shots or help to hide an abrupt decay tail, and they'll sometimes sit in the mix better than you might imagine.

Embedding Source Sounds into Game Actor Blueprints

When you consider the massive scale of many modern games, you'll appreciate that it's not very efficient to have an artist go around and place lots of objects, and then a sound designer go around and find exactly the same objects to add sound to them. Since most objects will get reused numerous times throughout a game (e.g. tree type A), it would be useful if we can embed the sounds themselves in the Actor. Then we would have global control over the sound itself (through the Sound Cue), but we wouldn't have to place them all. If things needed changing, we would only need to alter the cue, not each of the 500 Ambient Sounds!

In the illustration below, two trees are highlighted (*Temple Clearing 02*, Bookmark 6). These are actually Blueprint Actors {GAB_Tree_Blueprint} that have both the tree mesh and an ambient one-shot sound embedded.

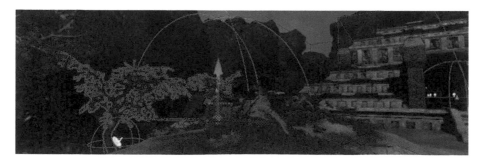

We've seen examples of this already in the shooter game, where you opened up various ship Blueprints and replaced the sounds. Open the {GAB_Tree_Blueprint} by either double-clicking on the asset in the ➡Content Browser or by selecting the asset in the ➡Viewport and clicking on Edit Blueprint in its ➡Details panel. When the ➡Blueprint Editor window is open, look at the ➡Viewport to see the components in this Blueprint.

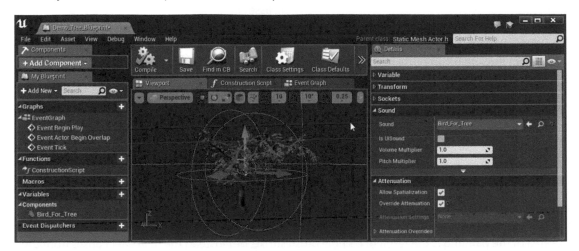

Here you can see the static mesh component ({Tree}) and the audio component (the Sound Cue {Bird_For_Tree}). This means that wherever this Blueprint is used, it will automatically refer to and spatialize this Sound Cue along with the visual asset. In some levels you may be hearing a lot of sound, but when looking around for the Ambient Sounds in the level, there appear to be none. This is because they are part of the Blueprint Actors. Much of what we've done in the demo levels is in the level Blueprint to make things easier to follow and understand, but some of this might more typically be done in Blueprint Actors, particularly if you have multiple instances.

Exercise 01_07: Embedding Sounds in Actor Blueprints

In this exercise you're going to make your own Blueprint Actor that has an embedded audio component so you can reuse it throughout your level.

Actor Blueprint, components, audio component, static mesh

1 Open up the exercise level.
2 In the ➡Content Browser click Add New/Blueprints/Blueprint Class/Actor and give it an appropriate name. (You can also create Blueprints from the Blueprints icon in the toolbar with New Empty Blueprint Class.)
3 Double-click it to open the ➡Blueprint Editor (Don't forget to read Appendix B: Blueprint primer!).

4 Find the static mesh asset {Demo_Small_Generator} in the ➡ Content Browser (or another of your own choosing) and select it.

5 In the ➡ Components panel of your Blueprint click Add Component/Static Mesh (Demo_Small_Generator). Note that it is adding the component that you have selected in the ➡ Content Browser.

6 Do the same again to add your sound. Select the asset in the ➡ Content Browser then Add Component/Audio (Your Asset). Given that this is not a triggered sound, you will want to choose either a looping Sound Wave or a Sound Cue with a looping node in it.

7 Select the audio component in the ➡ Blueprint Editor/➡ Viewports and determine its Attenuation settings.

8 Click on the Compile button in the ➡ Blueprint Editor (top left).

9 You now have a new Blueprint Actor that you can drag and drop into your level.

Ambience Recap: An Artist's Approach

Much of this chapter has dealt with creating background ambience to make your game world seem alive and real. A useful analogy when considering ambience is that of an oil painting. When you look at a finished oil painting, you get the impression of a complete and convincing picture. However, not one area of the painting is the result of a single brush stroke, but instead the final effect arises from the combination of layer upon layer of paint. You should think of your ambience in the same way. The final effect will need to be built up of many different layers of distant, mid-distance, and close sounds to produce the final effect.

Occlusion Issues

Summary : Triggers, fading Ambient Sounds in/out for occlusion

Triggers and Switching Ambience

So far we've managed to give our different areas (caves and jungle) a separate audio identity by careful use of the Radius/Extents and Falloff settings for our Ambient Sounds, but this is mainly because we've had relatively simple area shapes to deal with. Game engines typically do not have particularly sophisticated systems for dealing with audio occlusion (where sounds are attenuated by passing through materials such as walls) and so often we need to deal with this by hand. Imagine how you might approach an area like the one represented below. You could no longer just use large area loops since the jungle sound would be heard inside the temples, and the temples are awkward shapes that don't align neatly with spheres, boxes, capsules, or cones.

One solution is to use lots of overlapping sound areas with different shapes to work your way around and within the buildings, but that would be a lot of work and could lead to phasing issues between instances of the same sound playing simultaneously. A more pragmatic approach that is often used is to simply switch off the exterior sounds when you go inside (and switch on interior sounds) and vice versa.

In the image below, you can see the issue (*Temple Entrance*, Bookmark 7). The Ambient Sound [Swamp_Loop_01] that forms the background audio for the jungle protrudes into the temple, so you will hear it even when inside. Although not particularly realistic, many games use a simple method of placing a trigger in the entrance of a building or area and using this to switch the ambiences on or off.

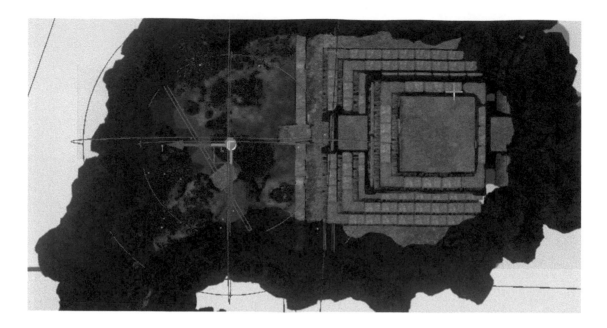

Open the Level Blueprint and find the "Ambience Switching" section. A sphere [Trigger] at the entrance to the temple gives us an <On Actor Begin Overlap> event in the [Level Blueprint] when the player walks through it. This is used to <Fade Out> the outside ambience and <Fade In> the temple music [Temple_Music_01_Loop].

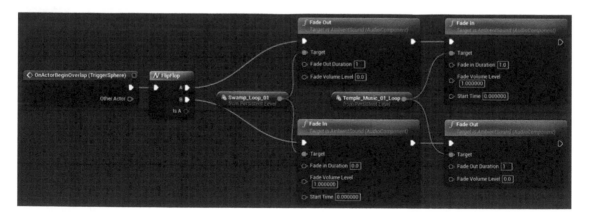

The Auto Activate option for the temple music [Ambient Sound] has been disabled in its ➡ Details panel. In other words it does not start playing when the level starts, and so it will be silent until the <Fade In> command is received.

The <FlipFlop> node alternates between its two outputs. It will send an execute command out of A, then B, then A, etc., so if the player walks back out of the temple, then the outside ambience is faded back in and the inside faded out again. We'll be returning for a deeper look at occlusion later in Chapter 07, but for the moment this simple switching approach can work effectively.

You could of course extend this approach to deal with all the different Ambient Sound areas in your level, setting up Sound Cues that include both area loops and imaginary source one-shots, and then switching between them as you move between locations. See Exercise 05_01 in Chapter 05 for an adaptable system using arrays for this.

Since occasionally things don't go to plan, it is a good idea to also have some kind of completely global subtle background tone throughout your whole level. Silence is a real glaring error and immersion breaker, so if the switching system does go wrong (maybe the sound is slow to be streamed from disk for example), then the game won't sound completely broken.

Exercise 01_08: Switching Ambience

In this exercise we are going to use a Blueprint system for switching ambience when the player goes into or out of the buildings in the *Oasis* area of your level.

[Trigger], <FadeIn>, <FadeOut>, <FlipFlop>, <Gate>, <Sequence>

1　In the *Oasis* area of the exercise level (Bookmark 2), choose one of the buildings to concentrate on first. For example in the ➡ World Outliner, search for "Building_02". You already have attempted some

inner/outer ambiences for this area using Ambient Sounds but have perhaps found this difficult to get right since this building is an awkward shape.

2 Place a [**Trigger**] in the doorway of the building. Remember these can be found by searching for Trigger in the ➡**Modes** panel. You'll see that you have different trigger shapes available. A [**Box Trigger**] will work well for this, so click on this in the ➡**Modes** panel, drag it into your level, and position it in the buildings doorway.

3 Use the scaling widget (with the [**Box Trigger**] selected, cycle through move/scale/rotate using the Spacebar) to flatten the box out so we get the trigger occurring just when we want it.

4 Open the [**Level Blueprint**], and with the [**Box Trigger**] still selected in the ➡**Viewport**, right-click in the Blueprint ➡**Event Graph** and select Add Event for Trigger Box/Collision/Add OnActorBeginOverlap. When the player overlaps (i.e., walks through) this will trigger an event to be output from this node.

5 Add references in the ➡**Event Graph** to the Ambient Sounds you want to toggle on or off. For example you might have a Jungle_Area_Loop and a few other one-shot loops that overlap with the building. You will also want an Inside_Building_Loop. To do this select them in the ➡**Viewport**, then right-click in the ➡**Event Graph** of the [**Level Blueprint**] and click Add Reference to— (make sure the Context Sensitive option is checked in the ➡**Graph Action Menu**). See Appendix A: Core Concepts/Referencing In-game Actors within Blueprint.

6 To create the <**FadeIn**> and <**FadeOut**> nodes, you should click and drag out from one of the <**Ambient Sound**> references you have just created. There are different types of fade in/out nodes depending on whether you are targeting an Ambient Sound or an audio component (which we'll look at later). Adding the node in this way ensures that you are using the right one.

7 Now attach all the references to Ambient Sounds you want to be affected to the relevant target inputs of the <**FadeIn**> and <**FadeOut**>, and adjust the Fade Durations.

8 Add the <**FlipFlop**> and connect the system up as shown in the illustration above.

9 If your player will be starting the game from outside the building, then disable the Auto Activate (in the ➡**Details** panel) for the building's [**Ambient Sound**]. When the player enters the building, this will fade in, and when they leave, it will fade out again. The reverse will occur for the outside Ambient Sounds.

10 If you have an overlapping player-oriented one-shot system (Exercise 01_06) that you can still hear when inside the building, then you will need to toggle this on or off as well. You can do this by adding a <**Sequence**> to each output of your <**FlipFlop**> nodes, which allows you to trigger more than one thing from an event, or by triggering it from the output of the <**FadeIn**>/<**FadeOut**>s. Use one of these to stop the POS node and the other to restart it.

11 You might note a number of other actions you can take on your Ambient Sound, such as <Play>. You could connect other in-game [Trigger]s to this to play one-off sounds in your level, such as dialogue instructions or specific sound events (don't forget to disable the Ambient Sound's Auto-Activate option).

Reverb

Summary : [Audio Volumes] for reverb

The characteristics of a space can change dramatically according to its size and the materials within it since these affect the way that sound is reflected around. Think about the difference between singing in the shower and singing in a large cathedral for example. For your environments to sound convincing to the player, you need to carefully select the appropriate reverb setting for each space and apply this to sounds that occur within it (you can specify if you don't want it applied to specific sounds, and we will look at that later in the section on sound classes in Chapter 08).

As you enter the temple (*Temple Upper*, Bookmark 8), you will notice that your footstep and weapon sounds have reverb applied, and as you move through different sized rooms in the temple, you'll hear that the type of reverb changes accordingly. The type of reverb effect is set in the ➡Details panel of the [Audio Volume] Actor, and you can specify the volume of the reverb effect and how long it takes to fade in after you enter the volume (this is to stop any abrupt changes).

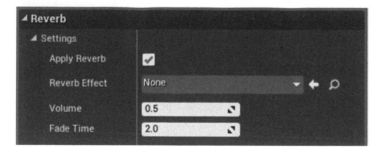

Exercise 01_09: Reverb

In this exercise you are going to add reverb to *Cave 01*, *Cave 02*, and the *Oasis Buildings* using [Audio Volume]s.

[Audio Volume], reverb effects

1 Go to one of the caves or buildings in your exercises level, then search the ➡Modes panel to find the [Audio Volume] and drag and drop it into the map.
2 Resize the [Audio Volume] to match your building using the scaling widget.

3 In the ➡Content Browser menu View Options, make sure that the Show Engine Content option is checked so that you can see the reverb effects included in this folder. Pick an appropriate reverb effect for the nature of your building and set the Volume and Fade Times.

4 Before you can hear the reverb being applied in your level, you need to rebuild the level's geometry. You do this from the ➡Toolbar menu Build/Geometry/Build Geometry.

5 Now add reverb to the other buildings and caves in the level, rebuild the geometry, and test them in game.

Triggering Sounds with Key or Controller Input

Summary : Triggering sounds directly with key of controller inputs

In the basement of the temple (*Temple Lower*, Bookmark 9), you can use the stone button in front of the fire pit to stoke the flames and…well, we won't spoil the surprise. We have looked at how to turn Ambient Sounds on and off when the player overlaps a [Trigger] that has been placed in the game, but you might also want to trigger a sound or a piece of dialogue when a player interacts with an object or button by using it (typically through pressing X or A on the controller or E on the keyboard).

Trigger Use Events

In order to trigger events from key or controller inputs anywhere in the level, we could just create a <Key Event> in the [Level Blueprint] and link it straight to a <Play Sound Attached>; however, we want this input to work only when the player is actually standing next to the relevant button. See the "Interact" section of the Level Blueprint.

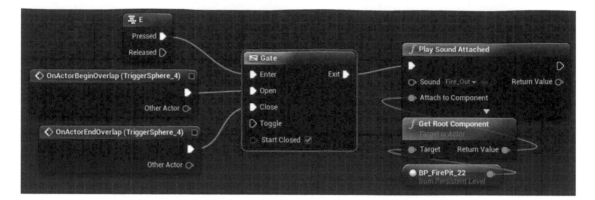

In order to do this, we use a <Gate> node that is opened and closed by the [Trigger] around the button. This way the <Key Event> E will not be allowed through to trigger the sound unless the player is in proximity to the button.

Exercise 01_10: Triggering Sound Events

In this exercise we will look at adding a sound that can be triggered by with a key input when using a button in the game world.

<Key Input Event>, <Play Sound Attached>

1 In the back room of *Building 02* of your exercise map, there is a button that will open the door when you have set it up. Behind this door is an exciting present: a reward for having come this far!
2 Place a [Trigger] around the button (from the ➡Modes panel) and resize it using the scaling widget.
3 With the [Trigger] selected in the Viewport, right-click in the [Level Blueprint] and Add Event for Trigger—-/Collision/OnActorBeginOverlap, then do the same to add OnActorEndOverlap.
4 Create a <Gate> and connect these up so that Begin opens it and End closes it.
5 Create a <Key Event> for E. The quickest way is to right-click to bring up the ➡Graph Action Menu and type "E key". Connect this to the Enter input of the <Gate>.
6 Create a door opening sound and add it to a <Play Sound Attached>. You need to then attach this to the door mesh in the level. With the door selected in the ➡Viewport, right-click in the ➡Event Graph of the [Level Blueprint] to open the ➡Graph Action Menu. Find the <Get Root Component>, and this will add the node preconnected to a reference to the door mesh

(see Appendix A: Core Concepts/Referencing In-game Actors within Blueprint for more). Now link this to the Attach to Component of the <Play Sound Attached>.

7 Connect the output of your <Play Sound Attached> to the <Play> node for the [Matinee] we have already provided in the *Building 02* section of the [Level Blueprint] (this opens the door). We will be looking at matinees in detail in Chapter 07.

8 See Appendix A: Core Concepts/Key and Gamepad Inputs and Appendix A: Core Concepts/ Events and Triggers/Trigger Use for more.

Exercise 01_011: DIY: Building Your Own Level

In this exercise you can have a go at building your own level. It is not essential, but the better understanding you have of the level designers work, then the better you can work together. Plus it's fun!

Static mesh, snapping

1 Open the Map: ExerciseMapEmpty.

2 In the ➡Content Browser select the Game folder and filter the results by Static Mesh. This will show you all the visual assets available to build your level.

3 Drag and drop static meshes from the browser into your level, and use the widgets (cycle with the spacebar) to move/scale/rotate them.

4 You may find it useful at times to use the Snapping functions in the Viewport to snap the Actors to certain grid, rotation, or scaling factors (see Appendix A: Core Concepts/ Manipulating Actors).

5 You will probably also want to add some lights. Find these in the ➡Modes panel.

6 If you've seen assets in other projects that you'd like, then you can migrate them to use in your project. Just open the project, select the asset, and right-click and select Asset Actions/Migrate. You will then need to specify the content folder of your project. Make sure you have permission to use any assets before making your game publically available!

7 Now apply all the skills you've learned in this chapter to create a convincing and immersive audio environment.

8 There are many levels and assets available via the Marketplace page of the Epic Launcher if you want to take this further.

Conclusion

Although the learning curve has no doubt been a little steep at times, you now have all the basic skills to populate a level with ambient audio and reverb. We've emphasized the implementation here, but do not overlook the importance of sound design. It is no good showing off a load of techniques if the end result just doesn't sound any good. This is why the game sound designer, and as we will see later the game composer, needs a new skillset, one that encompasses all the skills from previous media (being a good sound designer and being a good composer) as well as all the new skills involved in implementation.

Recap:

After working through this chapter, you should now be able to:

- Create area loops, source loops, and source one-shots using [**Ambient Sound**] Actors and Sound Cues;
- Apply appropriate falloff distances and filters over distance;
- Use the Blueprint <**Player Oriented One-Shots**> node to implement player-oriented sounds;
- Embed sounds into game Actor Blueprints;
- Switch ambiences on and off via triggers for occlusion purposes;
- Implement reverbs;
- Implement triggers on touch (beginoverlap) and use.

Summary : Sound Cue systems, sequential variation, layered variation, modulation-based variation, parameterization

Project : DemoCh02Cave01 **Level :** Cave01

Introduction

You can jump forward or backward between the series of caves in this level by using the] or [key. Move left or right using A and D, with Space to jump.

In the immortal words of industry veteran Brian Schmidt, "Anyone who still thinks there is a one-to-one relationship between a game event and a wave file just doesn't understand game audio." Procedural sound design is about sound design as a system, an algorithm, or a procedure that re-arranges, combines, or manipulates sound assets so they might:

a. produce a greater variety of outcomes (variation or non-repetitive design)
b. be more responsive to interaction (parameterization).

This approach to sound design exists on a spectrum from procedural sound design, where we tend to be manipulating pre-existing assets, to procedural audio, a term more frequently used when systems of synthesis are used to generate the sounds themselves (with much in between that combine both approaches). Procedural audio is an increasingly important field, but one that requires its own tools and is worthy of its own study. We will refer you to some further reading on the website, but for the purposes of this book, we will concern ourselves with systematized approaches to sound that are easy to implement in most game engines or middleware.

Procedural sound design is a key facet of audio for games. When we interact with objects in the real world, the physical processes that produce sound are never repeated in exactly the same way. Even a repeated mechanical action is subject to slight changes because the materials have changed since the last action (through change in temperature or the loss of a few atoms!), and of course the sound is travelling through air and reflecting around an environment, both of which add their own variations to the sound. For some elements of game audio, repetition is important—indeed the presence of sounds encoded with meaning (that need to be the same in order to be understood) is part of the audio aesthetic of what makes games sound like games. Other types of audio are more about immersion than gameplay (or "ludic") function, and for these to convincingly represent some kind of reality, simply repeating exactly the same Sound Wave or failing to respond appropriately to a variety of interactions is not going to cut it.

The ever-increasing amount of interactivity we have in games has an impact on the number of potential audio outcomes. Look around you, and find a small object:

Place it on the table = 1 sound
Do it again a few times = 3 more sounds
Drop it from a short height onto the table = 1 sound
Drop it from a short height a few more times = 3 sounds
Drop it from a different height a few times = 4 sounds
Now place it on a different surface, say the floor, a few times = 4 sounds
Drop it from two heights a few times = 8

So far we'd have to record, edit, import, and implement 24 sounds for this object. Now look around the room for all the other surfaces it could potentially collide with and repeat the process above. Then choose the next object in the room, and repeat the process, then the next . . .

Do you see the problem? The idea that we can prerecord the whole range of potential audio outcomes is simply impossible.

Historically these issues have always been brought into sharp focus by the restricted memory (RAM) that was available for audio. With the previous generation of games, you had to pull audio from the game disk and hold many sounds (ones that required instantaneous playback) in RAM, while streaming other, less time-sensitive ones (such as music, long ambient loops, and dialogue) from the disk itself. The amount of RAM was highly variable, but you might hope in a best-case scenario for anything between 25–35 MB and typically 12 streams. We have a lot more RAM to play with in the latest generation of consoles (260MB as an example) and since the advent of internal hard drives as standard, we're now able to play sounds directly from these rather than having to load sounds into RAM from the game disk. Despite these advances and continued increasing resources for audio in the future, we hope you can see from the principles discussed above that this does not mean that a procedural approach to sound design has become any less relevant—indeed given the scale of some modern games you could say that it's more important than ever. (And don't forget that the majority of people play the majority of their games on cell phones!)

Before you start work on a game, you need to be fully informed about the capabilities of your platform and the approach to RAM and streaming that the programmers have decided to take (and ideally you should be part of this debate).

The first two caves of this map (Bookmarks 1 and 2) provide an example of how we can bring an environment to life with some very simple procedural sound design approaches and how this simultaneously has the advantage of a lower memory requirement.

Cave 01 and *Cave 02* share exactly the same layout, and as you walk through them you should notice that they sound very similar. The ambience for *Cave 01* consists of a three-minute long

stereo loop around 30MB in size. For many platforms or download restrictions, this would have blown the entire memory budget already, and if you were to spend any length of time in here, you would probably start to notice its repetitive nature.

We will go through *Cave 02* more thoroughly in the Sequenced Variation section below, but for the moment just note that we have produced an ambient environment very similar to *Cave 01* (and arguably better since it is more alive with variation) through a series of very simple sound systems that allow us to do this using 14 individual sound samples with a total size of 1.7 MB (and we probably could have gone significantly lower with some more complex approaches!) Procedural sound design by its nature implies a more modular approach to sound design, constructing a final sound event from elements of sound rather than playing back one complete sound.

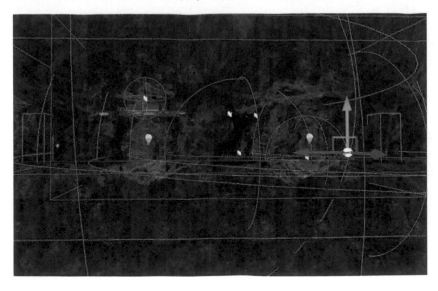

Sample Rates and Audio Compression

Summary : Sample rates and audio compression

Given that this chapter is in part about creating variation within restricted memory situations, we should recap some basic principles before moving on.

Sample Rates Revisited

After cleanly editing the sounds, you will remember from Chapter 00 to also look at the sample rate since high sample rates mean high memory requirements. You should always use your ears when trying out different sample rates, but if your DAW has a frequency spectrum view, this can be very useful when you're first starting. Looking at the frequency spectrum of both the {Gieger_01} and {Liquid_Water_Drips} Sound Waves used in *Cave 02*, we can see that they have quite a bit of energy all the way up to around 11kHz, so remembering the Nyquist-Shannon theorem (that you need to sample at a rate at least twice that of your highest frequency), these have been resampled to 22kHz before import.

{Gieger_01}:

{Liquid_Water_Drips}:

The low cave tone that forms a backdrop for the entire level, on the other hand, has little sound energy above around 2.3kHz. In theory we could have resampled this at 5kHz, but it started to sound a little crunchy so, deciding to live life on the edge, we went for a sample rate of 8kHz. As we said—always use your ears as the final judge.

{Cave_Tone_LP}:

In addition to looking at the frequency content of the sound itself, you should also consider the playback medium that you're developing for to inform your decision on what sample rates to use. Speakers for portable consoles do not have a great frequency range, so there would be no point in using some sample rates for your audio. If you get the opportunity, you should try running some white noise through the speakers of your platform and looking at the results. You may be unpleasantly surprised! These decisions are of course complicated by the fact that people can also switch to headphones, but when you look at the frequency response of most consumer headphones, they are typically not great either.

In addition to using a frequency spectrum view (and your ears) to decide on the most appropriate sample rate for your sounds, you should also consider each particular sound's importance within the game and/or how often it will be heard by the player. For example the sound of glass smashing during each of 10 climactic boss fights might be preserved at a high sample rate. In order to achieve this, you may choose to lower the sample rate, and thus sacrifice the quality, of the distant background sound you hear only once in level 17d.

Audio File Compression

We know that high quality audio takes up a significant amount of memory and, although the latest generation of consoles might have rendered this less of an issue than it once was, the restrictions around file size for downloadable games and the memory available on portable platforms mean that it is still going to be a very important consideration for many projects.

In order to deal with this, almost all platforms use some kind of audio file compression (not to be confused with audio compression effects). The best known of these audio file compression methods of course is the MP3. This lossy format works on the principle of perceptual redundancy, using knowledge of psychoacoustic principles to remove sounds (and therefore data) that are hard to hear, such as high frequency sounds or sounds that are masked by other, louder, simultaneous sounds. The problem with some audio file compression formats, MP3 included, is that they take processing time and power to decode and are therefore rarely suitable for the kind of instantaneous playback required in games.

The Unreal Engine allows you to set a different Compression Quality for each of your sound files via the ⇒Generic Asset Editor and will then automatically apply the appropriate compression codec for each platform when you package out your project. Open the ⇒Generic Asset Editor by either double-clicking on the {Sound Wave} or by right-click/Edit.

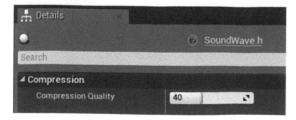

If you float the mouse over the Sound Wave after adjusting the Compression Quality, you can see the predicted Ogg Size (Ogg Vorbis compression format).

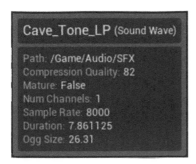

Cave_Tone_LP (Sound Wave)

Path: /Game/Audio/SFX
Compression Quality: 82
Mature: False
Num Channels: 1
Sample Rate: 8000
Duration: 7.861125
Ogg Size: 26.31

Depending of the nature of the sound, you can achieve audio file compression of up to 10:1 (but you will more typically be using 3:1–8:1), which is pretty essential for most scenarios considering that CD-quality audio takes up around 10MB per minute.

Unfortunately this compression does come at a cost elsewhere since the processor needs to decompress these sounds in real time and this is competing with all the other game processing demands. So now in modern consoles, the challenge becomes less about RAM memory for audio and more about restricting the demands you are placing on the processor by trying to decompress all of your now available sounds. This becomes an issue of mixing, which we will be looking at in Chapter 08.

Sequenced Variation

Summary : Asynchronous loops, random timings, controlling random events for clusters of activity, concatenation for variation

Sequenced variation is all about changing the time relationships between, or order of, sounds to generate variety.

Time-based Variation

Asynchronous Loops

Loops sound loopy, which is sometimes alright for electrical or mechanical sources but is more often not alright for immersing your player in a convincing environment. One thing that can break up this sense of repetition is to have simultaneous loops of differing lengths so that they create variation as they come in and out of phase with each other.

Asynchronous Loops through File Length

In *Cave 02* (Bookmark 2) you should hear some water dripping sounds (A in the illustration above) that hopefully avoid feeling too loopy. Go to the ➡ Content Browser and find the Sound Cue {Asynchronous_Drips_01_CUE}.

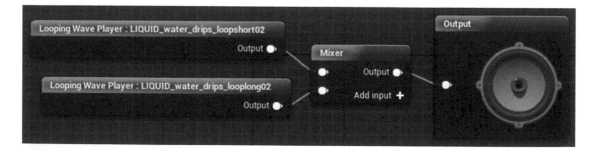

What's important to generating variation in this cue is that although both the sounds are looping (the -Wave Player- has its Looping option selected), they are of different lengths. This means that each time one loops around it will be playing in combination with a different section of the other. Given that the two water dripping samples are uneven lengths, they won't come back into synchronization for some time, and therefore you won't hear the same sound combination repeated.

Asynchronous Loops through Pitch Shift

Now have a look at the Sound Cue around the machine (B) in *Cave 02*. Look in the ➡Details panel/Sound and use the magnifying glass icon to browse and find the cue {Asynchronous_ Machine_Pitch} in the ➡Content Browser. Double-click the cue to open the ➡Sound Cue Editor. Here we've saved even more memory by actually using the same sound twice, but playing back a second version that is at a different pitch (via a -Modulator- node). This will affect the length of the sound, putting it out of phase with the original version. In this case one version is playing back at 0.8 of the original pitch and the other at 0.72.

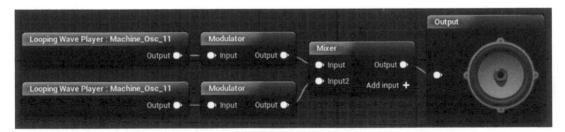

You could also use a random -Delay-. At the start of the game, a random offset for the two sounds would be selected, making the resulting sound different each time. Although, as we've said above, machines and electrical sources tend to be loopy by nature, this variation can add a bit more life and character.

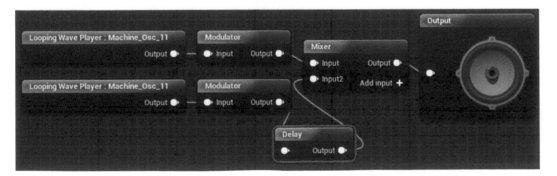

Random Time: Blocks

This again relies on the principle of changing the time relationship between sounds in order to generate variation.

In the ➡ **World Outliner** find the ambient sound **[Wind_Rand_01]** (C) then locate and open the Sound Cue **{Wind_Rand_01}**.

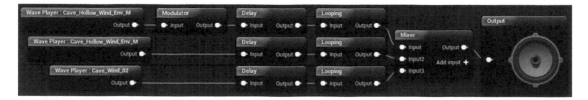

This uses -**Delay**- nodes to randomly offset two wind samples (the first one is actually used twice, one with a -**Modulator**- also varying the pitch). As the sounds themselves are about 6.5 seconds long, the random delays of anything between 1 and 6 seconds will lead to a fairly constant but always changing overlap between the wind sounds.

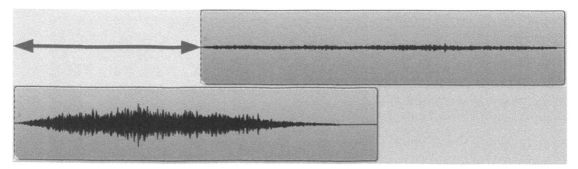

Random Time: Fragments

Using individual one-shot elements is much more effective than long loops in saving memory and providing the variation to make your game world feel real and alive. We have seen examples of this already in Chapter 01, 'Source One-shots'.

There are two creatures of the same type in the grass patches of *Cave 02* (D). The sound for these {Creature_01_Rand_Fragments} is generated by a number of one-shot sounds, none of which are longer than 2–3 seconds (these are actually recordings of a stomach after a particularly potent chili!) Just as we did in the jungle area of Chapter 01, we're playing back these one-shots with a -**Looping**- -**Delay**- (and adding some volume modulation for additional variance).

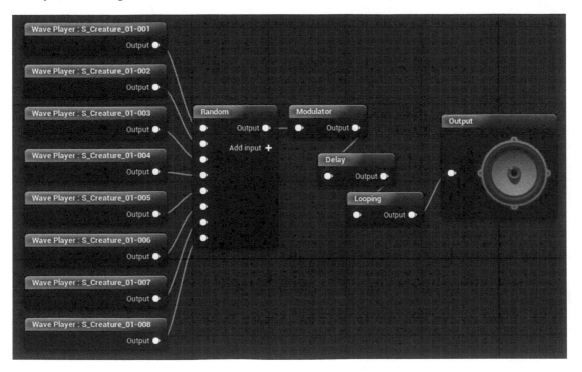

Remember, as we discussed in Chapter 01, these internal delays within a Sound Cue will not generate overlapping sounds since the -Delay- only starts once the current sound has finished playing. It works here because these are short sounds with short tails. If your sounds are longer and it doesn't suit to hear them one at a time, then you'll need to look back at using the -Mixer- node as we did in the Chapter 01 Polyphonic or overlapping One-Shots section.

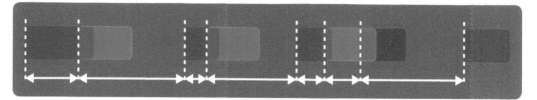

Controlling Random Events: Clusters of Activity

The nature of randomizing events tends to generate a similar texture over time, but living things often produce sounds in clusters of activity with longer pauses in between, so for these we need some additional control over the random process.

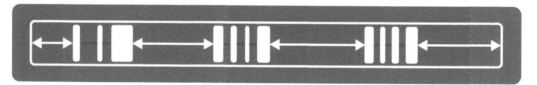

The last element in this Cave (E) is a clicky type creature {Creature_02_Gieger_01_Cue}. This is broken into clusters of activity, as the looping delay triggers not just one sound, but a cluster of 4 events (with randomized timing via the -Delay-) using the -Concatenator- node (which we will be looking at in more detail shortly).

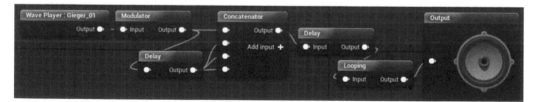

Exercise 02_01: Time-based Variation

In this exercise we will be adding further variation to the *Cave* and *Oasis* areas of your level.

As we continue to add more variety to the level through procedural approaches, you might want to revisit your area loops and scale back the amount of activity in them since we will now be replacing some of these loops with more variable versions.

1 Using some of the Sound Cue techniques described above, add some more life and variation to your map. Focus on the *Cave 01* and *Oasis* areas. For example:
 a. Asynchronous loops for water dripping in *Cave 01*;
 b. Overlapping randomly timed blocks for a wind effect in either the *Cave 01* or *Oasis*;
 c. A random fragments approach to animal sounds in the *Oasis* and a clustering approach to some of these (you can also set a loop count in the -**Looping Node**- to set a sound to loop a given number of times—after a randomized -**Delay**-, you could randomly choose between several -**Loop**- nodes with different counts to achieve a clustering effect.)
2 There are some sounds provided in the exercise folder, or import your own.
3 Reminders:
 a. Edit files and resample appropriately before importing;
 b. Import your files by dragging and dropping files into a folder in the ➡ **Content Browser**;
 c. Create a new [**Sound Cue**] either from the ➡ **Content Browser's** Add New menu, or by right-clicking in an empty space in the ➡ **Content Browser**;
 d. Open the ➡ **Sound Cue Editor** by either double-clicking on your Sound Cue or right-click/Edit;
 e. To add sounds to your ➡ **Sound Cue Editor**, either just drag and drop from the ➡ **Content Browser** or select the waves in the browser then right-click to add to the cue preconnected to a node;
 f. Preview your cue in the ➡ **Sound Cue Editor** by either playing the whole cue or a specific node.

Concatenation

Concatenation is a process of seamlessly stitching together a series of individual sounds. Unlike the delays and randomization used so far, concatenation places the sounds immediately up against each other in time, recreating the sense of a continuous sound.

Many types of sound can be edited successfully into individual chunks (taking care to split at zero crossing points). Then these chunks can be concatenated, or stitched back together but in a random order.

The original wave file:

Edited into chunks:

Randomly re-ordered for variation at runtime:

Concatenation for Variation in Loops

The first example in *Cave 03* (Bookmark 3) is the background room tone (A). This is a filtered recording of a train that has been edited into short chunks.

Find the Sound Cue {Room_Tone_Train_Concat}. Note that we're not actually using the -Concatenate- node within the Sound Cue since this has a specific function we don't need yet.

A looping -**Random**- node will wait until the previous sound has finished before choosing the next and so will perform the stitching perfectly well.

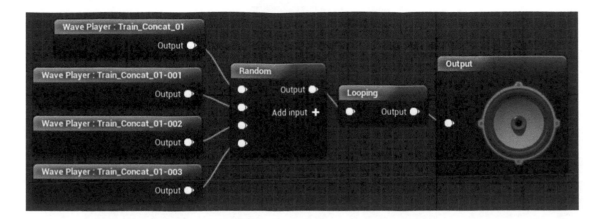

You won't hear the second item, the machine (B), until you turn it on in the game by getting close to it and pressing the use key (E). This starts the slightly rickety machine that powers the elevator. This uses a [**Trigger**] around the machine to ensure the player is within a certain distance before they can use the machine (with <**KeyPress**> E) before playing the [**Ambient Sound**] (for which the Auto Activate has been disabled).

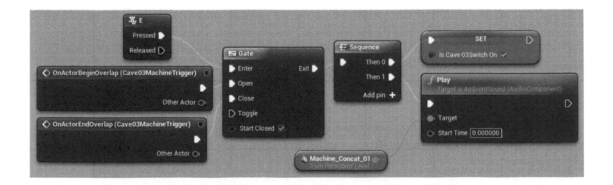

In the Sound Cue {**Machine_Concat_01**}, select the Sound Waves in turn and listen to them individually using the Play Node icon from the top toolbar (or by double clicking on the –Wave Player- nodes themselves). Then listen to the Sound Cue as a whole (Play Cue) to hear them being stitched back together to form the continuous noise of the machine.

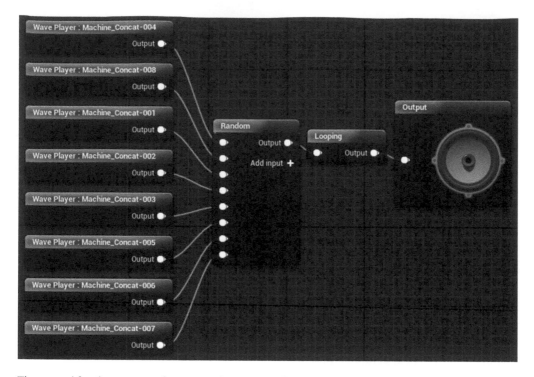

The sound for the stream of water in the center of the cave (C), and that of the elevator when it moves (D) are also Sound Cue examples of concatenation ({Water_Stream_Concat} and {Elevator_Concat}). See also the {Poison_gieger} Sound Cue for the radioactive gas on the floor of *Cave 04*.

The final sound in this room is probably the one you noticed first: the broken public address message repeating: "Emergency containment breach, please exit through the gift shop" (E). This does actually use a -Concatenate- node (at last!) since we want to stitch the speech back in a particular order. See the Sound Cue {PA_Concat}.

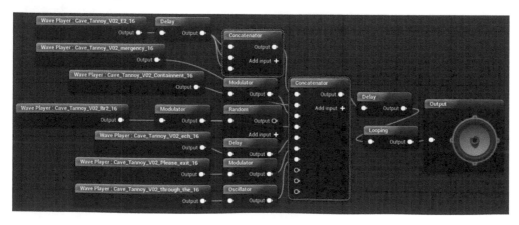

Here we've split the sentence up into chunks and applied a variety of modulations and delays to each chunk to give the impression of the system breaking down. The -**Concatenator**- node will play each of its inputs sequentially and so will stitch our sentence back together in the right order. There is also another -**Concatenator**- on the "E" of "Emergency" to provide a stuttering effect. We'll be returning to this kind of sequenced concatenation for dialogue in a lot more depth in the advanced dialogue sections in Chapter 11.

Layered Concatenation

Concatenation really comes into its own when you layer up a couple of audio systems since we're not only getting the randomized order, but we're also getting a randomized combination of sounds as well. The big wheels in *Cave 04* (Bookmark 4) consist of three layers of concatenated sounds (and one looping sound), Sound Cue {**Wheel_Platform_Concat**}.

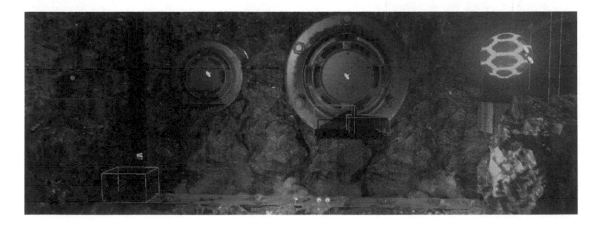

The first layer is the rubbing element,

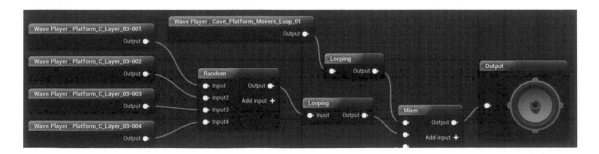

Then the rumbling,

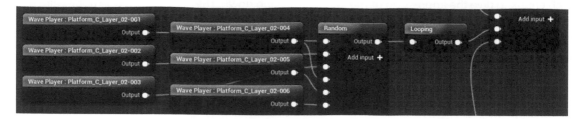

and finally the twisting.

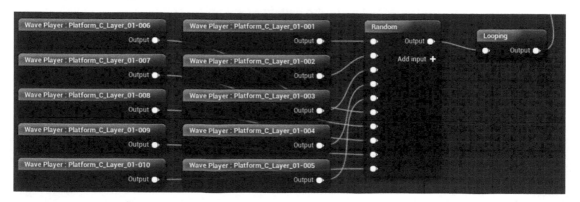

Since the wheels are different sizes, we've also applied a pitch shift via the ambient sound ➡Details panel. The smaller wheel is played back at 1.2 of the original pitch and the larger at 0.9. Listen to it again in-game, then open up the Sound Cue to listen back to the different sections via the Play Node icon in the ➡Sound Cue Editor.

Concatenation for a Chain of Events

Like we saw with the public address system above, the -Concatenate- node allows us to sequence a chain of sounds to play one after another. This has allowed us to alleviate repetition and save memory throughout the level in every cave we've been in through the one sound that has always been there—the player's footsteps. Normal walking-pace footsteps are ripe for concatenation since they naturally consist of two parts: the heel and the toe.

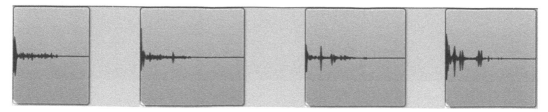

By editing these into separate elements, we can then randomly recombine them using the
-Concatenate- node.

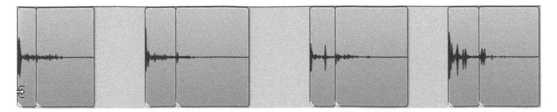

In this illustration there were 4 original samples of a footstep on a cave floor-like surface. These were
edited into heel and toe sections (a and b). Each time the Sound Cue {Cave_Footsteps_Concat} is
called, it will randomly choose one of the heel sounds, and then randomly choose one of the toe sounds.
Instead of playing back the 4 original heel and toe sounds, this system will give us more variation.

Original sounds:

1 (a+b), 2 (a+b), 3 (a+b), 4 (a+b)
= 4 possible footstep sounds

After concatenation:

1a—1b, 1a—2b, 1a—3b, 1a—4b
2a—1b, 2a—2b, 2a—3b, 2a—4b
3a—1b, 3a—2b, 3a—3b, 3a—4b
4a—1b, 4a—2b, 4a—3b, 4a—4b
= 16 possible footstep sounds

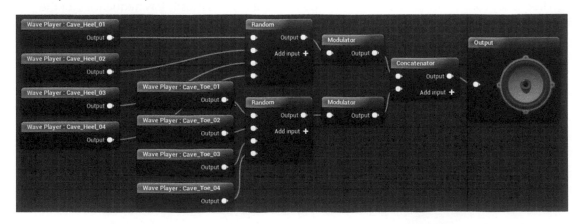

You need to shoot your way through the electrical orb to get to the next cave (stand on the platform
next to the cannon and press E). When you score a hit, the orb plays a short hit sound followed by a

series of sparks. Here we've used the -**Concatenate**- node to chain a series of sound types since we want larger sparks first then progressively smaller ones.

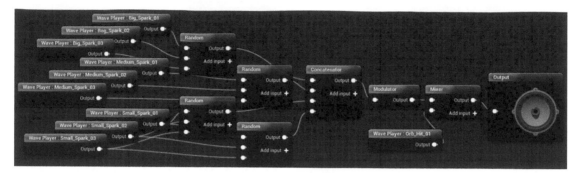

You'll also find -**Concatenate**- in action for the crackles preceding the radio dialogue in the desert Chapter 04.

Concatenate Sample Rates

Sometimes you may find yourself designing sound for games that have ultra-low memory budgets, perhaps for a portable toy or game. Here's a cunning use of concatenation that can allow you to preserve some of the high quality elements of the sound that are important.

Have a listen to the Sound Cue for the cannon fire in *Cave 04*, {Cannon_Fire_Concat}. Now have a listen to an alternative version {Cannon_Fire_Orig}. Can you hear the difference? Hopefully not, but there's a significant difference in the file sizes.

If we look at the original sample for the cannon fire sound, we can see that there's an initial burst of high frequency content for the crack of the weapon fire, but then it's mostly low frequencies for the final two-second rumble.

What we've done for the version used in the game is to split the file, retaining a high sample rate for the crack chunk, but then choosing a lower sample rate (and consequently a smaller file size) for the rumble.

These files are in the ➡Content Browser:

{Cave_Cannon_All}—The original file at 44.1kHz = 234kb
{Cave_Cannon_Trans}—The edited crack at 44.1kHz = 44kb
{Cave_Cannon_Tail}—The edited rumble at 16kHz = 70kb

When we -Concatenate- these two elements back together, we get a sound that is virtually indistinguishable from the original, but now the total size is 114kB—a savings of 120kB that we can now put to good use somewhere else (we did say it was pretty cunning).

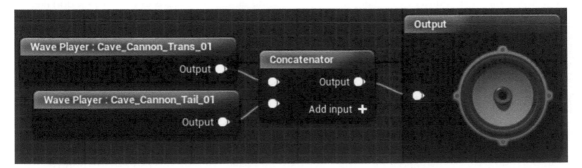

Exercise 02_02: Concatenation for Variation

In this exercise we will focus on concatenation techniques for implementing the sound in the *Cave 02* area of your level.

-Concatenate-

1 Using some of Sound Cue techniques described above, add even more life and variation to your map. Focus on the *Cave 02* area. For example:
 a. Make an atmospheric background tone for your *Cave 02* by splitting up a loop into concatenated chunks;
 b. Experiment with concatenated loops for the machines or water features;
 c. Create layers of different concatenated elements for the moving platforms that take you up the rock face;
 d. Replace the elements within the footsteps Sound Cue {Cave_Footsteps_Concat} with your own heel/toe sounds;
 e. Create a Sound Cue for the broken door mechanism in the *Cave 02: Upper* area that concatenates a randomized chain of sound events. The Blueprint system is already made for you in the "Broken Door" section of the [Level Blueprint].

Multiple Start Points

You can reuse parts of a longer file without the need to edit since we can start playing back the file at any point.

The cave floor crumbles into *Cave 05* (Bookmark 5), then you again hear rock debris as you cross the two bridges. All these sounds are actually playing back using different sections of the same sound file.

Open the [Level Blueprint] and look at the "Cave 05b/Rock Falls" section. The top <Play> node is triggered from the initial rock fall and plays the entire file. Then the [Trigger]s placed on each bridge again play the sound but now with different start times, so they play different parts of the audio file (as indicated by the red markers in the waveform image below).

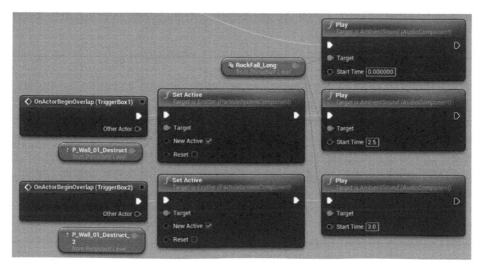

If you have a system like this available to you, then you will usually be asked to add the markers to your audio files in your audio editor. Wave files contain a header that programmers can access to retrieve the marker position information.

Exercise 02_03: Start Points

In this exercise we will be adding a changing rock fall effect to *Cave 02* in your level.

<Multigate>, start time

1 As you walk to the right of the door in the *Cave 02: Upper* area, a [Trigger] has been placed near the rocks ([Rockfalls_Trigger]). Create the impression that this wall is unstable with some random rock falls. A system has been set up in the [Level Blueprint] for you (Cave 02—Rockfalls), but you will need to add your {Rockfalls} Sound Cue to the level as an [Ambient Sound].
2 Disable Auto Activate using its ➡Details panel.
3 Now create a reference to it in the [Level Blueprint]. With the ambient sound selected in the ➡Viewport, right-click in the [Level Blueprint] and choose Create a Reference to—. (See Appendix A: Core Concepts/Referencing In-game Actors within Blueprint)
4 Replace the <AmbientSound_Placeholder> reference with yours to link this up to the <Play> objects that are triggered from the randomized <MultiGate> and specify an appropriate Start Time for each depending on where in the file you want it to play from.
5 Try recreating this system to add further rock fall areas to your cave.

Layered Variation

Summary : Random combinations of elements for variation, deconstructing sound events, scalability

You don't need thousands of sounds in memory to get thousands of different sounds out of your system. We've looked at how you can use a modular approach to sequence your sound elements to create new combinations for non-repetitive variation. Another technique is to vary the layers of sound elements that are heard, for example by randomly choosing one of three possible sounds for each element.

Randomizing the combination of layers of sound elements can vastly increase the number of potential outcomes with only a few additional sounds. For example if you had three sounds in memory that had the potential for being layered in any combination, you could hear the following:

Sound 1

Sound 1

Sound 2

Sound 3

Sound 1 + Sound 2

Sound 1 + Sound 3

Sound 2 + Sound 3

Sound 1 + Sound 2 + Sound 3

This will give us 7 different combinations and 7 different sound possibilities.

If we had 5 sounds in memory:

```
1,  2,  3,  4,  5,
1+2,  1+3,  1+4,  1+5,
2+3,  2+4,  2+5,
3+4,  3+5,  4+5,
1+2+3,  1+3+4,  1+3+5,1+4+5,  2+3+4,  2+3+5,2+4+5,  3+4+5,  5+1+2,  5+1+3
1+2+3+4,  1+3+4+5,  2+3+4+5,  4+5+1+2,  5+1+2+3,
1+2+3+4+5
```

This would give us 31 different combinations. 7 sounds would give us 127, and 10 would result in a possible 1,023 combinations!

Don't forget that while this greatly increases the variation and possibilities for parameterization (as we'll see later), the dynamic range of such systems is a lot less predictable.

Simple Random Combinations

Impacts are good candidates for layered variation and in *Cave 06* (Bookmark 6)—you can trigger a set of spikes to rise up from the floor to incapacitate the hapless guard who's patrolling this area.

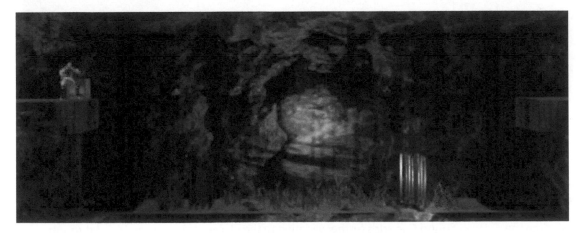

The spikes have a [Trigger] attached to them. When the player triggers the spikes, this opens the <Gate>. If the [Trigger]s collide (<OnActorBeginOverlap>) with the bot, then it was in the wrong place at the wrong time and our impact [Ambient Sound] is played.

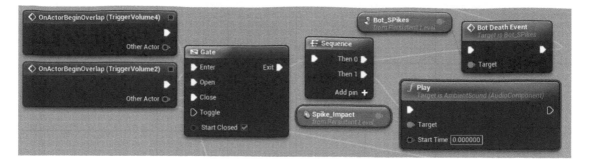

The Sound Cue {**Spike_Impact**} randomly combines one of each of the following elements:

Swish X 3
Thump X 3
Flesh impact X 3

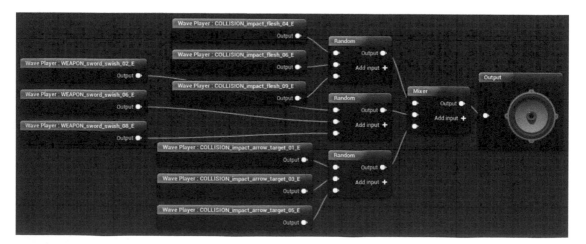

Random Combinations with Individualized Pitch and Delays

The bot in the next *Cave 07* (Bookmark 7) is unfortunately patrolling an area where explosive barrels sometimes fall from the ceiling. If you get the timing right, you can put him out of action too.

This time the {Barrel} Sound Cue adds further variation to the elements being combined through the use of a -**Modulator**- that randomizes the pitch and volume and through a varied -**Delay**- on the wood impacts and wood debris elements.

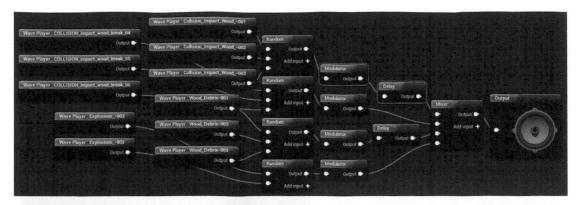

You can see how we are now starting to think about our sounds not as one-off Sound Waves but as modular sound systems that layer up the separate components of the event. So a wooden barrel explosion is not just a Wooden_Barrel_Explosion Sound Wave, but procedurally combines the elements of explosion, wood impact, wood break, and wood debris.

Deconstructing a Sound for Procedural Use

This modular approach demands that you really start to think about the individual elements that are present within a final sound event in order to deconstruct it into its different sound-producing components.

In *Cave 08* (Bookmark 8) the retreating forces have blocked the way with a series of large rocks. Fortunately you are armed with explosives that allow you to clear the route by pressing E when in proximity of the rocks.

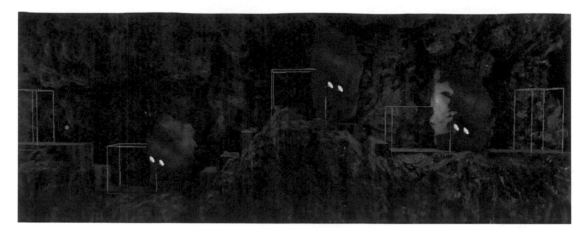

We've split the event across two Sound Cues simply for ease of viewing.

At the top of the hierarchy we have the sound event—rocks exploding. This is separated into two broad events—{Rocks_Destroy} and {Explosion_Elements}—and within these are the component parts (or modules) that make up the sound.

The {Explosion_Elements} Sound Cue procedurally combines:
Crack—the sharp initial transient of an explosion
Thump—the low-end thump
Bloom—the explosive force pushing through the air and into the environment
Tail—the final dissipation of the sound energy

Each time the Sound Cue is played, one of each of these element groups is chosen and then combined to form the final explosion sound. We may take up a little more memory than just using 4 complete explosion sounds, but now we'll have a huge variety through the different combination of these elements, not just the same 4 sounds used repeatedly (you can think about explosion sounds as consisting of many different elements—this is just one).

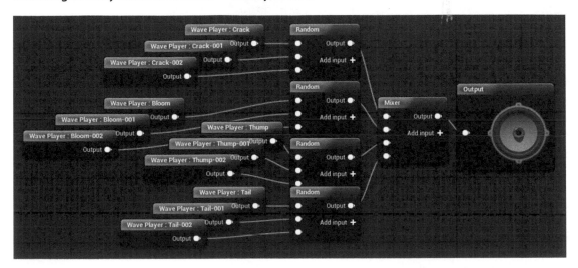

The {Rocks_Destroy} Sound Cue takes a similar approach, combining the elements of large rock impact, medium rock impact, debris, and dust debris (along with the usual variations produced through the -Delay- and -Modulator- nodes).

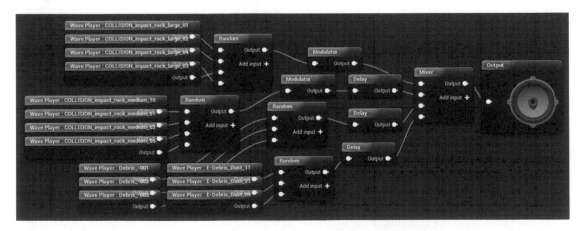

When the player is in proximity to a rock (i.e., within the [Trigger]), this opens the <Gate> to allow the <KeyEvent> to spawn the explosion emitter <Destroy>, the rock Actor, and <Play> the ambient sounds.

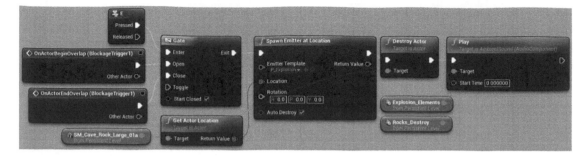

As we get further into Blueprints, you'll find it invaluable to watch their operation as you play. Try this now by opening the [**Level Blueprint**] and locating the "Rocks" section. If you have one available, then move this panel onto a second screen and watch it while you play this section of the game. You can also free up your mouse to move around within the Blueprint by holding the Shift key and pressing F1. Click back in the game Viewport to regain in-game control (see Appendix C: Testing, Troubleshooting, and Good Practice/Watching Blueprints).

Scalability

So far we've looked at approaches to non-repetitive design that utilize either variations in time or order, which you could think of as sequenced variation or in terms of the variation produced through combining different layers (layered combinations).

The useful thing about both of these approaches is that they also allow us to set up systems that are very scalable to different platforms. Multiplatform development is very common these days (being pretty much the norm for AAA titles), but for a variety of reasons your memory budget for audio will likely be different for each one. All of the sequenced or layered systems make use of the -**Random**- node, and this has an additional function that can allow us to automatically scale our assets for different platforms. The Preselect at Level Load option allows us to set the number of inputs to a -**Random**- that should be active. When the level loads, it will randomly choose your designated number of inputs and, importantly, will not load those that have not been selected.

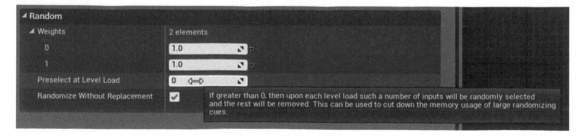

So for platform X with lots of memory available, you could leave this at 0 so all random sounds will be available; however, for platform Y you could set this to 8 (as below). On level load, 8 inputs would be randomly chosen and only those sounds loaded into memory, and since these 8 would be different every time, you'd still have some further variation each time the player starts the level.

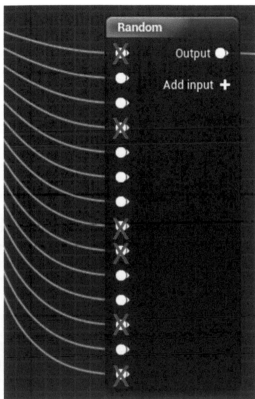

Exercise 02_04: Layered Variation

In this exercise we will be adding a modular explosion system to the *Cave Tunnel* area of your level.

-Modulator-

1 On the right of the doorway in *Cave 02: Upper* in your exercise map, there is a loose rock wall that you can blast your way through by setting an explosive charge (E). After this first wall, there are several more as you make your way through the *Cave Tunnel* that is revealed.

2 Using the assets provided or your own, create a Sound Cue that uses a modular procedural approach to vary the layers of the explosion sound effect.

3 The Blueprint system is already set up in the [**Level Blueprint**] "Cave Tunnel—Rock Explosions" section, so just add your Sound Cue to the ambient sounds in the level. You can find these using the ➡World Outliner—[Rock_Explosion_01], [Rock_Explosion_02], etc.

4 Using the Sound Cues above as a guide, layer together groups of different elements using a -**Mixer**- node.

5 Introduce -**Modulator**- nodes to vary the volume and pitch and -**Delay**- nodes to change the time relationships between the elements. You might also want to experiment with the -**Enveloper**- node that we will be looking at in the next section.

Modulation/Modifiers for Variation

Summary : Pitch and volume modifiers, envelopes, oscillation, wavetables

Of course the theoretically best solutions for procedural or modular approaches to sound design are to modulate or process the sounds themselves for variation without needing to load additional alternative sounds at all. This takes some processing power to achieve (usually vanishingly small for simple modulations) but doesn't require any more memory in addition to that taken up by the basic sound itself. So use whatever DSP (digital signal processing) is available to create variations on the sounds you have rather than simply putting more sounds in memory.

Pitch

From simple variation to radical change and envelopes, varying the pitch of a sound is one of the simplest and most effective methods of generating variation in your sounds.

Reuse Sounds for Different Sized Sources

In the physical production of sound, pitch is related to the size of the object. The larger or longer the pipe, the longer the string, or the bigger the surface, then the lower the pitch of the sound it produces. Given this fact, the most obvious application of using pitch shift to vary your sound file is when you have different sized versions of the same object. Pitch in this case is generally best modulated around the center (i.e., 0.8 min to 1.2 max rather than 1.0 min to 1.4 max) so that the source's character doesn't change too dramatically.

In *Cave 09* (Bookmark 9) there are three stone blocks that regularly pound down onto the cave floor (you must time your movements to get through unscathed). Given that each of these is essentially the same material but a different size, we've used the same Sound Cue ({**Pounder_Impact_01**}) but with different pitch settings for each one.

The [**Ambient Sound**] that's triggered for the smallest ({**Pounder_Impact_01_Cue_3**}) has a pitch multiplier of 1.25, the largest block 0.4, and the medium 1.0.

If you find in a game level that you have objects of similar materials but different sizes, it's worth seeing if you can represent them through different pitches of a sound first before using additional sounds (see also the moving platforms referred to previously in *Cave 04*).

Transformative Reuse

In addition to changing the pitch for similar objects of a different size, sometimes a change in pitch can alter the sound's character more significantly. If you've ever tried extreme changes of pitch in your audio editor, you will know what a huge impact this can have on the nature of the sound itself.

Cave 10 (Bookmark 10) illustrates how you can use pitch shifting to radically change sounds for different uses. There are two types of creatures located in the grass patches of the cave, one sounding like some loose chickens and the other like some rats. These both use exactly the same samples, only at different pitches (see {Chickens_01_Cue} and {Rats_01_Cue}). One of the elevator concatenation sounds is also reused in this room, this time pitched down to 0.2 to form a looping room tone. In *Cave 12* the {Machine_Concat} from *Cave 03* has been reused in a pitched-up form for the sound of the moving platforms.

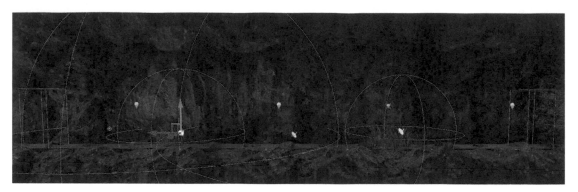

Pitch Envelopes

In addition to simply playing back sounds at different times, we can apply pitch changes over time through the use of an envelope. In *Cave 11* (we've run out of bookmarks!), there are three pits of lava that squirt out the occasional bubble of deadly gas—avoid them!

In this cave you'll hear an irritating mosquito. This only uses two samples that are held in memory but generates variation in the sounds by applying different pitch curves via the -Enveloper- node.

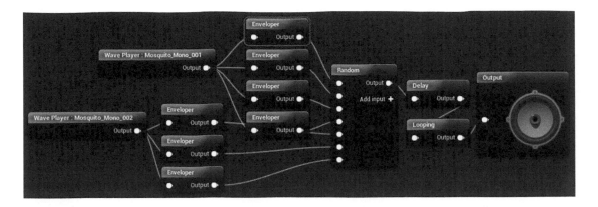

This mosquito is played as randomly delayed one-shots, and each time it randomly picks a different envelope curve. Open the {**Mosquito_001_Cue**}, select one of the -**Enveloper**- nodes, and double-click on the Pitch Curve to open the ➡**Curve Editor.**

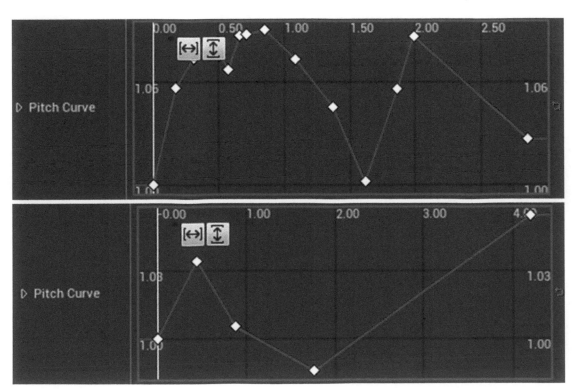

The bubbling lava in the cave ({Bubbling_Lava}) is given variety through pitch envelopes as well, but this time they are set to loop.

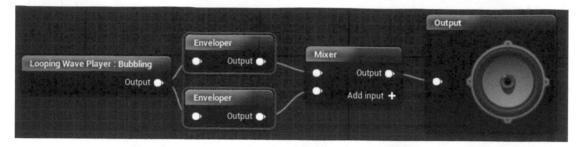

Taking care that the pitch at the start of the loop and end of the loop are the same (to avoid any sudden jumps as it loops around), the two envelopes are set to loop indefinitely. As the two envelopes are different and the two loop lengths are different, this gives us a constantly changing relationship between the two.

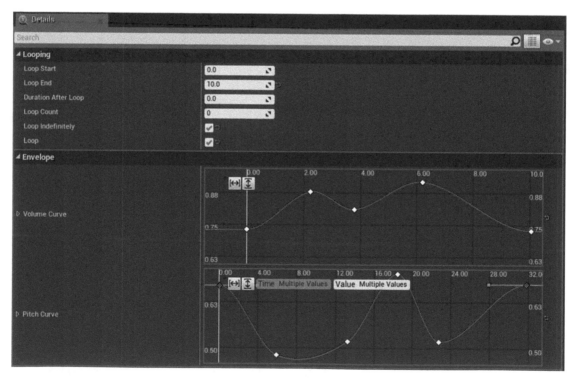

Exercise 02_05: Pitch Reuse

In this exercise we will be making use of pitch variation to add sounds for the fans and ventilation units in the *Cave 02* tunnel area.

-Enveloper-, curve editor

1 Along the walls of the *Cave Tunnel* are a number of fans and ventilation units. Add ambient sound source loops to these, making appropriate use of Pitch to represent their size. You can adjust the pitch either in a -Modulator- of the Sound Cue, in the -Output- of a Sound Cue, or in the ➡Details panel of the ambient sound itself.

2 As you emerge out of the *Final Cave* (Upper Section), there are some animal remains lying around. Add some flies around these remains using a random choice of pitch envelopes for variation.
 a. Edit the curves of an -Enveloper- node—double-click the envelope in the ➡Details panel to open the ➡Curve Editor.
 b. Create a new curve point with Shift and click, click and drag points to move, and use the mouse wheel zoom in/out.
 c. Click and hold RMB to move the view around, and right-click on points to change the curve type.

Also see Appendix A: Core Concepts/Transforming and Constraining Variables and Parameters/Reading through Curves

3 Try adding -Modulators- to some of your other sounds in the level. Although a Sound Cue with a -Looping Wave Player- will not modulate each time it loops, it will pick a different pitch each time the player starts the game.

Volume

We've used a fair amount of volume modulation throughout the level already through randomizing values within the -**Modulator**- node, but by changing the volume envelope on a sound we can also generate the impression of different sounds while only holding one set of sound data in memory.

One-shot Volume Envelopes

The pipes in *Cave 12* emit random steam bursts that you must avoid in order to cross the lava pit successfully. Every time a steam burst plays, it is playing back the same Sound Wave {SteamBlast}, but via a Sound Cue {Steam_Blast_Env} that randomly chooses one of three different volume envelopes to apply.

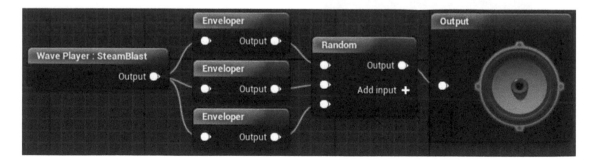

In addition to changing the attack envelope for the steam, we can of course also change the length of the sound by bringing the envelope down to 0.0 before it has finished. The -**Enveloper**- also has modulation options (in its ➡**Details** panel) so that you can randomly vary the overall volume as well between defined Min/Max ranges.

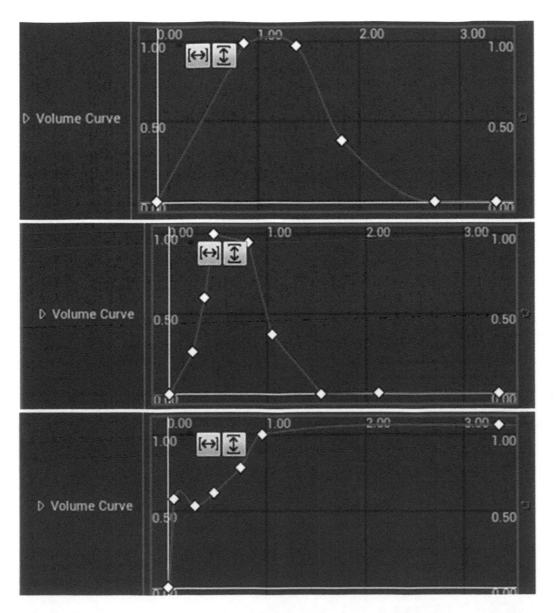

Although we're randomly choosing between envelopes, the envelopes themselves are of course preset. If you wanted a more random range of attack or decay settings, you could use the <Fade In> and <Fade Out> nodes in Blueprint and feed them with random float values. You can hear this in operation for the second steam vent [Steam_Blast_02], in the "Cave 12" / "Steam Blasts" section of the Level Blueprint.

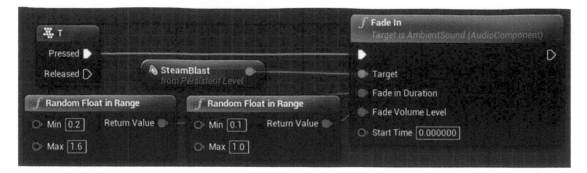

Looping Volume Envelopes

If you listen to the wind in *Cave 12*, you should hear that this varies in intensity. Here we have taken a relatively short wind sample (7 Seconds), set it to loop, and then applied a long envelope to it (32 seconds) that is also set to loop {Wind_Looping_Env}. Since it is not easily divisible within the length of the envelope, the loop of the sound itself will remain out of phase with the envelope, creating further variation.

There's also an additional -**Enveloper**- that applies a short fade in (over two seconds) when the sound first starts. Since the sample itself is designed to loop, the start of the sound is at full volume (to match with the end of the sound), so if we just started it without an envelope, this would be very abrupt.

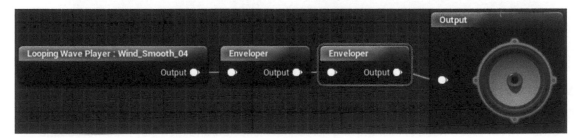

Exercise 02_06: Volume Envelopes

In this exercise you will be adding a varying wind tone to the *Cave 02* tunnel section of your level making use of volume envelopes for variation.

-Enveloper-

1 Go back to the *Cave Tunnel* and add a varying hollow wind sound to this section.
2 Use a relatively short wind sample in a -**Wave Player**- that is set to loop (in its ➡ **Details** panel).
3 Connect this to two -**Enveloper**- nodes, the first of which will create a smooth start to the sound, and the second one set to Loop Indefinitely.

 a. Create a long varying curve for this second loop and set the Loop Start and Loop End points to match.

 b. Make sure that the start and end values as it loops are the same or else you'll get a sudden jump in volume as it loops around.

Oscillation

An oscillator produces a continuously changing variable around a central value. In the case of the -Oscillator- Sound Cue node, it uses a sine wave shape to determine the changes in values over time, and we can vary the amplitude and frequency of this oscillation. *Cave 13* is full of oscillations!

Volume Oscillation

Open up the Sound Cue {Machine_Osc_A} for the first machine (A) and select the Wave Player. Play just the -Wave Player- node to hear the original sound unaffected, and then play the whole Sound Cue, and you'll hear that the sound is being processed quite radically by the -Oscillator- node.

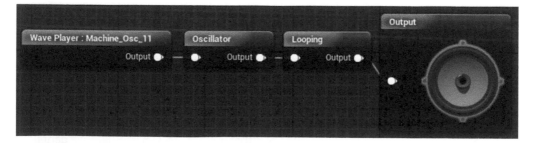

The oscillator has a fixed amplitude of 1.0 and is centered around 1.0, so we will get volume ranges oscillating between 0.0 and 2.0 with a frequency of 5Hz (in other words, 5 times a second since the frequency setting in the Unreal Engine actually represents twice the frequency of the sine wave's modulation for some mysterious reason).

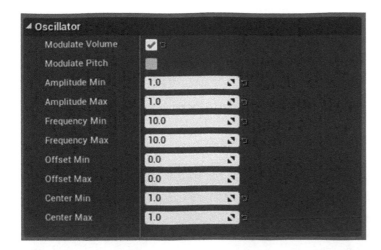

In the next example (B), different frequencies of volume modulation have been used to represent the different sized cogs and platforms, with the smaller ones moving faster than the larger ones ({Platforms_Osc_01-03}). The -**Oscillator**- takes the relatively continuous wave sound and breaks it into pulses of activity, setting these pulses to different speeds (frequency min/max 1, 2, 6, and 16, respectively) to match the size of the moving cogs.

Pitch Oscillation

Machine (C) actually reuses the same Sound Wave as (A), but this time the pitch is oscillated ({Machine_Osc_C}). Note that this time the center of the sine wave value that's oscillating the pitch is 1.2, meaning that with an amplitude 0.4 we'll get a version of the original sound that ranges from 0.8 to 1.6 of the original pitch.

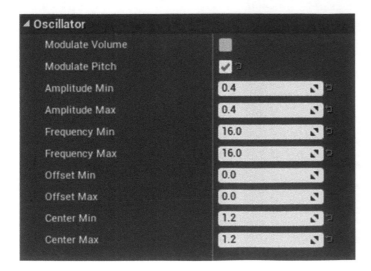

Pitch + Volume Oscillation

The wind {Wind_Osc_01} (D) is oscillating both the pitch and the volume of the source sound, and since we want these to be different values, we've used two separate -Oscillator- nodes (there's also an -Enveloper- to give the wind a slight fade in/out each time it is triggered from the randomized -Delay-).

Sounds with lots of high frequencies are particularly good candidates for envelopes or oscillations since our perception of frequencies changes with volume. Although this is just a volume change, we perceive the frequency characteristics of the sound to be changing too.

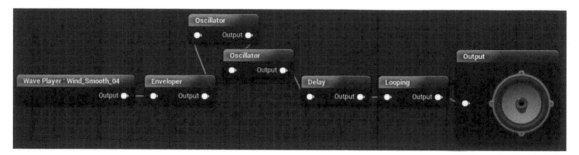

Since the wind is an occasional one-shot that we want to vary (rather than the looping machines or cogs), there is some more variation in the effect derived from differences in the min/max ranges. For example the amplitude and frequency of both the volume and pitch oscillators will vary each time, as will the offset. The offset represents where we start along the trajectory of the sine wave and can be a useful variant to avoid an otherwise predictable movement.

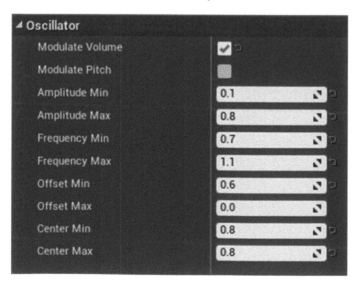

Before moving on, also have a look at the Sound Cue {Wind_Whistle} (E) that is used in the top right-hand side of this cave that again makes use of oscillators along with volume envelopes and randomization to bring some variation to the wind sounds in the cave.

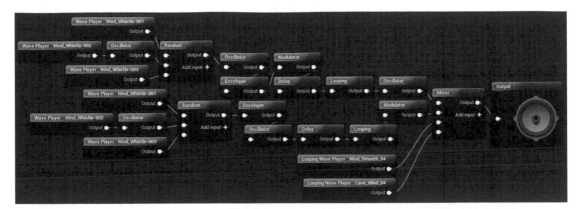

At the time of writing, in the Unreal Engine we don't have the ability to access the -Oscillator- parameters for real time changes, but you could have several versions of a sound with different oscillation settings and crossfade between them in response to game parameters. For crossfading between sounds based on game parameters see the Parameterization = Interactivity section below.

Exercise 02_07: Oscillators

In this exercise we will be using oscillators to generate the sounds for the machines in the *Final Cave* section of your level.

-Oscillator-

1 Open the exercise map and go to the *Final Cave* section.
2 Create some source loop [Ambient Sound] Actors for *Oscillating Machine 01* and *Oscillating Machine 02* in this area.
3 See the amount of different sounds you can get from one sound source by using various Pitch and Modulation settings of an -Oscillator- node in your Sound Cues.
4 The function of the -Oscillator- node requires a little more explanation than most. See Appendix A: Core Concepts/Sound Cue Nodes for details.

Wavetables

Taking memory saving techniques to their (il)logical extreme, the computer in *Cave 14* plays a well-known tune (badly). The total file size required to play this tune (or any other you can think of) is

a little bigger than the size of the wave file used to produce it: 3.9 kB (which as you will appreciate by now is tiny!)

We've included this example as a slightly perverse homage to the history of game audio, when all of the sounds and music in a game might have been produced from a few very small samples (and a bit of FM synthesis if you were lucky!) Although such lengths would not be necessary today, the principles behind this (controller data manipulating individual notes) will in fact never be obsolete with regard to interactive music, and we'll be returning to this discussion later in the Chapter 12.

The method here is analogous to wavetable synthesis. The sound source is just 10 cycles of a sine wave (just 45 milliseconds of sample memory) in a -**Looping Wave Player**- that produces a tone (as any repeating wave cycle would). By using different Pitch Multipliers (playing the sample back at different rates), we can get all of the different notes we need.

In this instance a <TimeLine> node is used like a musical sequencer. When this starts to play, it sets pitch using a Float Track and fades notes out when needed via an Event Track.

The original sample tone was generated at 220Hz (pitch A3). To get the other notes, their Pitch Multipliers were scaled accordingly.

Exercise 02_08: Wavetables

In this exercise you will be creating a wonderful piece of haunting music using the wavetable machine in the *Final Cave* section of your level (or not).

1. We have set up a musical machine in the *Final Cave* section of the exercise map.
2. Find the "Wavetable Machine" section of the [Level Blueprint] and edit the <Timeline> to make a tune (see Appendix A: Core Concepts/Others/Timeline).
3. In the float track Pitch, you can define a series of pitches by creating points on the track with Shift + click and defining their values.
 a. C3 (130.81Hz)—the pitch multiplier would be 130.81/220 = 0.595
 b. D3 (146.83Hz)—the pitch multiplier would be 146.83/220 = 0.667
 c. E3 (164.81Hz)—the pitch multiplier would be 164.81/220 = 0.749
 d. F3 (174.61Hz)—the pitch multiplier would be 174.61/220 = 0.793
 e. G3 (196.00Hz)—the pitch multiplier would be 196.00/220 = 0.890
 f. A3 (220.00Hz)—the pitch multiplier would be 220.00/220 = 1.0
 g. B3 (246.94Hz)—the pitch multiplier would be 246.94/220 = 1.222
 h. C4 (261.63Hz)—the pitch multiplier would be 261.63/220 = 1.189
4. In the Event Track Fades, you can define events that will fade out notes when required.
5. Move the event on the End Event Track to the end of your piece.

Parameterization = Interactivity

Summary : Using conditions and in-game parameters to affect changes in sound.

The best way to avoid repetition is to have your sounds be truly reactive, not passively sitting there but responding to game events. The ability to change the asset, the pitch, and especially the volume in response to game parameters opens up a world of interactive possibilities, and hence a world of variation.

Many of the procedural sound design approaches above lend themselves to being driven by game variables/parameters since the more modular our sound system, the more we can affect individual elements of it in response to game events.

Of course, the greatest integration between game parameters and sound could be achieved if we were actually creating and manipulating the sounds themselves through synthesis, not just basic aspects of the sound like volume and pitch, but that really falls within the bounds of procedural audio, which is beyond the remit of this book. If you are interested in this area, then see the Further Reading section of the website, which includes a link to the UE4OSC project. This allows you to communicate parameters and events from the game in real time to other applications such as Max or PD, which are more suitable for developing procedural audio systems.

There is going to be a bit of a jump in complexity now, but these are core concepts that we will be returning to several times in the rest of the book, so if you can grasp them now, then things will be a lot easier later on. Have a quick scan through Appendix A: Core Concepts/Controlling Audio Components before proceeding.

Take a deep breath . . .

Swapping out Sounds with -Branch-

We have set up some procedural approaches to constructing sound out of modular elements through both sequencing and layering approaches and some methods of further modulating the sounds for variation, but so far this has all been on a randomized basis. Now we are going to look at how you can use game events or parameters to decide which elements of the system are played.

The final area *Cave 14* provides a possible escape route out of the caves, but you need to fix the machines that operate the fans first.

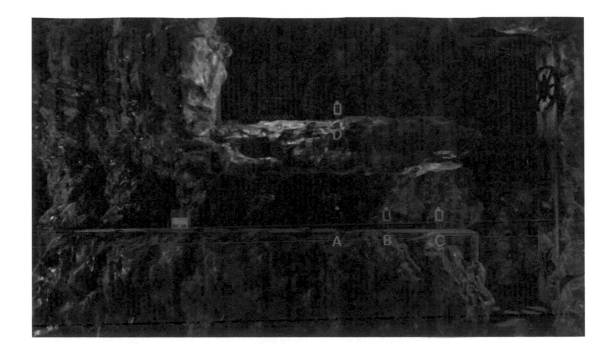

Use button **A** (by pressing E), and you will hear the grinding whimper that tells you that things are not really working properly. However, if you walk further along you can find a wrench that will enable you to fix it.

Our Sound Cue {**Fixable_Machine**} has two Sound Waves in it and a -**Branch**- node that will allow us to determine which one is chosen to be played depending on a condition set through gameplay.

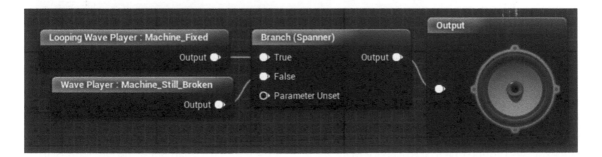

You can also do this control specific elements within a more complex Sound Cue.

In the Blueprint we have created a variable named Wrench. This variable has a default value of False, as the player does not have the wrench. When the player picks up the wrench (by overlapping the [Trigger] around It), this variable is set to True. When the player interacts with the machine, the <Set Boolean Parameter> node checks this variable to find its state (since it's a Boolean variable, it only has two—True or False). It looks in the Sound Cue to find the parameter that matches its name Wrench, in this case finding the -Branch- node parameter and setting this to the current variable state. So if the player has not picked up the wrench (False), the Sound Cue will play the {Machine_ Still_Broken} Sound Wave, but if the player has the wrench (True), it will play the {Machine_Fixed} looping Sound Wave. See the "Wrench" section of the [Level Blueprint].

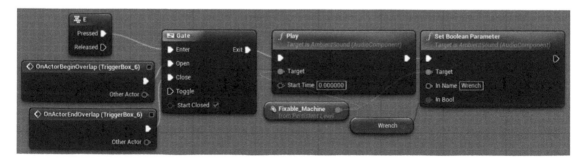

This is a very simple example of how we can begin to use game parameters and conditions to influence the audio. You can perhaps imagine how we might use this technique to swap out different layers of a modular procedural Sound Cue such as the explosions in *Cave 08*/Exercise 02_04. We could have one core explosion Sound Cue that is used for many different objects, but we swap out some elements of it depending on whether they are present in the object exploding—a flammable whoosh for example.

You should have already taken a look at Appendix A: Core Concepts/Controlling Audio Components. Now also read Appendix A: Core Concepts/Variables, Parameters, and Numbers.

Exercise 02_09: Boolean Conditions to Sound Choice

In this exercise we are going to go back and extend the Sound Cue we created for exploding the rock blockages in the *Cave Tunnel*. This exercise is quite tricky—but you'll learn a lot!

<Set Boolean Parameter>, -Branch-, <Play>, variables <Get> and <Set>, print string

1 Go to the *Cave Tunnel* area of the exercise map (Bookmark 4).
2 In front of a couple of the rock blockages in the tunnel (e.g., *Blockage_03*), there are some gas pipes that you can turn on (press E). We are going to use this as a variable to control whether a flammable element is added to the explosion sound or not.
3 Locate the ambient sound next to the second rock blockage in the tunnel. [Rock_ Explosion_03]. Select it and then right-click/Level/Find in Level Blueprint (it's in the "Cave Tunnel" / "Blockage 03" section of the Level Blueprint).
4 From this reference to the ambient sound, drag out and create a <Set Boolean Parameter> node. Set its In Name to Gas. Then connect this so that this node is triggered from the output of the existing <Play> node.
5 Locate your Sound Cue to which this ambient sound refers (look in the ➡Details panel of the ambient sound and use the magnifying glass icon to locate it in the ➡Content Browser).
6 Double-click the Sound Cue to open the ➡Sound Cue Editor. Add another input to the -Mixer- and create a -Branch- node to attach to this. Now select the -Branch- node, and in the ➡Details panel set the Bool Parameter Name to be Gas.
7 Find or create a flammable whoosh type sound that can accompany the explosion if the gas is on. Attach this as a -Wave Player- to the True input of the -Branch-.
8 In your [Level Blueprint], check the In Bool of the <Set Boolean Parameter> and play this section of the map. Since your Boolean variable is set to true, you should hear your additional flammable layer in the explosion here. Go back to the [Level Blueprint] and uncheck it then play again. Now it should be absent.
9 We now need to set up the system so that your variable is changed when the player interacts by switching on the gas pipe in the level.
10 Create a Boolean variable in the [Level Blueprint] by clicking on the + Variables icon in the ➡My Blueprint panel. Name it Gas_Switch. Compile the Blueprint using the Compile icon on the top left and then make sure that this Boolean's Default Value is False (unchecked) in its ➡Details panel.
11 Drag and drop it onto the Blueprint ➡Event Graph to create a <Get>, and connect this up to the In Bool input of your <Set Boolean Parameter> node.

12 We can now set the condition of this Gas_Switch Boolean dynamically in Blueprints. Look at the "Gas Switch 01" section in the [Level Blueprint] nearby. An event will come out of the <Gate> here when the player uses the switch in-game. Drag and drop your Boolean variable Gas_Switch again into the ➡Event Graph, but this time create a <Set> node. Check the Boolean value of this node to be True and connect it to the output of the <Gate>.

13 Drag out from the <Set Boolean Paramter> to create a <Print String>, then connect the <Get> of the Gas_Switch variable to the In String input of this <Print String> (this will automatically create a convertor from the Boolean value to a string variable). You can now see the changing conditions (False/True) printed to the screen as you play (also see Appendix C: Testing, Troubleshooting, and Good Practice/Watching Blueprints/Print String).

14 Now if you explode the rock blockage without the gas switch on, it will play your standard explosion sound, but if you play it again with the gas on, you should then hear your additional flammable layer. You can now try setting up a similar system for the [Rock_Explosion_04].

15 If this all works the first time, then well done! You got lucky. To check how things are working, it's good to watch the Blueprint while you play. See Appendix C: Testing, Troubleshooting, and Good Practice/Watching Blueprints.

16 If you're struggling then take a look at the exercise screenshot for this system, which is downloadable from the website.

Parameters to Pitch with <Set Pitch Multiplier>

You now need to power up the two fans that will allow you to float up to the upper cave. Button B (in the illustration above) starts the lower fan and C the upper one. Hold down E to increase the speed of each fan to maximum before you jump!

While the player is holding E, the system starts a <Timeline> containing a Float Track. This can store a set of values over time. In this case it is set to output numbers from 0.0 to 1.0 over 8 seconds, increasing the speed of the fan. Remember a float is just a floating point number—in other words a number that contains a fractional part, not a whole number or an int (integer).

If the player releases the key having reached the max fan speed, then it is held for 10 seconds (using a <Delay>) and then the <Timeline> is reversed so the numbers ramp down again. As we want to represent these changing conditions to the player (so they know when the max speed has been reached), we're taking this 0.0 to 1.0 value and passing it to the <Set Pitch Multiplier> node that targets the ambient sound for the fan [Fan_01] (referencing the Sound Cue {Fan_01}). Obviously the values 0.0–1.0 aren't particularly useful ones for the pitch of the fan, so we have mapped (or scaled) these numbers onto a more suitable range (e.g., 0.0–1.0 becoming 0.6–1.2). See Appendix A: Core Concepts/Transforming and Constraining Variables and Parameters.

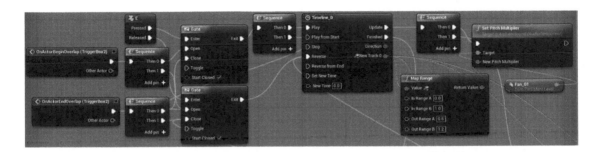

In this example we are using the <Timeline> to give us a ramp up in pitch over time, but you could use any parameter in game to set the pitch of your sound. If you want it to only update its pitch when played, then just trigger the <Set Pitch Multiplier> from the output of a <Play> or <Play Sound Attached> node. If you want it to continuously update, then you need to trigger it from an <Event Tick>, or as we have done here, from the Update output of a <Timeline>.

Exercise 02_10: Read <Timeline> for Pitch Control

In this exercise we will look at how we can set the pitch of sounds in response to game events.

<Set Pitch Multiplier>, <Key Events>, <Set Volume Multiplier>

1 In your exercise level find one of the machines that you added a looping oscillating Sound Cue to in the *Final Cave*. See Exercise 02_07 (e.g., *Oscillating Machine 02*).
2 With this ambient sound selected in the ➡Viewport, right-click in the [Level Blueprint] ➡Event Graph and Create a reference to—.
3 Drag out from this to create a <Set Pitch Multiplier>. Set the New Pitch Multiplier to 0.5.
4 Do this again to create another one, and this time set this New Pitch Multiplier to 1.5.

5 Set up a couple of <Key Events> to test this. Right-click and search for "T" to create a T <Key Event>, link this to your first <Set Pitch Multiplier>, then create a <Key Event> "Y" to trigger the second (see Appendix A: Core Concepts/Key and Gamepad Inputs).

6 Play the game in this area, and when you're near your oscillating machine, press T and then Y to hear its pitch change.

7 Now let's apply some timed pitch changes. Create a <Timeline> node. Right-click for the ➡Graph Action Menu and select Add Timeline. Double-click this to open the ➡Timeline Editor.

8 Click on the f+ icon to create a new Float Track, name it Pitch_Track, and create some points on this track to represent your pitch change over time. For example you might want to go from 0.5 to 1.5 over 3 seconds. Press Shift and click on the line to create key points on the line. Click and select and drag to move them (see Appendix A: Core Concepts/Others/Timeline for more on the <Timeline> Node). Set the length of the timeline to be 3 seconds. Select the ambient sound in the level and set its initial Pitch Multiplier to 0.5 so that it matches the start of your <Timeline> track and doesn't suddenly jump to it.

9 Once you have set up your Float Track values, return to the ➡Event Graph tab at the top.

10 Reconfigure your graph so that the T <Key Event> goes to the Play from Start input of the <Timeline>. Send the Update output to now trigger your <Set Pitch Multiplier> and link the Pitch_Track output to set the New Pitch Multiplier.

11 Play the game and test your Float Track to pitch system.

12 Now set up a trigger use system (see Appendix A: Core Concepts/Trigger Use) so that the player can go up the machine and use it (E), triggering a pitch change instead of the <Key Event>.

13 You could link this up to the spotlight [Final_Cave_Spotlight] so that it acts like a generator that is powered on for the light. In the lights ➡Details panel, set its Rendering/Visible to False, create a reference to it in the [Level Blueprint], and then drag out from this to create a <Set Visibility> node. Trigger this from the Finished output of the timeline.

14 You could also add a <Set Volume Multiplier> to automate its volume as well.

Parameter-based Crossfades with -Crossfade by Param-

For the second fan (Button C), we want to add a little more interest, so as the fan gets faster, new sound elements are introduced representing the increasing speed and strain. We're changing the pitch again (with the <Set Pitch Multiplier>), but this time we are also changing the volume of various sound elements.

The value of the Float Track from the <Timeline> is now being scaled from 0.0–1.0 to 0–100 by setting a Float Parameter within the Sound Cue {Fan_02} named Fan_Speed.

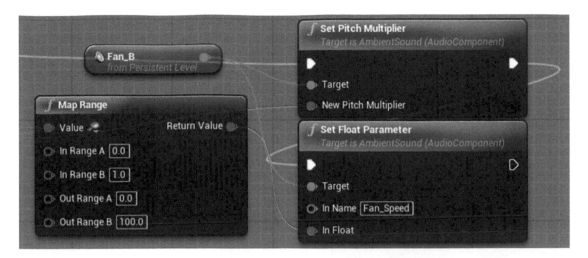

Inside the Sound Cue this named parameter is picked up by a -**Crossfade by Param**- node, which has a parameter of the same name.

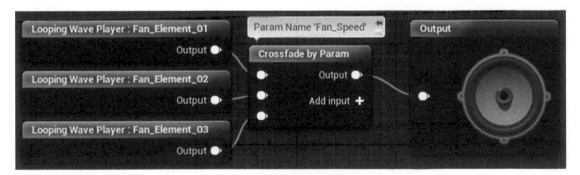

The image below illustrates how the 0–100 parameter range is used to control the volume of the three fan sound elements.

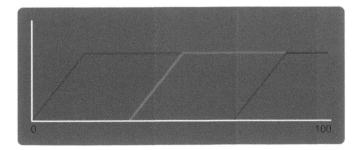

As the parameter Fan_Speed increases from 0.0 to 100.0, the three sound elements will gradually fade in, starting with the {**Fan_Element_01**} (in red), then {**Fan_Element_02**} (in blue), and finally {**Fan_Element_03**} (in orange). So as the parameter coming from the timeline increases, each sound is going to gradually come in and ramp up in volume until at the maximum fan speed all three are playing. You can see these volume changes as well as hear them by using the Stat Sounds Console command (see Appendix A: Core Concepts/Console Commands).

In the -**Crossfade by Param**- node you can set the value at which the parameter will start to fade in each input, where this fade in will end (i.e. reach maximum volume), and where it will start and end its fade out. For example the first element (0) will start playing when the parameter is 0.0, and as the parameter increases to 25.0, it will gradually fade up. The second element will start fading in at this point until it reaches its maximum volume when the parameter is at 50. In this instance we want all the sounds to remain playing when the parameter is at its maximum so the *Fade Out Start* and *End* values are the same.

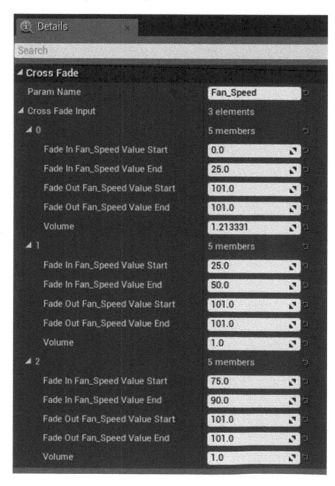

Again we are using the Float Track of a <Timeline> to control our crossfades here, but you could control them with any parameter or variable you have within the game.

Exercise 02_11: Controlling Crossfades with Crossfade Param

In this exercise we will explore how you can use the -**Crossfade by Param**- node in the Sound Cue to control the volume of various elements of a sound in response to game parameters.

-Crossfade by Param-, <Set Float Parameter>

1 In the *Final Cave* you will have noticed a platform up against the rock face that will allow you to progress to the next section. Unfortunately they are not yet working. First you need to power up the generator.
2 Go to the *Lift Generator* on the left and add an ambient sound to the level.
3 Now create a Sound Cue for this ambient sound. It should comprise three elements that will gradually fade in as the machine powers up over time. Connect these three elements as -**Looping Wave Player**-s to a -**Crossfade by Param**- node then connect this to the output of the Sound Cue. You'll need to add a third input to the -**Crossfade by Param**- node by clicking on the Add Input button.
4 Select the -**Crossfade by Param**- node, and in its ➡ **Details** panel set the Param Name to be Generator_Power. Set all the Fade Out Param Value Starts and Ends to 1.0, and then adjust the Fade In Param Value Starts and Ends so that they fade in at different times up to 1.0 (see the image in the demo above for a reminder).
5 Assign this cue to your ambient sound and create a reference to this in the [**Level Blueprint**].
6 We have created a trigger use and release system around the generator machine and connected this to a <Timeline> node for you -see the "Final Cave" / "Lift Generator" section of the Level Blueprint.
7 Create a new float track in the <Timeline>. Set it to go from 0.0 to 1.0 over 8 seconds and change the Length of the <Timeline> to 8.0. Then return to the ➡ **Event Graph** and drag out from the reference to your ambient sound to create a <Set Float Parameter> node. Connect the output of the <Timeline> Float Track to the In Float of this <**Set Float Parameter**> node. Also connect the Update output of the <Timeline> to trigger the <**Set Float Parameter**>.
8 Set the In Name of the <**Set Float Parameter**> node to Generator_Power.
9 This time the system is set to Play the <Timeline>, not to Play from Start, so the player may stop their interaction before it has reached the end. We have used the Released output from the <Key Event> to Stop the <Timeline>, which will stop it at its current position from where it will continue when the player interacts again.

10 Play the game and you should be able to hear the layers build up as you hold down the use key E. If you release it, they will hold at their current levels until you use it again (you could also Reverse this <Timeline> with another key).

11 We have already set up a Boolean parameter to track whether the generator is on. Connect the Finished output of your <Timeline> to this <Set Generator On> node.

Using User-defined Curves

The ability to take parameters or variables from the game system and map them onto user-defined curves is a core technique that we will be returning to many times in the book, for example in Chapter 04 to control layers of music and in Chapter 07 to control the audio response to impacts or player speed for footsteps. It's worth having a quick read of Appendix A: Core Concepts/Transforming and Constraining Variables and Parameters/Reading through Curves before moving on.

Once you have been blown up to the upper cave by the fans, you need to operate the generator (D) to get it to the correct setting before the elevator will work (using E to speed up and R to slow down). The correct setting is indicated through the audio.

There are three elements in the Sound Cue:

The first rises linearly in volume and has a pitch curve.

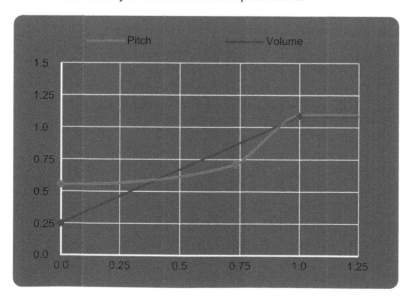

The second has a different volume curve, and its pitch curve has a sharp definition halfway along to indicate the optimum setting for the generator.

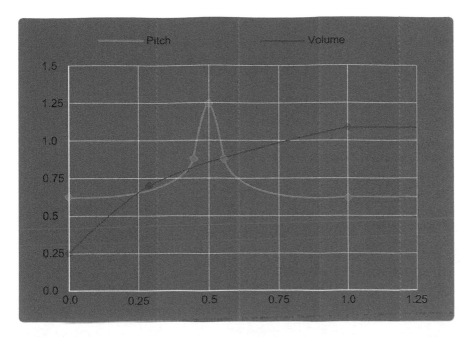

The third element has a sharp volume rise towards the end to indicate that the player is overstressing the generator.

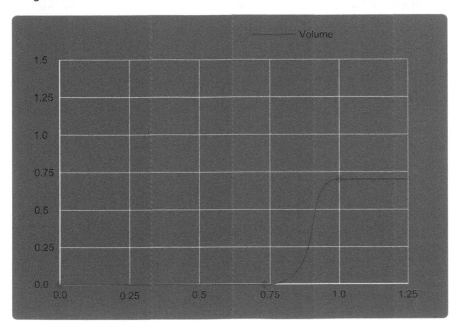

By adding just a little more complexity, we can get a system that allows us to define our own curves to read through rather than the linear movement between two values we have had up until now. Of course we could use curves in the Float Track of a <Timeline>, but the approach below is infinitely more adaptable and useful.

Since we are now using some non-linear values, the -**Crossfade by Param**- is no longer useful. Instead we are using the -**Continuous Modulator**- that allows us to change the volume or pitch of the sound in response to named parameters. As you can see from the image below in the Sound Cue {**Final_Elevator_Generator**}, there are three -**Continuous Modulator**-s that will control the volume for each element, and an additional two for the pitch.

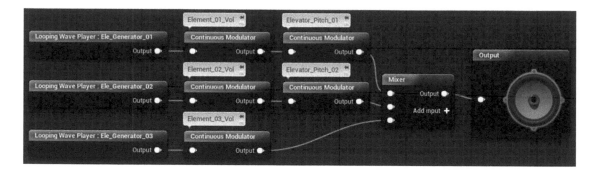

The controls for the <Timeline> are slightly different this time since we're using E to increment the values and R to decrement. This means the player can adjust them until the generator is ready (when the generator value is in the right range, it uses a <Branch> node that allows the lift to function).

Rather than directly apply the value of our <Timeline> Float Track to our parameters, now we are using this value (0.0–1.0) to read through curves. The X-axis in a curve is referred to as Time, and the Float Track parameter is used to read through this and output the value of the curve at that position via the <**Get Float Value**> node. Although it's called time, we can treat this simply as an X value to read out the curve's Y setting at this position (note that if you just want a linear relationship between your game variables and pitch/volume, you can use the Min Input/Max Input/Min Output/Max Output settings of the -**Continuous Modulator**- to clamp and map them to an appropriate range).

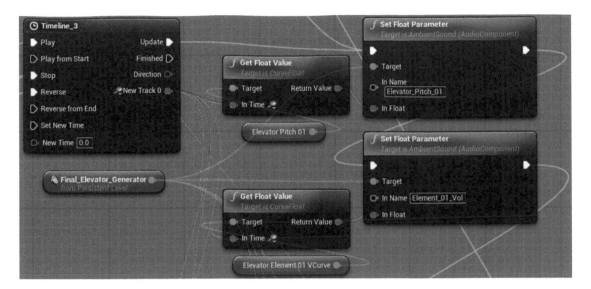

The curves are set using curve assets that have been created in the ➡Content Browser (for example {Elevator_Pitch_01}), and we have used curve variables to hold these in the [Level Blueprint]. As you can see above, the Elevator_Element_01_VCurve variable (containing the {Elevator_Pitch_01} curve) is read by the <Get Float Value> node, and the Return Value of this sets the float parameter Elevator_Pitch_01. This corresponds to the name of the parameter of the -Continuous Modulator- in the Sound Cue.

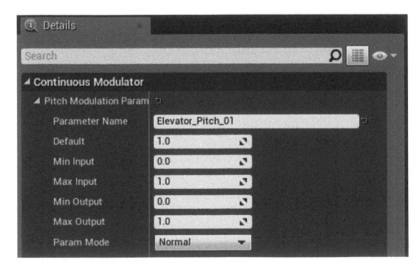

Curves have many applications in game audio. Don't worry if this all seems a little overwhelming for the moment—we will be revisiting them on numerous occasions throughout the book.

Exercise 02_12: Using User-defined Curves

In this exercise you will explore the system for the moving platforms in the cave which uses curves to vary the volume and pitch of different sound elements in response to the speed the player sets.

-Continuous Modulator-, <Set Float Parameter>, {Curves}

Note: This machine will not start unless you have <Set> the Generator On Boolean to True in the last exercise. If you are starting directly from here, you will need to change its default value to True in the ➡My Blueprint Tab.

1 Now that the generator is on (Exercise 02_11) you can use the machine on the right-hand side of the rock face (*Speed Control*) to start the moving platforms that will take you up to the next section.
2 When next to the machine press E to start it and O to speed it up/P to slow it down.
3 Setting this whole system up from scratch would take quite a bit of time, so we have already put it in the level with some placeholder sounds in the "Moving Cave Platform" area of the [**Level Blueprint**]. What you should do for this exercise is to replace these with some of your own and generally poke around to get familiar with the concepts being applied here.
 a. Our <Timeline> float track is being used to read through curves to set various float parameters via the <Set Float Parameter> nodes. The In Name parameter names of these relate to the parameter names of the -**Continuous Modulator**-s inside the Sound Cue {**Final_Cave_Platforms**}.
 b. The curves we are using are referenced by the curve variables in the [**Level Blueprint**]. You can find these and see (and edit) their curves by selecting the curve variables in the [**Level Blueprint**] and looking at their Default Value.
 c. Note how we have made sure that the Volume and Pitch multipliers of the ambient sound objects in the level match the values at the start of their respective curves so that we do not get a sudden jump when the curve values start to be applied.
4 Swap out the sounds with your own and experiment with changing the shape of the curves (see Appendix A: Core Concepts/Transforming and Constraining Variables and Parameters/ Reading through Curves). You could also adapt this to read through curves created on float tracks of the <Timeline> itself rather than using separate curves.
5 You have made it to the penultimate exercise in Chapter 02, so sit back and have a nice cup of tea! We appreciate that the last few exercises have been pretty tricky, so if you've made it through then well done, but if you're struggling a little then that's fine as well. We will be revisiting these kinds or parameterized approaches at numerous times, so you can have another go later on.
6 The final exercise and next chapter are a lot easier—we promise!

Exercise 02_13: First Pass

Using everything you have learned about ambience and procedural approaches to sound design, go around and implement sounds for the other areas in the exercise level. Next we will be adding music and then dialogue before returning for a second pass to make things real in Chapter 07 and good in Chapter 08!

Monitoring Memory and Level Streaming Approaches

As we've said there are many reasons for adopting a procedural, modular, or parameterized design approach, but in many cases the critical issue is the RAM available. If you go over then your sounds simply won't work or you'll be taking memory away from other systems—and they won't be happy! Whatever your platform and whatever its specifications, you need to monitor your audio memory.

Asset Checking

The first thing to do is to have a look through the files themselves to see if there's anything you've overlooked. Firstly you can right click on your audio folder in the **Content Browser** and select *Size Map* to get a graphical representation of the file sizes. Then in the ➡ **Content Browser**, select View Options/View Type/Columns to see some additional information about your files.
Check the following:

> **NumChannels**—If your sounds are spatialized and playing back from a point source in the game, then it makes no sense for them to be stereo files (in fact stereo files will not spatialize but will be played back directly to the players ears).
>
> **Sample Rate**—Check for any anomalies such as that 96kHz sample that slipped through the net!
>
> **Compression/Ogg Size**—When you import a sound the compression setting is set to 40 by default, but it might be appropriate to have some less prominent sounds at a lower value, and the very important sounds you want at high quality to be a higher value. These settings will obviously impact on the Ogg Size.

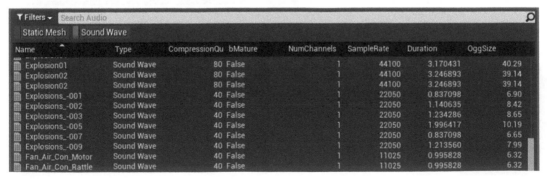

Name	Type	CompressionQu	bMature	NumChannels	SampleRate	Duration	OggSize
Explosion01	Sound Wave	80	False	1	44100	3.170431	40.29
Explosion02	Sound Wave	80	False	1	44100	3.246893	39.14
Explosion02	Sound Wave	80	False	1	44100	3.246893	39.14
Explosions_-001	Sound Wave	40	False	1	22050	0.837098	6.90
Explosions_-002	Sound Wave	40	False	1	22050	1.140635	8.42
Explosions_-003	Sound Wave	40	False	1	22050	1.234286	8.65
Explosions_-005	Sound Wave	40	False	1	22050	1.996417	10.19
Explosions_-007	Sound Wave	40	False	1	22050	0.837098	6.65
Explosions_-009	Sound Wave	40	False	1	22050	1.213560	7.99
Fan_Air_Con_Motor	Sound Wave	40	False	1	11025	0.995828	6.32
Fan_Air_Con_Rattle	Sound Wave	40	False	1	11025	0.995828	6.32

Memory Checking

All game systems have a range of debug tools for the developers to use to get information about what's going on in the game system. In the Unreal Engine you can see some of the audio ones by going to the drop down arrow for your Viewport and selecting Show Stats or by using the Console commands (see Appendix A: Core Concepts/Console Commands).

If you go to the Stat menu below the Show Stats option and choose Advanced/Audio, the Audio Memory Used will give you the running total size of the sounds that have played.

The Console command "ListSounds" will also give you a list of these sounds to the output log (Window/Developer Tools/Output Log).

And the Console command "Stat Sounds" gives you a list of the currently active sounds and their size.

```
Active Sounds:
 Sorting: disabled Debug: disabled
 Index Path (Class) Distance
   0. /Game/Audio/SFX/Asynchronous_Machine_Pitch_CUE.Asynchronous_MAchine_Pitch_CUE (Master) 783.32
      0. Wave: Machine_Osc_11, Volume:   0.12 (FL: 0.06 FR: 0.00 FC: 0.00 LF: 0.00, LS: 0.07, RS: 0.00), Owner: Asynchronous_MAchine_Pitch_CUE_6
      1. Wave: Machine_Osc_11, Volume:   0.13 (FL: 0.06 FR: 0.00 FC: 0.00 LF: 0.00, LS: 0.07, RS: 0.00), Owner: Asynchronous_MAchine_Pitch_CUE_6
   1. /Game/Audio/SFX/Asynchronous_Drips_01_CUE.Asynchronous_Drips_01_CUE (Master) 267.03
      0. Wave: LIQUID_water_drips_loopshort02, Volume:   0.75, Owner: Drips
      1. Wave: LIQUID_water_drips_looplong02, Volume:   0.75, Owner: Drips
   2. /Game/Audio/SFX/Creature_01_Rand_Fragments.Creature_01_Rand_Fragments (Master) 285.53
      0. Wave: S_Creature_01-008, Volume:   0.56 (FL: 0.06 FR: 0.43 FC: 0.13 LF: 0.00, LS: 0.00, RS: 0.00), Owner: Creature_01_Rand_Fragments_15
   3. /Game/Audio/SFX/Creature_01_Rand_Fragments.Creature_01_Rand_Fragments (Master) 1262.77
      0. Wave: S_Creature_01-007, Volume:   0.37 (FL: 0.00 FP: 0.23 FC: 0.00 LF: 0.00, LS: 0.00, RS: 0.14), Owner: Creature_01_Rand_Fragments_2
   4. /Game/Audio/SFX/Creature_02_Gieger_01_Cue.Creature_02_Gieger_01_Cue (Master) 883.30
      0. Wave: Gieger_01, Volume:   0.10 (FL: 0.00 FR: 0.07 FC: 0.00 LF: 0.00, LS: 0.00, RS: 0.03), Owner: Creature_02_Gieger_01_Cue_19
   5. /Game/Audio/SFX/Cave_Tone_LP.Cave_Tone_LP (Master) 5053.59
      0. Wave: Cave_Tone_LP, Volume:   0.22, Owner: Cave_Tone_LP_2
   6. /Game/Audio/SFX/Wind_Rand_01.Wind_Rand_01 (Master) 442.98
      0. Wave: Cave_Hollow_Wind_Env_M, Volume:   2.03, Owner: Wind_Rand_01
 Total sounds: 7, sound waves: 9
 Listener position: X=1561.911 Y=-3235.020 Z=1111.150
```

These are all very useful methods of seeing what is going on in your level, but none of them are actually useful for tracking the overall audio memory requirements for your level. Given that many Sound Cues pick from a random selection of sounds, a play-through of the level with stat audio will only give you the total size of the ones that actually played during that particular play-through. For the next play-through this could be different because different sounds may play. This means that unfortunately the only way of accurately tracking your potential memory footprint is that fun utility loved by everyone throughout the world—the spreadsheet. Remember if all else fails, a good way of tracking your success in audio memory management is by the number and intensity of angry looking programmers marching towards you.

Level Streaming

Open the **Map: Cave_Streaming** then open the ➡**Levels** panel from the Window menu. You can see here that there is one persistent level, but also two audio levels.

It is often useful when there are several people working on a map for them to actually put their content into different levels. These can all be loaded and you can switch their visibility using the ➡**Levels** panel (the eye icon). This means that you can make alterations to your audio level, and whenever someone else loads in the persistent level, it will load in the latest version of your level as well. The other useful thing about this is that we can stream in different levels as we play through the game.

For example with all levels loaded we see this:

This is actually a composite of the persistent level (the master level) containing the graphics:

Together with Audio_Level_01, which contains the audio for the first half of the level:

And Audio_Level_02, which contains the audio for the second half of the level:

Given that this audio is for different parts of the level, we don't actually need to load both audio levels in at the start of the same. We can load Audio_Level_01 when the game starts, and then at a point where we get close to the audio for the second half we can unload Audio_Level_01 from memory and load in Audio_Level_02.

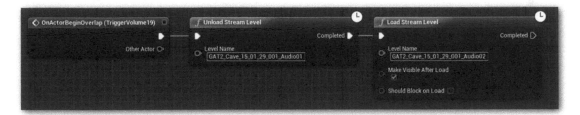

Another approach that is widely used is to hold the music for different areas in separate levels that are streamed in when required. You will need to work closely with your programmer and the rest of the team to decide on the best approach to this for your game, but it can be very useful for dealing with memory issues and implementing your audio in your own audio levels is a good working practice to get into. See Appendix C: Testing, Troubleshooting, and Good Practice/Working in Separate Audio-only Levels for more.

Sound Streaming

At the time of writing, the streaming options remain experimental so investigate with caution!

You can switch on the audio streaming options from the Edit/Editor Preferences/Experimental/ Show Audio Streaming options.

Each {Sound Wave} now has an additional option to allow streaming and the priority for that wave.

In the Edit/Project Settings/Audio menu, you also can now determine the number of streaming sounds that will play at once. Talk to your programmer about the options for streaming audio on the particular platform you are developing for.

Conclusion

A procedural approach to sound design should become an integral part of your game audio toolkit. With this approach asset creation and implementation can no longer be considered as separate activities—you need to design sounds with their interactive use in mind. Through considering sounds as the product of separate components with a modular approach, you can begin to consider your collection of Sound Waves, or your Sound Bank, as a palette from which you can take and reuse elements in different combinations for different things. This not only allows you to keep the resource requirements lower than having unique sounds for everything, but can also help to unify groups of sounds by sharing some common characteristics.

This being said, however, do not forget the importance of great sound design! Once you are familiar with some procedural approaches, it is easy to get carried away and start trying to build everything this way, but sometimes just using a great sound that has been lovingly crafted in your DAW is just the best way to go for some circumstances. Use procedural sound design when appropriate, but use it in combination with great sound design.

For further reading please see the up-to-date list of books and links on the book website.

Recap:

After working through this chapter you should now be able to:

* Choose appropriate sample rates and audio file compression settings;
* Use sequenced and layered variation techniques in Sound Cues;
* Use envelopes and oscillators for pitch and volume variation;
* Create parameterized audio systems using conditional branches (True/False Boolean variables);
* Control the volume and pitch of audio components with in-game parameters;
* Track audio memory usage.

Music Part A: Quick Start 03

Summary : Interactive music forms, playlists, decay tails, parallel and transitional music replacement

Project : DemoCh03MusicRacer01 **Level :** Racer_C

Introduction

In this chapter you'll get a very quick introduction to game music. We'll talk briefly about some of the principles and systems, but don't worry too much about how these are working since we will be going into them in more depth in the following chapters. For the moment this map is about getting you started with exploring some of these ideas in a practical way by writing or editing some music and importing it into the racer game we've provided.

If you want to jump right in and hear the final system in place, then open the Map: Racer_C. If you really want to get your music into the game straight away, you can skip to Exercise 03_05: Manual Looping and Onwards.

You can hear the music interact while you play, or you can control the system yourself manually by using the following shortcut keys:

- 1—Lap 01 loop
- 2—Lap 02 loop
- 3—Lap 03 loop

Q—Win
E—Lose
F—Stinger for speed boost
C—In the lead layer on/off
X—Drafting layer on/off
R—Vehicle damaged layer on/off

For simplicity in all the music examples, we'll be using stereo wave files, but there's no reason that you couldn't use surround music mixes (see Chapter 07 for the method of importing multichannel files), although you should be careful with this. The surround channels in games play a vital role in terms of immersion and provide the player with vital gameplay information (such as the location of NPCs), so any distinct spatialized sound will tend to be considered as being part of the game world. In situations where you want the music to unnerve the player, it can work well to play on this ambiguity, but in general the more subtle approach of putting some of the music's reverb in the surrounds often works better.

Interactive Music Principles

Music is used in lots of different ways in games and for some of these, for example music for cutscenes, the process of writing and implementing music is pretty much exactly the same as it would be for film. We're going to focus on the aspects that are unique to games and the implementation techniques that are used to deal with the two key challenges for interactive music in games:

a. How do I write and implement music that matches and enhances gameplay?
b. How can I write and store enough music to cover gameplay that is of indeterminate length?

We will be looking at the principles and implementation techniques for (a) in this chapter along with Chapters 04 and 05, and we will be dealing with (b) in the advanced music sections of Chapter 12. The chief challenge in music for games is that there is an inherent conflict between music and gameplay that we need to overcome.

Player Autonomy v. Musical Structure

Most music has a time-based structure. In order to feel satisfying, things need to happen on bars and beats and sometimes in longer musical phrases. In games the player has autonomy and is largely in charge of when things happen, and so game events more often than not do not happen to coincide nicely with bars and beats and phrases. As Clint Bajakian says, we have constant compromise between "contextual responsiveness and musical integrity."

Here are some key musical forms that help us deal with this challenge.

Ornamental Forms

This form is where we might have a long piece of background music and then introduce occasional musical stingers over the top to highlight events or actions. Sometimes we want to acknowledge an event or reward the player but do not want to necessarily instigate a large-scale change in the music. The challenge here is that the stingers can happen at any moment, so we need to write the music in such a way so that they won't musically conflict with what might happen to be going on in the accompaniment at the time. A typical solution to this would be to use percussive stingers or to have the background music be fairly tonally static so the stinger will always fit (there are some other more complex solutions offered in Chapter 12).

Parallel Forms

Sometime referred to as vertical re-orchestration, this is music that consists of several tracks or stems playing in sync and in parallel. Game variables can then change the relative mix of the stems without interrupting or breaking the musical structure. This form is good for representing changes in states or parameters in the game since we can bring different layers in and out, and by different amounts, to represent different things. We could also use two different arrangements or performances of the same track and seamlessly crossfade between them to change the emotional intensity. However, while it is good for the flow of the music (and the flow of the game), it doesn't provide quite the same emotional kick or reward as a nicely timed cadence or transition to a new piece.

Transitional Forms

Transitional forms are sometimes referred to as horizontal resequencing or branching forms since they represent the transition from one piece or section of music to another. These kinds of significant timed changes in music can be the most dramatic and rewarding to the player, heightening their sense of triumph. But they present the greatest challenge since the events we want to respond to rarely coincide with musically appropriate transition points.

Algorithmic Forms

Although one could argue that all interactive music is procedural to some extent, algorithmic forms typically work with much more granular or note-level music events. This makes them much more flexible and responsive, but they are more complex to implement. We'll be looking at these in more detail in Chapter 12. In terms of algorithmic techniques currently applied in games, you could say that they are most effective in both representing changes in states and in providing variation in musical materials that might be playing for long periods of time.

Summary

Ornamental: Micro rewards and events
Parallel: Changes of and within states and flow
Transitional: Significant changes of state, macro rewards, and triumph
Algorithmic: Changes of and within states and musical variation

Ambient Sounds or Blueprints?

We could implement all the following systems by referencing ambient sound Actors in the game level rather than nodes in Blueprint, and indeed you will find some games that do this. This is entirely personal preference, but we like to keep things clear. For audio that has a source in the game world, use an Actor in the game world. For audio that doesn't have a source in the game world (in other words is played back directly to the player), use Blueprints. Consistency helps you to keep organized, remember where things are, and find them quickly.

Playlists

Typically in a racing game, you might have a series of precomposed tracks that play until complete then move onto the next track. These might play in a completely random order or a particular sequence. As we noted in Chapter 01, the -Random- node, when linked up to a loop in a Sound Cue, will only choose the next sound once the previous one has finished playing. We can use this to our advantage if we want to create a randomized playlist. In the ➡Content Browser find the Sound Cue named {Playlist_Random}. Double-click it to open the ➡Sound Cue Editor. The -Looping- node will continue to trigger the -Random- to play these endlessly.

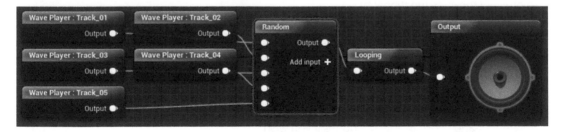

Map: Racer_A

Play the game and listen to the randomized playlist.

The -Concatenator- node will play through its inputs in sequence and so is more useful if you want tracks to appear in a particular order (see the {Playlist_Ordered} Sound Cue). In this case the -Looping- node will restart the -Concatenator- once all tracks have been played, restarting the complete playlist.

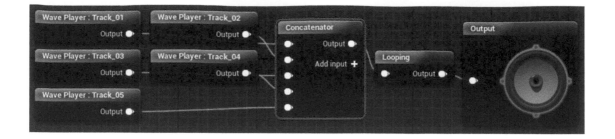

Exercise 03_01: Playlist

We are going to take a little break from the main exercise level for this chapter and implement some of your music into a racing level. We will be returning to the exercise level in Chapter 04.

In this exercise you are going to create your own playlist for the racetrack level.

<Play Sound Attached>, -Concatenator-

1 Open the **Map: Racer_A**.
2 Search the ➡**Content Browser** for either the {**Playlist_Random**} or {**Playlist_Ordered**} Sound Cue.
3 Double-click to open the ➡**Sound Cue Editor** and use the Play Cue and Play Node controls to preview the cues' functionality.
4 Import some of your own music tracks by dragging and dropping them into the Audio/Music folder of the ➡**Content Browser**. Make sure these are in the correct format (i.e., 16 bit 44.1kHz wave files) and that there are no spaces in the file names.
5 Add these to your Sound Cue by dragging and dropping them from the ➡**Content Browser** into the ➡**Sound Cue Editor**.
6 Use them to replace the existing Sound Waves. You can also add additional inputs to the -**Random**- and -**Concatenator**- nodes if you wish.
7 Play the game to make sure it works, and then try to recreate these cues from scratch. From the ➡**Content Browser**—New/Sounds/Sound Cue, right-click in the ➡**Sound Cue Editor** to create the required nodes.
8 Remember to then reference the Sound Cue you are using from the <Play Sound Attached> node in the [**Level Blueprint**]. Open the [**Level Blueprint**] from the Blueprints icon on the ➡**Toolbar** and find the <**Play Sound Attached**> node. Then with the Sound Cue still selected in the ➡**Content Browser**, click on the arrow key of the <**Play Sound Attached**> to assign it.

Level Music, Loops, and Decay Tails

Map: Racer_B

It might be that you want to have a single track that loops around for the whole of the level (as was common in old school games). This is easily implemented, but you need to be aware of a key technique in order to get your loops to sound smooth. When you select the start and end of your loop in your DAW and export, you might get something like this:

With a little care regarding zero crossings (see Chapter 00), this will loop alright when you import it and make it a -**Looping Wave Player**- in your Sound Cue.

Exercise 03_02: Looping Level Music

In this exercise we will import some of your music to use in a -**Looping Wave Player**-.

-Looping Wave Player-

1 Open the **Map: Racer_B**
2 Export your looping music track from your DAW, and then drag and drop it into the ➡**Content Browser**.
3 Open the Sound Cue {**Music_Loop**} and replace the -**Looping Wave Player**- with your sound. Remember to go to its ➡**Details** panel to set it to be Looping (don't try to use the -**Looping**-node, as this is for looping the system and not the sounds themselves!)

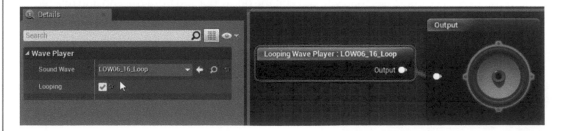

4 Play the game and listen carefully to your music. The {**Loop**} Sound Cue is already referenced by the <**Play Sound Attached**> in the [**Level Blueprint**].

Decay Tails

You may have noticed that your loop feels a little lumpy, with every loop around being obvious and making the music feel more repetitive than it need be. The reason why is actually down to how we edit and prepare our music. Although in your DAW the sound may appear to finish at the end bar line (specifically if you're looking at a MIDI track), when you listen you'll notice that the natural decay of these sounds actually lasts significantly longer. Although a few styles of music can work well when split into loops for interactive use, most have instances where the tails of notes or the decay of the reverb fall across the bar line and into the next bar. If we chop our music up at bar line points, then we won't hear these decays and the music will sound unnatural.

Loop with Integrated Decay

One solution to get your loops sounding smoother is to integrate the decay tail back into the start of the loop. That way when it loops around, you'll still hear the decay of the final notes.

Audio File: Mix Paste

If you're working with an audio file, then you can edit the decay portion from the end and mix paste it back into the start (or simply put it on another track and mixdown both).

MIDI File: Repeat and Export the Second Version

If you're working with MIDI files, then you won't see the decay tail, but you will hear it. The trick here is to duplicate your loop so that you have two versions, one immediately after the other. If we mixdown the whole thing then edit the resulting file in half, the second half will be our loop but will already contain the decays from the first version.

Listen now to the {Loop_Integrated} Sound Cue and compare it with the straight {Loop}.

Exercise 03_03: Integrated Loop

In this exercise you are going to import your track with an integrated decay tail for use in the game.

-Looping Wave Player-

1 Open the **Map: Racer_B**.
2 Using the techniques described above, integrate the decay tail of your track into the start.
3 Import this new track into the ➡**Content Browser** then find the Sound Cue {**Loop_Integrated**}. Replace the current **-Looping Sound Wave-** with your new track.
4 Open the **[Level Blueprint]** and replace the reference to the old {**Loop**} cue with your {**Loop_Integrated**} cue. With your Sound Cue selected in the ➡**Content Browser**, use the arrow in the **<Play Sound Attached>** to assign it.
5 Play and listen—it should sound better!

Play Then Loop

The bright sparks among you will have noticed a problem with this: The first time we start the cue, we hear the decays of sounds that haven't even played yet! What we actually need is to play the original loop first, then loop the version that has the integrated tails.

In the **Map: Racer_B** Sound Cue {**Play_Then_Loop_01**}, you can see that we can use a -**Concatenator**- node to chain these two tracks together.

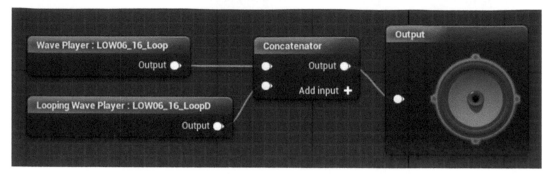

Unfortunately at the time of writing, the -**Concatenator**- node is not sample accurate, and so you may find a short pause between the two files. Another alternative way of achieving the same result is to actually start both versions at the same time but use an -**Enveloper**- node to keep the looped version silent until the first version has finished (you'll often find yourself having to think of workarounds to get the results you want!)

The {**Play_Then_Loop_02**} cue has an example of this. Our loops in this case are 6.48 seconds long, and so the -**Enveloper**- is set to bring the volume of the looping version up after this time has elapsed.

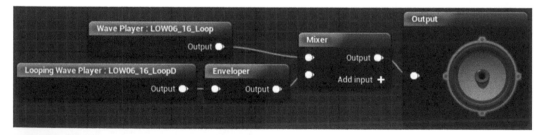

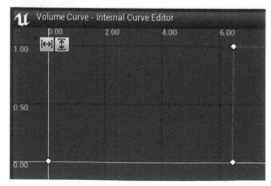

The logic of the audio playback system dictates that if a sound is set to a volume of 0.0, it won't actually start playing. This makes sense but causes a problem for us here, since it won't actually start the loop until it starts to fade in, making it out of sync. In order to avoid this, we've set the initial volume of the envelope to be 0.001 instead of 0.0.

Exercise 03_04: Play then Loop

In this exercise we will chain together two versions of one of your two tracks: the first version without the decay tail integrated and then the second looping version.

-Enveloper-

1 Open the **Map : Racer_B**.
2 Export two versions of your track:
 a. the normal track;
 b. the version with the decay tails integrated.
3 Import these into the ➡ **Content Browser**.
4 Create your own version of the {**Play_Then_Loop_02**} Sound Cue that includes your tracks, the first as a -**Wave Player**- and the second as a -**Looping Wave Player**- (check the Looping option in the ➡ **Details** panel).
5 Select the -**Enveloper**- node and double-click on its volume curve to edit it in the ➡ **Curve Editor**.
 a. Create a new point with Shift and click, click and drag points to move, and use the mouse wheel to zoom in/out.
 b. Click and hold RMB to move the view around, and right-click on points to change the curve type.
 c. Set the first point of the curve to be a value of 0.001 (use the Value box at the top of the screen when the point is selected). Then add another two points at the time when your first track will be coming to an end to ramp the curve up to a value of 1.0.
6 Replace the Sound Cue reference in the <**Play Sound Attached**> of the [**Level Blueprint**] with a reference to your new Sound Cue and test.

Looping Manually

Map: Racer_C

One way to avoid all this hassle with decay tails is to replace a simple looping system with one that actually retriggers the sound at the looping point but allows the remainder of the sound to play out. With such a system we can export our waves from the DAW with their decay tails intact and these will still be heard while the cue restarts.

Open **Map: Racer_C**—this is the full racer system with our temporary music in place. If you open the [**Level Blueprint**], you can see that now the system uses a <**Timeline**> node (which is set to the length of our desired loop) to retrigger the <**Play Sound Attached**> that contains our music cue.

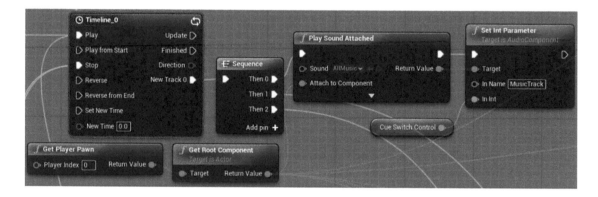

This means that in this version of the game you can import your Sound Waves with their decay tails included at the end.

We'll be looking more specifically at how these systems work in subsequent chapters, but even if you don't get any further into game music implementation than swapping out some tracks in this level, the concepts around loops and decays are fundamental. You should practice exporting your music in a variety of ways until you're comfortable with these ideas. That way when you are asked for loops, you can provide ones that will sound good and not clunky.

Exercise 03_05: Manual Looping

In this exercise you will set up the manual looping system that will allow you to import all the rest of your tracks into the complete system.

<Timeline>

1 Open the **Map: Racer_C**. This has the complete music system in place.
2 Render out your track from your DAW, this time including an additional bar/measure at the end that includes the decay tail. Import this to the ➡**Content Browser**.
3 Rename your Sound Wave to {**Lap_01**} by selecting it in the ➡**Content Browser** and pressing F2 (or right-click/Rename).
4 Open the **[Level Blueprint]** and double-click on the **<Timeline>** node to open the ➡**Timeline Editor** (see Appendix A: Core Concepts/Others/Timeline).
5 Change the Length value to the length of your loop. Remember this is the point at which you want to restart the cue, not the total length of the cue.

6 Now use the tab at the top to return the ➡**Event Graph**.
7 Open the Sound Cue {**All_Laps**} and add your track to the first two inputs of the -**Switch**- (parameter unset and 0). Remember that this is not a -**Looping Wave Player**- since now we are doing the looping in the **[Level Blueprint]**.
8 The Sound Cue {**All_Laps**} is already referenced by the **<Play_Sound_Attached>** in the "Laps" section of the **[Level Blueprint]**.
9 Start the game and check that the **<Timeline>** is looping your track correctly. If not then go back and adjust the Length of the **<Timeline>** until it is.

Stingers/Ornamental Forms

Sometimes you just want to acknowledge an action or event in the game without having a major change or transition in the music. Stingers, or ornaments, are one-shot music cues that simply come in and play over the top of the current music loop.

Since these typically can occur at any moment, it's important that you write them in such a way that they will fit musically along with anything that might be happening in the accompaniment. In the Racer_C map, there are stingers implemented to reward the player for picking up a speed boost.

Exercise 03_06: Stingers

In this exercise we will add a musical pickup stinger to the game.

1 Open the Map: Racer_C.
2 Make sure you have completed Exercise 03_05 so that you already have your Lap_01 loop in place.
3 Create a Stinger for the speed boost pickups that will sit well when played over the top of your existing Lap_01 track. Export it from your DAW and import it. Rename it to {Stinger}.
4 Open the {Stinger} Sound Cue and add your Sound Wave.
5 Add your Sound Cue {Stinger} to the <Play_Sound_Attached> in the "Stinger" section of the [Level Blueprint].
6 Play and test.

Simple Parallel Forms

Parallel forms, where we control the volume of a set of synchronized tracks or stems, are straightforward to implement since we can trigger all our stems from the same <Timeline> and then just adjust their volume in response to game events.

{InTheLead_Layer}
{Damage_layer}
{Lap_Music}

In the "In the Lead" and "Damage" sections of the [**Level Blueprint**], you can see where this takes place. A variable has been created In_the_lead_layer_volume and is <Set> to either 1.0 or 0.0 depending on your position in the race.

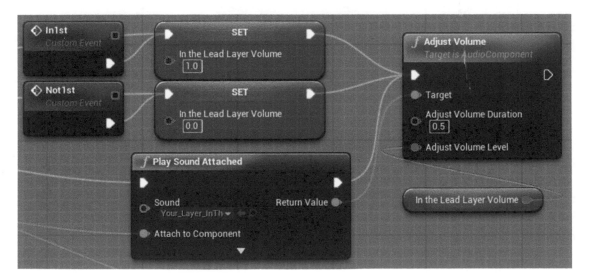

The damage layer works slightly differently in that it increases the volume incrementally each time the player's vehicle gets damaged, but the principle is the same.

Exercise 03_07: Parallel Layers

In this exercise you will add two parallel layers to the music system.

Sound Cue

1 Write two other music tracks, an "in the lead layer" and a "damaged" layer, that will work when played on top of your existing {Lap 01} music. Ensure they are the same length.
2 Import these and add them to the {InTheLead} and {Damaged} Sound Cues respectively.
3 Play and test.

Simple Transitional Forms

Transitional forms usually present more of a challenge than ornamental or parallel forms since we don't know when things are going to happen in-game. In this game we don't know when the player is going to cross that start line and start the second or third laps.

To keep things relatively straightforward, we've constrained the system to only switching at the loop point (i.e., when the timeline triggers). The laps are set by changing the variable Cue_Switch_Control in the [Level Blueprint].

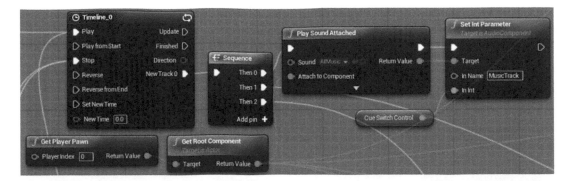

This controls a -Switch- node inside the Sound Cue {All_Laps}, so when it is next triggered by the <Timeline>, it will now play the next lap (or win or lose). Don't forget that switches, like all other nodes, consider their first input as 0, not 1.

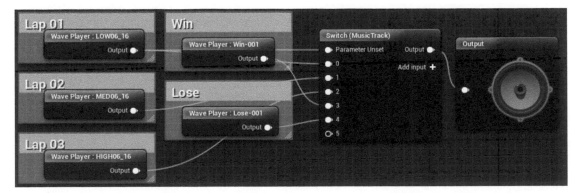

Exercise 03_08: Transition Tracks

In this exercise you will add two new tracks for Lap 02 and Lap 03 to which the music will transition. We will also add the win and lose cues to complete the whole music system for the game.

-Switch-

1 Write two new versions of your {Lap_01} music. Try to make them increase in intensity as the race goes on. Ensure they are at the same tempo and length as {Lap_01}.
2 Import the tracks and add them to the -Switch- in the Sound Cue {All_Laps}.
3 Write music cues to play when the player wins {Win} or loses {Lose}.
4 Add these to the Sound Cues {Win} and {Lose}. The win and lose tracks will both play and then stop.

Looking at our **Map: Racer_C**, you can see that actually each lap does not just play one track, but makes a randomized choice between three variations of that track. As players might be playing for quite a while, this maintains some interest.

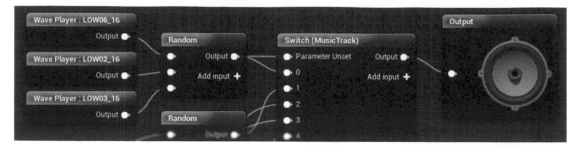

Exercise 03_09: Variation

Add some variation to your music.

1 Write a few variations for the music of each lap and import these. Edit your {**Laps_All**} Sound Cue to randomly choose between these variations for each lap.

Conclusion

Hopefully now you have a good understanding of the different types of interactive music forms and how to write for and prepare assets for use in them. Decay tail solutions may seem like a bit of an annoyance, but getting this right makes a lot of difference to the final polish of your soundtrack.

For further reading please see the up-to-date list of books and links on the book website.

Recap:

After working through this chapter you should now be able to:

- Use music playlists in your game;
- Export you music with an integrated decay tail;
- Use concatenation or envelopes to achieve a play then loop system;
- Compose for parallel forms;
- Integrate music into a switching music system;
- Understand the principles of interactive music forms: ornamental, parallel, transitional, and algorithmic.

Music Part B: Basics and Parallel Forms 04

Summary : Adjusting parallel music layers in response to game parameters

Project : DemoCh04Desert **Level :** Desert01

Introduction

Hopefully through composing and editing music and swapping your tracks into the racer level, you're starting to get a good appreciation of the principles involved in interactive music. In this chapter we're going to look at how you can start implementing music yourself, beginning with some basic uses before moving on to look in depth at some examples of what you can do with parallel forms. To keep it sImple in this chapter, we'll mainly be treating each Sound Cue as one piece of music or track, but don't forget that you can build variation Into your cues by swapping out multiple versions of the same piece.

As a composer you may find some of what follows a bit tricky at first. Many composers make a very good living simply writing their music and then handing it over to other people for implementation. If that is your aim, then you should have gained a reasonable understanding of the concepts from putting your music into the racer. If, however, you want to be able to have more control over how your music is used and be able to innovate in this field, then you'll want to develop your understanding of what's going on under the hood. Having this understanding will mean you can be more involved in the design process—better for your music and better for the game.

Music Basics

Summary : Source music, one-shots, timed events, stingers

You can use the keys 1–9 to skip to different locations within the game. If you're jumping into the level, you can press G to get the weapon.

Source Music

One type of music you can use in your games is source music, which is music that's coming from sources within the game world itself. This is good at defining the time period, location, or culture in which we hear it. For example if you heard dubstep on the radio, it would give you the distinct

impression that you weren't walking into a Kindergarten. As well as defining the place where you hear it, you can use sources of music in your games to draw the player towards or away from certain areas. The sound of a radio or other sources playing would usually indicate that there are some people nearby. Depending on your intentions, this could serve as a warning, but players may also be drawn toward sources of music out of curiosity. In the *Mountain Village* (Bookmark 1), there is a bit of a shindig going down in one of the houses—best to avoid!

This is simply an ambient sound Actor. If your music is playing in a certain space, you can apply some effects in your DAW to help create this impression. In this case we've filtered the music so it sounds like it's coming from inside the house.

Exercise 04_01: Source Music

In this exercise you will look at adding some source music tracks to the *Village* area (Bookmark 5) of your exercise level.

1 Open up your exercise level.
2 Add some music sources to this area using [Ambient Sound]s. Think about how to make these loop nicely (see the Level Music, Loops, and Decay Tails section in the previous chapter) and try to apply different types of FX to the music in your DAW according to its location or playback device (for example you could "radio-ize" one of the sources coming from the radio asset in the level).
3 Don't forget you can set your Sound Wave to loop after import by double-clicking on the Sound Wave and checking the Looping option in the ➡Generic Asset Editor.

One-shots

As the level starts, a quiet ambient music cue is started. This forms a backdrop to the one-shot music cue that plays as you come over the horizon just outside the village (Bookmark 2). We're using the <Play Sound Attached> node throughout this level, and for music it makes sense to attach it to the

player so it will play directly to their ears. Since we'll be using this a lot, we've set up a variable Player Component that we can reference each time we need it. We'll look at how to do this in the exercise below.

For one-shots such as this, it is important that they don't play each time the player goes through the [Trigger] since this just sounds silly. A <DoOnce> node only allows the first trigger through for our {Epic View} cue in the "Epic View One-Shot" section of the Level Blueprint.

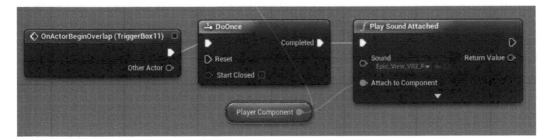

Exercise 04_02: One-shot

In this exercise we will add a musical one-shot to your level that is triggered as you leave the village.

<Get Player Character>, <Get Root Component>, <DoOnce>, Player location variable

1 First create a variable to which you can attach the music for reuse throughout the level. (There is one already in place for our placeholder systems, PlayerComponentPlaceholder, but it's good to practice this for yourself).

2 Open the [**Level Blueprint**]. In the ➡**My Blueprint** panel on the left, click on the + Variables icon to create a variable. In its ➡**Details** panel, name it PlayerComponent and choose the variable type Scene Component from the drop-down menu. The quickest way to find it is to start typing the name in the search box.

3 An <**Event Begin Play**> node already exists in the [**Level Blueprint**], so locate it (in the Initialize section) and create the following nodes nearby: <**Get Player Character**> and <**Get Root Component**>.

4 Drag your new variable PlayerComponent into the ➡**Event Graph** and choose to create a <**Set**> node from the options that appear.

5 Connect this up to the spare output of the <**Sequence**> node as shown below.

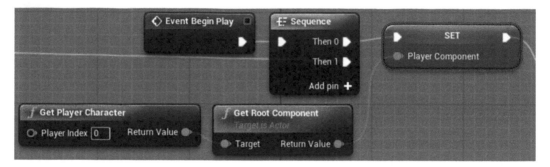

6 Create a [**Trigger**] in your level in a position where you want to play the one-shot (from the ➡**Modes** panel). Adjust its scaling (using the scaling widget—Spacebar) so that the player will definitely overlap it while walking out of the village.

7 With this [**Trigger**] still selected in the ➡**Viewport**, right-click in the [**Level Blueprint**] and choose Add Event for Trigger—/Collision/Add On Actor Begin Overlap.

8 Connect this event via a <**DoOnce**> to the execute input of a <**Play Sound Attached**> and link up your variable Player Component to the Attach to Component input of the <**Play Sound Attached**>.

9 Reference your Sound Wave or Sound Cue in the <**Play Sound Attached**>. Play and test.

Music for Timed Events

Often the most effective, and least complex, way of using music in games is to use it only for particular scenarios or events that last a set amount of time. This way you can use a linear piece of music that builds naturally and musically to a climax. Although it appears that the player is in control, the scenario is set to last for an exact amount of time, whether they achieve the objective or not.

In *Desert Area 03* (Bookmark 3) there is a timed mini-game. You need to light the flares (by pressing E), then move the device next to the wall (E) and use it (E) to smash your way into the temple to throw the switch inside. All these events are timed to take place so that the musical climax will arrive at the same time as the completion (or failure) of the task.

At the end of the sequence, there's a camera tracking shot up to the flare on the tower, and we want this to coincide with the music. Although you can have events trigger when a sound file has finished playing (<Bind Event to OnAudioFinished>), this isn't always appropriate since the climax of the music occurs earlier than the end of the sound file (followed by decay tails, etc.).

In this case we've set a timer to trigger the event from the musical climax (125 seconds in), rather than the actual end of the sound file. The <Set Timer> creates an event of the given name that we can then reference elsewhere in the Blueprint from a <Custom Event> node (see the "Timed Event" section of the [Level Blueprint]).

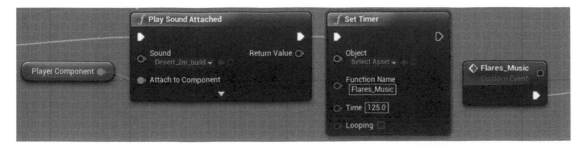

Exercise 04_03: Event Sync

In this exercise we will look at how to synchronize game events with music for the "Mountain Pass" area of the level.

<Timer>, <Custom Event>

1 The mountain pass into the desert has been blocked. You need to light the fuse to blow up the obstacle. This system has been implemented for you in the "Mountain Pass" section of the [**Level Blueprint**] (E to light the fuse).
2 Write a piece of music that builds up to hit a climax at exactly 16 seconds in. Import it.
3 Take a link off the <**Sequence**> node and use this to start a <**Play Sound Attached**>. Don't forget to attach the Player Component variable you made earlier to your <**Play Sound Attached**>, and of course reference the new music you just imported in this node as well.
4 Create a <**Set Timer**> node and set its Time to be 16 seconds. Link to this from the output of your <**Play Sound Attached**> to start it. In the Function Name of the timer, give it a name such as Trigger_Explosion.
5 Create a <**Custom Event**> and name it the same as the Function Name you just gave. This will now output an event after 16 seconds.
6 Connect this <**Custom Event**> up to the explosion system provided in the "Mountain Pass" section of the Blueprint.
7 Play. Bang!

Ornamental Forms/Stingers

As we noted above, musical stingers can be effective in acknowledging a player action or event without requiring significant changes in the music.

In *Desert Paths* (Bookmark 4) the path downward splits into multiple routes. The force won't guide you, but our stingers will. Again there's a background ambient music layer for this to sit against, but this time with the addition of some drums ({Con_Layers_L1_V01_22} and {Drums_fast_22}).

There are two types of stingers: the percussion stinger indicating a wrong turn {Percussion_Stinger_1_22}, and an ocarina flurry that indicates that the player is on the right path {Ocarina_Stinger_3_22}. These both fit over the background music since it is quite ambiguous in nature. Sometimes we will want stingers to be in tune or in time with a changing accompaniment, but we'll look at these more advanced systems in Chapter 12.

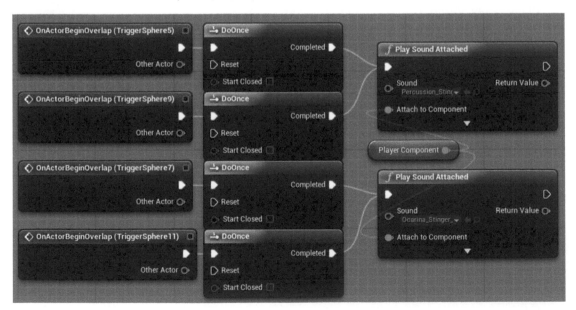

For the moment we are just triggering the stingers with some [Trigger]s placed along the desert paths.

Exercise 04_04: Stingers

In this exercise the player needs to cross the dangerous *Chasm* that they come across after exiting the mountain pass. As they successfully jump to each platform, we are going to reward them with a stinger.

<Trigger>, <Do Once>, <Play Sound Attached>.

1 Write a piece of music that can serve as a background loop, then several short stingers that can play over the top of this.
2 Import your files and add all your stingers to a -Random- node in a new Sound Cue {Stingers}.
3 There is an <OnActor BeginOverlap> node that comes from a [Trigger] placed toward the edge of the chasm in the "Stingers" section of the [Level Blueprint]. Connect a <DoOnce> node to this and then a <Play Sound Attached> with your background loop in it (remember to set it to loop!)
4 In the same section there are several other <OnActor BeginOverlap> nodes. Connect these to another <Play Sound Attached> that references your {Stinger} Sound Cue. Remember to connect both the <Play Sound Attached> nodes to your Player Component variable.
5 At the end of the stingers section of the level, add another [Trigger] in the level and use this to fade out your background loop. Create an <OnActor BeginOverlap> event from this [Trigger] and connect this to a <FadeOut> node, created by dragging out a wire from the Return Value of the <Play Sound Attached> and searching.
6 Play, and be careful! You could also add some stingers that play if the player falls off by adding some [Trigger]s below.
7 Some of the rock platforms are a little unstable. You could extend the system by using an alternative stinger for these as a warning.

Parallel Forms

Summary : Fading music layers in/out, controlling music layers with in-game parameters

By writing and exporting music as separate tracks or stems that are synchronized, we can then vary the volume of each stem to produce different musical arrangements.

Switching or Fading Layers (Parallel Forms for Orientation)

In the *Desert Floor* (Bookmark 5) area you need to navigate your way across the desert floor to find the items dropped by your comrades. Given the shifting dunes it is hard to see them, so you need to rely on the music to guide you.

Each of the pickups (2 X Ammo, 1 X Weapon) has two sphere [Trigger]s that form concentric circles around them and control the volume of our musical layers. On entry to the desert floor area, a [Trigger Sphere] starts off all our layers.

> Layer 01 remains on throughout the area {Con_Layers_L1_V02_22}.
> Layer 02 comes in when the player hits the outer sphere around a pickup
> {Con_Layers_L2_V01_22}.
> Layer 03 comes in when the player is very close to the pickup, triggered by the inner
> sphere {Con_Layers_L3_V01_22}.

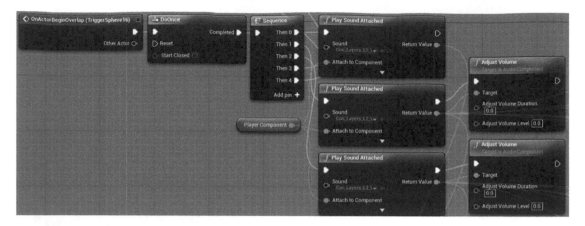

As you can see from the figure above (in the "Desert Path Stingers" section of the Level Blueprint), the volume of both Layer 02 and Layer 03 are immediately adjusted to 0.0, then (below) brought up in volume as the player enters their respective [Trigger Spheres] and back down again when they leave.

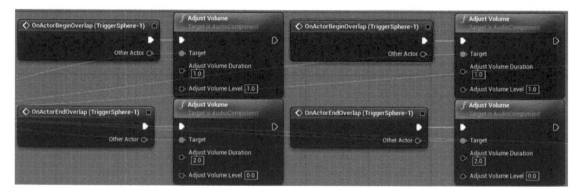

Exercise 04_05: Adjust Volume to Bring in/out Parallel Layers

In this exercise we are going to change the mix of our parallel music layers in response to the player operating a series of *Bridges* that lead across to the *City Walls*.

<Adjust Volume>

1 In the *Bridges* section of the exercise [Level Blueprint], there is an event from the [Trigger] at the start of this area and several E <Key Event>s passing through <Gate>s that come from the switches that the player will use at each bridge intersection. We are going to use these to bring in the layers of music as the player progresses.

2 Write some music that will work as 4 layers or stems. The first will serve as a background layer when we start the crossing, then the other three will get switched on as each section of the bridge is opened. Test this out in your DAW by muting and unmuting the stems to make sure they will work effectively. Import them and change their names to {Layer_01}, {Layer_02}, {Layer_03}, and {Layer_04}.

3 Create 4 <Play Sound Attached> nodes and reference the 4 layers of music you just imported. From the first <OnActorBeginOverlap> (Start Music), connect a <DoOnce> leading to a <Sequence> and add output pins to trigger your 4 <Play Sound Attached> nodes. Remember to attach your <Player Component> to their Attach to Component inputs.

4 For the latter three <Play Sound Attached> nodes, drag out from their Return Value outputs to create an <Adjust Volume> for each. Set these to Adjust Volume Level to 0.0 immediately. This will set up your 4 layers in sync but will immediately mute layers 02, 03 and 04.

5 Now create three additional <Adjust Volume> nodes, again by dragging out from the <Play Sound Attached> nodes of layers 02, 03, and 04. Set these <Adjust Volume> nodes to bring up the volume of the layers to 1.0 over a duration of 1.0 (or whatever time period sounds best for your music).

6 We will trigger these from the outputs of the <Play> matinees already in the system so that each time a bridge section is opened, the volume of one of the layers is adjusted so that it fades in.

7 At the end of this section, add a [Trigger] to the level to <Fade Out> all of the layers (this actually stops the sound rather than just adjusting its volume to 0.0). You could leave the background track on and integrate it into the next exercise if you would prefer.

8 Don't forget to watch what is happening in your Blueprint while you play to troubleshoot any problems. See Appendix C: Testing, Troubleshooting, and Good Practice/Watching Blueprints.

Using Variables to Determine Volume (Parallel Forms for Proximity)

We've noted above how parallel forms can be highly effective in representing game variables, and since the tracks or stems are always synchronized, we can bring them up or down in volume and the overall effect will still remain musically coherent. In the last example, we looked at how to switch layers on or off (or <Adjust Volume> to fade in/out) in response to [Trigger] Actors placed in the game world (we don't use the actual <FadeIn>/<FadeOut> nodes since these actually act like play and stop).

To be able to fade in and fade out parallel layers actually gives you a lot of scope for implementing your music, and it may be that you want to pause here and play around with these techniques for a while. The following sections get quite a bit trickier, so take it slowly.

Now we're going to control the volume of our layers directly with variables from the game. If you can master the following techniques of tying game variables to the music, it will open up a lot of creative possibilities.

Linear Variables to Volume

As the player enters the [Trigger Sphere] at the bottom of the ramp leading up the fort in the *Desert Area 06* (Bookmark 6), the background layer of our music is started {Proximity_Background_V01_22}. An additional layer {Proximity_Layer_01_V01_22} then gradually gets louder the closer they get to the entrance to the fort. (See the "Ramp to Gate" section of the Level Blueprint.)

Controlling Audio Components with Variables

Previously we've applied changes to our audio by applying nodes directly to the Return Value of the <Play Sound Attached>, for example with the <Fade Out>, <Adjust Volume>, and <Set Float Parameter> nodes.

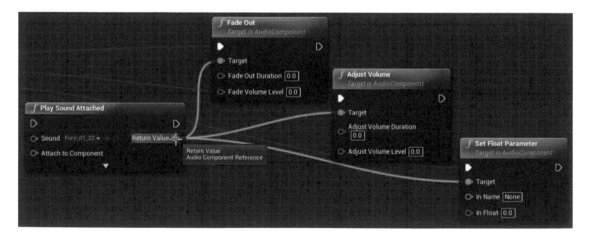

As the systems get more complex, we're going to keep things a little neater by using an AudioComponent variable in Blueprint to hold our cue. When a sound plays, it creates what

is called an audio component. This is a programming function, the details of which we don't need to worry about too much. What it does mean is that we can store this in a variable and then act on it in various ways elsewhere in the Blueprint, keeping things a bit tidier than linking to the Return Value all the time. The <Set> node in the illustration below is taking the audio component produced by the <Play Sound Attached> and storing it in our Proximity Component variable (like we did earlier for our Player Component to attach <Play Sound Attached> nodes to).

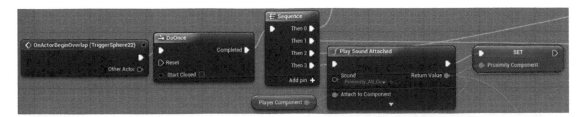

We can then <Get> this variable anywhere in our Blueprint to act on it in the same way.

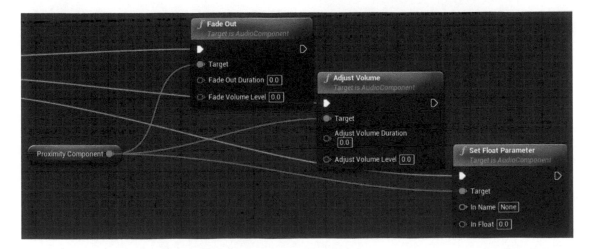

In this case we're going to get the distance between the player and a [Target] that is located at the entrance to the fort and use this to control the volume of a second layer within the Sound Cue.

The Get Distance System

We want to convert the distance between the player and the fort into a value between 0.0–1.0 to set the volume of the second layer. When the system is triggered, we use a <Get Distance To>

node to capture the current distance (in Unreal Units) between the player (<**Get Player Character**>) and the target ([**TargetPoint2**]), and set the float variable DistanceToMax to this value. The <**Normalize to Range**> node takes this DistanceToMax value as its Range Max value. Having set this it will now scale the value input from 0.0–1.0. Since we want the value to go up to 1.0 (to make the second track louder) while the distance actually goes down to 0.0, we've inverted this value by subtracting it from 1.0.

The original [**Trigger Sphere**] opens a <**Gate**> that lets through an <**Event Tick**>. An <**Event Tick**> gives an output every frame and so is useful to use when you want to keep values constantly updated.

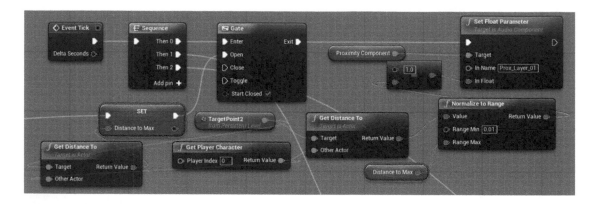

The outcome of our distance calculations is drawn in by the <**Set Float Parameter**> node (that is also being updated every frame by the <**Event Tick**>). The <**Set Float Parameter**> is targeting our audio component variable Proximity Component and is using this value to change the value of a float inside the Sound Cue {**Prox_Layer_All**}.

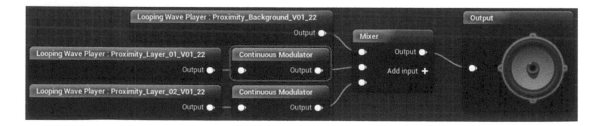

Inside the Sound Cue is a -**Continuous Modulator**- node, and as you might remember from Chapter 02, this allows us to use a named parameter (in this case Prox_Layer_01) to vary either the pitch or volume of a sound.

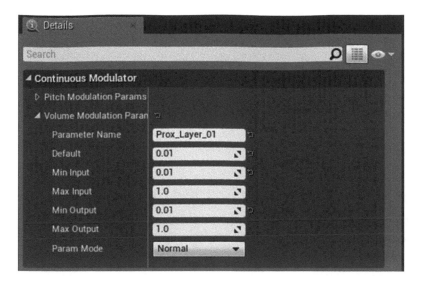

We've set the Min values of the -Continuous Modulator- to 0.01 so that it always plays even though you won't hear it. This ensures that the layers stay in time since if it did drop to 0.0, it would not play. When it did start to play again, it would do so from the start—thus putting it out of time with the other layer.

Exercise 04_06: Linear Variables to Layers

Having crossed the bridges, you are now on a path leading to the *City Gates*. We want to increase the musical tension as you approach, so we are going to gradually bring in an additional music layer the closer you get.

-Continuous Modulator-, get distance

1 Write two looping tracks of the same length. The second track is going to gradually fade in to increase the tension, so you can preview this effect in your DAW by using volume automation curves (or just by hand using the volume of this track).

2 Create a new Sound Cue with a two input -Mixer- and connect it to the --Output- node. Add your first track directly to the mixer, and send the one that is going to fade in through a -Continuous Modulator- before going into the mixer. Remember to make them both -Looping Wave Players-.

3 Select the -Continuous Modulator- and give it the Parameter Name DistanceToGate. Set its Default, Min Input, and Min Output to 0.01 and its Max Input and Max Output to 1.0.

4 Find the "Distance to Gate" section of the [Level Blueprint]. Add your Sound Cue to the <Play Sound Attached> and set the In Name of the <Set Float Parameter> to match the Parameter Name of your -Continuous Modulator- (DistaceToGate).

5　Play the game, and you should hear your first track start as you pass through the [Trigger] and then your second track fade in as you approach the city gate.

6　Now create a [Trigger] just inside the city gate. Use this to play a stinger and <Fade Out> of the music tracks, then close the <Gate> after the <Event Tick> to stop the system.

Curves to Volume

Being able to link any parameter or variable in the game to your music will give you lots of ideas for how the music can be used to relay information to, or evoke emotion in, the player. But we don't always necessarily want a direct relationship between the parameter value and the musical volume. In the example above, for instance, the distance to the gate (0.0–1.0) directly relates to the volume of the layer (0.0–1.0). Remember that 0.0–1.0 in the Unreal Engine is not the same as 0.0–1.0 in your DAW, since the system doesn't take account of the logarithmic nature of perceived loudness so there are lots of good reasons for having greater control through using curves. For example what if we wanted the music to fade up gradually over distance, but then get quite a bit louder when we are right towards the end?

In order to have this greater control of the relationships between game parameters and music, we can use curves. As we seek the different values of the curve using the game variable, we can change the value that corresponds to it by changing the curve shape. We have looked at this concept already in the Parameterization = Interactivity section of Chapter 02 and in Appendix A: Core Concepts/ Transforming and Constraining Variables and Parameters/Reading through Curves. It might be a good idea to go back and have a read of this again to refresh your memory.

As you enter the desert fort in *Desert Sneak* (Bookmark 7), the first and second courtyards have guards. You need to sneak up behind them to take them out (E) without alerting the others.

The distance from each guard is linked to the volume of the second layer in our Sound Cue {Proximity_All}, Sound Wave {Proximity_Layer_02_V01_22}. This time, however, we don't want a linear fade over distance, but instead want to bring the volume up sharply when you get close to heighten the tension. We're still getting the distance from the player to the bot and normalizing this (0.0–1.0), but now the value is used to read through a volume curve {DistancetoBotVolume}.

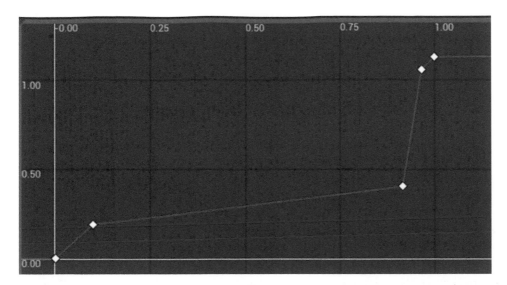

As you can see below, the system is just the same as for the linear parameter leading up the gate, the only difference being that we're now reading through the curve instead of applying this parameter directly.

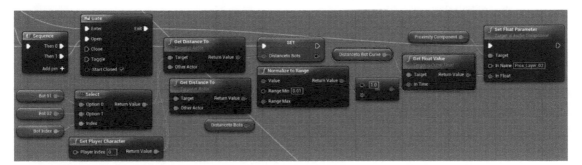

We've also added a little stinger to accompany their tragic demise.

Exercise 04_07: Variables to Music Layers (Curves)

In this exercise we are going to tweak the previous system for the music approaching the gate to read through a volume curve instead of applying the distance to the gate directly to the volume of the second music track.

{Curve}s

1 Return to the "Distance to Gate" section of the [**Level Blueprint**] you constructed for Exercise 04_06.
2 In the ➡ **Content Browser** create a new curve asset (Add New/Miscellaneous/Curve) and choose a Float Curve.

3 Double-click it to open the ➡Curve Editor. Edit the curve to represent how you want the music track 02 to fade in over distance. Create a new point with Shift and click, click and drag points to move, and use the mouse wheel to zoom in/out. Click and hold RMB to move the view around, and right-click on points to change the curve type (see Appendix A: Core Concepts/ Transforming and Constraining Variables and Parameters/Reading through Curves).

4 The X-axis represents the distance 0.0–1.0 and the Y-axis represents the volume of your track 0.0–1.0.

5 In the [Level Blueprint]/➡MyBlueprint panel, create a new variable (+) and set its Variable Type to Curve Float in its ➡Details panel.

6 Compile the Blueprint (top left icon) so that you can add a Default Value to this variable. With your {Curve} asset selected in the ➡Content Browser, add this to the Curve Variable using the arrow icon.

7 Drag and drop your curve variable into the [Level Blueprint] to <Get> it. Drag out from it to create a <Get Float Value> node and feed the Return Value from this into your <Set Float Parameter> that controls the volume of the -Continuous Modulator-.

8 Use the inverted <Normalize to Range> value to go into the In Time of this <Get Float Value>.

9 Experiment with the shape of your curve until you get the musical effect that you are happy with. (Remember you can download images of the complete exercise systems to help you out from the website).

Mix Automation for Parallel Layers

Once you're into the main courtyard in *Desert Courtyard* (Bookmark 8), it all kicks off! Unfortunately it appears your stealthy approach hasn't worked. Here we have a number of game variables (number of bots killed and player health) that are linked to the music, as well as an automated music mix change when a special state (called fury mode) is activated. There's quite a lot going on here, so we'll cover each aspect individually. See the "Desert Courtyard" section of the Level Blueprint.

The two background layers are controlled through the -Continuous Modulators- marked "Drums" and "Background".

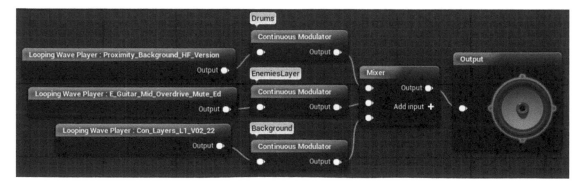

The EnemiesLayer ratchets up in volume as you dispatch one, two, and three enemies, again using a -**Continuous Modulator**- (first enemy = 0.5 vol, second enemy = 1.0 vol, third enemy = 1.4 vol).

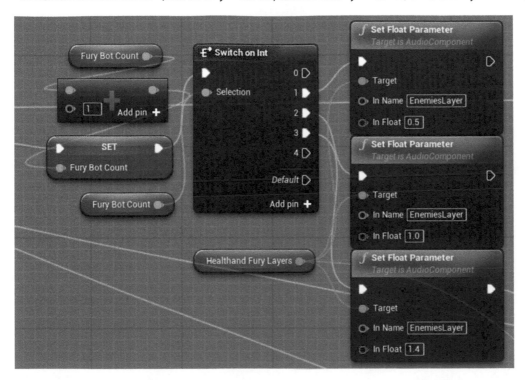

As the player's health decreases, the {**HealthChoirMain_ED_22_Cue**} gets louder.

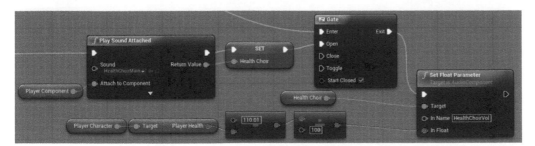

When the player has killed three guards a special mode is unlocked—"Fury!!!". This puts the game into slow motion and increases the amount of damage from the player's weapon.

Although we want to leave the health choir unaffected during fury mode, we want to fade out the other parts and then bring them back in once fury has timed out. We could use <**Adjust Volume**> nodes to do this, but we want more control over the fade curves, so we have used a <**Timeline**> with Float Tracks that are going to automate the volume changes over time.

When the player triggers fury mode, the {Fury_01_22} Sound Wave is played and the <TimeLine> started. As the <Timeline> plays through, the Float Tracks set the different float parameters of the -Continuous Modulators- within the {Health_Fury_Main_Stems} Sound Cue.

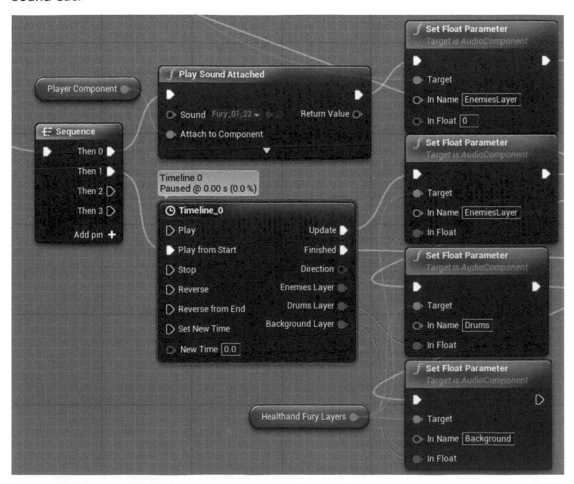

The combination of parallel music layers controlled via continuous modulators, along with the kind of mix automation that <Timeline> Float Tracks can give you, should allow you to do some pretty funky stuff!

Exercise 04_08: Automated Music Mixes

Having come through the city gate, you are now in the *Outer Walls* section of the map. To your left are some stairs leading down to the *Outer Wall Vaults*. In this exercise we are going to create some automated mix changes in your music in response to player actions.

<Timeline>

1 The player needs to search the *Outer Wall Vaults* (Bookmark 8) to locate two pieces of the door mechanism to fix *Handle 01*. Once *Handle 01* has been used, they can operate *Handle 02* to open the *City Gates*. As they collect the pieces, fit them to the mechanism, and operate the handles, we will change the mix of the music in response to the task completion.

2 Most of the system is in place in the [Level Blueprint], you just need to compose the music and set up the Sound Cue.

3 Write three layers of music. The background is going to play all the time. When Item 01 to fix Handle 01 has been picked up, Layer01 will fade in, and when it's been successfully attached, it will fade out. This will happen again with Layer02 for picking up and attaching Item 02. When Handle 01 is used (E), Layer03 will come in, alongside quiet versions of Layer01 and Layer02. When Handle 02 is used, a stinger will be played and the three layers faded out.

4 Write the stinger and keep it as a separate Sound Wave. Add it to the <Play Sound Attached> named "Stinger".

5 Set up your other tracks in a Sound Cue as below, and name the Parameter Names of the -Continuous Modulators- as indicated.

6 Reference this Sound Cue in the <Play Sound Attached> named "Auto".

7 In the system, this <Play Sound Attached> sets its Return Value to a variable Auto_Cue that the various <Set Float Parameter> nodes target using the named continuous modulator parameters.

8 Play through the game sequence and note how the layers come in and out to different degrees as the <Timeline> Float Tracks automate the volume levels.

9 Experiment with changing the shape of the Float Track fades.

Conclusion

You can do a lot with parallel forms, but sometimes we want the music to transition to a completely new piece, or to change at a musical point for a greater emotional impact. You may have noticed, for example, how the stingers we have used so far to finish off our pieces are not really that satisfying since they just play at an arbitrary point alongside the fade out of the other musical parts. In order to give the music more impact, we need to look at how to handle musical transitions.

For further reading please see the up-to-date list of books and links on the book website.

Recap:

After working through this chapter you should now be able to:

* Create looping parallel layers or stems of music, and fade these in and out in response to game events or triggers using the <Adjust Volume> node;
* Use parameters/variables from the game to set the volume of particular stems using -Continuous Modulators- in their Sound Cue;
* Control the relationship between the game parameters and the volume of the music using curves, and instigate automated mix changes between the layers by feeding these -Continuous Modulators- values from Float Tracks of a <Timeline>.

Summary : Crossfading tracks, transitioning between musical chunks, transitioning on bar lines, transitioning to musically aligned positions, transition matrices

Project : DemoCh05Offices01 **Level :** Offices01

Introduction

We've seen how parallel forms of interactive music can be effective in supplying information to the player while maintaining the integrity of the music's form. Sometimes, however, we want to make more substantial changes to create more radical shifts in the music that have a greater impact on the player. For this we need to transition from one piece of music to another, preferably at a musical juncture.

You can skip between locations in game by using the keys 1–8.

Clunky Transitions

Summary : Unmusical transitions

Nasty

Once you start listening for it, you'll be amazed at how much music in games is simply a clunky crossfade from one piece to another. The problem with transitional forms is of course that we don't know when a particular event is going to take place. Any of the following relationships between the two pieces of music are possible.

By choosing to use transitional music, we're hoping to take advantage of the potentially greater emotional impact that can be produced by moving from one piece to another (rather than simply changing the mix between layers), but if we don't do this right (i.e., musically), then this impact is at best lost and at worst becomes jarring and unpleasant, defeating the purpose of choosing a transitional form in the first place.

Open the **Offices01** level and play through the first couple of rooms from ***Offices Room 01*** (Bookmark 1). You've been tasked with stealing blueprints of the latest innovation from the shadowy Nagasony Corporation, whose hi-tech offices overlook 2050 Tokyo. Stealth is key. The transition from ***Offices Room 01*** to ***Offices Room 02*** is an example of simple location-based switching, where different pieces of music are associated with specific locations.

When the levels starts, the **{Room_01}** looping wave starts, then a **[TriggerBox]** on entry to ***Room 02*** **<Stops>** this and plays **{Room_02}** (an only slightly nicer **<Fade Out>** finishes this second piece as you get to the top of the stairs).

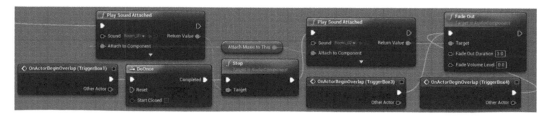

<Play>, <Stop>, <Fade In>, and <Fade Out> can of course be used to control music for any event in the game, but there are better, more musical ways, and more musical means more satisfying for the player (having said this, sometimes bad music transitions can work for shock value).

Crossfades (and When to Use Them)

In some circumstances a simple fade in/fade out crossfade between tracks can actually work effectively, but you need to carefully consider the musical style in order to allow for a range of very different outcomes depending on the player's approach.

If your music is quite ambiguous, then you can crossfade between one track and another without it sounding too clumsy. People will notice if a rhythm is interrupted, they will notice if a chord sequence never gets to resolve, and they will notice if a melody is left hanging in space. If none of these things were there in the first place, then you won't have set up these expectations. So just avoid rhythm, tonality, and melody?

There are a few genres that can suit this kind of approach, the easiest being the kind of atonal soundscape typical of horror-style music, but other drone-like ambient or even very flexible cartoon-like music can work alright. It's all about having the system of how you're going to implement the music in mind when you write or commission the music.

On entry to *Offices Room 03* (Bookmark 3), another cue starts {Ambiguous_03}. As you will note this is very harmonically static, with only a subtle sense of pulse. When we interrupt it by crossfading

to a new piece (press E by the computer in the office on the left to switch on the lights), it feels reasonably smooth since there is not a strong musical structure there to be broken in the first place.

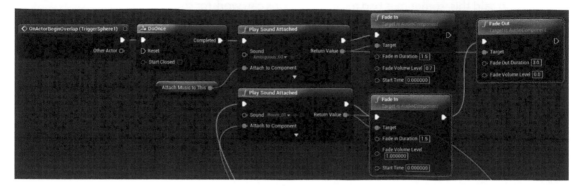

Exercise 05_01: Crossfades and Ambiguity

There are several different ways you can handle the selection of music tracks such as using arrays, switches within Blueprints, or switches within Sound Cues. Although it may make It initially slightly more confusing, we're going to vary the methods between each exercise so that you get experience of several of them, then you can choose the method you're most comfortable with for your own work.

Arrays

Before you leave the *Outer Wall Vaults* section of the game, you can explore a little more and discover a *Secret Vaults* area (clue: the draft from these rooms has blown out one of the flaming torches—use it). We are going to create some dark and spooky music to unnerve the player as they move through (there was talk in the village of treasure being kept here, so explore thoroughly!)

1 Write some music that is quite atonal and rhythmically ambiguous (think horror-style music) as two looping tracks, one more intense than the other.

2 Import them and set them up either as looping Sound Waves (double click to set to loop) or as Sound Cues with looping wave players. Find the "Secret Vaults" section of the [Level Blueprint]. Drag out from the <Play> that controls the movement of a "very bad thing" and create a <Sequence> node. Now drag out from the <Sequence> node's second output to create a <Play Sound Attached> and attach the Player Component to its Attach to Component input.

3 Drag out from the Return Value of the <Play Sound Attached> to create a <Fade In> node and trigger this from the Output of the <Play Sound Attached>. Drag out again to create a <Fade Out> and trigger this from the first output of the <Sequence>. Because of the order in which you are doing it, this will fade out the track that is currently playing and fade in any new track. Set the Fade In/Out *Duration* to 1.5 seconds.

4 We're going to set up a system that plays your first track on entry to the room, crossfades to the second when the "very bad thing" gets close (using an <OnActor Begin Overlap> from

a trigger attached to it), and then crossfades back to the first track when it moves away (using the <OnActorEndOverlap>).

5 Although there are only two tracks in this system, we're going to up the complexity a little to create a system that's reusable for crossfading multiple tracks that might be more useful to you in the future than the simple fade in/fade out already described in the demo level.

6 In the ➡MyBlueprint panel, click on the + icon to create a new variable. In its ➡Details panel, name it Music Tracks, change it to Variable Type Sound Base, and click on the 3X3 squares symbol next to this to make it into an array. An array is simply a type of variable that can contain multiple elements.

7 Compile your Blueprint, then you can see under the Default Value for this variable the option to add your first music track as the first element in the array (0), then click the + sign to add a second element (1) and assign your second track.

8 Drag this variable into the ➡Event Graph to create a <Get>, then drag out from this to create an array/<Get> and connect this to the sound input of your <Play Sound Attached>.

9 Create a new variable of type integer and name it Current Track, drag it into the ➡Event Graph to create a <Get>, and link this to the Index input of the <Get>. By changing this Current Track variable, we can now choose which element of the array we want the <Play Sound Attached> to use—in other words, we can choose which music track to play.

10 Drag your new variable Current Track into the ➡Event Graph again, but this time create a <Set> and set its value to 1. Trigger this from the <OnActorBeginOverlap> from the "very bad thing," then link its Output to trigger the <Sequence> object. When the player enters the room, the <Play Sound Attached> will play the music track in the default index of the array (0). When the "very bad thing" overlaps with the player, the index of the array will be changed to 1, triggering the sequence that will fade out the playing track and then fade in this new one.

11 Now create another <Set> for your Current Track variable that will reset the index of the array back to 0 when the very bad thing moves away. Trigger a new <Set> with a value of 0 from the <OnActorEndOverlap> then use this to again trigger the <Sequence> object.

12 When the player leaves the area (<OnActorBeginOverlap> exit area), trigger the <Fade Out> to end the music. (See the exercise screenshots on the website for more help if required.)

13 Although this had been a little more convoluted than perhaps was necessary, you now have an extendable system that you can use to crossfade multiple music tracks between each other throughout a game level, and since it's not based around musical time, you can probably see how you could use exactly the same system to crossfade between multiple ambiences around your level by simply adding [Trigger]s at each transition point.

Masking Transitions

Another very effective way to avoid musical clumsiness in transitions is in effect to hide them. A loud sound or a piece of dialogue that temporarily ducks the music can be a good opportunity to swap out your music without needing to resort to more complex systems since they will mask the clunky transition.

Once the lights are on in *Offices Room 03* (Bookmark 3), you can plant the explosive device on the door to enter the next area. Musically there is a simple <Fade Out> of the previous piece when the next music system starts, but this is masked by audio that builds up to a large explosion.

This masking effect can be helped by some quick ducking of the music in the mix (we'll be looking at mix changes in Chapter 08). Like crossfades, this can work perfectly well in the right circumstances, but when the music is more exposed, we need to look at how we can better control when it changes.

Musical Transitions

Summary : Transitioning between musical chunks, transitioning on bar lines, transitioning to aligned points in a track

Although crossfades or masking can be effective, they are never going to be totally satisfactory from a musical point of view, and if it doesn't work musically, it's less effective emotionally. What does it mean to transition musically?

Transition Potentials

Let's look at a typical game scenario:

Exploring—Stealth_01
Bored (if we've been exploring for a long time, we might ramp the music right
 down)—Bored
Spotted by enemy or alarm—Action

Low health—Health
Land successful blows on enemy—Hits
Defeat enemy—Triumph
Get killed—Death

The hits are easy since we can just play stingers over the top, so that leaves us with stealth, action, health, triumph, and death. We need to carefully consider the possible transitions that might occur between these cues, as illustrated in the following diagram.

Transition Junctures

We will also need to consider how and when we want to allow each piece to transition to each other piece. This might be a global decision or more likely a series of choices particular to the nature of the music in each track. Some tracks will suit immediate transitions (non-rhythmic subtle ambient tracks) while others will sound bad unless the transition happens on a bar line. Depending on the system you use, this will either be defined by parameters you set in the system (which is what we will be doing) or through markers that you can embed in the music tracks themselves through your DAW. Many audio editors have the ability to store extra information in the wave file, which contains a header with non-audio information known as metadata. Using metadata to hold your markers is better than chopping up the wave itself, as your programmer can call these but will still have the original file in order to enable a short volume envelope to fade the music out. The white arrow indicates when the transition is called.

At Immediate

This immediately stops (or fades out) the current cue and plays the new cue from its start (either at full volume or with a fade in).

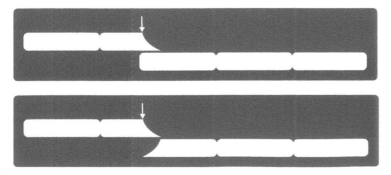

At End

This transition waits until the end of the currently playing cue to switch to the new cue.

At Measure

This starts the new cue (from its start) at the next measure (bar) boundary.

At Beat

This will play the new cue (from its start) at the next musical beat of the currently playing cue.

At Custom

You might want to transition out of the currently playing cue at a custom juncture.

At Immediate Aligned

This will transition immediately to the second track, but at a point in time that is aligned with the first.

At Measure Aligned

This transitions at the next measure, but to the same position in the new cue rather than at the start of it.

At Beat Aligned

This transitions at the next beat, but to the same position in the new cue rather than the start of the new cue.

The easiest way of keeping track of all this is to use a transition matrix like the one illustrated below. In this you can note how you want each track to be able to transition to each other track. Read along each row from the left to see how this track may (or may not) transition to each of the other tracks.

	Stealth	Bored	Action	Health	Triumph	Death
Stealth		AtMeasure	AtBeat			
Bored			AtBeat			
Action	AtMeasure			AtImmediateAligned	AtBeat	AtBeat
Health	AtMeasure				AtBeat	AtBeat
Triumph						
Death						

As you might appreciate, this can all get rather complicated to implement, but there are some relatively simple systems with which we can achieve most of the things we might want.

Working with Chunks: Measure-based Transitions

If we write our music in relatively short blocks (i.e., one bar) and only allow the transitions to be triggered at the start of these blocks, then we can react relatively quickly to game events while maintaining a musical continuity. The added bonus is that this is pretty simple to set up.

A looping system is set up that outputs a trigger every measure/bar (or whatever the length of your chunks). This goes into a switch. The game events will determine the index of the switch (i.e., which output to send the trigger). The events will change the index immediately, but the trigger won't come through and play the new piece of music until the measure, meaning that the transition will be at a musical juncture.

Offices Room 04 (Bookmark 4) is monitored by security cameras. You need to sneak past these in order to disable 4 control panels that will activate the door to the next area. If a camera detects you, the music transitions to highlight the danger (and a bot emerges to check out the situation). You can go and hide in the side office (with the opened door) until the coast is clear again (close the door 'E' !). If for testing purposes you want to start immediately outside of this room, then B will start the music system.

Decay Tails Revisited

In our earlier discussion for the racer levels, we looked at how it's important to keep, or embed, the decay tails in order to keep your music sounding smooth. Since this uses a retriggered system that allows the end of the file to play out while the new piece comes in over the top, we can keep the tails

on when we export from our DAW. If you're working with live recordings and you don't have a natural decay for every chunk you want to use, then you can just leave an extra bar at the end, but give it a short fade out. This isn't perfect but will help your music to flow much better than simply cutting them off at the bar/measure line.

Controlling a Switch

We have used a <Switch on Int> node so we can change the switch index in response to events, but nothing will output until the <Timeline> pulse (on the bar line) comes through (remember that nodes consider their first input or output to be input 0 or output 0, not input 1 or output 1).

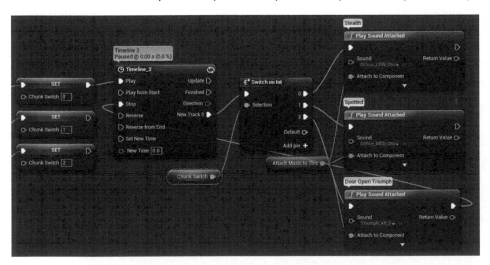

The <Timeline> is set to be the length of our chunks (one bar/measure—1.85 seconds), is set to loop, and has an Event Track with the new track event positioned at 0.0.

We've created an integer variable Chunk_Switch to control the <Switch on Int> index, and this is <Set> to switch to 0 when the player enters the room, to 1 if the player is detected by the cameras, reset to 0 when the bot gives up and stands down, and set to 2 if the player manages to turn off all 4 control panels and open the door. This final <Play Sound Attached> also stops the <Timeline>, as we want the music to end after this final {Triumph_Alt_3} cue.

Don't forget to build in some variation to your cues, as these short chunks can quickly become repetitive and loopy. For example the {Office_Low_Chunks} cue randomly chooses one of 4 possible variants.

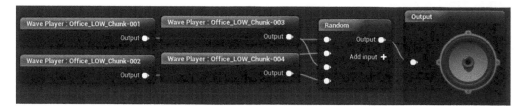

Of course we could implement exactly the same system by operating a -Switch- inside a Sound Cue. The Sound Cue {Transition_Chunks} has a -Switch- with the parameter name Transition_Chunk_ Switch. We use a <Set Int Parameter> node to target the <Play Sound Attached>, and the same variable we used to <Set> our other switch in response to events is now used to <Set> the Chunks_ Switch_02 variable that is passed into the Sound Cue.

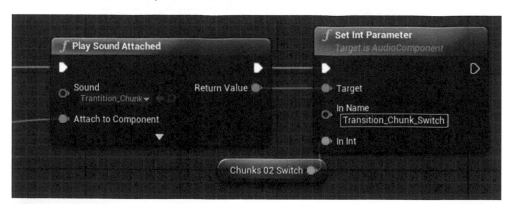

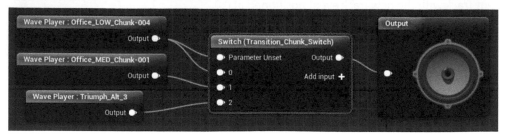

We will be using this system in our next example.

Exercise 05_02: Transition Chunks

In the last chapter you opened the door to the *City Courtyard* section of the level (you can also cheat by pressing C if you are starting directly from here). In the courtyard you must go around and throw the three switches (by pressing E) to open the door into the next section. If the patrolling bot in this area spots you, then they will set off an alarm and reset the switches. The good thing is that the bot is very forgetful, so if you go and hide in one of the side rooms, it will turn off the alarm and return to its patrol—which is useful.

1 These systems can get quite complex, so the good news is that we have premade them for you. All you need to do is assign your music tracks and set up the <Timeline>.
2 Write three short tracks one measure/bar long. Write a few variations of each so the music doesn't get too repetitive.
3 Create three Sound Cues: {Stealth_01} for when you are unnoticed, {Action_01} for when you have been spotted, and {Triumph_01} for when you unlock the door. In each cue use a -Random- node that picks between your variations.
4 Assign your cues to the appropriate <Play Sound Attached> nodes in the "City Courtyard" section of the [Level Blueprint].
5 Open the ➡Timeline Editor by double-clicking on the <Timeline>, and change its length to the length of your tracks in seconds. Remember this is the length at which you want to restart the track to loop, not the length of the actual file that includes the decay tails.
6 Your tracks are started by the event from the <Timeline> going through the <Switch on Int>, and the game events control the Index of this switch by changing the Int.
7 Play the game and you should hear that the music changes/transitions at the start of a measure/bar.

Transitioning on Measure in Longer Pieces

Sometimes you'll want to be able to use longer pieces of music with a more extended musical structure but still transition musically.

Rather than having the music in chunks that are retriggered, we will allow the music to play through much longer loops. We will still keep the <Timeline> events on measure but only let them through when we want to trigger a transition to a new cue. We do this by inserting a <Gate> between the <Timeline> and the <Switch>. This <Gate> will remain closed (i.e., it will not let the trigger pulse through) until a game event calls a change. This will open the <Gate> and, after the next available trigger has gone through, immediately close it again.

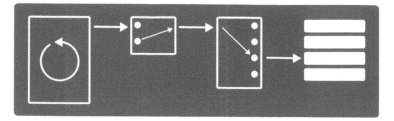

In *Offices Room 05* (Bookmark 5) there are a number of laser sensors that you need to avoid, carefully timing your movements around the room to make it to the exit. If you accidentally get caught by one, then you have a few seconds to make it back to the start of the room and hit the reset button before the room fills with deadly gas.

You can see below how the game events (enter room, trigger laser, reset, and reach the end) <Set> a track to play and open the <Gate>. When the next <Timeline> event comes through, the <Sequence> object on the right will apply a short fade to the currently playing track and play the new one.

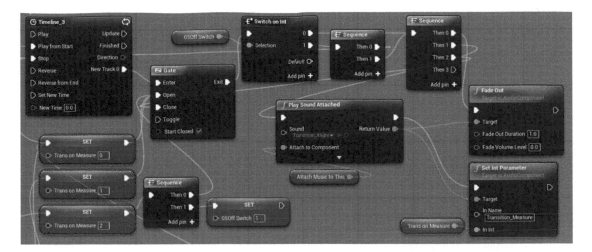

This time we have used a -**Switch**- inside the Sound Cue. Since we are now using longer pieces of music, we don't have the need to be picking randomly from a series of chunk variations. (Alternatively you could set up an Array of cues like you did for exercise 05_01 if you have lots to deal with.)

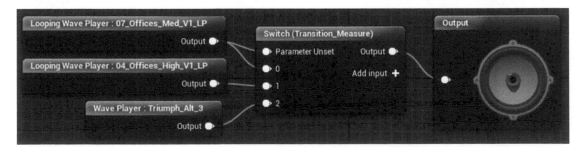

When the game events happen, the variable Trans_On_Measure is set and the <**Gate**> opened so that the next bar line event from the <**Timeline**> can go through. This first triggers a <**Fade Out**> of the track that is currently playing and then triggers the <**Play Sound Attached**>. This has a <**Set In Parameter**> attached that will take the value of the variable Trans_On_Measure and use it to set the Transition_Measure parameter that controls the -**Switch**- inside our Sound Cue. Using this method we can use longer pieces and then transition on the bar line to the start of a new piece in response to game events.

Pre-syncs or Ramps

The problem with transitioning on the next measure or bar line is that, although it may be musically satisfying, the music can sometimes feel like it's not reacting quickly enough to acknowledge game events. When an event happens, particularly one significant enough to warrant a transition rather

than just a stinger, we want the music to acknowledge it immediately, but of course this brings us back to the issue we highlighted at the start of this chapter—the irreconcilable differences between arbitrarily timed game events and musical events.

A good solution to this is to use a pre-sync cue. This is a music cue that we can start to fade in immediately once an event has happened and which builds towards the actual transition, thus heightening its impact even more.

For example think about a bar/measure of music with a snare drum in eighth beats (quavers) getting louder. If this was synced to the current measure, then we could start to fade it in at any time, it would still work as a build up to the transition, and because it can start to fade in immediately, we will be giving the player an immediate acknowledgment of their actions or the event. Another name for this might be a ramp track, a one-bar measure that ramps up to an oncoming transition.

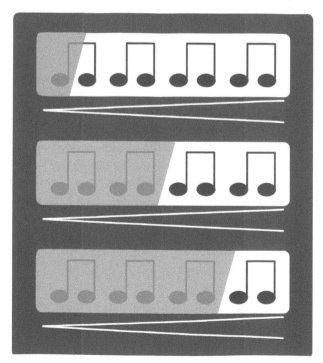

Go to the "Room 05" section of the [**Level Blueprint**], uncheck the box on the <**Gate**> in the Pre-Sync section so that <**Gate**> now starts as open, and play this section again. Hopefully you can hear that this is more satisfying.

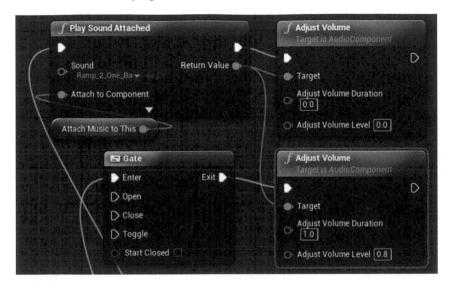

As you can see this is pretty simple to set up. The one measure pre-sync cue referenced by the <**Play Sound Attached**> is actually played at the start of every measure from the <**Timeline**> so that it is in sync (you might think of this as a parallel approach—and you'd be right, but we're talking about it here because its use is in pre-empting transitions). Its volume is immediately adjusted to 0.0, only to be faded up by the other <**Adjust Volume**> node when the event happens (in this case the call to transition to the higher intensity track). The <**Gate**> is simply there so that you can switch this system on and off to hear the difference. You could also have another pre-sync or ramp track that leads into a transition down in intensity.

Exercise 05_03: Transition on Measure and Pre-sync

Once you have got past the courtyard, you enter the *City Streets*, a warren of alleyways. You must find three items in this location in order to bribe your way into the inner courtyard of the city. Unfortunately some of the alleyways have been rigged with trip wires that will bring the soldiers running! In this exercise you will create some longer tracks that transition on measure when there is a change of event together with some pre-sync cues to acknowledge them immediately.

1 As before this is a complex system, so we have set most of it up for you.
2 Write 4 tracks: {Stealth}, {Action}, {Triumph}, and {Death}. The {Stealth} and {Action} cues can be longer this time (but still the same tempo). The {Triumph} and {Death} should be one measure/bar long.

3 Now write three pre-sync cues. One that will lead from {Stealth} to {Action}, one that will lead from {Action} to {Triumph} and one that will lead from {Action} to {Death}.

4 Edit the {Streets_Music} Sound Cue and replace the 4 placeholder files with your own. Make sure that you connect the correct ones to the appropriate inputs of the -Switch-.

5 Add your pre-sync tracks to the appropriately named <Play Sound Attached> nodes.

6 Remember you may need to edit the length of the <Timeline> to match the length of a measure for your tracks.

Aligned Transitions

We can transition immediately, but to a time aligned position in the other track rather than the start of a new track, in order to maintain musical continuity between what might be different arrangements. To do this immediately would feel exactly the same as a parallel approach where we have the two synced cues running but then fade one in and the other out (the advantage would be that we are not actually playing the second track—thus saving that voice for something else).

What we are interested in here is transitioning to and from musical junctures. We won't look at transitioning immediately, but instead will consider what to do if we want to move to a new track that is aligned in time but on a bar line (you can transition immediately if you wish—simply remove the <Timeline> and <Gate> from the following system).

You might use this system if you have two arrangements of the same piece of music, perhaps one full and intense, the other more lyrical and full of yearning (or something like that). When events change you want to maintain the musical and harmonic flow, but swap to the different arrangement that perhaps has different instruments. You don't want to do this instantly (through a parallel approach), but instead want the change to happen on a bar line.

In *Room 06* (Bookmark 6) there is another laser security system, and again you must time your movement through the room to avoid the lasers or else the poisonous gas is released.

In order to transition to the same point in the new track that we are at in the currently playing track (although we are going to restrict this to happening at bar lines), we need to set up a timing system. We have done this using a <Set Timer> node. The length of this is set to when we want our tracks to restart. Remember this is not necessarily the exact length of the track since the track may include a decay tail at the end. The timer outputs a <Custom Event> called Music_Length (as defined in the Function Name) when it reaches this time. This means we have got to the end of the track, so this goes through and starts the timer (and triggers the <Play Sound Attached>) to loop the track around again. (Note that unlike the previous {Transition_Measure} cue this time the {Transition_Aligned_Measure} does not contain -Looping Wave Players- since we are looping the cue with the <Timer> in order to better maintain the sync for the aligned changes.)

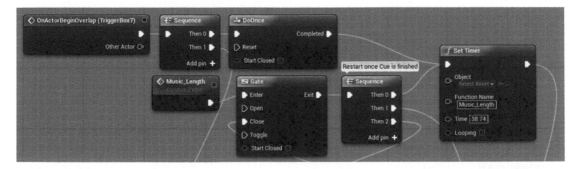

Just as before, the events in the game (getting caught by a laser and resetting the security system with the button by the door) set the variable that we are using to control the -Switch- in the Sound Cue. The difference is that now our <Play Sound Attached> does not start playing the new track from its start. Attached to its Start Time input is the current value of our timer. So the new track will start

playing at exactly the same time point that the old track was at—hence we are moving to an aligned point in the new track!

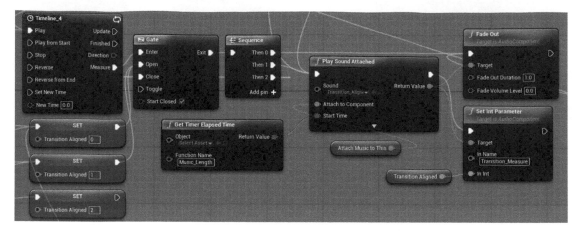

However, the changes are still only initiated when the <Timeline> event comes through, so we are aligned to the same point in the track but only actually transition to it on the next bar line.

Exercise 05_04: Transition at Aligned Measure

Down a back alley you locate a hidden entrance to the *Hidden Temple* (Nearest Bookmark 9). You must locate and pickup (E) three silver candlesticks. Beware the priest! If he spots you then he will raise the alarm and this will activate the security, blocking off the candlesticks. You'll have to exit the main temple and wait in the corridor outside until the alert is over. In this exercise you will implement some music that transitions on measure to aligned points between two tracks.

1 Write two pieces of music:
 a. Sneaky
 b. Alarm_Raised
2 The Sneaky and Alarm_Raised pieces should be different arrangements of the same music and you will transition between them on the bar lines, so preview this in your DAW until you find music that works. These can be longer pieces of music but must be at the same tempo.
3 The system is set up so you need to add references to your pieces as follows. Open the [Level Blueprint] and find the "City Temple Music" section. The <Play Sound Attached> here references the Sound Cue {City_Temple_Placeholder_Music}. Edit this cue and swap in your pieces. Remember to edit the length of the <Timeline> to match the measure/bar timings of your pieces.
4 Good luck. If you manage to get the candlesticks, then you can put them on the altar in the *Inner Sanctum* that you'll get to later.

Putting It Together

We've covered several approaches to transitional forms that you can obviously combine and adapt to the particular needs of any game you're working on. In *Room 07* (Bookmark '7') we put together a system that combines some of the things we've been talking about. You can have a look at the system in the [Level Blueprint] ("Room 07 Music" section) but we will just describe how the music works and then you can get on with the exercise.

Note that none of these systems has absolutely perfect timing given that UE4 does not yet have a sample accurate audio system - however this is promised in a future update!

This is an implementation of the system we started the chapter with.

The player needs to get around the room to use three switches to open the safe where Nagosony's darkest secrets are held. There are some security turrets on the ceiling which are triggered by the cameras and lasers. Luckily there are some fortuitously placed dividers around the room that you can hide behind to wait until the systems stand down.

The music operates as defined in the following transition matrix:

	Stealth	Bored	Action	Health	Triumph	Death
Stealth		AtMeasure	AtBeat			
Bored			AtBeat			
Action	AtMeasure			AtImmediateAligned	AtBeat	AtBeat
Health	AtMeasure				AtBeat	AtBeat
Triumph						
Death						

Exercise 05_04: Putting It Together

This exercise is a little different to the others since you will be doing it in the demo level itself. Write some tracks of your own that will suit the system above and then assign them to the array in the "Room 07 Music" section of the [Level Blueprint]. The system is currently set up for 4 bar chunks at 90BPM. To change this you'd need to edit the <Timeline> in the Music Pulse System sub-graph, changing the length of the <Timeline> to your musical chunk length and defining the beat and measure events to match that of your music. You'll also need to edit the Time value of the <Set Timer> node to the new musical chunk length.

A Musical Conclusion

Don't forget that interactive music in games is just one of many options regarding how music is used. Using source music that plays within the environment itself, having non-reactive music that represents the larger scale narrative, or even playing against the action on screen should all be options that have their place. Also remember that it is part of your role to sometimes argue for no music. As powerful an emotional effect as music can have through its presence, it can be equally powerful through its absence.

If we are going to have music that reacts to game events, we need to do it properly to attempt to find that compromise between contextual responsiveness and musical integrity we talked about in the opening to Chapter 03. Hopefully you've seen that, like with sound, you can't separate the asset creation from the implementation. For music to work at its best, it needs to be written with the interactive system that's going to be playing it in mind. This obviously has implications for how you perform and record it as well, since we might need to ensure a fixed tempo or sync or take a different (and more expensive!) approach to recording if we are going to need separate stems.

For most games, there should likely not be a music system, but music systems. These should work in tune with the particular requirement of the circumstances of the game within different scenarios or could even adapt to different playing styles. One answer to the challenge of interactive music is certainly a deeper integration with the game design itself. This will involve producers and designers understanding what music can bring and how it operates. It should inform the design of the game, not simply be an add-on to it. Sharing this understanding and making this happen is an important part of your role, and hopefully through the skills you've learned here, you should be able to create effective prototypes or implementations that can put across your ideas persuasively.

The flexibility and adaptability of music in early games was lost for a long time after the introduction of the very inflexible stereo wave as the de facto method for playing back music in games. Yes, this gave us better quality (and the opportunity for all those great marketing photos of the orchestral recording sessions), but at a real price in terms of musical innovation. If we look at the basic methods for both sound and music in games, we can see that they share a lot of common ideas.

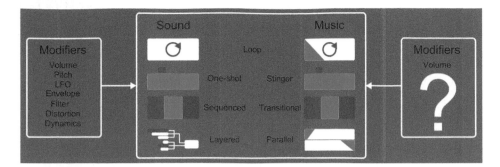

What music lacks are the modifiers that we can apply to sound. Why can't we change key in response to a game event, or even just change the instrument? Why can't we increase the accents on the bass line or change the note lengths to make a more legato version of the tune? If you think about it, we only really have one modifier for music in most systems—the volume of the track.

All these modifiers for music are available in our DAW, but by rendering out to waves, all this flexibility is lost. There have been some recent moves which may mark a return to MIDI and sample-based systems within games, and future technologies may open up the opportunity for these to match the quality you can get in your DAW (your massive orchestral sample libraries could be stored in the cloud, receive MIDI data from the game, then stream across a 5.1 rendering of the music in real time—which would be nice!) In the meantime take a look at the advanced chapter on music (Chapter 12) for some ideas to get you started with a more note-level, procedural, or algorithmic, approach.

Given the inherent conflict between the player's autonomy to act at any time and musical structures that require changes to happen at predefined times, none of the approaches outlined above actually offers a perfect solution, nor can they ever do so. If we want music to be the most emotionally effective it can be, then games systems have to actually become a lot more interactive than they currently are. In other words, they need to treat the music as an input to the game system and interact with it, timing some game events to the music rather than simply treating music as something that you trigger (a reactive system). By gaining knowledge of both the music and gaming systems as you have done, you can be in a position to really innovate in this area.

For further reading please see the up-to-date list of books and links on the book website.

Recap:

After working through this chapter you should now be able to:

- Crossfade between music tracks, making use of masking where possible;
- Construct systems that switch between tracks composed in musical chunks;
- Construct systems that enable transitioning on measure/bar lines of longer pieces;
- Switch to an aligning time in a new music track on a bar line;
- Devise and implement transition matrices.

Dialogue 06

Summary : Timed and triggered dialogue for advice, handling dialouge interuptions, using conditions and contexts for dialogue choices

Project : DemoCh06Castle01 **Level :** Castle01

Introduction

Trying to avoid clumsy game dialogue is particularly difficult, as there is often a huge burden put on dialogue as the sole driver of the game's narrative. Perhaps not yet as developed in terms of visual storytelling as film, where a couple of shots may convey several key story elements, games often rely upon dialogue to not only move the narrative forward but also to provide a great deal of instructional information to the player. Games also tend to operate within very well established genres (action, space opera, Tolkienesque fantasy, etc.) where it is hard to avoid cliché. Even if you are an experienced writer, this is challenging!

Dialogue typically falls into one of the following categories:

Informational

This dialogue provides the player with information they need to play the game. This might be instructions on how to use a piece of equipment or designating a rendezvous point. The key point with this dialogue is that needs to be clear and heard. It is clear and articulate and in complete sentences—very different from natural dialogue. This dialogue might be panned to the center speaker and typically also ducks other sounds so it is certain to be heard. The ideal aim is for the informational category to be subsumed into character so that any instructions necessary emerge naturally out of the character's speech. Failure to do this often results in the kind of clunky repetitive dialogue we want to avoid (see Chapter 08 for how to route dialogue to the center speaker).

Character

This dialogue conveys the thoughts and emotions of the speaker. It is more naturalistic than the informational style, as its emphasis is on conveying the emotions of the words. This is more likely to be spatialized in the game world, but may still also be bled into the center speaker for clarity (see Chapter 08).

Ambient/Incidental/Chatter/Grunts

This dialogue helps to set the scene for the location or situation you are in. Although crucial for establishing the ambience, the information conveyed by the words is not necessarily vitally important. This would be spatialized to originate from the characters in the game.

Preparation

Before importing your dialogue, it is important to consider the following:

- **Editing**—Make sure the dialogue starts at the start of the file and trim off any silence at the end.
- **High-pass Filter**—The mic will often pick up some low-end elements like feet or mic stand movement, so get rid of these by applying a high-pass filter.
- **Clicks and Pops**—Although you are obviously already using a pop shield, some of these can occasionally slip through—time to edit!
- **Breaths**—these can be important for some kinds of dialogue delivery but distracting in others. Try using expander functions to duck down audio below a given threshold.
- **De-essing**—sibilant elements can sometimes be unnaturally emphasized through the recording process, so try a de-essing plugin effect.
- **Levels**—Dialogue can have a huge variation in dynamic range, from a whisper to a shout. It can be particularly difficult to maintain even levels if you are recording your dialogue in different sessions, possibly in different studios. Using consistent equipment and maintaining the same physical setup can help with this, but short of sifting through thousands of lines and adjusting by hand, you could try an automated batch process that looks at average values.
- **Organization**—There can be many thousands of lines of dialogue in a typical game. You are going to need a good naming convention and some spreadsheet chops to keep track of everything.

Randomization

Summary : Types of random

We've discussed earlier in the book how repetition can destroy immersion in games. This is a particularly acute problem for dialogue. Since you were a baby, the human voice has been the most important sound in the world to you, and our hearing is most acute for the range within which human speech falls. It is the thing you pay most attention to, and you have spent your life understanding the subtle nuances in frequency, volume, and timbre that can change a compliment into a sarcastic snipe. Even if a character says the same line, in the same way (i.e., playing back the same wave) several

hours apart from the first time the character said it, chances are that we will notice this, and it will momentarily destroy our immersion in the game world.

The nature of games is that we are often in similar situations again and again and are consequently receiving similar dialogue (e.g., "Enemy spotted!", "I've been hit!"). This indicates that, for the most heavily used dialogue for each character, we need to record lots of different versions of the same line.

Project: DemoCh06Castle01
Level: Castle01

You can skip between the three locations in this level by pressing 1, 2, or 3. The player character needs to be close to objects in order to interact with them.

After choosing your character you will find yourself in a castle chamber in area *Chamber 01* (Bookmark 1), the back half of which is shrouded in darkness.

Clicking to move into the darkened back half of the chamber will result in comments such as: "I can't walk on over there without a light, else I'm sure to fall to my death!", "I'd better not", "I'd be mad to try that without a light", "What am I thinking, I need more light", "I must be an idiot, I need more light to cross", "What an imbecile, I can't cross that without more light", "I must be madder than a bag of spanners—I need more light to cross over there."

If you have a situation where you can anticipate that the player will be performing, or trying to perform, the same action numerous times, then this is an obvious candidate for a large number of variations on the same sentiment within a randomized Sound Cue (See {E22_01_No_Light} referenced from the "Chamber 01" / "Lights not on Warming" section of the Level Blueprint.)

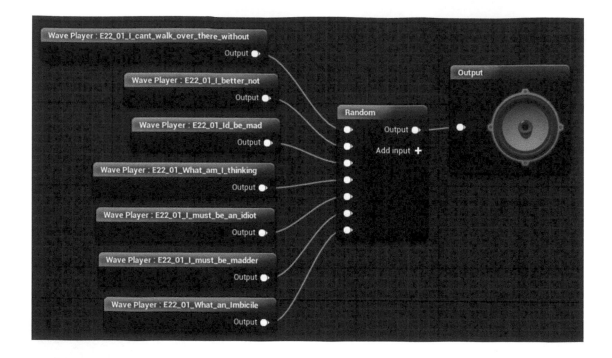

Better than Random? Randomize without Replacement

The problem with a purely random system is that you may, by random chance, get the same dialogue line repeated twice in succession, something that will definitely sound unnatural to the player. The randomize without replacement option provided in the -**Random**- node of the Sound Cue is a particularly useful one. This will keep track of which sounds have been played and randomly choose between only the sounds that have not been played recently. This is useful not only for avoiding the distraction of the same sound being played twice in succession, but also in spacing out the repetition of sounds.

For example:

a. The Sound Cue is triggered and sound 3 (out of a possible 0, 1, 2, and 3) is chosen and plays.
b. The Sound Cue is triggered again, but this time the -**Random**- node will only choose from sounds 0, 1, and 2. Sound 1 is chosen and plays.
c. The Sound Cue is triggered again. This time the -**Random**- node will only choose from sounds 0 and 2. Sound 2 is chosen and plays.
d. The Sound Cue is triggered again, and sound 0 is chosen to play. The -**Random**- node then resets itself so that all sounds are once again available.

This system is sometimes referred to as random cycle down in other engines to describe the random choice cycling down each time through the samples left available.

Dialogue for Advice

Summary : Timed dialogue, triggered dialogue

Timed Help Advice

As well as giving direct feedback on a player's actions, dialogue can often be used to offer advice or hints should a player become stuck. In *Chamber 01* (Bookmark 1) the player needs to interact with the handle on the wall before they can light the way to the back half of the chamber. As what is required is not necessarily that obvious, we've set up a hint system. (See the "Hint Timer" section of the Level Blueprint.)

On entry to the room, a <Delay> is started. This checks whether the room has actually been completed or the task (switching on the lights) completed using <Branch> nodes (which we'll be looking at shortly). If neither of them has, it plays the clue dialogue, "Hmm, I wonder what that lever over there is for?" (and some variations thereof).

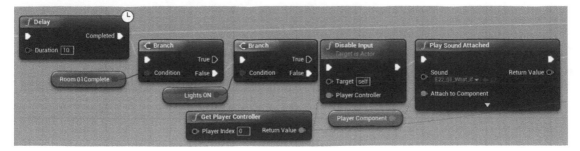

There is a similar hint system in *Chamber Two* that gives some slightly more enigmatic clues suggesting that the player should investigate the well at the center of the room ("Well, well, well," "Oh, well," etc.) Given the specific environment and approach of your game, you'll need to consider carefully the frequency of such hints so that they don't become irritating.

Triggered Advice

Another typical use for dialogue is to set up simple triggers on the entry to an area to give the player instructions or clues when they enter. Once the player lights the torches at the back of *Chamber 01*, there's a [Box Trigger] as they pass through the gate to warn them that they "need to be careful about the broken tiles."

It's often more immersive if these only play once using the <DoOnce> node.

Exercise 06_01: Dialogue Advice

Return to the *City Streets* area of the exercise map. We know that the player needs to collect some items in the area in order to bribe their way into the *Inner Sanctum*, but the player does not. Help the player by adding some dialogue to the characters in this area so that they can offer some advice (the enemy bot systems set up here for the music systems in Chapter 05 may prove a little irritating while you're working on dialogue, so you can disable them by pressing K when the game starts).

1 Find Character 01 in the *City Streets* area of the map (use ➡World Outliner to search).
2 This character needs to advise the player. Something along the lines of "You won't get into the inner sanctum through force. The guards are bananas about food though; you could bribe your way in." Record a few variations of this line including more highly amusing puns on the other items—apples and dates.
3 Add these to a randomized Sound Cue {Character_01_Dialogue}.
4 Set up a system for Character 01 so that the player needs to press the use key to interact (a [Trigger] in the level opening a <Gate> on proximity to the character that lets the E key event through to the <Play Sound Attached>). Attach the <Play Sound Attached> to the character by selecting the character in the level then creating a <Get Root Component> in the [Level Blueprint] (it will automatically create a reference to the character) then link this to the Attach to Component input.
5 Find Character 02 near to the guards at the inner sanctum gate. Set up a timed reminder for this character such as "Those guys are always hungry," "They'll do anything for a bit of grub," etc. Create a [Trigger] on entry to the *City Streets* area to start a <Delay> (after passing through a <DoOnce> to stop retriggers) leading to a <Play Sound Attached>. Loop the output of the <Play Sound Attached> back into the <Delay>.
6 Attach the <Play Sound Attached> to the character. With the character selected in the Viewport, right-click to <Get Root Component> and connect this to the <Play Sound Attached> Attach to Component input.

7 Remember to set the attenuation for this character's speech in the -**Output**- node of the Sound Cue so that you don't hear it everywhere.

8 You could randomize the <**Delay**> time by dragging out from its Duration input to create a <**Random Float in Range**> node.

Dialogue Interrupts

Summary : How to handle interrupted dialogue with overlaps, fade outs, blocking until finished, global ducking

One of the things that will stand out for you once you start listening closely to game dialogue is how we haven't really solved the problem of interruptions yet. There's something about simply stopping or fading out a line that just doesn't sound like how we respond to interruptions in the real world.

Bad/Better/Better-er

Bad

In ***Chamber 01*** (Bookmark 1) you can click on various items to get some more, not very useful, information about them, like "It's a wooden crate," "It's a metal grate on the floor," and "It's a burning torch."

If you click rapidly on these, you'll hear that they repeat the new line while the old one is still playing. This obviously sounds very silly since people are not typically polyphonic (i.e., we can only say one thing at a time!)

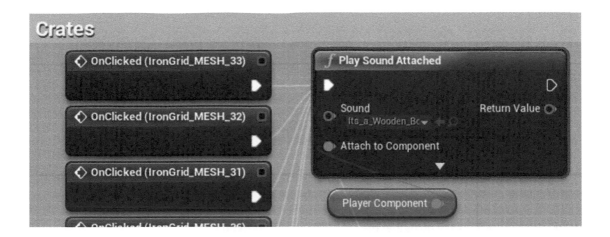

Better

When clicking in the darkened back half of the chamber, you'll hear that these dialogue lines do not play over each other, since we've now set the already playing line to be faded out should a new line be called. Although it is still not that satisfactory, you might choose to do this when it's important that the new dialogue line is heard.

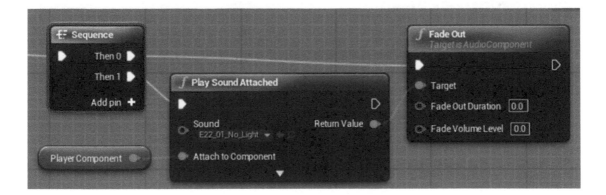

Better-er

In *Chamber 02* (Bookmark 2) you can see a different approach where you can simply block any interruptions, not allowing the new file to be played if there is one ongoing. Click on either door to get a "door locked" message. If you click again while the line is still playing, you will not get the new line.

Presuming the player does not already have the key (<**Branch**> is False), the dialogue line "It's locked!" is played and the <**Gate**> node is closed, blocking any further input to the <**Play Sound Attached**>. The <**Gate**> will not open to allow another line of dialogue through until we receive the <**Custom Event**> LockedDoor1_Finished, telling us that the currently playing line is finished and opening the <**Gate**>.

It's always important to not only acknowledge a player's actions, but to also point out if a command is not possible right now. In this case we've used a <**MultiGate**>. This node increments the output each time it receives an input. So when the player first clicks on the door, it plays the dialogue, but if it's clicked again it will play a negative input sound. When the dialogue has finished, the <**MultiGate**> is reset, allowing for the next dialogue line if clicked on again. (See the "**Chamber 02**"/"Door01" section of the Level Blueprint.)

Exercise 06_02: Don't Interrupt!

The Character 03 in the *City Streets* section of the map offers some advice as to where to find the dates. Set up a system so the player cannot interrupt them while they are talking.

<Assign on Audio Finished>

1 Find Character 03 in the *City Streets* and set up a use system like you just did for Character 01 (see Appendix A: Core Concepts/Events and Triggers/Trigger "Use").
2 Create some dialogue such as "You want a date? Try the back alley over there behind me," "I haven't had a date in ages, but I think the delivery boy might have dropped some in the alley behind me," etc.
3 Attach the <**Play Sound Attached**> to the in-game character as you did in Exercise 06_01.
4 Put a <**Gate**> between the use system and the <**Play Sound Attached**>.
5 Create an <**Assign OnAudio Finished**> node by dragging out from the Return Value of the <**Play Sound Attached**> and searching for "Finish". Use the output of the <**Bind Event to OnAudioFinished**> to close the <**Gate**> then the output of the <**OnAudioFinished**> to re-open it. This means that the player won't be able to retrigger the dialogue while the previous line is still playing. (Don't forget the exercise screenshots from the website for more help)
6 See if you can extend this system to use the negative click response discussed above.

Global Interrupt

It is hard to keep track of every possible piece of dialogue that might be playing if you need to stop them for some global event such as a player death, so instead of a complicated tracking system, we've used a {SoundMix} that ducks all dialogue if the player falls to their death through a cracked floor tile in *Chamber 01*.

All dialogue in the level is assigned to the {RPG_Dialogue} Sound Class, so when we instigate (or push) a Sound Mix ({DuckforScream}) this is set to duck this Sound Class.

The Sound Mix is set to last for 4 seconds (long enough for the game to reset) and so will automatically switch off (or pop) when complete. (See the "Collapsing Floor" section of the Level Blueprint.)

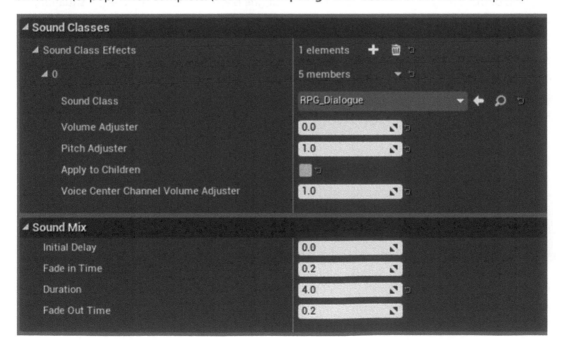

If you have several of these sorts of global dialogue events that need to mute any other dialogue that may be playing, you could assign them to a Sound Class that automatically calls a specific mix when they are played. This is called a passive Sound Mix. This, together with general mixing approaches, is dealt with in Chapter 08.

Stacked/Queued Dialogue

There may be instances where you want to hold a new dialogue line until the current line or event is finished and then play it, rather than simply discarding it, because it may be important. We'll look at this in Chapter 11.

Conditions and Dialogue Choices

Summary : Books, integers and arrays for tracking variables and selecting dialogue choices

Players can feel a much greater involvement in the game when the dialogue comments on their past actions since it creates the impression of a real and intelligent world. Equally there are fewer more effective ways to break a player's immersion in a game than simply getting the dialogue wrong—for example your comrades muttering "It's quiet" in the middle of a pitched battle.

Dialogue is often an indicator for a change in AI state, and you are reliant to a great extent on the effectiveness of these AI systems to ensure that your dialogue is appropriate to the current situation; however, it's also important for you to understand how to deal with tracking game conditions so that you can improve the use of your dialogue.

Simple Conditions and Dialogue Choices

Clicking once on the rat in *Chamber 01* results in the insightful observation "It's a rat." Click again, and you kill the rat—"I've killed a rat, I feel powerful." If you click on the rat again after this, you will observe that "It's a dead rat."

The rat's condition (alive or dead) is held in a Boolean variable, sometimes called a Bool. As we have previously discussed, a Boolean is a type of variable that is either True (alive) or False (dead), and this determines which line of dialogue is played. Storing conditions using Booleans allows you to start to more intelligently choose which lines of dialogue to play. In this case we use a <Branch> node to test the condition of the Rat_01_State variable. If True then "It's a rat," if False then "It's a dead rat." (See the "Chamber 01" / "Rat01" section of the Level Blueprint.)

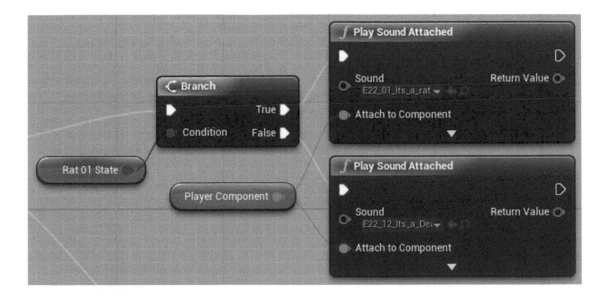

You can see that the use of Boolean variables to track conditions in the game is widespread. Another example is used to see whether the player has completed the first task (using the lever to switch the lights on). If the lights are on, then the player can move to the back of the chamber, if not, then the hint about turning the lights on is given.

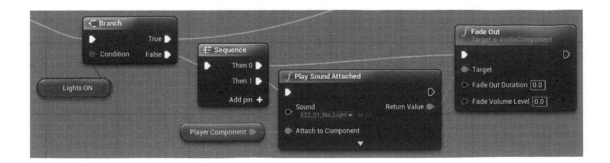

Exercise 06_03: Conditional Dialogue

We want Character 04 to show a little situational awareness in that they can see whether you have collected the apples or not.

1 Set up a use interaction system for Character 04.
2 Record some dialogue like "I know they like apples for sure" (and variations of), and "I see you already have some apples, try searching for something else."
3 Add these to two separate Sound Cues {No_Apples} and {Got_Apples}.
4 Send your use system through a <Branch Node>. This is going to check whether the player has already collected the apples.
5 Create a Boolean variable in the ➡ My Blueprint panel (+ in the Variables section) and name it Apples_Condition in its ➡ Details panel. Compile the Blueprint and then set the Apples_Condition Boolean to a default value of False in the ➡ Details panel.
6 In the "City Streets" area of the [Level Blueprint], there is an event called Collected Apples. Use the event here to <Set> your Apples_Condition Boolean to True (drag and drop the variable into the ➡ Event Graph to create a <Set>).
7 Connect your Apples_Condition variable to the <Branch> node and send the True output to play the {Got_Apples} Sound Cue, and the False to the {No_Apples} Sound Cue.

Counts to Dialogue Choices

In some cases we might want to respond to a numerical value, such as how many times something has happened or how many objects a player has picked up. In *Chamber 02* (Bookmark 2) there is a character who has strong feelings about animal welfare. If you leave the rats in Chamber 01 and 02 unharmed, then he is pleased, however kill one rat ("Ratkiller!") or both ("Rat Genocide!"), and he's less impressed.

Each time a rat is killed, the integer variable Rats_Killed is added to and then when you come to interact with the character, this variable is used to decide on the selection of a <Switch on Int> node that will choose a corresponding dialogue line. (See the "Rat Friend" section of the Level Blueprint.)

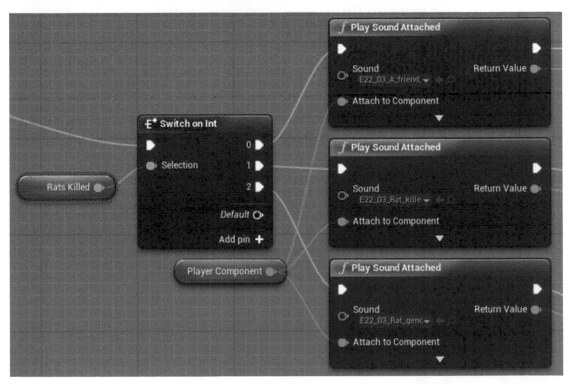

This use of a <Switch> index makes the process transparent, but you could equally use a variable that directly affects a -Switch- inside a Sound Cue. We avoided these earlier when looking at music since if the cue is playing any change in the switch parameter will make the new sound automatically start playing, something we didn't want in the music system. However since our dialogue is not continuous like music but more of a one-shot event, these can now be utilized. See the exercise below.

Exercise 06_04: Tracking Numbers

There are two guards by the gates to the *Inner Sanctum*. The guard on the left will respond to how many items you have collected.

1 Find Character 05.
2 Record some dialogue such as "Only one piece of food! That's not enough for a growing lad like me," "Two pieces of food? Well I guess we could share, but Godfrey is not going to be happy about it," and "Ah three pieces of food, that's more like it. Go and talk to Godfrey."
3 Set up your three Sound Cues as {Character_05_One}, {Character_05_Two}, and {Character_05_Three}, create a use system for Character 05, and connect it to the input of a <Switch on Int> node.
4 We have already set up the Food_Num variable in the Pickups section, so just <Get> this and connect it to the Selection input of your <Switch On Int>.
5 Connect three <Play Sound Attached> nodes to the three outputs of the <Switch On Int> in order (0, 1, and 2) and assign your three cues. Since the index of the <Switch on Int> is controlled by the variable Food_Num, the system will play different cues depending on the number of items the player has picked up.

Tracking Multiple Actions or Inventory for Dialogue Choice

Once you start dealing with more than a few game conditions or variables, it starts to become harder to organize and remember what is what. For the player's inventory, we've stored the multiple conditions in a single place—an array. We could of course do this with a series of separate Boolean variables, but an array keeps things neater, and we can interrogate the content of the array to inform the decision of which sound is played.

In the *Forest* area of the level (Bookmark 3), the player can interact with a tradesman (on the left). This character will respond in a variety of ways depending on what items you took from the chests in *Chamber 02*.

No Items

"I see you have achieved nothing in your quest thus far, how disappointing."

"You have nothing of interest to me."

Chalice Only

"Ah, a diamond encrusted chalice, how pretty."

"Lovely chalice."

"I'm sure that chalice will look charming on your mantelpiece, should you ever get home."

Vial Only

"Ah I see you have limitless patience, just wait a moment while I finish this book."

"I'll be with you in a jiffy."

"Just a minute and I'll be with you."

"Yes, any minute and I'll tell you what you need to know."

"Just bear with me a minute."

Vial and Chalice

"Hmm, I see you have everything. Remember (son/lass), nobody likes a smartass."
(See the Character, Contexts, and Dialogue Choices section below for more on this gender switch.)

A Boolean array variable called Inventory stores each item's condition. Index 0 stores the chalice condition, and index 1 the vial. We don't need an index for the scroll wheel mouse since we don't allow the player to pick that up. As each item is picked up, an <Insert> node is applied to the array to put the condition True into the appropriate index. (See the "Forest" / "NPC Tradesman Inventory" section of the Level Blueprint.")

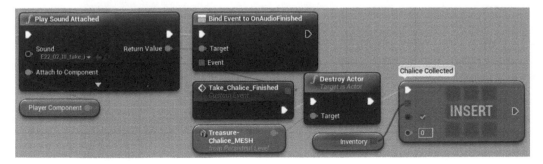

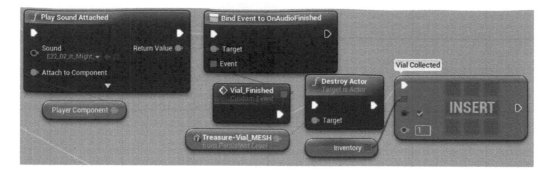

When the player comes to interact with the trader, we <Get> the contents of these indexes and use a bit of logic to determine which line to play. UE4 has a number of logic gates available to help us with these sorts of comparisons. Their exact operation can be found in the tooltip text when floating the mouse over the nodes.

Has the player picked up just one item (<XOR> will only answer True if inputs are different)?
It they have just one item, is it the chalice?
If yes—play chalice line
If no—play vial line

Do they have both items or no items (i.e., the <XOR> was False)?
If the <AND> is True they have both—play both line
If the <AND> is False they have none—play none line

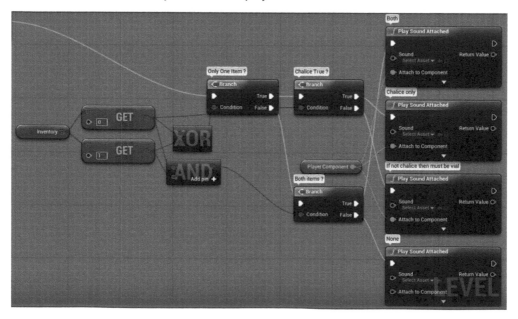

Exercise 06_05: Arrays for Tracking Dialogue Conditions

Godfrey the guard is very particular about his menu. Only if you collect all the correct items will he let you through the gate into the *Inner Sanctum*.

{Array}

1 We have set up the system to add items to an array as the player collects them. An array is a container for a number of variables (see Appendix A: Core Concepts/Variables, Parameters, Numbers, and Arrays).
2 This is stored in the array variable City_Inventory. Whether the player has the items or not is stored as Boolean variables: in index 0—apples, index 1—bananas, and index 2—dates.
3 Record the following lines (or brilliant equivalents) and set them up in separate <**Play Sound Attached**> nodes.
 a. "Apples and dates? That's greats—but you ain't coming in!"
 b. "Apples and bananas? I'll feed them to my llamas. Not enough to fill me!"
 c. "Bananas and Dates? This combo I hates! I need some apples too for the right mix."
 d. "Well, well! That's a good feast that will fill this beast. I guess you could just slip in while I'm not looking."
4 <**Get**> this Boolean array by dragging and dropping it into the ➡ **Event Graph**.
5 **Create** three <**Get**> objects to get the contents of each index of the array.
6 Set up and attach the logic system illustrated below. This tests each of the conditions and gives you a True output to connect to the appropriate dialogue line.

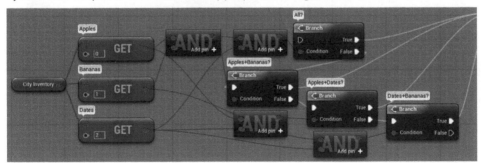

7 Connect a trigger use system around Godfrey (Character 06) and use it to trigger the top <**Branch**> node.
8 Link the output of the <**Play Sound**> you have created for when the player successfully bribes Godfrey and link it to the "Inner Sanctum Door Open" section of the Blueprint.
9 You could also set up additional <**Branch**> nodes for separate responses if the player only has one of the items.
10 Instead of having separate <**Play Sound Attached**> nodes, you could set this all up in a single Sound Cue that has a -**Switch**- node and is controlled through attaching a <**Set Int**>. The value of your int could be set to corresponding switch values by the True outputs. Try this.

Conditions to Sound Cue Branching Choices

You'll note that for each of the conditions, apart from vial only, the lines can be said in any order. For the vial we want the first line to acknowledge that the player has the vial, and then subsequent lines to be randomly picked from a selection. In order to do this, we set an additional Boolean variable that tracks whether this line has been played. The Vial_Played variable is used to set a -**Branch**- node within the Sound Cue itself via the <**Set Bool Parameter**> node. This works under the same principles as the conditions to dialogue choices above, only this time we are setting a -**Branch**- within the Sound Cue instead of using a <**Branch**> to choose between two Sound Cues. All of the above systems could be done like this. We kept them as separate <**Play Sound Attached**> nodes just to make it clearer as to what was going on.

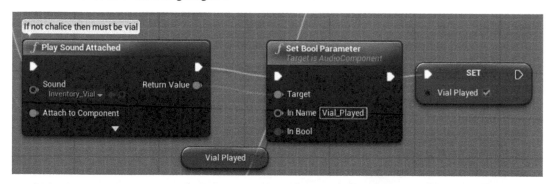

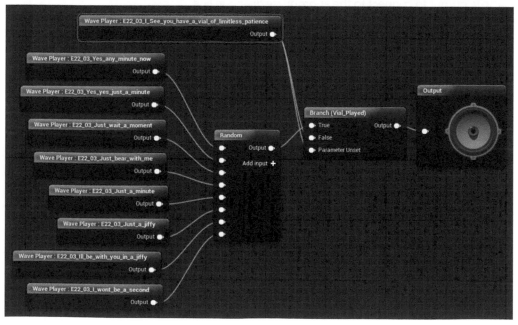

Branching Dialogue

Summary : Branching dialogue systems

From the exercise above, you might perhaps begin to see how you might apply these ideas of conditions and branches to form a branching dialogue system. A branching dialogue system is where you might be able to have a continued conversation with an NPC, with the character responding differently depending on your choice of line during each interaction. Branching dialogue is typically deeply integrated with the game's database and character systems in order to keep track of the multiple conditions that might arise.

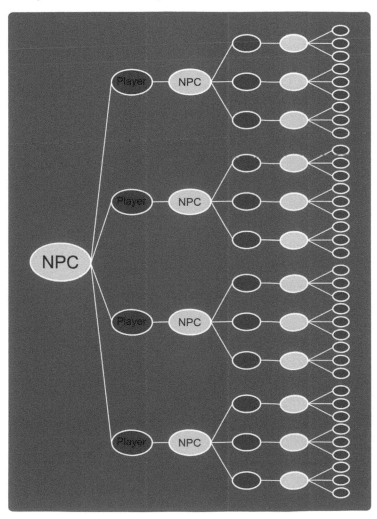

One of the essential tools for a branching dialogue system (and indeed any dialogue) is the spreadsheet, where you can easily track the route that the interactions might take.

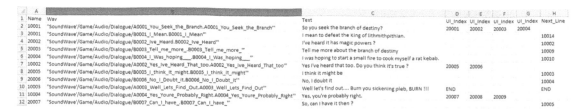

You import spreadsheets to Unreal to form data tables from which you query the contents of the rows and columns in order to populate variables for your system. Double-click on the data table {Dialogue_Branching_05} to see the data table that results from importing the spreadsheet above.

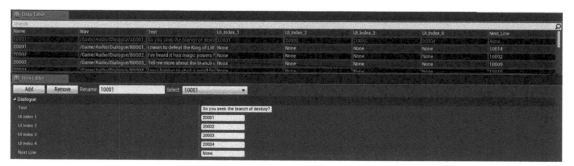

In the *Forest* area, the character on the right is an old crone—who has something you want! Play the game to see if you can persuade her to hand it over.

When the player first interacts with the crone, we play a short movement animation and then get the contents of the data table, first looking at the row defined by the variable Crone Dialogue Line. The default value of this variable is 10001, so we get the values stored in the row whose name column matches.

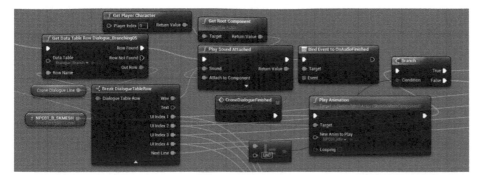

The <**Break DialogueTableRow**> separates out all the column data on that row so we can access the different variables. Not shown above is the internal name column. This defines the name of the row that allows the <**Get Data Table Row**> node to find the row to extract data from.

Wav: This is the name of the Sound Wave to be played.
Text: This is the abbreviated text used to populate the HUD buttons.
UI_Index: These point to the rows that contain the text for each HUD button.
Next_Line: This defines the next line for the NPC, depending on which line (HUD button) the player chooses.

The Wav column contains the name for the dialogue Sound Wave, and this is passed to the <**Play Sound Attached**> to play the crone's first dialogue line. The UI_Index columns define the row values where the possible player responses are stored. We look at these rows and get the string (text) to populate the HUD. At the same time we store the Next Line value from the row. If the Next Line column contains the string "END", then this means that this particular branch has come to an end, so we <**Branch**> off (True) to play an ending animation. (See the "Forest" / "Old Crone Branching" section of the Level Blueprint.)

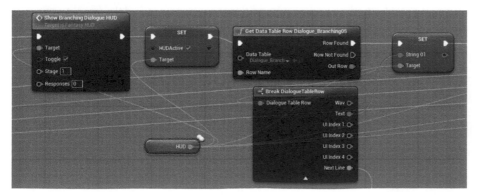

When the player clicks on the HUD, it gets and plays the wave file from the appropriate row and sends the next line value to set the next line for the crone. Then the system goes around again. This is a fairly simple branching dialogue system but should be pretty extendable to your needs once you get your head around it.

Note that in order for the data table to correctly populate, the Sound Waves must be loaded into memory or it won't find the references to them. In the *Forest* area, you'll see an ambient sound [AllDialogueSounds-ForLoading]. This references a Sound Cue that contains all of our dialogue Sound Waves. Although it's set not to Auto Activate, and so never actually plays them, this serves the function of ensuring that the data table can correctly find the references.

Exercise 06_06: Branching Dialogue

In this exercise you will experiment with swapping in your own branching dialogue for Character 07 in the *City Streets* area of the exercise map.

{Data Table}

1 Locate Character 07 in the *City Streets* area of the exercise map and interact to follow the placeholder branching dialogue system.
2 Now try replacing this with your own branching dialogue system.
3 Find the Character_07_Branching.csv file in the exercises folder.
4 Edit this with Excel (or other spreadsheet software) following the system outlined above.
5 You'll need to import your dialogue lines to the ➡Content Browser and then right-click/Copy Reference to get the full path to these files to enter into the Wav column (also be sure to add " " around the whole pathname).
6 Add all your dialogue files to a Sound Cue and place this in the level using an [Ambient Sound] Actor. Set this not to Auto-Activate in its ➡Details panel.
7 Right-click on the {Character_07_Branching} data table and select Reimport. This will replace our placeholder data table with your new one.
8 If you import your own CSV file, then make sure you use the same headings and the import options in the figure below for the system to work correctly (our template is available on the website).

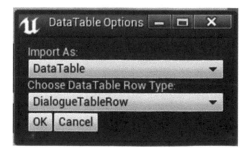

Characters, Contexts, and Dialogue Choices

As you can already imagine, handling a large amount of dialogue for lots of conditions and characters can quickly become a huge challenge. The Unreal Engine's built-in dialogue tools can help us address some aspects. The {Dialogue Voice} asset allows us to set up characteristics for each of our characters in the game:

 Neuter, masculine, feminine, or mixed
 Singular or plural

Then we can use the {Dialogue Wave} assets to set up contexts that determine which wave file is played depending on the characteristics of the two characters that are interacting. At the start of the game, the player is asked to choose their player character and is given the choices of:

Female group

Male group

Male

Female

(Note that we don't actually create the groups of characters in the Demo level—it's just for illustration!)

This defines the {Dialogue Voice} to use for the opening announcement. See the "Opening VO Dialogue" section of the Level Blueprint. (In the demo level the character choice does not actually alter the dialogue for gender but you could set up conditional bools within Sound Cues as discussed above.)

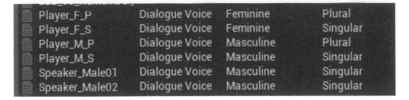

Player_F_P	Dialogue Voice	Feminine	Plural
Player_F_S	Dialogue Voice	Feminine	Singular
Player_M_P	Dialogue Voice	Masculine	Plural
Player_M_S	Dialogue Voice	Masculine	Singular
Speaker_Male01	Dialogue Voice	Masculine	Singular
Speaker_Male02	Dialogue Voice	Masculine	Singular

So if the speaker (defined by its {Dialogue Voice} as being neuter/singular) is speaking to male/singular, it will use the line {E_22_InaWorld_Prince}, and if female/singular, the line {E_22_InaWorld_Princess} will be chosen.

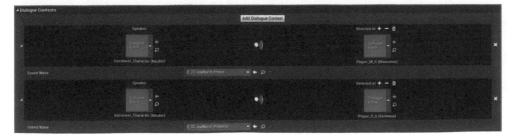

"In a world gone to hell, a **lone iron born warrior prince** must forge his destiny."

"In a world gone to hell, a **lone iron born warrior princess** must forge her destiny."

"In a world gone to hell, a ragtag **band of iron born warrior princes** must forge their destiny."

"In a world gone to hell a ragtag **band of iron born warrior princesses** must forge their destiny."

In this instance the speaker remains the same, but you could also vary the speaker (e.g., Guard_01 or Guard_02) so that the same line actually plays back different versions depending on who is speaking.

We've set up a variable for each player character type in the [**Level Blueprint**] (Player_F_S, Player_M_S, etc.) These have been created as array variables since this is required by the <**Make Dialogue Context**> node. As each menu choice is made, the character type is combined with the speaker in the <**Make Dialogue Context**> node, which is then referenced by the <**Play Dialogue Attached**>.

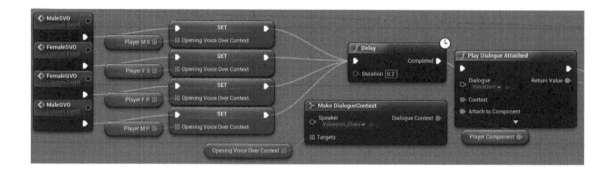

The variable Opening_Voice_Over_Context is also referred to by our inventory dialogue system to choose either the line "Remember son, nobody likes a smartass" or "Remember lass, nobody likes a smartass."

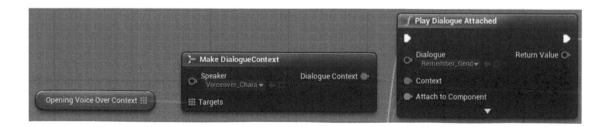

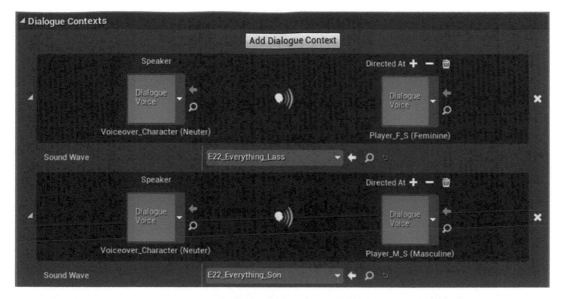

Although this may seem quite convoluted to set up, once you have grasped the concepts It provides a system with great potential to make your dialogue more context and character aware.

Exercise 06_07: Dialogue Contexts

When the player enters the "Inner Sanctum" area, the cry goes up "She's here!" or "He's here!" or "They're here!" (note that it might not be quite the welcome you're expecting!) The choice of phrase will depend upon the character type you choose using keyboard commands (F for female solo, M for male solo, or G for group).

{Dialogue Voice}, {Dialogue Wave}, <Make Dialogue Context>

1 On the steps up to the *Inner Sanctum* a triggered menu offers the player the choice to define their character type. Use this to define the choice of phrase that the crowd uses on entry to the Inner sanctum.
2 Create the following {Dialogue Voice} assets in the ➡Content Browser.
 a. {Guard}: gender—masculine, plurality—singular
 b. {Female} character: gender—feminine, plurality—singular
 c. {Male} character: gender—masculine, plurality—singular
 d. {Group} of characters: gender—mixed, plurality—plural
3 Create a {Dialogue Wave} asset in the ➡Content Browser. Double-click to open its ➡Generic Asset Editor. Add Dialogue Contexts (the button at the top) to create:
 a.Speaker: guard, Directed at: female

 b. Speaker: guard, Directed at: male

 c. Speaker: guard, Directed at: group

 4 Use the arrow on the left to expand each dialogue context and add your Sound Waves to the appropriate context:

 a. Speaker: guard, Directed at: female—"She's here!"

 b. Speaker: guard, Directed at: male—"He's here!"

 c. Speaker: guard, Directed at: group—"They're here!"

 5 Create 4 Dialogue Voice variables in the ➡ **My Blueprint** panel of the [**Level Blueprint**] (+).

 a. Female

 b. Male

 c. Group

 d. Player_Type

 6 Add the relevant dialogue voice assets to the appropriate variables as defaults.

 7 Go to the "Inner Sanctum Dialogue" section of the [**Level Blueprint**] and assign your {**Dialogue Wave**} to the <**Play Dialogue Attached**> node.

 8 <**Get**> your Player variable and assign it to the Target of the <**Make Dialogue Context**> node. Also assign the {**Guard**} variable as the speaker. (This will create a <**Make Array**> node in between)

 9 Drag and drop your Player_Type variable into the event graph to create the <**Set**> nodes. Leading from the <**Switch On Name**> node attach these <**Set**> nodes and assign the appropriate Dialogue Voice variable. Attach the output exec of each of these to the existing <**Set**> node for the character choice.

10 Don't forget that there are screenshots of all the completed exercise systems on the website to download if you get stuck!

Localization or Localisation?

Once you have got your script with all 30,000 lines worked out, it might dawn on you that most of the world does not actually speak English. The nine foreign language versions need their dialogue localized (if you're lucky it will just be French, Italian, German, and Spanish). Localization can be a huge job requiring very specific skills, which is why many outsourcing companies have sprung up to provide this service. These recording, editing, and organizational skills generally fall outside of the implementation remit of this book; however, the following are principles with which you should become familiar.

For the in-game cutscenes or FMVs (full motion videos), the foreign language dialogue will need to sync to the existing English language animations. It would cost too much to re-animate to match the timing of the new language. Many foreign language voice actors are very experienced in dubbing for films and so are expert at matching the rhythm and flow of the visuals to the new lines, but as you will appreciate, particularly with close ups on the face, this is difficult. You can use the English recordings

as a template for time reference so that the local actors can attempt to approximate the same timing. Given that some languages will require considerably more words or syllables to communicate the same sentence, this is never going to be ideal, particularly if your English performance is fast (meaning that your German version will be supersonic!) The new language files also need to match the exact length of the existing English language assets so that the overall file size does not differ.

The good news is that you may not need to replace the non-word-based vocals such as screams and expressions of pain, although we believe in some regions "Aiieee!" is more popular than "Arrgghhh!"

Localization is a specialist area that we do not have space to really go into here, but if nothing else it serves again to highlight the meticulous approach to organization and management required by dialogue in games.

Conclusion

It is often useful to be able to generate dialogue lines for prototyping the system before you go to record. An ideal way to do this would be to use a speech synthesizer to read through your spreadsheet and automatically churn out the lines, correctly named of course, as waves. We have built such a system for you! Download it from the website.

For further reading please see the up-to-date list of books and links on the book website.

Recap:

After working through this chapter you should now be able to:

- Use timed and triggered dialogue for advice;
- Handle dialogue interrupt by fading, blocking, or ducking;
- Use conditions, counts, and arrays for dialogue choices;
- Use dialogue contexts to play different lines depending on the speaker/listener.

Making It Real 07

Summary : Nested reverbs and prioritization, distance falloff algorithms, occlusion effects, moving sounds and sounds for moving systems, physics-based audio, sound for animations, cameras and the listener position

Project : DemoCh07Warfare01 **Level :** Warfare01

Introduction

Many game environments are imitations or at least hyperreal versions of environments that might be found in the real world. Therefore a player will have pretty clear expectations of what they might sound like, having experienced them in some form before. Even if the game is set in a fantasy world, we will still have expectations about the way sound will behave that have been developed through our lifetime of experience in the physical world. Although we shouldn't necessarily always focus on realism (see Chapter 08), the soundscape needs to be consistent and believable in order to support the verisimilitude (the appearance or semblance of truth or reality) of the experience.

You can skip between areas of the level in game by using the keys 1–9.

Sound Propagation

Summary : Nested Reverbs, spatialization, revealing detail over distance, ambient zones for occlusion, obstruction and exclusion

The way sound travels through air (and other substances) and reflects around an environment is generally approximated and fudged in various ways for games. This is in part due to the unrealistic dimensions in game worlds, but mostly due to the massive resources it would take to calculate it accurately in real time.

Reverb: Advanced

We looked briefly at adding {Reverb Effects} to areas of the game through the [Audio Volumes] in Chapter 01, but we will now return to look at a few more advanced techniques.

Sound emanates from a source and travels through matter in waves. Your ears either receive the sound directly (dry) or indirectly (wet) after it has bounced off the various materials it comes into contact with. We refer to this as reverb (short for reverberation). Typically you'd receive both these types of sound, and this gives you important audio-based information about the environment you are in. Non-technical people

might sometimes use the word echo to describe this effect, but unlike an echo, which is a distinct separate version of the sound being reflected, reverberation is a much more dense collection of reflections.

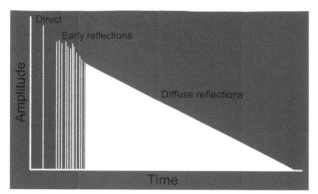

You can create and edit your own reverb effects in the ➡ **Content Browser**. If there don't happen to be any preset {Reverb Effects} in your game already, you can change the View Options (bottom right) of the ➡ **Content Browser** to Show Engine Content and see some in the engine content folder you can use (enabling this will also allow you to choose these {Reverb Effects} from the drop down menu of the [**Audio Volume**]). Double-click the {Reverb Effect} to open the ➡ **Generic Asset Editor** and see the pop-up tips for an explanation of each parameter.

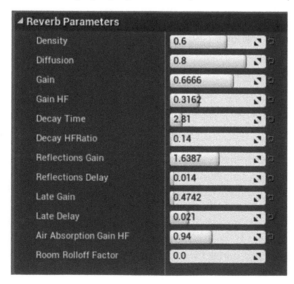

Constructing a reverb that sounds good is a hugely complex task in itself. Trying to model the way sound would actually reflect around a specific space in a game would require a significant amount of computing power, so in most games we usually use these kinds of precalculated reverb effects to apply to sounds in a given area.

As you'll remember from Chapter 01, reverb is controlled using [**AudioVolume**]s in the game level (you can also apply reverb as an effect via the <**Activate Reverb Effect**> node in the [**Level Blueprint**]). With these you can set the reverb effect, the volume of the reverb effect, and the amount of time it takes to be applied once the player enters the [**AudioVolume**]. This fade time is important since a sudden change between the reverb of two rooms can sound unnatural and jarring.

Nested Reverbs and Prioritization

When you start the level you are in the *Sewer Pipe* (Bookmark 1), which leads into a basement room in a bank. From here you can make your way up across the debris into the bank lobby.

The sewer pipe and basement room are straightforward [**AudioVolume**]s, but the lobby and back room in the lobby are more problematic. We could make a series of volumes, but the main L-shape of the lobby is clearly the same space, and the crossover of the [**AudioVolume**]s could lead to some audio artifacts.

Sometimes it is useful to enter geometry edit mode (Shift + 5, and then Shift + 1 to return to place mode) to see the [**AudioVolume**]s more clearly, and we can use this mode to edit the shape of the volumes to better suit the environment (hold shift while selecting a corner of the volume to move it). You can also choose different brush shapes as starting points when creating your reverbs.

In this case (as is often the case), the lobby room sits within (or is nested within) the larger volume that covers the whole of the ground floor of the bank, and so another thing we can do is to set its Priority to override the large one that it sits within.

The audio volume [Small_Back_Room] of the lobby has a priority setting of 3.0 (in its ➡Details panel) whereas the main lobby [Lobby] Audio Volume has a priority of 2.0.

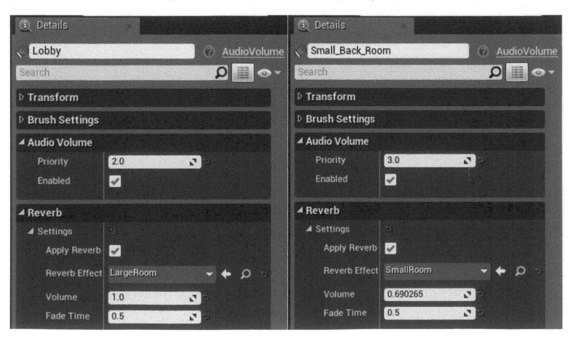

In fact the reverbs of both of these large rooms and the smaller back room actually already sit within a larger reverb that covers the entire street. There's a hierarchy of priorities: street reverb priority 1.0, lobby reverb priority 2.0, and small back room reverb priority 3.0.

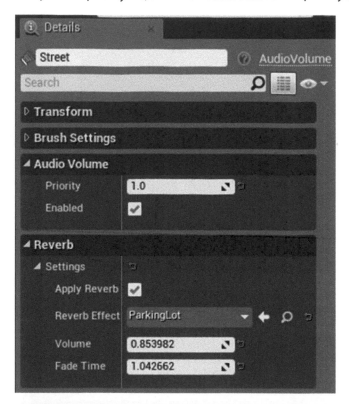

In order to more clearly hear the effect your reverb settings have, you can use a Console command when playing the game. Go to Bookmark 1 and start the game from the *Sewer Pipe*. Call up the Console with the ¬ (PC) or ~ (Mac) key and type "IsolateReverb" (type "ResetSoundState" to turn this

off). This removes the dry audio to isolate the reverb (you can also type "IsolateDryAudio" to remove the reverb to isolate the dry audio). Now play through this area up to the street and listen to the reverb changes. You can also see which reverb effect is currently active by using the Console command "Stat Reverb" (see Appendix A: Core Concepts/Console Commands for more on Console commands).

Exercise 07_01: Nested Reverbs

In this exercise we will implement a nested Reverb system for *Cave 01* of the exercise map.

Reverb prioritization

1 If you didn't do so already in Chapter 01, create a large [Audio Volume] that encompasses *Cave 01*. From the ➡Modes panel find the [Audio Volume] and drag and drop it into the level. Use the move/scale/rotate widgets (Spacebar to cycle) to position and resize it appropriately. Assign a {Reverb Effect} to it and set its Priority to be 1.0.
2 Now create another [Audio Volume] for the smaller cave area in the corner of *Cave 01–Side Cave*. Again apply a {Reverb Effect}, but this time one more appropriate for this smaller space. Set its Priority to be 2.0.
3 Rebuild the level geometry to hear the effects of the reverb volumes from the ➡Toolbar /Build/ Build Geometry.
4 Play the game and you should hear the appropriate reverb effects when inside the larger and smaller caves. Even though the smaller cave sits within the larger [Reverb Volume], its Priority setting means that it will override the larger volume. Check the active reverbs while playing by using the Console command "Stat Reverb".
5 Remember that in order for sounds to be affected by reverb, they must belong to a Sound Class that has the Reverb option ticked. See Chapter 08 for more on Sound Classes.

Reverb: Prebake

Sometimes you'll want greater control over the quality of the reverb applied since real time reverb isn't always the best quality. You can prebake your reverbs into the sounds and then use volumes to decide which sample to play or layer to apply. We'll go into more detail on this when looking at weapons in Chapter 09.

Spatialization

Sound spatialization in-game is literally a matter of life and death. The field of view for a typical first person shooter is between 65 and 85 degrees, so the majority of things in the world are actually off-screen. Sound plays a vital role in describing this off-screen space for the player and providing

information about the direction and source of other characters or objects in the game. Sound sources might be stereo, mono, or multichannel. They might originate from a single point source or come from a large area. Deciding what is appropriate for each sound and faking the physics of how sound behaves in the natural world is an important task in building a convincing and effective audio environment.

Unlike some types of music and stereo ambiences, the majority of sounds within the kind of 3D game environment we've been dealing with emanate from specific points within the 3D world. We provide mono assets, and the game system uses the position of these to decide how to pan the sound depending on your playback system. If you have a 5.1 or 7.1 speaker setup, then you will hear the sound come from all directions as you rotate around in the game world. If you have a stereo setup, then this information needs to be folded down into a meaningful stereo panning arrangement. Some engines and sound cards also implement HRTF systems for headphone listening. HRTF stands for head-related transfer function and attempts to describe the spatialization cues we get from the way that sounds reaching our ears arrive at slightly different times and are filtered and attenuated by the presence of our head. By applying the same changes to the left and right versions of a sound reaching our ears through headphones, a convincing recreation of a sense of location for the sound can sometimes be achieved (as our heads are all different sizes, the effect is based on an average and so not as successful as it could be).

Sound Source Types

Mono

Generally used for spatialized point sources such as the diesel generator in the street outside the bank.

Stereo

These sources play back directly to the player's ears and are not spatialized in the game world. They are typically used for music (such as the music stinger that plays as you exit the bank, or for distant ambient backgrounds (Area Loops from Chapter 01)).

Multichannel Audio: Quad, 5.1, and 7.1

Multichannel sound sources are sometimes used for music but are increasingly becoming the norm for long ambient area loops. Quad, or 4-channel, loops are common since they leave the center speaker free for dialogue.

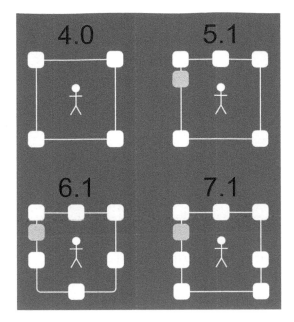

By using a specific naming convention, you can import multichannel files into a multichannel asset to use in the game. In the *Warehouse* (Bookmark 3) at the end of the street, there are two quad files: a warehouse ambience on the ground floor ([Quad-Warehouse]) and a quad music file on the first floor ([Quad-Music]).

Since both of these are quad, the source files were renamed according to the convention below:

Front-left:	Factory_Amb_fl.wav
Front-right:	Factory_Amb_fr.wav
Side-left:	Factory_Amb_sl.wav
Side-right:	Factory_Amb_sr.wav

	Filename Extension	4	5.1	6.1	7.1
FrontLeft	_fl	✓	✓	✓	✓
FrontRight	_fr	✓	✓	✓	✓
FrontCentre	_fc		✓	✓	✓
LowFrequency	_lf		✓	✓	✓
SideLeft	_sl	✓	✓	✓	✓
SideRight	_sr	✓	✓	✓	✓
BackLeft	_bl			✓	✓
BackRight	_br				✓

All these multichannel files play back directly to the speakers and so do not spatialize, which is what you'd generally want for looping ambiences or music.

There may be specific circumstances where you want to use a multichannel file for sources that are located in game (for example if you had a group of musicians or musical sources in game). You could of course simply implement these as separate ambient sounds, but then they would not be in sync. On the roof of the warehouse is an example using our <GAB_Quad_Sounds> macro. (You can press 'T' to toggle the background ambience off/on.)

Four [Notes] have been created that are used for the location of each sound (which now need to be imported as separate mono files). By using the <GAB_Quad_Sounds> (from the right-click ➡ Graph Action Menu), you can assign 4 targets for the sounds and define their falloff distances. Once you trigger the node to start (when the player enters the area), the sounds will be spatially located but will stay in sync. This macro is installed here when you install the levels:

PC: C:\Program Files\Epic Games\Engine Version\Engine\Content\GAB_Resources
Mac: /Users/Shared/Epic Games/Engine Version/ Engine/ Content/GAB_Resources

In order to spatialize the Sound Waves must have an {Attenuation} defined with its *Spatialize* checked. You can assign an {Attenuation} through the Sound Wave's ➡ Generic Asset Editor.

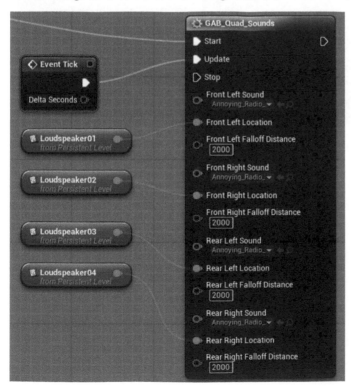

Directional and Diffuse Sources

Directional Sources

Although we've looked at the spatialized properties of mono sounds in the game, sounds often have a particular direction in which they are loudest/unfiltered rather than simply attenuating evenly in all directions from a central point. Many sound sources have a front where the sound is clear and back where the sound may be attenuated or filtered. Think of your voice, for example, or a megaphone. Using these controls can greatly support the reality of your soundscape.

In the street outside the bank, there is a public address system spouting propaganda (Bookmark 2). As you move around it, you can hear that this source is directional since the [Ambient Sound] is using a Cone attenuation shape.

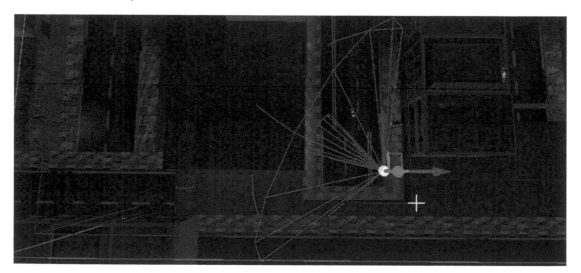

Within the inside cone the sound is at its maximum volume, then it attenuates to 0.0 at the outer cone position.

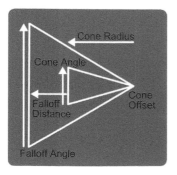

Diffuse Sources

In some cases a sound source will not come from a very specific point but from a larger source of sound, for example a large piece of machinery or a waterfall. In these cases you would then want to spatialize the sound when heard from quite a distance, but as you get closer you want the sounds to be more enveloping and the panning of the sound as a point source begins to sound wrong.

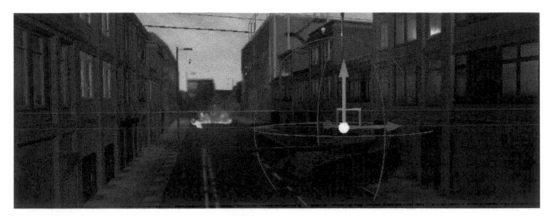

For the Tank 01 [**Tank_Diesel**] in the street, we've made use of the non-spatialized radius function of the ambient sound's attenuation settings. When the player is within this radius, the sound will no longer pan. This feels a lot more convincing for larger sound sources.

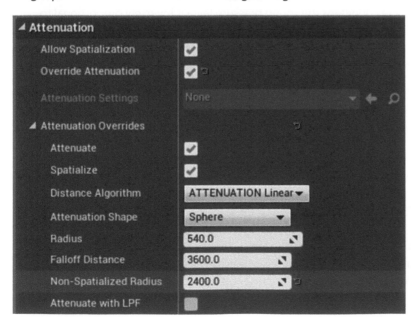

Exercise 07_02: Quad, Directional, and Diffuse Sound Sources

In this exercise we are going to explore adding sound with different source and spatialization properties to your exercise level.

1 Try the following:
 a. Add a quad ambience as an area loop to one of the areas of your level. There are two ambiences (cave and oasis) supplied in the exercise folder.
 b. These are set up already with the correct file naming convention, and so when you import them they will form a single quad Sound Wave asset that you can treat in the same way you would when setting up a normal area loop.
 c. If you want to import your own quad assets, then be sure to follow the naming convention outlined above.
 d. Try using the Cone attenuation shape on an [Ambient Sound] for some more directional sound sources.
 e. Add an [Ambient Sound] that uses a non-spatialized radius. For example you could edit one of the music sources in the *Mountain Village* area so that when you approached the house, the music would become less directional and pan less wildly.

Distance Attenuation and Detail over Distance

You may be asking yourself at this point why we don't simply replicate the way sound attenuates in air. We know that in normal outside conditions the sound pressure level is inversely proportional to the square of the distance from the sound source. In audio terms a basic rule of thumb is that sounds halve in volume (approximately 6dB) for every doubling of distance from the sound source. 'Normal' conditions are actually very rare, and the way sound attenuates is also affected by air pressure, temperature, and humidity.

In addition to the numerous aesthetic reasons why we might not want to have a "realistic" approach, there are a number of factors that impact on why this doesn't work for games:

- The recording, storage, and playback of sound cannot replicate the dynamic range of the physical world. Typically we record and store sound in 16-bit format. The range of numbers this allows for does not come anywhere near being able to represent the huge dynamic range of the physical world (the oft quoted comparison being the difference between a pin drop and a jet engine).
- Game distances are not the same as real world distances. Partly because operating a game character is a lot more clumsy than you might think, so they need additional space to avoid getting stuck in furniture all the time, and partly because this would make many games an endlessly boring trudge.

- If we were to imitate the natural attenuation curve of sound, then we would have a lot of very quiet, very distant sounds playing almost all the time, as the falloff distance would be very large. This would have negative implications both for the mix (the addition of all these quiet sounds would add up to take up headroom, a significant chunk of our available 65,536 numbers at 16 bits) and for the number of voices (simultaneous sounds) it uses, which is quite limited (as we'll discuss below in the section Prioritization: Number of Voices Control).

Most audio engines provide you with a range of options to tweak by hand how the sound will attenuate over distance for each source. When deciding which attenuation curve, or distance algorithm, to use for which sound, there is no substitute for actually previewing it in the game engine itself. Depending on the nature of the sound source and the specifics of what's going on at the time, you may find it more appropriate to use your ears rather than the starting points outlined below. The following distance algorithms in the Unreal Engine are used to determine how the sound is attenuated from the inner radius to the outer falloff distance.

Attenuation Linear

This is useful for area loops since it's highly predictable and straightforward to evenly crossfade between areas. The combination of two overlapping sounds dropping off to their Falloff Distance should produce a result that does not significantly drop in volume as you pass across the two, as the addition of the two always produces an equal value.

Attenuation Logarithmic

This is good for sounds that you only want to hear within a relatively short distance from their source. Depending on the exact circumstances, this may be good for enemy weapon sounds where you have multiple enemies within a relatively small area. The curve will give you a precise idea of the position of the sound source without allowing sounds to be heard too far from the source, which might muddy the mix.

Attenuation Inverse

As you can see, this can be heard from a significant distance away, but the amplitude only really ramps up when very close. This is good for very loud and distant objects. They will feel really loud up close and be heard from a distance as you would expect, but won't completely dominate the mix as they might otherwise do.

Attenuation Log Reverse

These sounds will be loud right up to their Radius Max and then suddenly drop off. Good for stopping sounds up against walls when other solutions are not practical.

Attenuation Natural Sound

This is an attempt at a more realistic attenuation curve that may be appropriate for certain sounds, particularly those with lots of high frequency content.

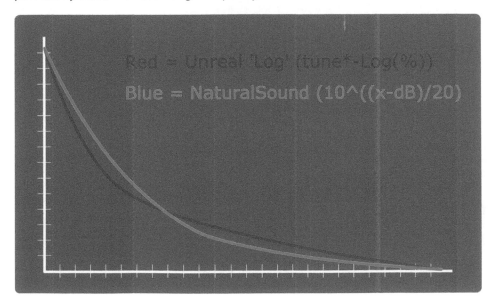

Filter over Distance

Applying a low-pass filter over distance is very effective for creating a sense of distance, making sounds appear far away or close by through an imitation of the way that high frequency elements of sound are absorbed by air over distance (although obviously in reality it is a lot more complicated than this!) We already looked at implementing this filter over distance in Chapter 01, but you can hear another example of this effect here by listening to the fire blazing around the Tank 02 [Tank_02_Detail_Distance].

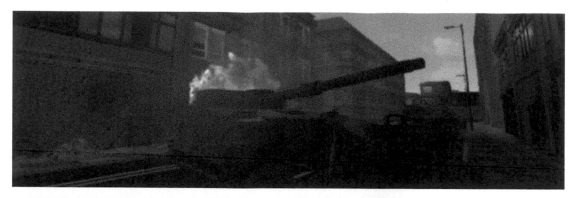

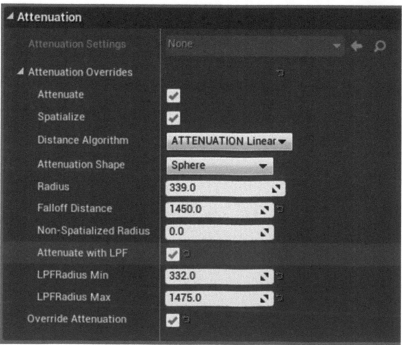

In some other game engines, you may need to fake the way that sound is filtered by the air over distance. You might do this by applying filtering in your DAW and then crossfading between the normal (dry) sound and the filtered (wet) one over distance using different attenuation settings for each Sound Wave in your Sound Cue. If you were going to get slightly obsessive about it, you could even have different versions of Sound Cues (using the same Sound Wave but with different low-pass filter settings) played depending on atmospheric conditions such as hot sunshine or dense fog (you can dynamically adjust the attenuation settings of an [Ambient Sound] by using the <Adjust Attenuation> node in a Blueprint).

Detail over Distance

While effective, the application of a simple low-pass filter over distance does not really capture the subtleties of how the different sound elements of some sources attenuate over distance. You can add a lot of depth and character to your objects in the game by applying different attenuations over distance to the different elements of the sound. You may have noticed in the above example that the attenuation settings for the fire are not defined in the ambient sound itself. They are actually defined by an -Attenuation- node in the Sound Cue {Tank_02_Detail_Distance}.

In addition to this, there are the three other layers that make up the complete tank source sound, each part of which has a different attenuation setting so that as the player approaches the vehicle, more details of the sound are revealed. Typically you'd be adding smaller, higher frequency elements the closer you get to the source. This approach is also good for weapons, although we need to implement it in a slightly different way—see Chapter 09.

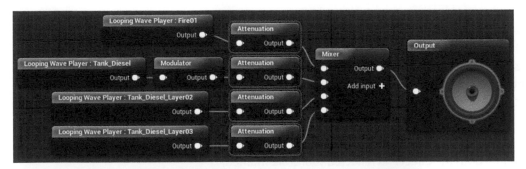

245

In theory you could use the -**Crossfade by Distance**- node in the Sound Cue for this, but since this, at the time of writing, actually retriggers the sounds as you cross the cut-off points, it is only really useful for short one-shot sounds, not loops, and even then you need to use with caution!

Exercise 07_03: Distance Algorithms, Filter, and Detail over Distance

In this exercise we will use a Sound Cue that contains Sound Waves with different attenuation settings in order to reveal further details of the sound source as you get closer.

1 In the center of the final *Inner Sanctum* area of the exercise level is a blazing *Fire Pit*. Create an [Ambient Sound] in the center of the fire.
2 Create a Sound Cue that contains several Sound Waves, each with their own -**Attenuation**- nodes leading to the -**Mixer**-.
3 Set up the Distance Algorithm, Radius, and Falloff Distance for each so that as the player approaches the pit, different details of the fire sound are revealed (for example, layering up low rumble, low crackling, high crackling, and hiss sounds).
4 Add further detail to your level by applying this idea elsewhere as well.

Occlusion, Obstruction, and Exclusions

We've looked at how sound describes the characteristics of a space as it is reflected around (reverb) and how the effect of sound traveling through air (attenuation and filtering) gives a sense of distance and localization. Other aspects of the acoustics of sound we have to engage with when designing and implementing sound for games are occlusion, obstruction, and exclusion. By default many engines do not take account of walls/windows to apply the natural changes in volume and filtering that would occur within the real world:

Occlusion—both the direct and reflected sound are muffled;
Obstruction—only the direct sound is muffled;
Exclusion—only the reflected sound is muffled.

Occlusion

When we enter the *Offices and Factory* (Bookmark 4) building at the end of the street, we would naturally expect the outside sounds to be attenuated and filtered as these sounds are occluded by the brick walls.

The extent to which the sound is attenuated in volume and altered in frequency content will be dependent on the material of the obstacle. Brick has a pretty significant effect as you can imagine, whereas if the sound were occluded by the paper walls of a traditional Japanese house, the effect would be rather different. As an illustration of the problem, consider a city block in the rain. With no occlusion implemented, you would hear the rain sound inside all the buildings.

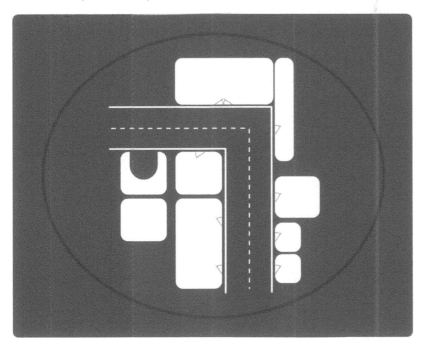

If you carefully placed a number of rain instances using ambient sounds, you might be able to arrange these so that they were only heard outside, but this would be quite a lot of work and also would be liable to phasing issues as multiple instances of the same sound overlapped.

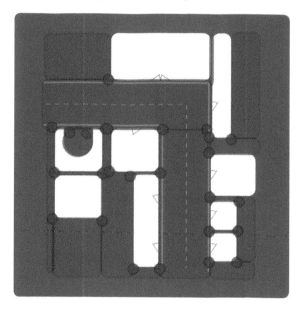

We would also have the same issue of ambient sounds overlapping into areas they should not be in terms of the different vertical floors of a building.

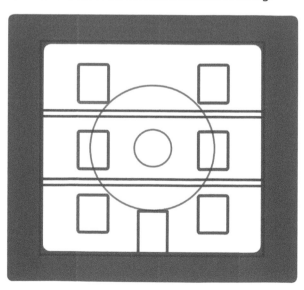

Toggle for Occlusion

The way we've dealt with this up until now has been to either carefully construct our ambient sounds' Falloff Distances or to toggle on or off the inside and outside ambience with [Trigger]s as we cross a threshold.

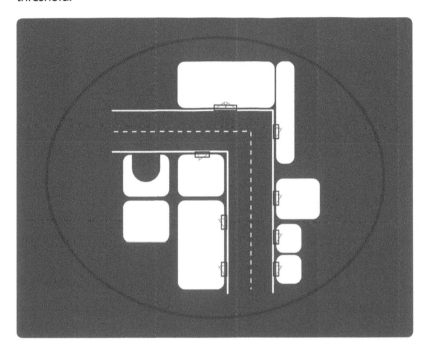

We have seen this triggered switching approach in Chapter 01 but have included another example here. As we enter the office ground floor, a [Box Trigger] toggles off the outside ambient sounds and switches on the sounds inside the lobby.

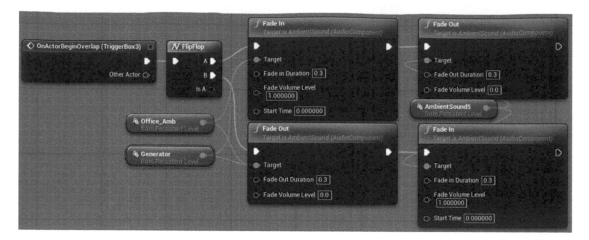

Of course there are a number of drawbacks with this approach:

- Unless you're going to make your own filtered/attenuated versions of the inside and outside sounds, then you will either hear only the inside ones or only the outside ones, which is not very realistic. This can be fine for some environments where due to the noise levels, or the degree of occlusion, you wouldn't hear these anyway.
- If the player is quickly entering and exiting rooms, then they can become aware of this trickery and this can affect their immersion in the game.
- The nature of a switch is that it is either one or the other—there is no midpoint. So a player hovering in the doorway is going to have a pretty odd experience of constantly switching between the two states.

Many modern game audio engines use what is called ray tracing for detecting occlusion. A simple path is traced between the sound emitters and the listener. If any geometry or objects interrupt this path, then a filtered version of the sound is played (either by filtering in real time or by playing a prerendered filtered version of the sound). Other engines, such as the Unreal Engine, require us to define the geometry for them.

Ambient Zones

It is often the case that the game engine does not have any awareness of the positions of walls in regard to occluding sound, so even if you do have a built-in occlusion system, you will have to do some work to define rooms for this system to work. The Unreal Engine provides a system for occlusion called Ambient Zones, a functionality available as a subsection within the [Audio Volume]s that we've already come across. In the case of our city block rain example, we could box out the buildings with ambient zones so that the rain was no longer heard inside.

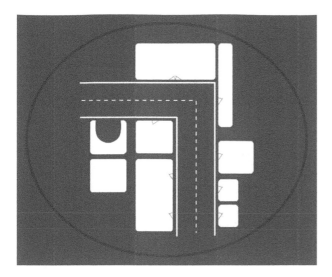

An important note to remember is that the effects of the ambient zones will only be heard if the sounds belong to a Sound Class that has Apply Ambient Volumes enabled.

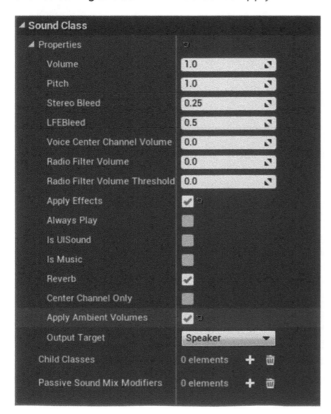

In this level the affected sounds are set to belong to the {Ambient} Sound Class (in the ➡Details panel of a Sound Wave or through the -Output- node of a Sound Cue). We will be looking at Sound Classes in more detail in the next chapter.

The settings of the ambient zones work as follows:

Interior Volume
The volume of things inside when heard from the outside

Interior LPF
The amount of filtering to apply to things inside when heard from the outside

Exterior volume
The volume of things outside when heard from the inside

Exterior LPF
The amount of filtering to apply to things outside when heard from the inside

The first room on the left (*Room 01*) has an [Audio Volume] around it with its ambient zone set to attenuate any sounds outside of the room by 0.5. As you enter this room, you can hear the generator in the main lobby getting quieter as the zone's Exterior Volume is set to 0.5. (Given the toggling of exterior ambience method we used when first entering the building you will need to start outside the building (Bookmark '4') in order to accurately preview all of the following Ambient Zone examples on the ground floor.)

Prioritization of Zones

Like the reverb, [Ambient Zone]s also have a priority system so you can nest zones inside one another. In *Room 02* there is an [Ambient Zone] for the room, and then another smaller [Ambient Zone] for the inner vault room. The inner vault has a higher priority, and so it will override the general room zone when you enter it (it is also set to attenuate the outside sounds further as you might expect).

Internal and External Sounds

Room 03 has some music playing inside. You can just hear this outside well, as the zone's interior volume is set to 0.2.

Filtering

Room 04 has a window looking onto the lobby, and this room has two zones in it. When you are by the window, the outside sounds are filtered less than when you are hearing them through the wall.

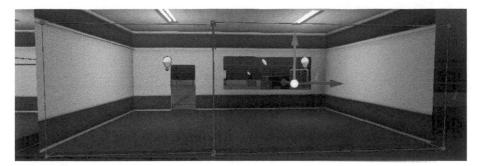

Obstructions and Exclusions

In addition to occlusion (where both the direct and reflected sounds are blocked), we must also consider two other scenarios. Obstructions are where there is an obstacle between the listener and the sound object, but the reflected sound emanating from the object and bouncing off the walls still reaches the listener. This obviously has a different sound from when all the sounds are on the other side of a wall for instance.

In this instance pillars are obviously blocking the direct path of the sound, so an [Ambient Zone] is created behind the wall with a filter applied to exterior sounds. This produces a very rough approximation of an obstruction effect.

Exclusions are where the sound reaches the listener directly from the sound source, but the reflections hit the obstacle. This would be typical of a sound and listener lined up through a doorway for example. You can hear this as you enter the elevator lobby at the back of the room.

Dynamic Occlusion

Having destructible buildings is quite common in games, and obviously when the geometry and nature of a space changes like this, we need to update the reverb and occlusion settings. In the room to the left of the elevator lobby is a button that you can use to blow up the outer wall—which is fun!

We could simply create a reference to the [Audio Volume] in the [Level Blueprint] to disable it using the <Set Enabled> node (shown top right in the image below, but unused), but a better approach is to give it some new settings for both its reverb and ambient zone properties. In the "Destructible Wall" section of the [Level Blueprint], you can see this in action.

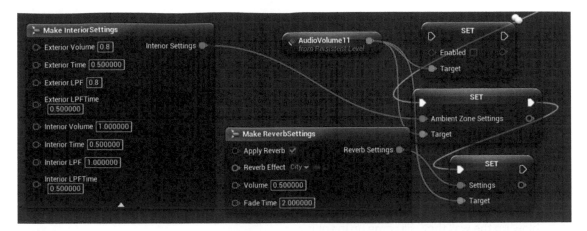

When the game starts, the audio volume has a {BunkerHall} reverb setting, and its ambient zones settings are set to attenuate any exterior sounds to 0.05 (since they are outside of this brick building). When the player uses the button to explode the wall, the ambient zone settings are changed to 0.8 (since now the external sounds will be heard through the hole in the wall). The reverberant nature of the space will also change with this wall missing, so we have applied a different reverb setting: {City}.

The elevators nearby also apply a similar system to change the occlusion operating when you are inside the elevator depending on whether the doors are open or closed.

Exercise 07_04: Occlusions and Dynamic Ambient Zones

In this exercise we are going to apply ambient zones to the *Cave Tunnel* area of the exercise map.

Ambient zones, <Make Interior Settings>

1 Go to the *Cave 02 Upper* area of the exercise map and create an [Audio Volume] (from the ➡Modes panel).

2 Use the move/scale/rotate widgets to make the [Audio Volume] encompass this upper part of the cave, ending up against the rock wall that you created the explosion sounds for in Exercise 02_04.

3 Add a {Reverb Effect} to the [Audio Volume] and set its Exterior Volume to 0.2. This means that when you are on the *Cave 02 Upper* side of the rock wall, you won't hear the fans and ventilation shaft sounds that are in the *Cave Tunnel*.

4 Select the Sound Waves or Sound Cues you used for the fans and vent shafts and make sure they are assigned to the {Ambient} SoundClass. Do this through the ➡Generic Asset Editor for Sound Waves and in the ➡Details panel of the -Output- node for Sound Cues.

5 Rebuild the level geometry from the ➡**Toolbar**/Build/Level Geometry.

6 Go and stand next to the rock wall. You should hear the fans and ventilation shafts, but only very quietly.

7 When the player explodes the rock wall, we want to change the ambient zone settings of the [**Audio Volume**] since the wall that was occluding the sounds is no longer there!

8 With the [**Audio Volume**] selected in the ➡**Viewport**, right-click in the [**Level Blueprint**] near to the **Cave Tunnel/Blockage 01** section and Create a Reference to—.

9 Drag out from this and create a <**Set Ambient Node Settings**> node. Trigger this from the <**Play Sound**> that plays the explosion Sound Cue you created in Exercise 02_04.

10 Drag out from the Ambient Zone Settings input to create a <**Make Interior Settings**> node.

11 Change the Interior Volume properties of this to 1.0.

12 Play the game again. You should hear the tunnel sounds initially occluded, then when you blow up the wall they will come up in volume.

Moving Objects and Moving Sounds

Summary: Sounds that move and sounds for objects that move using Matinee.

Whether the source is visible or not, making sounds move creates a more realistic and believable audio environment.

Sounds That Move

Take the elevator to the *Rooftop: Offices and Factory* building (Bookmark 6). As you step out, you will notice some flies buzzing around the trash. Listening in stereo, or even better on a surround setup, you'll notice that the sound of the flies is actually moving around you.

Moving Sound Sources with Matinee

Matinee is the system in the Unreal Engine for getting things to move, and in this case we've just created a flies Sound Cue and then used a Matinee to animate its movement. If you select the Matinee Actor that's near to the trash [**Flies**] and open it (Open Matinee in the ➡**Details** panel), you can see the ➡**Matinee Editor**. The sound's movement is animated by setting up a number of keys. These are the locations for the ambient sound at different points in time.

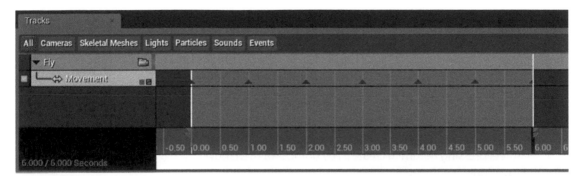

Try playing or looping the Matinee, and you can see the sound moving around in the Viewport.

You'll also hear some hawks flying around this rooftop, and this [**Ambient Sound**] is being animated by the Matinee [**Hawks**]. Both these Matinees are set to Play on Level Load and to be Looping.

Exercise 07_05: Moving Sounds with Matinee

In this exercise we are going to create some sounds that move around in the exercise level.

Matinee

1 Go to the *Canyon* area of your exercise map (Bookmark 6). Here we are going to create some bird sounds that circle around the player as they attempt to make their way across the canyon.
2 Create a randomized one-shot Sound Cue (using -**Looping**-, -**Delay**-, and -**Random**- nodes; see Exercise 01_04). Assign this to an [**Ambient Sound**] in the *Canyon* area.
3 Create a [**Matinee**] from the ➡**Modes** panel and place it next to your Sound Cue.

4 In the ➡Details panel of this [Matinee], set it to Play on Level Load and to be Looping.

5 Open the ➡Matinee Editor by clicking on Open Matinee in its ➡Details panel, and right-click in the left hand column of the ➡Tracks tab to create a New Empty Group.

6 With your [Ambient Sound] selected in the ➡Viewport, right-click on the name of your New Empty Group and choose Actors/Add Selected Actors.

7 Now right-click again on your New Empty Group and choose Add Movement Track. You should see a red, triangular key point appear. This is the starting position of your sound.

8 Click on the timeline at the bottom a few seconds in and press the Return key. This will create a new key point.

9 Now back in the ➡Viewport, move the [Ambient Sound] to the position you want it to be at this time. You should see a yellow line appear that represents the movement of your sound over time between these points.

10 Double-click the Stop button in the Matinee to reset it to the start and press Play. You will see the sound move to this new key point.

11 Set up a few more key points using the same method of selecting your point in time in the Matinee, pressing Return to create a key point, and then moving the [Ambient Sound] to a new position.

12 The green triangles on the timeline represent the looping part of your Matinee, so drag these to set them to the length of the timeline. If you want to extend the timeline, then drag the right-hand red triangle that represents its end.

13 Play the game and listen in wonder as your sound moves around you.

14 Make sure that the Attenuation of your Sound Cue (set in the -Output- node) is such that it won't move out of hearing range of the player.

15 Try adding some other moving sounds to your level.

Creating Movement

Given that this is an urban warfare environment and explosions are pretty important elements, we've created a Blueprint [GAB_ExplosionMovingSound] to add a bit of life and movement to these. This is particularly effective on a surround sound system.

While on the roof (Bookmark 6), try pressing M and you will see an explosion based around the public address system. No matter how good your explosions sounds might be, if they are just spatialized mono or stereo assets, they are going to lack the dynamic impact of explosions in the real world because in the real world sound moves!

If you select the [GAB_ExplosionMovingSound] Blueprint, you'll see in the ➡Details panel that you can add explosion core, right perpendicular, left perpendicular, left swoosh, and right swoosh sounds. This is triggered in the Level Blueprint by setting it the <Activate>—see the "Moving explosions" section.

The core is your basic explosion sound, the perpendicular sounds shoot off right and left from the explosion source (suited to explosion bloom type sounds), and the swooshes whizz towards and then past and behind you (suited to tails). As you can hopefully hear, this movement makes the experience a lot more impressive than a simple static sound and is an idea you could develop for a number of other applications (edit the Blueprint, from the ➡Details panel, to see how it works).

Exercise 07_06: Sounds with Movement

In this exercise we are going to add some moving explosion sounds to the level.

[GAB_ExplosionMovingSound], Blueprint

1 Find the [GAB_ExplosionMovingSound] Blueprint in the ➡Content Browser and drag and drop it into your level, perhaps in the *Canyon* or *Bridges* section.
2 With the Blueprint selected in the ➡Viewport, right-click in the [Level Blueprint] and create an <Activate> node. Since you had the Blueprint selected, this should automatically create a reference for it as well.
3 Pick a spare key input (e.g., J) and create a <Key Event> for it that triggers the <Activate> node (see Appendix A: Core Concepts/Key and Gamepad Inputs).

4 Add sounds to the Blueprint by selecting it in the ➡Viewport and using the ➡Details panel.

5 If you are using Sound Waves, remember that these will need attenuation settings so that they don't simply play back straight to the player. Create a {Sound Attenuation} asset in the ➡Content Browser and assign it to each Sound Wave you are using with the ➡Generic Asset Editor (double-click on the Sound Waves to open this).

6 Now try replacing the *Mountain Pass* explosion sound with this Blueprint.

Moving Objects That Make Sound

Most of the implementation of objects in your game that move, and create sound through their movement, will likely be set up by the animators that you work with, but it is worth having an understanding of how they work so that you can better implement their sounds.

Rotating Doors

Go back down the elevator to the *1st Floor* (Bookmark 5) and open (by pressing E) the door at the end.

Like the moving ambient sounds above, this door is controlled by a Matinee, and it is from this Matinee that we can get timed events to sync the sound to the movement. We could just create one sound that is timed to match the full opening (creak) and opened (clunk), but animations often change, so breaking up your audio into smaller events that can be triggered is a good habit to get into.

In this instance the E command that starts the Matinee immediately plays the creak of the gate movement, and then we get a Finished event from a <Matinee Controller> to trigger the clunk.

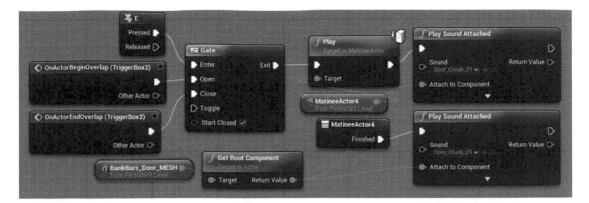

It is important to note that the Finished event derives from the red end marker in the Matinee (the small red triangle). Sometimes you may find that an animation has finished but your sound has not triggered. An incorrectly placed end marker is most likely the cause. See the "Rotating Door" section of the Level Blueprint.

Exercise 07_07: Moving Object Sounds

In this exercise we are going to add some sounds to the doors in the *Outer Wall Vaults* area of the exercise level.

<Matinee Controller>

1 Go to the *Outer Wall Vaults* area (Bookmark 8) of the exercise level and find the "Outer Wall Vaults" / "Doors" area of the [Level Blueprint].

2 First find Door_01 and Door_02 in the [Level Blueprint]. You can see that these have been set up with Matinees, and there is an E <Key Event> to open them and a <Matinee Controller> to let us know when the movement has finished.

3 Create two <Play Sound Attached> nodes and assign appropriate opening (creak) and opened (clang) sounds to them.

4 Select Door_01 in the ➡ Viewport and create a <Get Root Component> in the [Level Blueprint]. Attach this to the Attach to Component input of your <Play Sound Attached> nodes.

5 Test this in the game and then make the same setup for Door_02.

6 You might note that the end of Door_02 is not quite in time. Find the [Matinee] Actor in the ➡ Viewport and open the ➡ Matinee Editor using the Open Matinee button in its ➡ Details panel. Adjust the red track endpoint marker until it coincides with the final key event.

7 Find Door_03. This one you are going to Matinee yourself. In the same way that you moved the moving sounds in Exercise 07_05, make this door move (either move it or rotate it).

8 With the [Matinee] selected in the ➡ Viewport, right-click in the [Level Blueprint] and Create a reference to Matinee Actor—.

9 Drag out from this to create a <Play> node (in the cinematic list). Create a use system around the door to trigger this <Play> event. From the output of the <Play> node, connect a <Play Sound Attached> to play your opening (creak) sound.

10 Again with your [Matinee] selected in the ➡ Viewport, right-click in the [Level Blueprint] and this time Create a Matinee Controller for MatineeActor—. Use the Finished output of this to trigger your door opened (clunk) sound.

11 With the door selected in the level right click in the Event Graph to create a <Get Root Component> and attach this to your <Play Sound Attached> Attach to Component input.

12 Make sure that the red endpoint marker of the Matinee coincides with your final key point position. You can do this automatically by right-clicking on it and selecting Move to Longest Track Endpoint.

Open/Opening Loops

The metal grill in this first warehouse room (after Bookmark 5) is operated by the control panel on the wall. Pressing E starts the grill opening, but releasing E will pause it.

Because the opening of the grill might last an indefinite amount of time, we cannot just prerender a wave. Instead we use a looping wave that plays for as long as the grill is still moving (i.e., for as long as the Matinee is still playing). The <Gate>s are just to make sure that the player is in proximity to the control panel. E starts the Matinee then plays an open sound and the opening loop. This loop continues until either the player releases E (then it plays a stopped sound and stops the opening loop) or the Matinee finishes. See the "Grill—Button Held" section of the Level Blueprint.

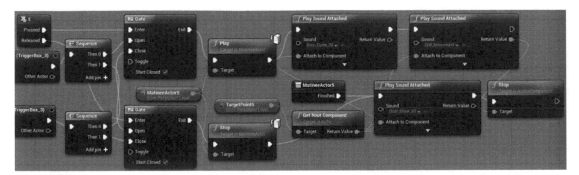

Matinee Events for Mechanical Systems

Often there are events within a Matinee that you want to sync sound to, but so far we've only been getting notifications when a Matinee plays or finishes. The [Crane] Matinee in the *Warehouse Room* contains an Event Track.

This Matinee will pick up the metal girders that block the entrance to this side of the roof and move them out of the way. This time the movements are more complex, so we have added an Event Track to trigger our sounds. These are created in the same way you create movement keys, only this time you give each event a unique name.

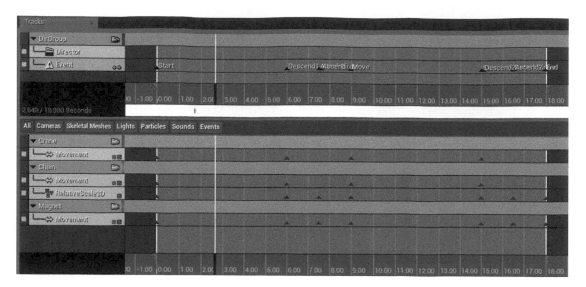

Then when you create a <Matinee Controller>, you don't just get the Finished event from which to trigger your sounds, but also a list of the other events.

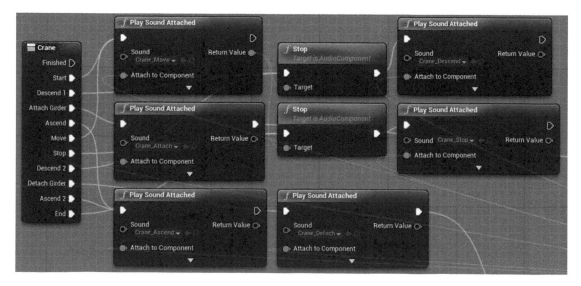

Compared to embedding the sounds in the Matinee itself, as we will see below with the Matinee Sound Track, this may seem like a hassle, but the advantage of this approach is that you can use looping sounds like we have here for the {Crane_Moving} cue. This means that with any in-game animation from a Matinee, it does not matter if the designers decide to change the speed of it (the Play Rate of the Matinee)—our sounds will remain in sync.

Matinee Sound Track

You can start the final machine, to the rear of the next room, with E as usual, but then speed it up or slow it down using the + or − keys. Here it is crucial that the audio remains synced, and so we have used the Sound Track functionality of the Matinee to embed our sounds.

As you can see, the Sound Track in the Matinee is very useful for closely synchronizing sounds to movement events; however as we have noted above, you can't use loops in these tracks, so depending on your needs you may want to use a combination of Sound Tracks and Event Tracks as outlined above.

Exercise 07_08: Matinee Sound Tracks

In this exercise we are going to add sounds to the moving platform system on *Cave 02* of the exercise level using a Matinee Sound Track.

[Matinee] Sound Tracks

1 Go to the *Cave 02* section (Bookmark 3) of the exercise map and find the Matinee [Cave02MovingPlatform01].

2 Open this Matinee then press play and watch its movement in the ➡ Viewport, thinking carefully about the type and timing of sounds that you might need.

3 In the ➡ Tracks tab of the Matinee, right-click on Platform_01 and choose to Add New Sound Track.

4 Select the Sound Wave or Sound Cue you want for a particular event in the ➡ Content Browser.

5 With your new Sound Track selected, move the playhead to the appropriate point and press Return to add a reference to your sound.

6 Add further sounds to your Sound Track until you have a complete system for the moving platforms.

7 Experiment with changing the Play Rate of the Matinee from its ➡ Details panel. Your sound events should stay in sync with the movement.

8 You may also want to add some events on an Event Track to cue any looping sounds you might want externally via a <Matinee controller> in Blueprint. Now do the same for the Matinee [Cave02MovingPlatform02].

9 Don't forget that any sounds added to the Matinee Sound Track will need their attenuation defining so that you don't hear them throughout the entire level.

Physics

Summary: Imitating aspects of audio physics in game such as the speed of sound, Doppler, and physics collisions

Speed of Sound

We've already talked about how sound in games does not always stick to what is acoustically accurate for a number of reasons. Once you've moved the steel girders with the crane, you can make your way up to the corner of the *Rooftop* (Bookmark 7), where using the control panel will give you a number of explosions at different distances to the player.

In some circumstances you might want the sound to reflect the physics of the real world more accurately (for example in more simulation type games), and here we have demonstrated how you

could produce a more realistic relationship between sound and light. As we know light travels faster than sound, so when you see a distant event (an explosion for instance), you will hear it a little later. We're taking the distance from the player to the explosion source and dividing this distance (in Unreal Units—approximately 1UU to 1cm) by 100 to get the distance in meters. This distance is divided by 343 (the speed of sound roughly being 343 meters per second at 20°C in dry air) to obtain the time to delay the sound by (we've also added a speed of sound scale factor, so you can control the strength of the effect).

Doppler

Another physics-based effect we can implement is the Doppler effect, which is the apparent shift in pitch produced by the relative movement of an observer and a sound source. You will probably be most familiar with this as the shift in pitch as a police siren passes.

The implementation is to simply add a -Doppler- node to your Sound Cue

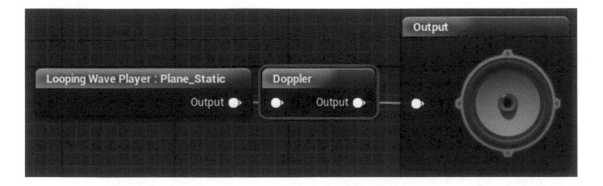

If you stand on the roof by the *Flyby Doppler* location marker and press K, you'll hear the ambient sound containing the Doppler Sound Cue {Plane_Doppler_Cue} being moved across the level with a Matinee (it is actually attached to the mesh [EuroFighter_Doppler], and it is this that is being moved by the Matinee [Plane_Doppler_M]).

Although this might work alright for slow moving objects, it is very abrupt and unusable on really fast sources (like planes or bullets). One of the many challenges with which some game engines present the sound designer is that processes are done and variables are changed at the frame rate of the game. Frame rates vary and, in terms of audio, are very slow. We can hear this issue in action when we have a fast moving sound source with a Doppler effect applied. Try finding the [**Plane_Doppler_M**] Matinee and changing its Play Rate to 2.0 for example.

Due to the variable for the Doppler effect only being updated per frame, the pitch of the sound jumps suddenly from high to low since the plane moves past you faster than the frame rate can handle in terms of producing a nice incremental pitch change.

Doppler: Faking It

Pressing L gives you an alternative approach using prerecorded flyby sounds. As we discussed in Chapter 02, the best results are often from a combination of system approaches and just using great recordings where appropriate.

The cube in the illustration above is attached to the plane [**EuroFighter_Doppler_Fake**] and has a tag (➡**Details**/Tags) with the name "PlaneSound". Whenever anything overlaps with a box we have set up around the player (see it in the ➡**Viewport** of [**MyCharacter**]), the [**MyCharacter**] Blueprint checks whether it carries this tag. If it does then it triggers the <CallFakeDoppler> event, which is picked up in our case in the [**Level Blueprint**] (in the "Doppler" section).

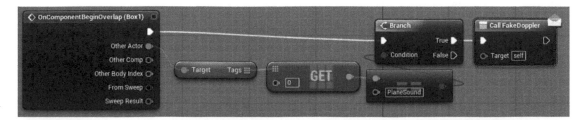

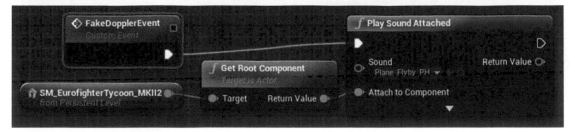

Since our flyby sound peaks at 3.0 seconds and we want this to coincide exactly with the moment when the plane flies past the player, we have set the box around the player that triggers this sound to be 500UU large. With the speed that the plane is traveling, this will trigger the sound to start at the right time.

Collisions

The sounds of collisions between materials present many challenges in games since the possible number of permutations is huge.

Simple Object Collisions

In the *Physics Room* (Bookmark 9), there are some objects that produce a sound when the player collides with them. These are implemented using simple trigger on overlap (collision) events, and since these objects are likely to be reused, we've made them into Blueprints that have the collision triggers and sounds embedded.

269

Select the [WarehousePipes01_Blueprint] and click on Edit Blueprint/Open Blueprint Editor in the Blueprint section of its ➡Details panel. Here you can see that we have created an <Event Hit> event that triggers a collision sound. Because you can sometimes get a very quick series of triggers from these kinds of collisions, we have blocked this temporarily with a <DoOnce> node that is only reset after a given <Delay>.

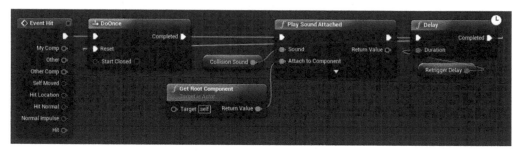

Since we have made the variables for the Sound and the Retrigger Delay time public (indicated by the highlighted eye icon below), these are editable in the ➡Details panel of the Blueprint in level.

Exercise 07_09: Simple Collisions

In this exercise we are going to construct some Blueprints that have collision sound effects built in.

<Event Hit>

1 Search the ➡ **Content Browser** for a {Static Mesh} that you might want to add a collision sound to, for example the {**Warehouse_Girders**}. Drag and drop this mesh into your ➡ **Viewport** somewhere in your exercise level.

2 In its ➡ **Details** panel click on Blueprint/Add Script and assign it to a folder (the Blueprints folder is probably a safe bet).

3 Double click on the new Blueprint you have created to open the Blueprint editor, go to the ➡ **Event Graph**, and create <Event Hit>, <Play Sound Attached>, and <Get Root Component> nodes.

4 Attach the <Event Hit> to the <Play Sound Attached> exec input and the <**Get Root Component**> to the Attach to Component Input of the <**Play Sound Attached**>.

5 Create a new variable in the ➡ **MyBlueprint** panel (+), edit its ➡ **Details** panel to make it of type Sound Base, and assign your sound (after compiling the Blueprint). Drag this variable Into the ➡ **Event Graph** and attach it to the sound input of the <**Play Sound Attached**>.

6 Since you will no doubt get multiple rapid hit events when you collide with this, you might want to implement a blocking system using a <DoOnce> and <Delay> like we did in the level example.

7 If you want to make the sound and retrigger delay time editable from the Blueprints ➡ **Details** panel, then you will need to make these public by clicking on their eye icon.

Velocity to Collision Sounds

What the game system is attempting to do here is to somehow replicate the interactions of different materials that produce sound. There is a great deal of research available on the physical processes that create sounds, and there is an increasingly important branch of game audio research that looks at how these can be implemented in games without the vast processing overheads of truly accurate simulations. The details of this subject, sometimes termed procedural audio, are for another book (see the further reading section of the website for a good one!) The reality is that within the processing power currently available for game audio, we are at the early stages of this brave new world and so often there is still the need to fake it.

The most important thing when dealing with variables arising from games physics is to be able to scale these variables into a useful and meaningful range of numbers for your audio. In addition to scaling the variables from physics events, it's also often useful to set thresholds (to clamp or cap the

numbers) so that the sometimes extreme numbers that might appear unpredictably do not result in an extreme audio event.

Velocity to Volume

The first control panel in the *Physics Room* controls the height of the first barrel (use + and - to control the height and E to release the barrel).

The first barrel is the Blueprint [Barrels_Vol] and has a simple relationship between the velocity at which the barrel impacts with the floor and the volume of the collision sound played. When this Actor collides with something, the <Hit Event> in the Blueprint is triggered and this causes a sound to be played, but instead of the simple collision above, we now get a Normal Impulse from the hit event that gives the velocity of the impact (this is converted from a vector to a float) and is then normalized (to a 0.0–1.0 range) to set the <Volume Multiplier> for the sound. Select the [Barrels_Vol] Blueprint or the barrel in game and Edit Blueprint to see the system.

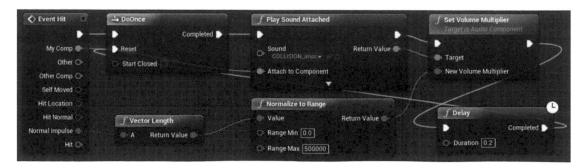

Velocity Reading through Curves

Since the sound of a collision will differ significantly with the velocity of the impact, the second barrel ([Barrel_Curves]) uses the velocity to read through a set of curves. We could have used switches within a Sound Cue to change the sounds, but this would have been a little binary with abrupt changes on the thresholds, so using curves gives us more flexibility.

The velocity of the impact (taken from Normal Impulse) is normalized then used to read out the curve values at that point. The figure below illustrates the velocity (X) to volume (Y) relationships for the three different metal impact sounds: light, medium, and heavy.

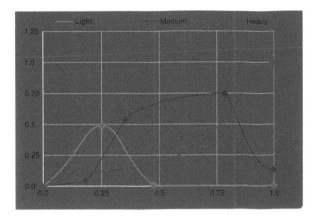

These are then used to modulate the volume of the different elements (you could also send the curve output to <Set Float Parameter>s and -Continuous Modulator-s in the Sound Cue to achieve the same effect). We looked at this concept of reading through curves in the Parameterization = Interactivity section of Chapter 02 and in the Curves to Volume section of Chapter 04. Go back and read Appendix A: Core Concepts/Transforming and Constraining Variables and Parameters/ Reading through Curves if you'd like to refresh your memory.

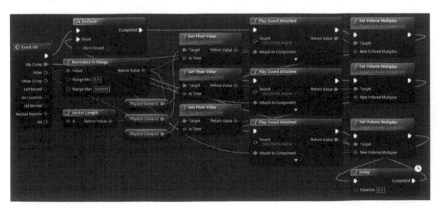

Sliding, Rolling, and Scraping

In order to work out if an object is rolling or scraping, we need to analyze the pattern of hit events received. If it's above a given threshold, then we'll treat it as a normal impact, but if we're getting lots of low velocity impacts within a given time frame (in this case 4 low impacts within 0.2 seconds), then we can assume that it's continuously in contact with a surface while still moving (i.e., sliding, scraping, or rolling).

For the blue barrels [**Barrels_Roll**], press + or − to increment or decrement the angle of the ramp, and E to release. You can also push the freestanding barrels in this area with R and hold the RMB while focused on them to implement a gravity gun type system to pick them up.

If we get the required number of low impact hits, we trigger a different sound and use the impact velocity to change the Volume Multiplier. A <**DoOnce**> node is used so that we only trigger one instance of this sound at a time (an <**OnAudioFinished**> event is used to reset the <**DoOnce**>).

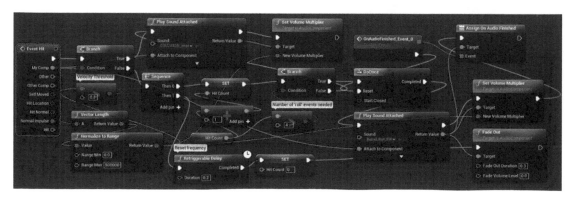

You will notice that you need to build in lots of belt and braces systems (i.e., double checking and limiting systems just to be sure, like the <DoOnce> above) for physics events since they can occasionally send out some extreme values outside of their normal range. See Appendix A: Core Concepts/Transforming and Constraining Variables and Parameters.

Exercise 07_10: Physics Collisions: Volume and Curves

In this exercise we are going to create some barrels in our level with collision sounds that respond to their impact velocity.

<Vector Length>

1 In the *Mountain Pass* area of the exercise level, there are a number of barrels up on ledges along the pass.
2 Select one of these barrel static meshes, and in the ➡Details panel choose Blueprint/Add Script and assign it a folder. (You need to keep the text 'Barrel' at the start of the Blueprint name as the 'Grav Gun' on the right mouse button is set to only interact with objects containing this text string.)
3 Double click the new Blueprint to open the ➡Blueprint Editor. In the ➡Event Graph create an <Event Hit> to trigger a <Play Sound Attached> and a <Get Root Component> node that goes Into the Attach to Component input.
4 Create a Sound Base variable (or audio component) to reference your sound, drag this into the Blueprint to create a <Get>, and connect this to the <Play Sound Attached>.
5 Drag out from the <Play Sound Attached> and create a <Set Volume Multiplier>.
6 Now drag out from the Normal Impulse of the <Event Hit> to connect a <Vector Length> node.
7 Create a <Print String> node and trigger it from the output of the <Set Volume Multiplier>.
8 Connect the Return Value of the <Vector Length> to the <Print String>.
9 Play the game and take a look at the range of impact velocities that you might get from the barrel (from the numbers printed to screen). You can push the barrels off the ledge using the R' key or use a 'Grav Gun' by holding the right mouse button.
10 Remove the <Print String> and link the Return Value of the Vector Length to the value input of a <Normalize to Range> node. Set the Range Max to be the highest velocity you saw.
11 Connect the Return Value of the <Normalize to Range> to the New Volume Multiplier of the <Set Volume Multiplier>.
12 Play the game and you should hear the volume of the barrel collision sound being modified depending on the velocity at which it hits the ground. Try placing several instances of your barrel Blueprint on different height ledges.
13 Like the previous exercise, you may wish to implement a system to block multiple rapid hits using a <DoOnce> that is reset by a <Delay>.
14 By creating a couple of <Play Sound Attached> nodes with recordings of impacts at different velocities and reading through curves to determine their volume, we can create a more realistic effect.

15 Set up two <Play Sound Attached> nodes with associated <Set Volume Multiplier>s.
16 Create two variables of type Curve Float and <Get> them in the Blueprint. After compiling the Blueprint, create two Curve Float assets in the content browser (under Miscellaneous) and assign these to your Curve Float variables in the Blueprint.
17 Drag from them to create a <Get Float Value> for each.
18 Use the Return Value from the <Normalize to Range> node this time to set the In Time at which we read through the curves, and send the Return Value of this to the New Volume Multipliers for each sound's <Set Volume Multiplier>. See the game example referred to above, the exercise screenshots from the website, and Appendix A: Core Concepts/Transforming and Constraining Variables and Parameters/Reading through Curves for more guidance if required.

Physics-based Collisions: Cascading Physics

You'd imagine that if you take the sound of one rock falling or one pane of glass breaking and applied it to 20 rocks or 20 panes of glass that when multiplied this might produce the appropriate sound for a group of these objects, but this isn't the case. The complex interference of Sound Waves when many collisions are occurring simultaneously means that any attempts to recreate 20 rocks falling or 20 shards of glass by playing back 20 individual impact sounds is doomed to failure.

When responding to physics, it's also very easy for your sound system to get overwhelmed with the number of events. Simply reusing the same sound for each individual collision does not work beyond a certain density of events because it can lead to too many voices being used, it can lead to phasing, and it just doesn't sound right. You could limit the number of occurrences of this sound to stop it taking up too many channels (using the {SoundCue} Voice Instance Limiting discussed later in the Prioritization: Number of Voices Control section), but this would not improve the sound beyond perhaps eliminating some of the phasing.

Go over to the window in the *Physics Room* (Bookmark 9) and shoot it, first as spaced single shots and then with a burst of fire. You will hear that after a certain rate of fire, the sound changes from single small glass breaking sounds to a larger glass breaking sound.

What we have done here is to set up a cascading physics system. If more than a certain number of events are happening within a given time frame, then change the sound to a recording of a larger event. This helps to keep the number of simultaneous sounds to a minimum as well as producing a more realistic effect. Consider this approach to any circumstance where you have a potentially large number of sound events (e.g., glass breaking, bricks falling, etc.)

For each hit event, we increment the Window Shot Count variable, and if this reaches more than 5, then we <Branch> to play the larger sound. This is reset after 0.3 seconds to set the timeframe.

In theory this is how the -Group Control- node in a Sound Cue should work. You can assign sizes for each of the inputs, and as soon as the number of active sounds exceeds that size, it will choose to play a sound from the next input down so you can set up a series of prerecorded small to large sound events. At the time of writing, this node doesn't actually work, so this is why we thought we would build our own!

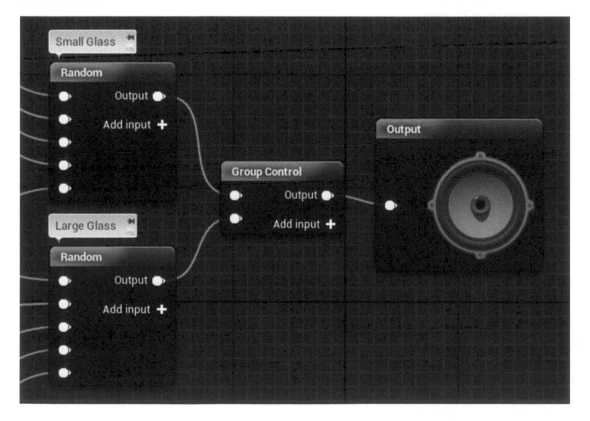

Exercise 07_11: Cascading Physics

In this exercise we are going to implement the sounds for a cascading physics system.

1 Go to the *Outer Walls* section of the map and find the windows that look out over the valley (*Cascading Physics Windows* near Bookmark 8).
2 In the "Outer Walls/Windows" section of the [Level Blueprint], we have set up a cascading physics system for you.
3 Create appropriate Sound Cues for the small single shot glass break elements and for the larger glass break events, and assign them to the appropriate <Play Sound Attached> nodes.
4 Experiment with both the count number and the delay time until you are satisfied with the effect.
5 This is a good example where a reusable Blueprint would be better that making systems for each instance in the Level Blueprint. Create a New Actor Blueprint (Add New / Blueprint Class / Actor). Find the {Factory_Window} static mesh and add this as a component. With this component selected create an <OnActorHit> event in the event graph and reproduce the system from the exercise Level Blueprint.
6 Remember you'll also need to create and use a new Window_Shot_Count integer variable within this blueprint. Once you've created the BP drag it into the level and try replacing all the windows with instances of your BP.

Prioritization: Number of Voices Control

Summary: Controlling the number of voices/channels of audio used in game

The number of simultaneous sounds (the number of voices, channels, or polyphony of the system) you can have in games is limited and dependent on the specifications of the console you are working on, the software system, and the other demands being made on the CPU.

In the early days of consoles, the maximum number of voices might have been limited to perhaps 6–8, and even now this is often very limited on mobile devices (the default number of channels in Unreal for Android devices is 12!) Even if you are working on a modern console or PC and have many voices available, you will be amazed at how quickly these can get used up, and if the voice count gets too high, then new sounds simply won't play—a problem we want to avoid.

One way to avoid this is to set up systems like the cascading physics one above that track the number of sound instances and swap out to different single sounds if a group gets beyond a certain number. The other thing to remember here is that perceptually we tend to consider things as a group when there are more than two of them, so it may be appropriate sometimes to simply use a sound effect that represents the group rather than specific instances. For example if there were a platoon of NPCs marching, it would be better to use the sound {Platoon_Marching} than trying to create this effect through each NPC's individual Foley sounds.

The considerations about channel count may also affect your decisions regarding attenuation falloff distances. As we noted above, a realistic attenuation falloff over distance would leave many sounds playing very quietly.

In order to avoid the worst outcome (important audio simply not playing), you need to consider grouping your sounds into different categories and devising some general rules as to the number of voices you will allow for each, depending on their importance to the game or the particular scenario. You can set up a number of rules to govern this in the Playback settings of Sound Waves (in the ➡Generic Asset Browser) and Sound Cues (in the -Output- node).

Here we can set the maximum number of instances of a sound we are going to allow (Max Concurrent Play Count) and the rule to apply should we go over this number:

- Prevent new
- Stop oldest
- Stop farthest (in terms of distance), then prevent new
- Stop farthest then oldest

Generally stop farthest then oldest and stop oldest will be the least obvious to the player, but there may be instances where the other rules are more appropriate. The Console command "Stat Sounds" will give you a read out of the number of sound instances dropped (see Appendix A: Core Concepts/Console Commands).

The good thing about this restriction is that it forces us to think carefully about the priority of sounds and to start thinking about the mix, which we will be coming onto in the next chapter.

Animations

Summary: Synchronizing sounds to animations

We're going to focus on tying sounds to footstep animations in this section, but the principles are applicable to any other type of animation you might have in your game. Repetitive footstep sounds do seem to irritate people more than most aspects of game audio. The first thing to do is to stop thinking of them as footstep sounds. Unless you have a particularly unusual anatomy, you do not take steps in isolation from the rest of your body. Therefore we should consider them movement sounds or Foley sounds (that include cloth movement as well), not just footstep sounds.

Footsteps 01: Anim Notifies

Find the [HeroFPP_AnimBlueprint01] in the ➡Content Browser and double-click it to open up the ➡Animation Editor (officially called the Persona Editor). Switch to ➡Animation Editing Mode from the options on the top right and then double-click on the {FPP_IdleRun01} Blend Space in the ➡Asset Browser bottom right. In the center window FPP_IdleRun/Samples, you can see that this Blend Space refers to the animation {FPP_RifleRun01}.

Double-click on this in the ➡Asset Browser, and you can see on the timeline at the bottom that this has a Sound Cue added directly as a notify in the animation itself. This enables you to very precisely align sounds with animation events. In this instance there are two notifies using the same footstep Sound Cue that have been synchronized with the landing of the character's feet.

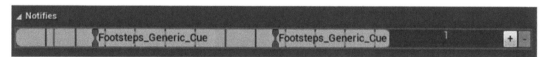

This simply plays back the randomized {Footsteps_Generic_Cue} Sound Cue.

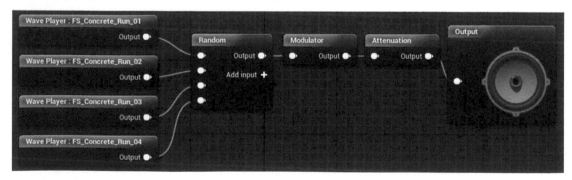

This approach works fine for many animations, but for footsteps of course we want to be able to swap in different sounds depending on what surface the player is on.

Exercise 07_12: Embedding Sounds in Animations

In this exercise we are going to look at a simple method for embedding sounds in animations.

1 Go to the *Footstep Surfaces* section of the exercise level.
2 Find the [HeroFPP_AnimBlueprint_01] in the ➡Content Browser, double-click to open the ➡Animation Editor and select the ➡Animation Editing Mode.
3 After double-clicking on the {FPP_RifleRun02} animation, you can see that this animation currently has no sounds or events attached so when you switch to it in game (by pressing the L key), you will not hear any footsteps.
4 Create a basic footstep Sound Cue in the ➡Content Browser and keep this selected.
5 Return to the ➡Animation Editor and right-click on the notifies timeline to select New Notify/ Play Sound. This will add the cue you have selected to the timeline.
6 Play the game again, and again press L to swap to the new animation, and you should now hear the footstep sound being triggered.
7 Go back to the ➡Animation Editor and add a further Play Sound notify event for the other foot and tweak the timings of these until it feels right.
8 Don't forget to apply some of the non-repetitive design principles discussion in Chapter 02 such as volume variation via a -Modulator- and -Enveloper-, or try concatenating some heel/toe samples for greater variation.

Footsteps 02: Surfaces

Part of the problem with repetitive footsteps is not actually about the footsteps themselves—it is about the variety of surface types and how often they change. Distances are not the same in games as in the real world. I can walk around my living room in 5 paces (and that's not just because of my salary). For various reasons (not least of which is the relative clumsiness of the control mechanisms), the spaces between objects in games need to be much larger than in reality—hence more footsteps. This already puts us at a disadvantage when it comes to repetition, but we also very rarely have continuous surface types in the real world. If you recorded yourself walking at the same speed on a continuous surface (if you can find one) then you would probably find the sounds very repetitive! Work with your artists to create and define a large number of surface types and change them frequently.

In order to play different footstep sounds for different surfaces or materials in the game, we need to set up our animation to trigger an Event Notify that we can pick up elsewhere, rather than embedding sounds into the animation itself. In the *Physics Room* (Bookmark 9), there is a concrete floor throughout, along with one strip of wood flooring and one of metal.

You can change the animation that the character uses by pressing the \ key. Now walk around the room again, and you will hear that the footsteps change depending on the surface you are walking on. If you open the [HeroFPP_AnimBlueprint02] Blueprint and again go to the ➡Animation

Editing Mode, you can see that this one now uses the {FPP_IdleRun02} Blend Space that references the {FPP_RifleRun02} animation.

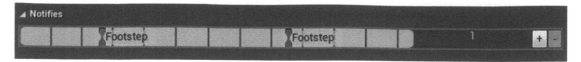

Instead of a Sound Notify embedded in the track, this now has an Event Notify (or two). Go to the ➡Graph Mode of the ➡Animation Editor (top right) and select the ➡Event Graph tab. Here you can see how this AnimNotify is used to <Cast> the player pawn to the [MyCharacter] Blueprint. This will allow us to pick up the events in this Blueprint and use them to trigger our footstep system.

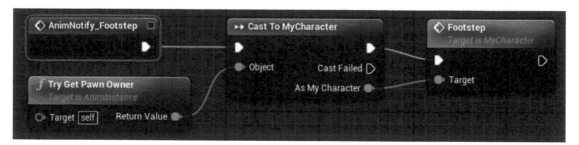

When this event is received in the [MyCharacter] Blueprint, a trace is then performed with a line straight down from the character to find out what surface it is currently on, or more specifically the physical material of the surface that the character is on. The physical material (or Phys Material) is a parameter you can set within the ➡Material Editor.

We break the result to expose all the variables, and then the resulting Phys Material (physical material) is used to control the switch that sets the variable Footstep Surface.

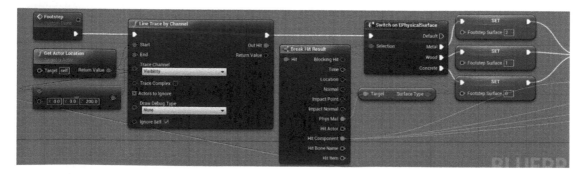

This integer variable is used to control the -Switch- inside the {Footsteps} Sound Cue to play the correct footstep sounds for that material. The sound is played back at the point of contact for the footstep from the Hit Component parameter.

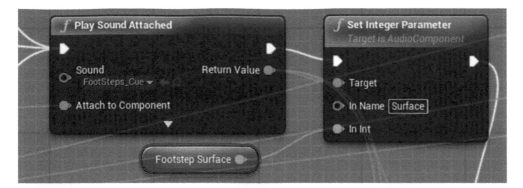

So now we get a different set of footstep sounds depending on the surface type the player is walking on.

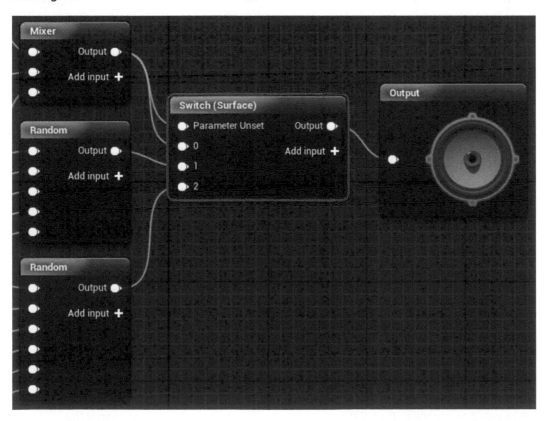

For landscapes you set the Phys Material in the {Layer Infos} used by the landscape. You can see these in the ➡Modes panel/Landscape/Paint/Target Layers.

Exercise 07_13: Footstep Surface Types

In this exercise we are going to implement some surface changes and set the character to pick appropriate footsteps sounds for each.

Physical materials, <Switch on EPhysicalSurface>, <Break Hit Result>

1 Go to the *Footstep Surfaces* section of the exercise level. You can see that the floor is comprised of some different surface types: metal and wood.

2 First we are going to create the Sound Cue, so source three different sets of footstep sounds—default, wood, and metal.

3 Add each sound type to its own -Randomize- node and connect them to a -Switch- with the default going to the parameter unset and 0 input, wood to 1, and metal to 2. Select the -Switch- parameter, name it Surface_Switch in its ➡ Details panel, and connect it to the -Output- node.

4 Go to the surfaces in the game and select the wood one first. In the ➡ Details panel, you can see the Materials it references. Use the magnifying glass icon to find this material in the ➡ Content Browser.

5 Double-click it to open the ➡ Material Editor. In the ➡ Details panel on the left, you can see its Physical Material. Set this to {PhysMat_Wood}.

6 Now do the same for the metal floor material, setting this (surprisingly enough) to {PhysMat_Metal}.

7 Open the [MyCharacter] Blueprint, and you can see in the "Footsteps" section that the <Line Trace By Channel> node is just set to trigger a default footstep Sound Cue {Cave_Footsteps_Concat}.

8 Drag out from the Out Hit to create a <Get Surface Type> node. When the line trace goes down from the player this will allow us to track the surface type that the players feet are colliding with. Drag out from the Return Value of this node and create a <ESwitch on EPhysical Surface Node>.

9 Delete the output from the <Branch> node that is triggering the <Play Sound Attached> and send this to trigger the <ESwitch on EPhysicalSurface> instead.

10 You can see that the <ESwitch on EPhysical Surface> displays the possible physical materials as defined in the project settings. You can also define and use your own Physical Materials. In the ➡ Menu Bar choose Edit / Project Settings / Physics. Here you can add additional materials and any that you add will show up in the <Switch on EPhysicalSurface> switch when you create this node. You then just need to create the {Physical Material} asset itself and choose your material from the Surface Type drop down menu in its ➡ Generic Asset Editor, and assign this to your material. If you create new ones you will need to recreate the <Switch on EPhysicalSurface> to update it with the new materials.

11 We're going to use the output of the <ESwitch on EPhysicalsurface> to control the Surface_Switch parameter in the Sound Cue you just created. Create a new integer variable named Surface_Type and drag this into the Event Graph to create three <Set> nodes. Connect these to the default (set the value to 0), Wood (set the value to 1) and metal (Set the value to 2).

12 Assign your sound cue to the <Play Sound Attached> then drag out from its Return Value to create a <Set Integer Parameter with the In Name Surface_Switch, and trigger this from the output of the <Play Sound Attached>. <Get> the variable Surface type and connect it to the In Int input. As the <ESwitch on EPhysicalSurface> received the surface type it will change the variable and therefore will change the position of the switch within your Sound Cue to call the appropriate footstep sound for this surface.

13 If that works then well done! It's quite tricky.

14 You can also define and use your own physical materials. In the ➡ Menu Bar choose Edit/ Project Settings/Physics. Here you can add additional materials, and any that you add will show up in the <Switch on EPhysicalSurface> switch when you create this node by dragging out from the Phys Material output of the <Break Hit Result> node. You then just need to create the {Physical Material} asset itself and choose your material from the Surface Type drop down menu in its ➡ Generic Asset Editor, and assign this to your material.

Footsteps 03: Creep/Walk/Run

Of course it is not just about surface types. In most games you can walk at different speeds, and with a gamepad the divisions between these are blurred, as the analogue controls interpolate between these states. In the Blueprint [MyCharacter], "Footsteps and Foley" section you can see that we've taken the input axis from the controller (Axis Value giving us between 0.0 and 1.0) to read through some curves that control the volume of our different states. The Keyboard Axis value gives us values between 0.0 and 0.5, so these are scaled by the modifier keys—Shift (run) by 2.0 and Ctrl (creep) by 0.3. Again see Appendix A: Core Concepts/Transforming and Constraining Variables and Parameters/Reading through Curves for a reminder if required.

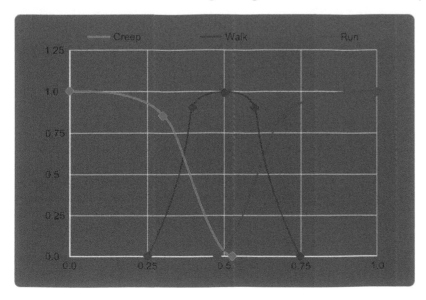

So actually our {Footsteps_Cue} Sound Cue is more complex than above since the -Mixer- is actually mixing together three footstep elements, the volume of which is being controlled by the <Set Float Parameter>s that target the three -Continuous Modulator-s.

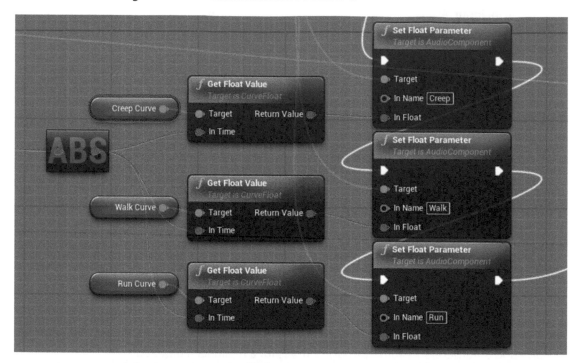

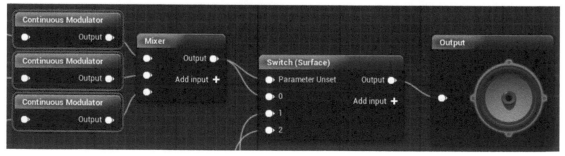

Exercise 07_14: Footstep Speeds

In this exercise you can extend your system to include different elements for creeping, walking or running.

1 We have already set most of this system up for you in the [MyCharacter] Blueprint.

2 Connect the output of the <Set Integer Parameter> node you created in the last exercise to the first of the <Set Float Parameter> nodes we have provided.

3 In your Sound Cue set up three -Continuous Modulators- with the parameter names creep, walk, and run. The volume of the elements you connect to these will be determined by the speed of the player as fed through the curves. Ideally you'd have these elements for each of the surface types in your game.

4 To run hold the Shift key, to creep hold the Ctrl key.

5 We have put in some default Curve assets, so you can edit these or replace them with your own.

Footsteps 04: Foley or Weapon Carrying Layers

To make a complete Foley system, we need to think about the whole sound that a player makes when they move. You can layer in other sounds depending on the players clothing, the weapons they're carrying, or other items. Using the blue pickup in this room, you can add a jangly armored vest to your character (the red pickup drops the vest).

The [VestPickup] Blueprint has a box component in it that generates an event when overlapped in its ➡Event Graph. We check this against the player class to make sure that it is the player that has triggered this event, not anything else, and if True we set the Boolean Has Vest within the [MyCharacter] Blueprint. (There is also an illustration here in the [MyCharacter] Blueprint of how you might implement foley layers for carrying different weapons.)

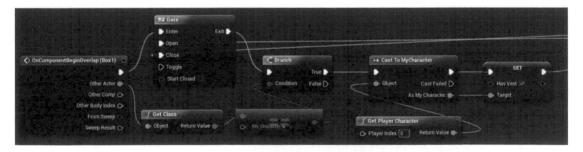

During a footstep event, the [MyCharacter] Blueprint queries this condition with a <Branch> node and if the condition is True, it plays the extra Foley layer.

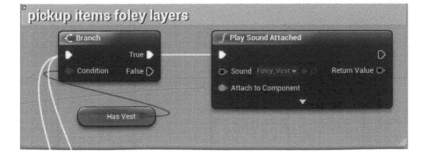

Exercise 07_15: Pickups and Booleans

In this exercise you will extend your footsteps system to include Foley layers that vary depending on what the player character is carrying.

1 In the *Footstep Surfaces* section of the map, there are a number of pickups named firewood, armour, and keys.
2 These set an appropriately named Boolean variable in the [MyCharacter] Blueprint "Foley" section.
3 Extend your footsteps system so that if their condition is True, they add an appropriate Foley layer to the footsteps sound.
4 You could neaten this system up by adding the Foley layers to your footstep Sound Cue itself by using the <Set Boolean Parameter> node to target the Return Value of the footstep's <Play Sound Attached>. You can then use -Branch- nodes inside the Sound Cue.

Footsteps 05: Other Notes

Think about when footsteps should and shouldn't be heard. If there is a firefight, you won't hear them anyway and they are just taking up valuable headroom and channels (voices), so you could think about changing the mix to take these out in such circumstances. See the discussion of passive sound mixes in the Passive/Automatic Mix Changes section in the next chapter.

NPC Footsteps

Any repetition in footstep sounds will be particularly acute if you have multiple NPCs all referencing the same Sound Cue within a confined area. Consider having a priority system for NPC footsteps. Limit the number of footsteps that can play at any given time (see the earlier discussion in this chapter about voice instance limiting in the Prioritization: Number of Voices Control section).

If you're going to have lots of NPCs referencing the same footsteps, then you could try using adaptive distance attenuation curves, swapping out their attenuation over distance to be tighter around the center of origin. You can either control a -Branch- node in the Sound Cue or <Set Attenuation Override>s in Blueprints.

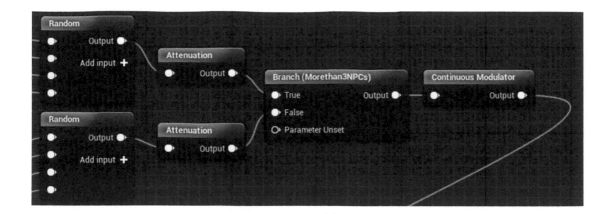

As we also mentioned earlier in the prioritization section, in terms of our perception of most things we usually class things as one, two, or many, if there are more than two things, we consider them to be a group rather than individual units. So in addition to perhaps prioritizing the nearest NPC footsteps, you (and your programmer) could develop a system where if there are more than X number of NPCs within a given area, you will not actually play their individual footstep (movement) sounds anymore, but will instead play the Sound Cue {ManyNPCsMovement}. This will not work under all circumstances (as the player will often need to locate individuals), but could save on the number of voices used and make them more convincing than the tat, tat, tat of repetition that you sometimes get.

Cameras and Cutscenes

Summary: Game cameras, the listener position and the implications for audio

Cutscenes and cinematic sequences in games use either prerendered video files or are created in real time within the game engine itself using scripted animation and movements. The ability to sound design a linear sequence such as a prerendered cut scene remains an important skill for the game sound designer. The skills are the same as film or animation sound design so we are not going to dwell on them here, but if you are doing an in-engine cutscene, there are some things you need to consider from an audio perspective

Go up to the rooftop on this side of the building (Bookmark 8) and use (E) the switch on the left. This will launch a cinematic flythrough to show you the positions of several snipers in this area. (You can switch to a scoped weapon by pressing 2—right mouse button to zoom, F to hold breath.)

In the [**Level Blueprint**] "Camera Fly-round" section, you can see that the E key input triggers a <**Set View Target with Blend**> node that deactivates the [**MyCharacter**] player controller camera and sets it to the new camera placed in the level [**Fly_Round_Camera**]. The camera movements are controlled in the Matinee via movement within a camera group in the same way as other moving objects, with the additional option of cutting between cameras with a director track.

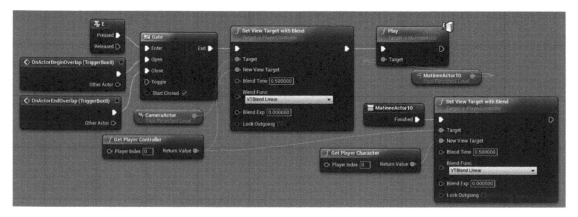

In the Unreal Engine the listener position for the sound defaults to the position of the camera. For this kind of level flythrough this works fine, but if your scenes are more cinematic, perhaps dialogue between two characters, then this becomes an issue. Dialogue scenes typically use what is called a two-shot where we see both characters in the frame, but we switch views to behind the character who is listening. Even if we set the dialogue to the center speaker every time we go back and forth between these two shots, the rest of the soundscape would flip left/right/left, etc. (see Chapter 08 for how to put dialogue in the center speaker). Obviously this is going to feel pretty strange, so the best approach during cutscenes is to mute the in-game ambience using a Sound Mix and actually trigger any sounds that are required from a Matinee Sound Track or Event Track as discussed above. You could

record your in-game ambience from a stable position and then import this to playback on a Sound Track. Frame rates can affect the rate of play of a Matinee, so although ambience is probably alright, you should embed any specific synced sounds into the Matinee itself.

Exercise 07_16: Cameras and Cutscenes

In this exercise you are going to create a flythrough sequence for a part of the exercise level and then a more cinematic cutscene.

<Get Player Controller>, <Set View Target With Blend>, [Camera]

1 Create a [Trigger] in the exercise level where you want a flythrough sequence to start. This could be to show the player what is coming up, along with some instructions as to what to do. This might suit the *Mountain Pass*, *Canyon*, or *Bridges* areas (Bookmark 6).

2 Create a [Matinee] (by dragging and dropping from ➡Modes panel) and place it next to your trigger. Name it "Flythrough" in its ➡Details tab. Then in the Cinematic section, check Disable Movement Input, Disable Look at Input, and Hide Player.

3 Create a [Camera] Actor (again by dragging and dropping from the ➡Modes tab) and place it in a position in the level where you want your flythrough to start. With the camera Actor selected, you will see a small box out on the bottom right of the screen which shows you the camera view.

4 Click on Open Matinee in the Matinee ➡Details panel and with the camera selected in the ➡Viewport, right-click in the ➡Tracks tab and select New Camera Group.

5 Now set up your camera movements in exactly the same way as you have done with other Matinee movement tracks, selecting the movement track then creating key events (pressing Return when focused on the timeline) and then moving your camera to a new position (see Appendix A: Core Concepts/Matinee for more). You can also create zoom effects by setting values on the FOVAngle track.

6 In your [Level Blueprint] create a <Get Player Controller> node, then drag out of its Return Value to create a <Set View Target With Blend> node.

7 With your Camera selected in the ➡Viewport, right-click in the ➡Event Graph and Create a Reference to Camera Actor. Now connect this to the New View Target of the <Set View Target With Blend>. The blend functions act like a crossfade between the player camera and this new camera.

8 Connect an <OnActorBeginOverlap> event from your [Trigger] to the <Set View Target With Blend> and then connect its output to a <Play> node that targets a reference to your Matinee.

9 To switch back to the player camera view when the Matinee has finished, create a <Matinee Controller> for your Matinee and connect the Finished output to a second <Set View Target

With Blend> that uses the **<Get Player Controller>** as Target and a **<Get player character>** as the New Target.

10 See the illustration of our system above for further guidance.

11 So far you have a flythrough where you will hear the in-game ambience from the point of audition of the camera. Now try setting up a more cinematic cutscene approach.

12 Open your Matinee and create a New Director Group. Put another [**Camera**] in your level and a New Camera Group in your Matinee. Setting key events in the director group will now allow you to swap cameras.

13 You will notice as you cut between cameras that the panning of the ambient audio is quite disconcerting. Try using a {**Sound Mix**} to mute the ambience at the start of the Matinee and use Sound Tracks in the Matinee itself for your cutscene sounds. See Chapter 08 for how to push and pop Sound Mixes.

14 A New Audio Master Track in your director group will also allow you to control the overall volume of any sounds played by the Sound Tracks in Matinee.

Cameras and the Listener

The second button on the *****Rooftop***** area (Bookmark 8) puts you in control of one of the tanks in the street below (W, A, S, and D to move and right mouse button to fire).

While in the tank, you can change the camera viewpoint in the way that you might in a racing game from the default camera to bumper cam or heli-cam by pressing E.

In the "Tank" section of the [**Level Blueprint**], you can see how we <**Set View to Target with Blend**> to switch to the tank's camera.

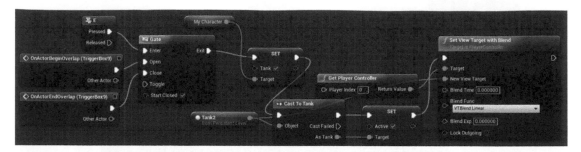

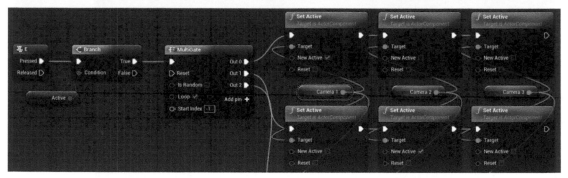

Then in the [**Tank**] Blueprint, the <**Key Event**> E is used to change which cameras are active. You can see how the cameras and their positions are set up in the ➡ Viewport of the Blueprint.

Exercise 07_17: Changing Cameras (and Listener Positions)

In this exercise you are going to explore the system for setting up and swapping between first and third person cameras.

<Set World Location>

1 Go to the ➡ Viewport of the [**MyCharacter**] Blueprint. In turn select the TPSCameraPos, and the FPSCameraPos. These are scene components that represent the third person and first person camera positions. Try moving them to a new position.

2 The # key swaps between these positions when playing the game.

3 Now look in the **[MyCharacter]** ➡**Event Graph**. This uses the system below to **<Set World Location>** of the camera component to the world location of the camera position scene components.

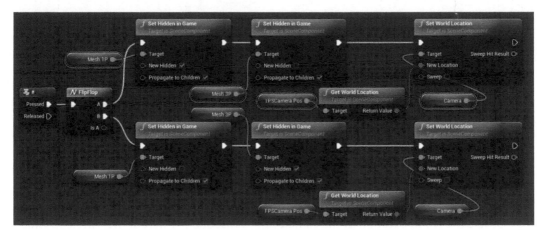

4 Try creating a new Scene Component (in the ➡**Viewport** panel) and positioning this as a 'Heli-Cam'. Go the ➡**Event Graph** and with the Hel-cam scene component selected in the components tab right click to create a **<Get world location>** node. Copy and paste one of the existing **<Set world location>** and **<Set visibility>** systems and attach your **<Get world location>** to the new location input. Set up the visibility states of the first and third person meshes depending which one you want to see. Replace the **<FlipFlop>** with a a **<MultiGate>** **(Set to loop)** to cycle between your three perspectives.

Separating the Camera and Listener Position

One thing that will take careful consideration among your team is where the player will hear the sound from. For a first person game, this is obvious—you will hear the world from the location of the player's head (i.e., the camera's location as set in the ➡Viewport of the [MyCharacter] Blueprint).

For 2D, third person, or fixed isometric view games, this is less clear. In some instances the sound remains attached to the player, but more often it is heard from a location in space somewhere offset from the player (i.e., the camera's position). When using a third person camera, we get a wider perspective than in first person view. We may see things that are out of sight of the player character. Sound from the camera's point of view can lead to you hearing things that you cannot actually see or to hearing the indoor ambience when the player character is still outdoors and vice versa. If you use the # key in the *Urban Warfare* level, you can switch between first and third person views and hear what we mean (the street at Bookmark 2 is a good place to hear this). This just sets the World Location of the camera, and consequently that of the listener position, to that of the different camera locations as defined in the Viewport of the MyCharacter Blueprint. See the "Cameras"section of the [MyCharacter] Blueprint.

When playing a 2D game, if we hear from the camera's perspective then we will hear everything on screen all the time, irrespective of whether the player character is actually close to the sound sources. However if we listen from the player character's perspective, this also sounds strange, as we will have sounds panning across quickly as the player passes them.

For the *Cave* level (Chapter 02), we have set the listener position to be between the camera and player, as this gives the best compromise between the two extremes. When the level starts, a <Set Audio Listener Override> is triggered. The [AudioListenerPosition] that is now set as the new listener position is an in-game Actor that we have attached to the player with an offset in the X-axis so it is further towards the camera (for more on attaching Actors to each other, see Appendix A: Core Concepts/Attaching: Attaching Game Actors to Other Game Actors).

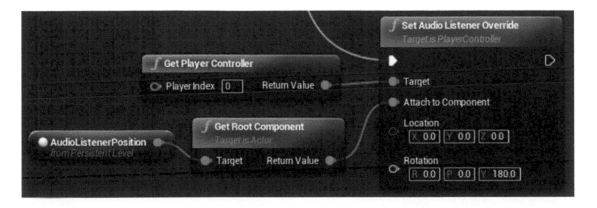

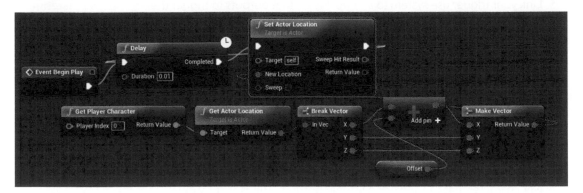

These are all tricky problems to solve, and the choices will mainly be down to the character of the game you are working on and what feels appropriate. You will also need to consider the falloff distances, whether or not to spatialize, and the radius within which spatialization stops (the non-spatialized radius), and experiment with these until you find an approach that works for your particular set up. (The Console command "Stat Sounds" will print the current audio listener position to screen—See Appendix A: Core Concepts/Console Commands).

Exercise 07_18: Listener Position for Listening Device

In this exercise you are going to set an alternative listener position for your player. Behind a large door in the *Outer Walls* area of the exercise level (*Guard Room*), some guards are having a heated discussion about the state of the security procedures around the city. You have a listening device that you can sneak under the door.

<Set Audio Listener Position Override>

1 Put a [Trigger] close to the door and set up a trigger use system.
2 In your [Level Blueprint] create a <Set Audio Listener Position Override> node (you might need to turn off Context Sensitive in the graph action menu).
3 The guardroom has an audio volume around it with ambient zone settings to muffle the dialogue. You need to find the XYZ location of a position inside the *Guard room*. The easiest way to do this is to place an object at the position you want (for instance a [Note] from the ➡Modes panel) and then make a note of its XYZ location settings (in the Transform section of its ➡Details panel).
4 Create a <Get Player Controller> node and connect this to the target input of the <Set Audio Listener Position Override>. Enter the coordinates you just noted in the <Set Audio Listener Position Override> node.
5 Link your trigger use system to a <Flip/Flop> that outputs to trigger the <Set Audio Listener Position Override> node or a <Clear Audio Listener Position Override>.
6 Play the game and you should now be able to use your listening device to better overhear the conversation.

Exercise 07_19: Offset Listener Positions

There may be instances where you want to separate the listener position from the camera, for example in a third person view where you want the player to hear the world more from the character's perspective. In this exercise we will look at creating a dummy component within the player character that can serve as a listener position. This is slightly different to the 2D example used in the Chapter 02 *Cave* level referred to above since this will rotate with the player rather than be fixed at an X-axis offset.

1 Open the {MyCharacter} Blueprint and go to the ➡Viewport tab.
2 In the ➡Components Panel choose Add Component / Scene, and name it ListenerPos. Move it to the location relative to the player you want to hear the sound from.
3 In the [Level Blueprint] create a <Get Player Character>, then turn off the context sensitive option to find a <Get Child Component> node. Connect the Return Value of the <Get

Player Character> to the *Target* of the <Get Child Component. (It will automatically create a conversion node).

4 Create a <Get Player Controller> and connect this to the *Target* input of a <Set Audio Listener Override> (again you may need to turn of Context Sensitive to find this), then connect the *Return Value* of your <Get Child Component> to the *Attach to Component*.

5 You then need to tell the <Get Child Component> node which Child Index to reference. If you look back in the [MyCharacter] ➡Components panel you can see that your ListenerPos is a child of the Capsule component. Count down through the components (0,1,2,3,etc) to find the Index number for your component (probably 9).

6 In the [Level Blueprint] set up a Key Press to <Flip/Flop> between triggering the <Set Audio Listener Override> and a <Clear Audio Listener Override> to test your system.

Conclusion

The ever-increasing power of game consoles gives us the opportunity to replicate real world physics as never before with proprietary systems that enable ray tracing for occlusion, real time delayed reflections, and filtering and convolution reverbs. Although this power can be important in enabling us to create a convincing sense of reality in games, next we need to consider when and how to use audio beyond the real in support of gameplay or narrative.

For further reading please see the up-to-date list of books and links on the book website.

Recap:

After working through this chapter you should now be able to:

- Use nested reverbs and prioritize these;
- Use appropriate distance algorithms for a variety of sources;
- Create obstruction, occlusion, and exclusion systems using ambient zones;
- Move sounds and objects using Matinee;
- Implement physics-based audio systems such as the speed of sound, Doppler, and collisions;
- Add sounds to animations and implement footstep and Foley systems;
- Use cameras for cutscenes and control the listener position.

Making It Good | 08

Summary : The roles and function of audio in games, mixing

Project : DemoCh08SpaceShip01 **Level :** SpaceShip01

Introduction

For a long time sound has developed with the aim of matching the increasingly photo-realistic look of games, hence "making it sound real". It's true that to some extent, one role of sound is to support the visuals by creating a sense of reality, adding weight and substance to what are after all simply a bunch of pixels. However, the exclusive pursuit of realistic sound displays a lack of understanding about how the human brain deals with sound. Here's the key point, and it's a biggie—with regards to the human sensory system, there's no such thing as 'reality' when it comes to sound. Take a moment, breathe deeply, and we will explain.

If you had 40,000 speakers, then it might be worth trying to accurately represent a real soundfield, and then we could use our perceptual mechanisms in a way akin to how we use them in the real physical world. As this isn't realistically possible (yet), we need to realize that the usual ways of listening do not apply. The phenomenon described as the cocktail party effect explains how the brain uses the difference in the time that sound arrives at each ear, and the difference in the sound itself (due to the head filtering and attenuation of one ear's version, depending on the direction of sound) to enable us to focus our aural attention on things of interest (i.e., at a cocktail party where there are many sound sources, you can still tune in to the fascinating conversation of the couple by the door who are discussing what an idiot you are). If you put a microphone in the middle of the cocktail party, made a recording, and listened back, it would be chaotic (unless it was a very boring cocktail party). With your *subjective* listening, you can choose to tune into different voices, but with the microphone's *objective* hearing, when you listen back to the recording, you won't be able to make anything out. In other words, microphones *hear,* but people *listen*.

Without a fully functional soundfield, we are no longer able to do this. It is therefore our job as sound designers to decide from moment to moment what the most important sounds are for the listener/player. If we try and play everything all the time, then we're going to end up with sonic mud that the user cannot decipher.

When deciding on what you want the player to hear, you'll obviously talk to the designers about the goal of the player in a particular scenario or the arc of emotion they want them to experience. We'll talk more about the functions of audio in games below and hopefully some of these ideas will inform your approach, but first let's consider some basic principles of the mix.

Mixing

Summary : Using Sound Classes and Sound Mixes

General Mixing Principles

There are some parallels to be made between the discipline of mixing sound for films and that of mixing for games, but perhaps a more fruitful comparison is to look towards music production. Film's language of distant, medium, and close-up shots means that the nature of the soundtrack is very often that of a shifting focus rather than an attempt to represent the soundscape as a whole. If you listen to an action sequence in a film, then you will notice that the mix is radically altered from moment to moment to focus on a particular sound or event and so is actually quite unlike the mix for games where, as the player is in control and the perspective fixed, we often need to try to represent many events simultaneously. We can use focus for specific effect, but the need to provide information to the player means that there often will be many elements present, so the challenges are more akin to those of music production than film production.

In a music mix, you have a number of simultaneous elements that you want the listener to be able to hear and choose what to focus on. You are allowing the listener the possibility of selective listening. In order to achieve this, you might think in terms of the arrangement, the panning, relative volumes of instruments, compression/limiting, EQ, and reverb. In a typical soundscape for a game, our concerns are similar.

Arrangement

The number of simultaneous sound sources—a product of the game's activity map, voice instance limiting, and occlusion

Panning

The spatialized nature of the sound sources (3D spatialized, stereo, and multichannel)

Volume

A product of the actual volume of the source together with the source's attenuation curve

Compression/Limiting

The overall headroom limitations of combining 16-bit sound sources

EQ

The design and nature of the sound sources themselves in terms of their frequency content

Reverb

The different game environments and their reverberant nature

If we consider the arrangement, we can see that the concept of mixing actually starts with the design of the game itself. The events in the game will govern the density and nature of the sound and music at any given moment. In the past, game audio has too often been treated as a fixed system—a network of processes put in place and then left to get on with it. Mixing a game needs to be integrated with the game design and should be dynamic and responsive to gameplay. Our game may vary significantly in terms of the intensity of the action taking place, and this should influence our choices.

For instance it might be more "real" to have a long hall reverb type in a particular game location, but if you know that the game design means that there's going to be a battle taking place, then this will affect your decision regarding the wet/dry mix of the reverb, or to have the reverb there at all. You will also make different decisions about the panning (the type of spatialization) and attenuation curves depending on the number of potentially simultaneous events, the distances involved, and the relative importance of being able to identify point sources.

In periods where there are likely to be fewer sound sources, these could be richer sources in terms of frequency content. If there will be many simultaneous sources, then you'll want to plan the frequency content so that they're not all fighting for the same space. You might dedicate certain ranges for the music or for the dialogue, leaving others for the main power of the sound effects. In the soundfield represented below, the different elements have some overlap in terms of their frequency range but enough difference so that when they are heard at the same time (imagine the image below being squashed in from each side) each one still has some room (another interesting approach is to tune your effects to fit with the music).

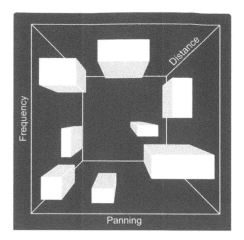

As well as the nature of the sounds themselves, it's worth considering a consistent starting point regarding the relative volumes of the different elements of your soundscape (although this can change dynamically as we'll see below). Some have approached this by setting some general ground rules for different types of sound (for instance the Unreal Engine guidelines suggest dialog ~1.4, music ~0.75, weapons ~1.1, and ambience ~0.5). This is of course based on the premise that the raw sound files are themselves at equal volume in the first place. We know of course that there's no such thing as equal volume, as our perception of loudness is subjective and dependent on the frequency content of the sound, not its amplitude. Having said this most people find that some kind of normalization strategy applied to groups of sounds in their DAW can save a lot of individual tweaking later (normalization is a basic function of any DAW that will scan the audio file to find the peak value and then increase the gain of the whole file so that this peak does not exceed a given value). Theoretically you should normalize all assets to 100%, as every good sound engineer knows that mixing should be a process of gain reduction, not boost.

Unfortunately in some genres, there can be an expectation that loud is good, but this doesn't recognize that our perception of volume is actually very subjective. Humans do not have an inbuilt reference level for volume, so we will compare the volume of a sound to the volume of the other sounds we have heard within a recent time window. If you are sitting quietly in the kitchen in the middle of the night desperately trying to finish writing a book and accidentally knock your cup of tea off the table, sending it crashing to the floor—this is loud. As you walk over to the aircraft that is warming up on the runway then you will also consider this to be loud. Intellectually you know that the jet engine is probably a lot louder than your breaking cup, but psychologically the cup felt louder! You will want to use the full dynamic range that you have available in order to highlight the differences between your quiet sounds/music and your loud sounds/music. In order for this event to feel loud, the other events around it must be by comparison relatively quiet. If everything is loud all the time then your players will simply turn it down and nothing will actually feel loud because your players have not experienced a quiet to compare it to.

Reference Levels

Mixing for cinema has long established a reference level to mix at, which is then replicated exactly in the auditoriums. Within this controlled environment, you know that audiences are going to be experiencing the film at exactly the same level that you are mixing at. Although there have been efforts to establish a common approach in games (such as an average of -23 LUFS—see this chapter's Further Reading section on the website for more background to this), there remains a variety of practices.

People play games in a variety of environments and circumstances and through a variety of mediums, from headphones to a mono television to a 7.1 THX-certified surround sound setup. If you are not mixing within a professional environment (and as beginners we'll assume that most of you aren't), then a good rule of thumb is to use other media to set a comfortable listening level—and then stick to that. Your users are typically going to be using their consoles for watching films and TV as well as listening to music, and they are not going to want to have to leap up and adjust their volume as they move between these media.

Sound Classes and Sound Mixes: The Unreal Engine Mixing System

When you are mixing a large number of elements, you obviously don't want to have to adjust the volume of each individual one every time you make a change. You can relate this to how you might mix music—by adding all of the drum elements (snare, kick, hi hat, and cymbals) to one group or bus called "Drums", you can quickly adjust the overall volume of all of them.

Sound Classes are the Unreal Engine's version of groups or buses. By assigning all of your sounds or music in the game to different Sound Classes, we can then affect them as a group. You can also set up linked hierarchies in the ➡Sound Class Editor/➡Graph and opt to affect any children of a particular class as well, for example not only having control over higher level categories such as music, dialogue and effects, but also having independent control over subcategories such as effects/ambience, props, or character classes.

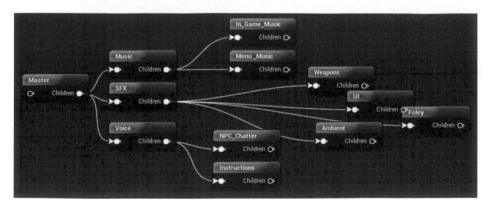

When we want to apply a {**Sound Mix**} to change the volume or pitch, we designate which classes we want it to affect (and whether the changes should apply to their children).

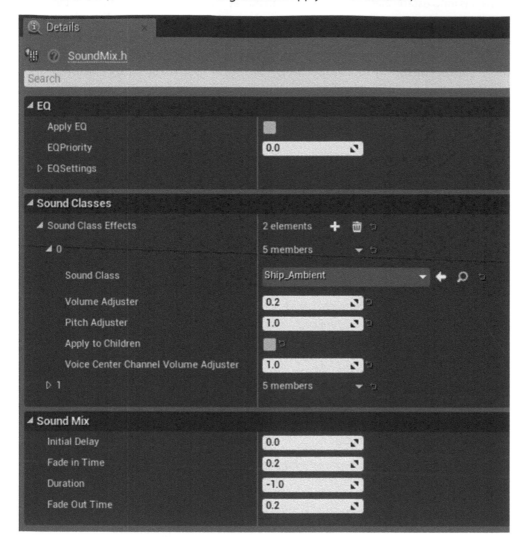

We'll go into this in more detail in a moment, but first we should note that the Sound Class also allows us to set up some additional properties for its members.

Sound Class Properties

Use the ➡ Content Browser filters to search for Sound Classes and double-click to open the ➡ Sound Class Editor. Select a Sound Mix in the -Graph window to view its -Details panel.

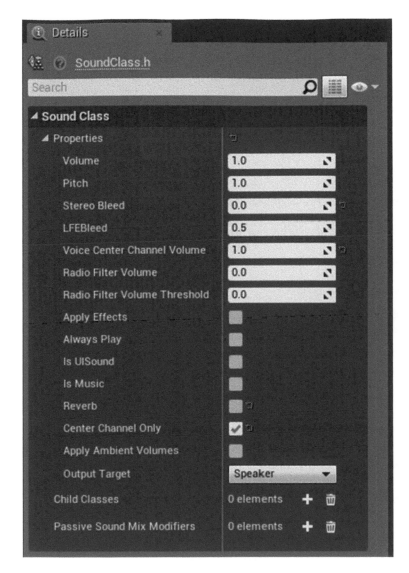

The Volume and Pitch apply a master control to anything attached to this class.

Stereo Bleed refers to the amount of a stereo sound source that should bleed into the surround speakers.

LFE Bleed is the amount of sound to bleed to the LFE channel (the low frequency effects channel that goes to the subwoofer speaker). You might want to avoid this for most sounds, saving the effect for specific instances.

Voice Center Channel Volume is the volume of the source that will go to the center channel or center speaker in a 5.1 and 7.1 speaker setup. This is traditionally reserved for dialogue in the cinema, and it can be useful in games if it is more important that the dialogue is heard than spatialized. You can also change this dynamically via a {Sound Mix}.

Radio Filter Volume and Radio Filter Volume Threshold applies a radio-like filter and setting to the sounds if the volume falls beneath a given threshold (i.e., it is heard through the center speaker and does not attenuate over distance).

Apply Effects governs whether sounds belonging to this class have effects such as filtering applied.

Always Play will prioritize the sound above others in a limited voice count situation.

IsUISound determines whether or not the sound will continue to play during the pause menu.

IsMusic designates the class as being music or not.

Reverb controls whether Reverb is applied to this class.

Exercise 08_01: Sound Class Properties

In this exercise you are going to add some instructional dialogue for your player in the style of radio-ized messages from your captain in the control room back at base.

{Sound Class}

1. Pick an area of the exercise map where you might want to give the player some instructions, for example about blowing up the wall in *Cave 02*, how to operate the machines in the *Final Cave*, instructions for removing the blockage in the *Mountain Pass*, or what they have to do in the *Outer Wall Vaults* in order to open the inner gate to the city.
2. Create your dialogue (maybe with radio type EQ and distortion effects) and assign it to a <Play Sound Attached> node.
3. Place a [Trigger] in the level and an associated <On ActorBeginOverlap> event in the [Level Blueprint] to trigger your <Play Sound Attached>.
4. Create a new {Sound Class} asset in the ➡Content Browser using Add New/Sounds/Sound Class, and name it {Radio_Dialogue}.
5. Double-click this to open the ➡Sound Class Editor.
6. With the node of your Sound Class selected in the ➡Graph, look at the ➡Details panel on the left and expand its properties.
7. Since this is instructional dialogue theoretically played back over the radio to the player's headset, we want to not apply reverb and set this to the center channel speaker if the player has a 5.1 setup. Uncheck the Reverb option and check the Center Channel Only option in order to achieve this.

8 You could alternatively control the amount of sound going to the center channel using the Voice Center Channel Volume option.

9 To make these options apply to your dialogue, you need to assign it to this {**Radio_Dialogue**} Sound Class. You can do this either through the ➡ **Generic Asset Editor** of the Sound Wave (double-click), or if you are using a Sound Cue, do it in the ➡ **Details** panel of the -Output- node.

10 The Sound Class settings of a Sound Cue will override those of any Sound Waves placed in it, so always check this if you are not getting the results you expect.

11 Play the game and test. Obviously you won't hear the center channel effect if you are listening with just stereo speakers or headphones since this is a 5.1/7.1 specific function, and you'll only note the absence of reverb if you're within an audio volume.

12 On a console that supports this functionality, you can also set its output target to be the speaker on the controller itself.

The Roles and Functions of Game Audio

Summary : Exploring some of the roles and functions of audio in games

Before you start thinking about a game mix, you need to be clear on what you want to be heard and why. In order to make a real contribution to the game, you should familiarize yourself with the roles and functions of audio so that you can be an advocate for its effective use. This way you can try and avoid the spreadsheet mentality of "See a ventilation shaft, hear a ventilation shaft." Look for opportunities to experience subjective or interpretive audio, sound that is heard via your character's emotional state or focus, as opposed to the strict realism of simply representing what's there. Don't be afraid to let go of the real.

As well as all of the storytelling and emotional functions that we're familiar with from film, audio plays a vital role in enabling players to achieve mastery of the game by providing them with information. These ludic (specifically game related) functions typically fall into the types outlined below, and we'll spend this chapter (and level) exploring some illustrations of these, as well as exploring mixing techniques. Since this chapter is really about principles, we'll go into some detail on the new mixing aspects on *Floor 01*, but after that we will just talk about the concepts at work.

The I.N.F.O.R.M. Model

Instruction

Audio to direct or encourage approaches to gameplay

Notification

Unsolicited audio conveying information about game, character, or object states that may prompt the player to perform certain actions or attend to certain matters

Feedback

Audio in response to action instigated by the player that indicates confirmation or rejection or provides reward or punishment

Orientation

Audio that geographically (or metaphorically) orientates the player

Rhythm-action

Synchronized input as a game mechanic (we'll be looking at this in detail in Chapter 12—not here)

Mechanic

Audio that is used directly as a game mechanic (excluding rhythm-action mechanics)

Instruction

There are many ways to convey information without instructional dialogue, but it remains a fundamental part of many games. The most obvious (but sometimes overlooked) thing to bear in mind is that your instructional dialogue must be audible! In some circumstances you will have control over all the sound sources in a room, in which case you can balance them so the dialogue is easily heard, however there may be other situations (in the heat of battle for example) where it is more problematic.

Sound Mix: Triggered Ducking

Project: DemoCh09SpaceShip
Level: SpaceShip01

You can skip between the areas of the ship using the keys 1–0.

There are a variety of circumstances where you might want to duck (attenuate) all the sounds or music in order for a specific sound to be heard, but this is most commonly used for instructional dialogue.

As you awake in the *Floor 01: Sleeping Quarters* (Bookmark 1), you're told "Wake up, the ship's under attack!". The console command Stat Soundmixes will display the active soundmixes to the screen while you play and it might be useful to do this for the following sections so that you can see what's going on.

As this dialogue is played, a {Sound Mix} is pushed on, and when it completes it is popped off.

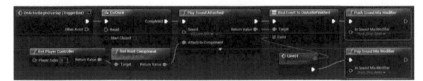

The other sounds in this area are set to belong to the Sound Classes: {Ship_Ambient}, {Exception_Class}, and {Tannoy}.

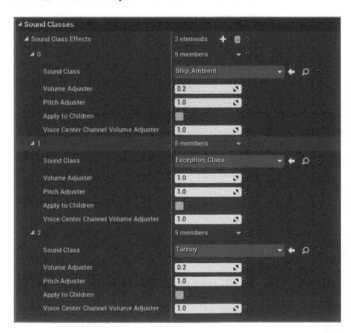

The Sound Mix {Duck_Ship_Ambient} is set to apply itself over 0.2 seconds and then remain on (duration settings of -1.0 stay on indefinitely). Since this mix doesn't have a set duration, we then need to remove it (pop) when the dialogue line has finished, which we do using a <Bind Event to Audio

Finished>. The effect of this is to duck down all the other sounds so that the instructional dialogue line can be clearly heard.

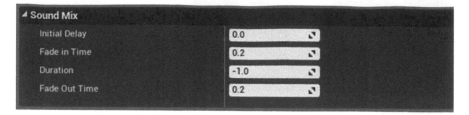

Sound Mix: Triggered EQ

In the *Floor 01: Corridor* you're told "Get out of there! You need to get to the bridge!" Note how this time the ducking effect is a little subtler—instead of reducing the volume of everything, we're applying an EQ setting via the Sound Mix to allow the dialogue to punch through the other sounds.

Although we've used it here for dialogue again, this technique is equally applicable when you want to highlight a big sound effect event while music is playing. Music, particularly a dense orchestral arrangement, often takes up a large range of frequencies, so the use of the EQ within the Sound Mix function is very useful in notching out a frequency range for a specific sound effect to momentarily shine through without disrupting the musical flow. The system for turning the mix on and off is the same as above.

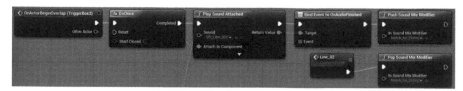

This time we're calling the Sound Mix that applies the EQ {Notch_for_Dialogue}.

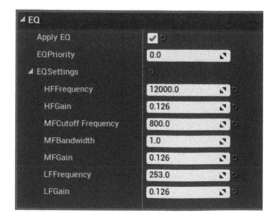

The EQ is a three-band EQ with a high and low shelf and a parametric mid. The frequency is in Hz, the gain is from 0.0 to 1.0, and the mid frequency bandwidth ranges from 0.1 to 2.0. One of the best approaches to working out some appropriate settings is to record the audio for a sequence of your gameplay and import this audio track into your DAW. There you can play around with the EQ within a slightly friendlier environment before attempting to imitate these settings within the Sound Mix. If you look in the "Initialize" section of the Level Blueprint you'll see that we've also implemented a {WakeUpFilter} mix as the level starts.

Exercise 08_02: Triggered Duck and EQ

In this exercise we are going to make the cave wall explosion in *Cave 02* a little more impressive by implementing a simultaneous Sound Mix change.

{Sound Mix}, <Push Sound Mix Modifier>

1 Go back to the *Cave 02 Upper* section of the exercise level and find the layered explosion system you implemented for blowing up the tunnel wall in Exercise 02_04.
2 We are going to use this event to trigger a {Sound Mix}. This will duck the ambient sounds and apply some EQ.
3 First you need to find all the sounds that you might hear in this area. Assign all of these Sound Waves or Sound Cues to the {Ambient} Sound Class.
4 Find the Sound Cue that you created for the explosion here ([Rock_Explosion_01], and assign this to a new {DoNotDuck} Sound Class.
5 Add a new {Sound Mix} in the ➡ Content Browser called {Duck_Ambience}.
6 Double-click this to open its ➡ Details. Under the Sound Classes/Sound Class Effects options, add a new element using the + sign and assign your {Ambient} Sound Class.
7 Set the Volume Adjuster to 0.2 so that when this Sound Mix is called all sounds that belong to the {Ambient} Class will be ducked to 0.2 of their original volume.
8 Set the Fade in Time to 0.0, the Duration to 2.0 seconds and the Fade Out Time to 3.0 seconds.
9 Go to your [Level Blueprint] and insert a <Push Sound Mix Modifier> node from the Output of the <Play> that plays your explosion sound (if you've done Exercise 07_04, you'll have a <Set> to change the ambient zone, so connect to this instead). Reference your new Sound Mix {Duck_Ambience} in this node.
10 Try this out in game, and then try applying some EQ changes as well. These are set in your Sound Mix {Duck_Ambience}. Remember that EQ will only apply to sounds that belong to classes that have their Apply Effects option checked (you can see what mix is active using the Console command "Stat Soundmixes")
11 You might also want to trigger a {Shellshock} tinnitus type whining sound when the explosion goes off. Assign this also to the {DoNotDuck} Sound Class.

Passive/Automatic Mix Changes

Passive Mixes for Dialogue

Obviously setting up a push/pop Sound Mix system for every line of dialogue in your game is going to be a pain. Fortunately the Sound Class has the functionality that allows us to call a specific mix (when certain criteria are met) whenever a sound registered to that class is played.

After the explosion in *Floor 01: Corridor*, a hole is punched through the wall into the *Floor 01: Server Room* and you're told "Go through the lab section to your left. Hurry—the airlocks are going to go!"

This line {Vo_Line_003} is assigned to belong to the {Ship_Dialogue_With_Passive} Sound Class. As you can see in the ➡ Sound Class Editor, this has a passive Sound Mix that calls the {Duck_Ship_Ambient} mix. Anytime a sound belonging to this Sound Class is played, it will automatically apply this Sound Mix. It will also automatically pop off the mix when the sound has finished playing—which is handy!

Passive Sound Mixes have some additional parameters (min volume/max volume thresholds) that govern whether they actually start or not and you can set these according to the following three different usage scenarios:

a. Always Apply the Mix

If you want the mix to always be applied, then set your Min Volume Threshold to be 0.0 and your Max Volume Threshold to be high (e.g., 10.0). When a sound from the designated Sound Class plays, then its volume will always be above the Min Volume Threshold and below the Max Volume Threshold, therefore the Sound Mix you've referenced will be applied.

b. Auto-ducking Other Sounds If Designated Sound Class Is Too Quiet

If you only want the mix to be applied if a sound is played too quietly, then set your Max Volume Threshold to the cutoff point from where you want the mix to be applied. When a sound from the designated Sound Class plays at a volume between 0.0 and max, then the Sound Mix will be applied. Typical use would be to assign this passive Sound Mix to your dialogue class so that if the dialogue is playing too quietly, it will auto-duck everything else so you can hear it.

c. Dynamic Range

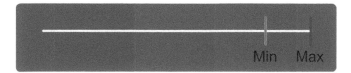

If you want something to have a particular impact, then you can temporarily duck the other sounds to give it more headroom. This clears the voices that you probably won't hear anyway and allows a greater dynamic range. If the sound plays loudly (i.e., above min threshold but below max) then the Sound Mix will be applied.

Note that the values of min/max are derived from the volume of the sound. That is its playback volume as designated by its attenuation curve. This is not the same as the sound's actual volume. Many systems in other engines do actually track the real volume of the sound, which is more effective for this kind of side-chain effect.

Auto-attenuation or Culling for Dynamic Range

If you go to the end of the corridor, you can hear an explosion sound with the Dynamic Range effect referred to above. The Sound Cue {Explosion_With_Passive_Cull} belongs to Sound Class {Culling_Class}. For its passive Sound Mix, the Min Volume Threshold is set relatively high, so the culling effect will only take place when it is loud. If you walk close to it, you can hear that it is a dramatic loud explosion that momentarily blocks out all other sounds, but as you're further away becomes more of a background sound.

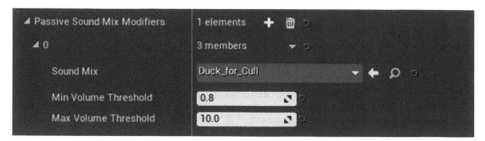

As we discussed at the opening of this chapter, we notice changes and differences in volume rather than having an awareness of absolute values. If you have a big event happening that you want to have real impact, then the best effect is going to be achieved by preceding it with a quiet section to make the dynamic contrast more dramatic. This is of course not always possible, but in addition to the culling technique outlined here, you could also affect a preduck strategy that momentarily brings all the sounds down in volume immediately before loud events such as explosions or car crashes.

All platforms have some sort of built-in limiting system to stop distortion. These are often clumsy and unpredictable, and so it's really best to avoid these systems having to be applied in the first place. There are also, however, increasingly intelligent systems of automation that can really help the overall mix of the game. Given the huge dynamic range of sounds in the physical world and the limited dynamic range that can be represented by 16 bits of information, it is not surprising that achieving the feeling of a wide dynamic range in games is a particular challenge. We've discussed how the level design can contribute to this, but we also need systems in place that will allow for the intelligent management of which and how many sounds are playing so that the combinations of these sounds do not cause clipping and bring in the blunt instrument of the limiter. Chirping insects may add an important element of immersion to a game environment when you are creeping around, but in the midst of battle you will not hear them, as they will be masked by the louder sounds. An automated system that monitors the current levels of the sounds at the player's location and will cull the quieter elements, that you won't hear anyway, will both clean up the mix in terms of frequency content and create some additional headroom for the sounds you do want to hear.

There has been a considerable amount of clever work done on interactive mixing for game audio in recent years that falls outside of the introductory remit of this book. We would encourage you to undertake some further reading in this area by following the links on the website.

Exercise 08_03: Passive Mixes

In this exercise we are going to set up an automated ducking system for whenever dialogue is played in the game.

1. Create a new Sound Class {**Dialogue_Ducking**} and assign all your dialogue Sound Waves or Sound Cues to it. Remember you can select and adjust multiple Sound Waves simultaneously by selecting them all and right-clicking to open a ➡**Generic Asset Editor** that will apply to all.
2. In the Passive Sound Mix Modifiers section of the {**Dialogue_Ducking**} ➡**Details** panel, add an element by using the + sign.
3. Reference the Sound Mix {**Duck_Ambience**} you just created in Exercise 08_01 since this is already set up to duck any sounds belonging to the ambient class.
4. Set its Min Volume Threshold to 0.0 and its Max Volume Threshold to 10. This will ensure that it is always called.
5. Play the game. You should find that every time your dialogue is played the ambient sound ducks out. You might want to create a new {**Sound Mix**} since the settings of the {**Duck_Ambience**} you used for the explosion may not work as well for dialogue ducking.
6. If certain sounds are not ducking, then it's probably because they don't belong to the {**Ambient**} Sound Class. You could create additional Sound Classes for these and add them as Children of the {**Ambient**} Sound Class. You can do this by dragging and dropping them onto the ➡**Graph** of this class and connecting them as Children. Make sure the Apply to Children option is checked in your Sound Mix, and your Passive Sound Mix Modifier will now apply to these as well.
7. You might also want to set up a Passive Sound Mix Modifier for the weapons sounds so that they duck the quieter elements of the ambience (the area loops for example) or Foley. During weapons fire you probably would not hear these anyway, and by ducking them out we allow more headroom for the weapon sounds. Better still would be to only use the looping or retriggered elements of the weapon sound to instigate the duck so that the ambience is already coming back up during the tail portion, not waiting until after it has finished.

Sound Mix: Base Sound Mix and Mix Modifiers

All the Sound Mixes we've applied so far have actually been mix modifiers. These are mixes that you can push on or pop off at will and also apply simultaneously, as we will see in a moment. We can also apply a base Sound Mix via the <**Set Base Sound Mix**> node. This, however, is a permanent mix that you cannot pop off. You might have a use for this if you find that you want to make some global changes to the relative volumes of different types of sound or classes as a fixed setting across the whole game.

In the *Floor 01: Server Room* we have a problem. The airlocks are malfunctioning, and every 20 seconds or so all the air is sucked out and we are in a floating vacuum. Your helmet has a detect mode (press H) that should help you locate the passkey to the elevator at the far end.

For this scenario we need multiple Sound Mixes to be operating simultaneously, one for the air vacuum effect (which attenuates and equalizes everything out) and one for the detect mode (which highlights the beeping of the key in the mix). After a lead-in sound, {Airlock_Out_02} and the {Airlock_Malfunction} mix are implemented (this has a timed duration of 7 seconds, so doesn't need to be popped off). This mutes everything, including the {Exception_Class} that the {KeyCard} Sound Cue belongs to.

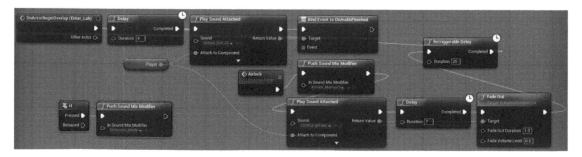

In order to bring this back up during the detect mode (instigated by the H <Key Press>), we apply another modifier mix. The adjuster settings work as multipliers, so if the {Airlock_Malfunction} mix

adjusts the volume of our {Keycard} by 0.1, then our mix modifier {Detection_Mode} needs to have a Volume Adjuster value of 10.0 to bring the overall volume back to 1.0.

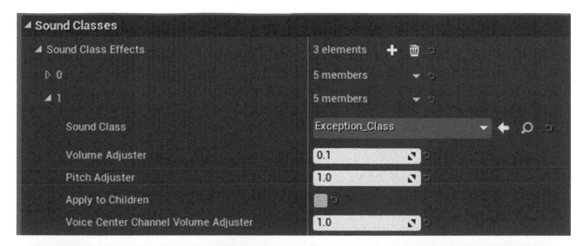

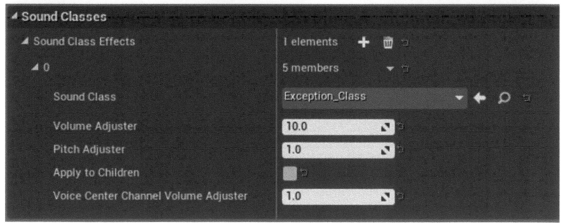

Note that as you can have multiple Sound Mixes at the same time, but not multiple EQs, there is also an EQ priority system to determine which EQ should take precedence. This uses the same approach to priorities that we have seen with the audio volumes and reverb (i.e., the higher the number, the greater the priority).

Sound Mixes have many uses in shaping a player's experience, but they are also very useful when prototyping and developing your level. It is very handy to set up some mixes that solo particular types of sound (ambience, music, objects, dialogue, weapons, cats, etc.) that you can call up with some shortcut keys. See the Testing the Mix section later in the chapter.

Exercise 08_04: Sound Mix Modifiers

In this exercise you are going to experiment with multiple Sound Mixes.

EQ priority

1 Find an area of your exercise level where there is a lot of different audio going on (the *Inner Sanctum* for example).
2 Identify all the sounds that are playing in this area. One way to do this would be to play the area and set the Console command "Stat Sounds", which gives you a list of active sounds on screen (you can also use the Console command "Stat SoundMixes" to display the active Sound Mixes). See Appendix A: Core Concepts/Console Commands.
3 Find out what Sound Class these are assigned to (in the ➡Details panel of Sound Waves or the -Output- nodes of Sound Cues).
4 Devise a Sound Mix to focus on a particular group of sounds (music, dialogue, fireworks, etc.), set up a <Key Event> in the [Level Blueprint], and trigger a <Push Sound Mix Modifier>.
5 Play the game to test that this works and then set up a new Sound Mix that might modify this one, for example the first mix might bring everything down apart from quiet ambience and dialogue, then you might apply a modifier mix that brings the music back up.
6 Remember that simultaneous mixes work as multipliers, so if you brought the music down to 0.2, you will now need to apply a Volume Adjuster of 5.0 to bring it back to 1.0.
7 Now try applying some EQ settings with your mixes and test out the EQPriority settings—remember that the mix with the higher value will override the other.
8 Don't forget that you can set up sophisticated systems of parent/child relationships within the ➡Sound Class Editor and choose whether or not your Sound Mixes Apply to Children.

Notification

Notifying the player about states within the game is a key role for audio.

Note that the gameplay and systems from here on are simply there for you to experience some of the different functions of audio in game, so we will not go into any detail regarding their systems or have any exercises (with the exception of the decoy system, which introduces the <Make Noise> function). But feel free to have a look yourself.

Character State

As you pass through the *Floor 02: Pipe Corridor* (Bookmark 2) section, you'll get repeatedly hit by the bursts of fire and steam shooting out from the pipes that line the walls. You'll need to pause on the way down in order to regain some health.

In order to notify the player about their current health state, we've applied both a Sound Mix (EQ) and a system that brings in a heartbeat sound on low health. These kind of subjective sound states that represent how a player character might be feeling through the audio can be very effective in immersing the player.

See the [BP_GAB_PipeExlosion] Blueprint and the "PlayerHealthSystem" section in the [MyCharacter] Blueprint.

NPC State

One of the most essential pieces of information that sound often provides us with is that of the current status of enemies or other NPCs in the world. In this instance (*Floor 02: Turret Section*), the NPC is actually a series of gun turrets that the player needs to sneak past. (Bookmark 3)

When the player is visible to the turrets, they power up and enter a scanning phase. If the player is still visible when this phase starts, they will fire, but if not they will power down when scanning is complete. It's important that the player knows what state the turrets are in so they can time their movements, and it's the audio that provides this information.

See the "Turrets" section of the [Level Blueprint] and the [BP_Turret] Blueprint.

Object State

Sound can also indicate the state of objects. In the *Floor 02: Mind the Gap* section (Bookmark 4), the player must try to cross a deep shaft by moving a series of girders into place.

The control panel is in a side chamber, so the player must rely on listening to gauge whether the objects are in position.

As you move each girder, the different sound elements change pitch to indicate the correct position to the player. This is done by reading through curves in <Timelines> to <Set Float Parameters>. The left hand button resets the system.

See the "Girders" section of the [Level Blueprint].

Game State

In the next area *Floor 02: Puzzle Pipes* (Bookmark 5), you must fix the broken pipes by finding suitable parts around the room. As you do so, you can hear the three steam sounds get muted one by one to indicate your progress.

See the [BP_GAB_Puzzle] Blueprint.

Feedback

This is audio that provides feedback on player actions either to just acknowledge input or to provide punishment or rewards.

Pickups

In certain genres of games (particularly platformers), the repetitive nature of the pickup sounds serve as a kind of conditioned response to punish or reward the player. Whether it's picking up stars, coins, or powerups, the sounds are there to reward the player with a pleasurable confirmation of achievement.

In *Floor 03: Power Cell Pickups* (Bookmark 6) you need to collect 6 healthy power cells and deposit them in the mechanism within a given time to power up the door. There are several healthy cells around the room, but unfortunately there are also some unhealthy ones too—these cause damage to the player. In the Blueprints for the two object types, there are different sounds that provide immediate positive or negative feedback to the player when they are picked up (collided with).

Although we have droned on a great deal about the need for variation in your sounds, these types of feedback sounds are an exception to the rule. These sounds are the equivalent of earcons in computer software, like the sound that tells you you've got mail, in that they are sounds that carry specific meaning. Although a typical coin or star pickup sound may go up in pitch if you collect more within a given period of time, for symbolic sounds like these, we are primarily interested in the information they convey rather than the sound itself, so the repetition of the same audio sample in this case is less of a problem than it has been in other circumstances. As the player is concerned with the learned meaning of the sound, rather than any information conveyed by the nature of the sound itself, we don't want the distraction of variation where the player might be forced to think about the sound more. If there were variations in the sound, the player would be forced to consider questions like why is this sound different and what is it trying to tell me, rather than simply being able to acknowledge the information that the presence of the sound has provided.

See the [BP_DoorAccessPanelGame], [BP_DoorPowerCell_Healthy] and [BP_DoorPowerCell_UnHealthy] Blueprints.

HUD Interactions

In the real world, sound is often used to provide a user with a confirmation of their action. Think of your cell phone or the ATM. Sound gives you the message that the button you've just pressed has in fact been acknowledged. This kind of confirmation sound is even more important in games, where the amount of feedback you get through their physical interfaces is often limited. Some interfaces may have rumble functionality, where you can get some (haptic) feedback to confirm your actions, but many have none and so it's important to have the player's interactions confirmed with sound as a representation of the tactile feedback of the physical world.

After you complete the powercell pickups task, the *Floor 03: Fuel Cell Storage Door* requires a key code (it randomizes between 592 and 437). When designing sounds to be used for this sort of menu navigation, you need to use sounds that somehow convey the notions of forwards/backwards and accept/decline.

It is difficult to generalize about the sounds to choose that might have these kind of positive (forward/accept) or negative (backward/decline) connotations. If we look at a rule of thumb from speech patterns that we could use, it might be that positive meanings are often conveyed by a rise in pitch, negative by a fall in pitch. By using slight variations on a few sound sources, it is easier to produce a positive or negative version that conveys this meaning than using completely different sounds. This also gives them an identity as a family of related sounds, rather than simply a collection of unrelated ones.

Your sounds will have more coherence and unity if you link them with the theme of the game world itself or with an aspect of the object that you're interacting with. If your game is set within a dungeons and dragons type world, then the UI menu sounds might be made of armor and sword sounds, if set in a sci-fi world, they might be more electronic in nature. If you're going to have menu music playing while the game is in this mode, then you might consider how the UI sounds will fit with this. You could pitch shift your UI sounds so that they were in the same key as the music so that they did not sound too abrasive against it, or you could use musical tones that fit with the style and notes of the background music. This may not be appropriate in all cases but can add a nice sense of polish to your menus.

See the [BP_DoorAccessPanelGame], [Player], and [WBP_HelmetHUDInterface] Blueprints.

Orientation

In addition to describing off screen space, audio can also serve the function of helping a player to navigate a level.

Navigate

The main corridors have been blocked on *Floor 04: Air Ducts* (Bookmark 7), so you'll have to navigate your way through the air duct system (press F for a flashlight, and C to crouch).

You can call up your tracking device (T) to help guide you through this maze of ducts. As you pass each juncture, the tracker will speed up if you're going the right way.

See the [Player] Blueprint for the flashlight system, and the "Ventilation Shaft Tracker" section of the [Level Blueprint] for the tracker system.

Attract

Audio can act to draw attention to things, whether it be objects in the game or on-screen instructions. In the *Floor 04: Corridor Hatches* area (Bookmark 8), you need to find three audiologs that have been hidden in security hatches. If you listen carefully, you can tell when you are walking over a security hatch, as the footstep sound changes slightly. Press E to open the hatch and listen to the audiologs.

See the [BP_Floor], [Player], and [BP_AudioLog] Blueprints.

Repel

As well as attracting players, audio can also repel them. This might be through hearing the presence of NPCs or more literally in the case of *Floor 04: Radiation* (Bookmark 9), where the player must avoid the radioactive pods and mines in the room. On proximity to the pods, you can hear radioactive sounds as they start to affect your health. The mines start beeping on proximity, and if you don't move away, they explode!

See the [GAB_Mine_BP] and [GAB_Radiation_Pod_BP] Blueprints.

Rhythm-action

We'll be looking at this concept in Chapter 12.

Mechanic

Audio can sometimes be an important game mechanic.

Recall/Learn

You need to hack your way into the final *Generator Rooms* (Bookmark 0). Hacking (by pressing E) the computer terminal in the room on the right gives you a pitched code. You need to recall this pitch sequence for the key code to the door.

See the [WBP_MusicalCodeHUD] Blueprint and the "Musical Key Code" section of the [Level Blueprint].

Decoy

There is a guard patrolling this area. Do not attempt to tackle her directly but instead lure her over to a corner so that you can sneak past. Press R to throw an object that will make a noise and cause the guard to investigate (the player's footsteps and gun shots will also alert the guard, so press Ctrl to sneak).

Since there is a new audio technique being used here, we'll go into it in a little more detail. The [**Player**] Blueprint handles the throwing of the [**ThrowObject_BP**] projectile.

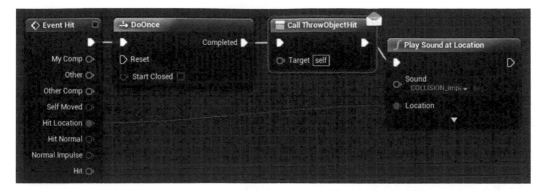

When this hits something, it plays an impact sound and calls an event within the [**Player**] that triggers a <**MakeNoise**> node. Only pawns can have a pawn noise emitter component or a pawn sensing component, so although the make noise event comes from the location of the hit event, this is why we have to do it in the player Blueprint.

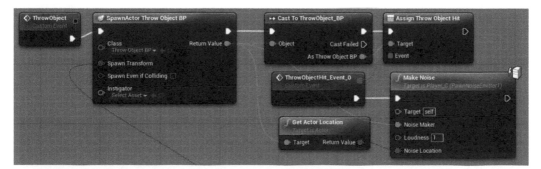

The bot, [**BotChar_NewMesh**], contains a pawn sensing component that listens for the Make Noise event, and its behavior tree {**BotAITree**} references the Blueprint [**BTS_CheckForEnemy**]. Should the bot hear the make noise event, this changes the bots usual patrolling behavior so that it now goes to the location of the noise source.

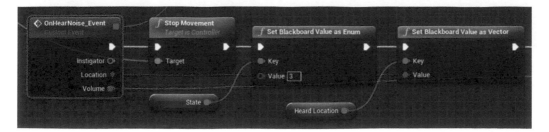

329

Exercise 08_05: Make Noise

In this exercise you will implement a make noise event to draw the guards away from the gate to the *Inner Sanctum*.

<Make Noise>

1 You can bribe the guards at the gate to the *Inner Sanctum*, but you can also lure them away by making a noise.
2 Open the [MyCharacter] Blueprint and create a <MakeNoise> node in the "Make Noise" section of the Blueprint. Create a key press 'N' event to trigger this <MakeNoise>. (The MyCharacter Blueprint already contains a PawnNoiseEmitter component which is required for the <MakeNoise> to work).
3 Create a <Get Player Character> node and set this as the creator of the noise by connecting it to the *Noise Instigator* input of the <MakeNoise> node.
4 Create a <Get Actor Location> node and connect this to the *Noise Location* input to define the origin of the noise.
5 Now when you play the game, you can make a noise (N) and the guards will come and investigate. Run away and then sneak through the gates they have left unguarded.

Mask

In the *Floor 05: Engine Room* you need to take out the engines without the security turrets sensing your presence. Creep (hold Ctrl) and use the sound of the engines as they cycle up to their most intense to mask the sound of your shots (shoot the red control panels).

See the "Final Engines" section of the [Level Blueprint], the [Player] Blueprint and the [BP_Turret2] Blueprint.

Testing the Mix

Getting an effective mix for your game is all about understanding what aspects of the audio are important to the player right now. You can't play everything all the time because no matter how good your approach to managing frequency content, you'll soon end up with sonic mud. Hopefully we have given you some ideas about the roles and functions of audio that can be useful in understanding how you might want to prioritize certain sounds for gameplay reasons.

Sound Mixes are also very useful when testing your level. Sometimes you want to focus on getting a particular sound, dialogue, or music system right, but you just can't hear it clearly. Sound Mixes are very useful for hearing what different groups/classes of audio are doing.

First you can see what is going on with your audio in regard to Sound Classes by using Console commands (see also Appendix A: Core Concepts/Console Commands).

When playing the game, press the ¬ key to bring up the command line and type "listsoundclasses". This gives you a list of how many sounds in each class are playing. This can also be useful in telling you whether you have any sounds ungrouped (i.e., not belonging to any Sound Class).

```
Cmd: listsoundclasses
Listing all sound classes.
Class 'Master' has 3 resident sounds taking 881.03 kb
Class 'Culling_Class' has 0 resident sounds taking 0.00 kb
Class 'Characters' has 0 resident sounds taking 0.00 kb
Class 'Exception_Class' has 0 resident sounds taking 0.00 kb
Class 'Ship_Ambient' has 14 resident sounds taking 1954.67 kb, and 11 real time sounds taking 317.63 kb
Class 'UnGrouped' has 7 resident sounds taking 1074.68 kb
35 total sounds in 6 classes
```

Another useful command is "showsoundclasshierarchy". This shows a list of all your Sound Classes and any parent/child relationships within them.

To see what mixes are currently active, you can use the command "Stat SoundMixes". You can of course set up key events in your [**Level Blueprint**] to trigger Sound Mixes. It is often useful to have a set of Sound Mixes to isolate certain types like ambient, music, dialogue, etc.

You can call Sound Mixes directly from the Console using the command "SetBaseSoundMix". Follow this with the name of your Sound Mix.

Finally, you can modify the volume of any Sound Class using the command "ModifySoundClass" followed by the name of your Sound Class and then "Vol= (***)".

Another useful tip is to have your DAW constantly recording the game in the background. That way you can go back and compare any changes you made with how things sounded before to help you come to a more objective decision about whether you actually improved things or not!

Conclusion: Audio Concepting

In conclusion to this chapter, we'd like to say a few words about the importance of developing practical examples of your ideas and concepts.

People, including sound designers, are generally not very good at talking about sound. Instead of writing design documents and talking about it, go and do it. If you've got a great idea about a gameplay mechanic based on sound or an audio feedback mechanism you think would work really well, don't just tell your producer about it—make a mock up and show them.

You need to understand your tools well enough to break them, use, and abuse them in ways not intended to illustrate your point. Whatever the engine you will eventually be using, you can mock the idea up in the Unreal Engine or Cycling '74 Max, and then if the idea gets accepted, the programmers can do it properly for you later.

As well as understanding the game's mechanics, you should also get your hands on any early concept visuals as soon as possible. In Windows Movie Maker or iMovie, take a still image of this concept art, drag it across the timeline, and add an audio track to it. Try creating a one-minute environment ambience for this location or do the same with an animation. With just the still image on the screen (or a series of images), create an imagined scenario where this character or creature will interact with things. Get the movement sounds and vocalizations in. To try out visual concepts very quickly, sometimes artists will grab a bunch of imagery or video clips from a variety of sources and roughly put them together (sometimes referred to as ripomatics). If you're pushed for time, you could take a similar approach by taking bits of the soundtrack from your favorite films or games and blending them together to see quickly if this is the direction that people are after.

Putting in the extra effort early on to provide audio concept tracks will achieve a number of things:

a. It will tell you quickly what people don't want. People are generally not very good at articulating what they do want (particularly in terms of audio, where most people lack the vocabulary) but are very good at telling you what they don't like when presented with an example. Don't get too attached to your sound ideas—they will no doubt change a number of times. Always keep them, however, and then when the producer comes around in 6 months' time looking for some new sounds for this creature, play them your original ones that they rejected. They'll probably think they're perfect! Either that, or they'll sack you.
b. The great thing about making mockups and concept tests is that they can feedback into other areas. If you make a concept sound for the creature that you've got some concept art for, then show it to the animator, chances are that, consciously or not, some of your elements will influence the final animation.

c. Providing early concept sounds will also form an early association with particular characters or objects. People will get used to hearing them with your sounds so that it will begin to sound not quite right without it!

d. Using sound to illustrate aspects of gameplay will get other people starting to be interested in the sound of the game, to realize its potential impact, to get into discussions, and to offer input and ideas. All this increases communication, which is what you want to be able to have a positive impact on the game design.

Of course the thing that will drive your concepts more than anything will be an understanding of the nature of the game itself and of the roles and functions you want the sound and music to achieve.

For further reading please see the up-to-date list of books and links on the book website.

Recap:

After working through this chapter you should now be able to:

* Understand some of the roles and functions of audio in games through the INFORM model;
* Use triggered and passive Sound Mixes;
* Implement systems using making and hearing noise.

Advanced: Weapons

09

Summary : Handling inputs, one-shot, retriggered and looping weapon systems, environment and distance layers, bullet impacts, casings and whizzbys

Project : DemoCh09Weapons01 **Level :** Weapons01

Introduction

Since this section is advanced, we are going to presume that you are pretty familiar with all the core techniques we have covered so far and are at the stage where you can have a good poke around the demo systems to see how they work and try things out. With this being said, there are no exercises in the following chapters, and we will just give an overview of the principles at work and a general guide to how the systems are operating.

Alongside vehicles, the weapons in your game will require some of the most complex systems for effective implementation, and you'll also need to work closely with your animators. The real impact of a weapon sound is highly dependent on the environment it is in, so alongside the mechanics of the weapon itself, you'll also need to consider systems for the reflection and tail elements as well as the character of the sound when heard over distance.

It is of course crucial that players can locate enemies through the source of their weapon sound, so NPCs will retain strong spatialized mono elements, but given the importance and impact of the player weapons, you'll typically be using high quality stereo or even quad sources for these. Like vehicles, the weapon systems for games remain an area of real specialization often making use of advanced proprietary tools, but we'll attempt to introduce you to some of the basic principles here to get you started.

In the map you can switch to the different weapons using the following shortcut keys:

1—Pistol
2—Assault rifle retriggered
3—Assault rifle tail
4—Machine gun
5—Sci-fi beam weapon
6—Grenade launcher
7—Assault rifle feedback
8—Rifle
9—Assault rifle shells

System

Before we go on to look at the specific weapons themselves, we'll give a brief overview of the system. The Edit/Project Settings/Input/Bindings allow us to set up inputs from the gamepad or keyboard.

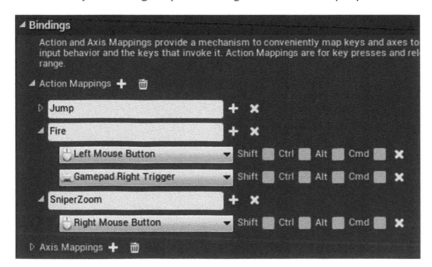

We can then receive these events in our Blueprints.

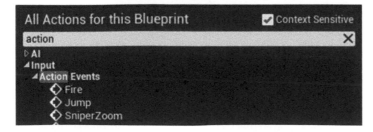

At the start of the game, all the weapons are attached to the player and set to be hidden in the [**MyCharacter**] Blueprint, apart from the default pistol. The weapon Actors are also set to their respective variables (e.g., class Blueprint [**WP_Pistol**] here is set to Weapon_01).

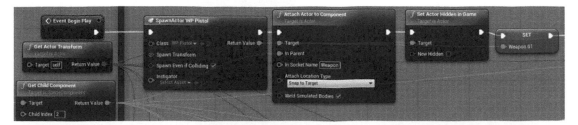

The number keys 1–8 show/hide the weapons and set the variable Active Weapon.

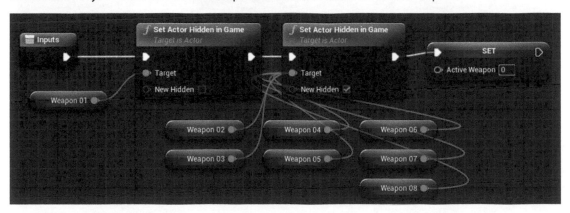

When the player fires (i.e., we receive <**Input Action Fire**>), this is cast to the appropriate Blueprint so that we can pick it up there and trigger the weapon system.

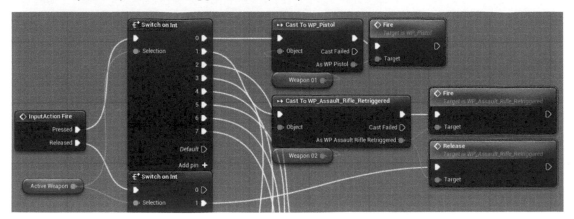

The image below shows the input action fire received in the [WP_Pistol] Blueprint.

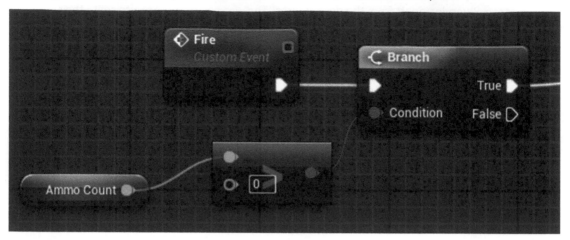

One-Shot, Retriggered, or Loop?

The rate of fire for your weapon will determine the system that you use for playback.

One-shot

Go to the *Target Range 01* (Bookmark 1) and press 1 to select the [WP_Pistol].

This weapon fires only once when the trigger or LMB is clicked.

In the [WP_Pistol] Blueprint, you can see that it first checks the ammo count before playing the sound. The <DoOnce> stops any further input until reset by the <Delay>, which has the effect of limiting the possible fire rate of the weapon.

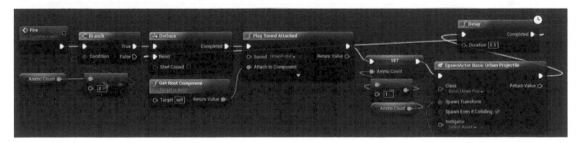

As many weapons are based on the repetition of a mechanical process, you will find that they do not vary a great deal from shot to shot. Variation in weapon sounds tends to come from the reflections around the environment they are in, which we'll be looking at shortly. However, some very subtle pitch modulation can work to create some variation and also to alleviate the phasing that can occur with multiple instances of the same weapon sound.

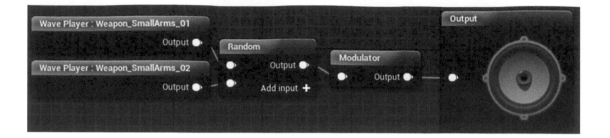

Retriggered

Press 2 to select the [WP_Assault_Rifle_Retriggered].

This weapon will fire for as long as you hold down the LMB, or until you run out of ammo.

The [WP_Assault_Rifle_Retriggered] Blueprint has a <Release> event that will close the <Gate> and stop the weapon firing. While the <Gate> is open, the <Delay> feeds back through the <Gate> to keep the weapon firing (until you run out of ammo).

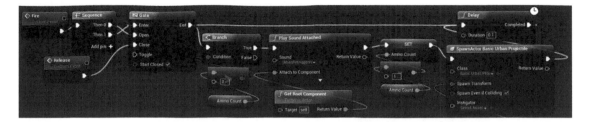

You can set the <Delay> or fire interval according to how many rounds per minute you want the weapons to fire. The fire interval is equal to 60 divided by rounds per minute.

Retriggered weapon sounds usually work well for mechanical-based weaponry, however there are two issues. The first is that as the sounds are overlapping, this can use up your voice count very quickly (see the discussion below). The second is that if your sample is relatively long, and you are retriggering frequently, you can produce phasing caused by the interference between the waveforms (you can alleviate phasing to some extent by using a -**Modulator**- node within your Sound Cue to make subtle pitch variations).

For the current RPM of 600 (delay of 0.1), you can see that this produces up to 10 simultaneous versions of the gunshot produced by their overlap (use the Console command "Stat Sounds" to see a total of the number of sounds currently playing). If there are a number of enemies using this weapon, then you'll run out of channels pretty quickly, and if they are for the player's weapon, then they will likely be in stereo—so double the problem. See below for an alternative approach.

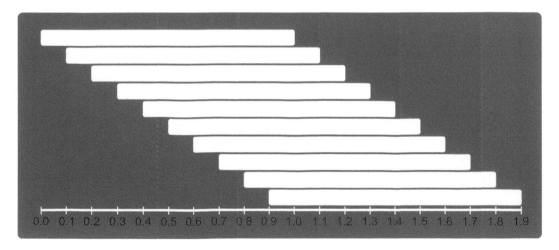

Retriggered with Tail

Press 3 to select the [WP_Assault_Rifle_Tail].

Another solution to both phasing and voice issues is to use a short fire sound that retriggers but then to add the longer tail element when the input trigger is released.

The [WP_Assault_Rifle_Tail] has a FireInterval of 0.075 seconds, which is equivalent to 800 rounds per minute. This time the firing sound that's retriggered is only the very short initial crack of the weapon. Only when you release the key (or run out of ammo) do you hear the longer tail section.

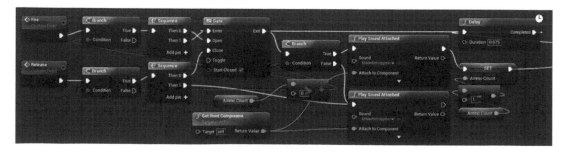

The system is similar to the [WP_Assault_Rifle_Retriggered], but this time the <Release> event (when your key or button is released) triggers the tail part of the sound. We've added another <Branch> condition here as well so that you don't just hear the tail in isolation if you have already run out of ammo.

By using relatively short fire samples and leaving the tail until the release of the button or trigger, we can avoid some of the worst effects of phasing and limit the voice count. But sometimes we want to go even faster!

Loop with Tail

Press 3 to select the [WP_Machine_Gun].

The issues mentioned above with retriggered weapons become acute with weapons such as miniguns, which have very high fire rates. These weapons can achieve fire rates as high as 6,000 rounds per minute (this is why they are most often vehicle mounted, as you need the vehicle to carry the weight of all the ammo!)

Let's take a slightly less extreme example of a weapon that fires 3,000 rounds per minute (i.e., one round every 0.02 seconds). In the first 0.4 seconds after the player has pressed the fire button, the sound has been triggered 20 times and is therefore taking up 20 of our voices already. If this firing sound sample is actually one second long, before it has finished playing you will have 49 voices being used! With such extreme rates of fire, the retriggered approach breaks down, and we need to look at a looping solution. By editing out a looping portion of the weapon fire sound into a separate file, we can loop this element and then add the tail on the trigger or button release.

The [WP_Machine_Gun] Blueprint implements the system described above. Another difference now is that we need to set up an ammo counting down system independent of the firing event (since nothing is being retriggered). This is done with a looping [Delay] node that decrements the ammo count every 0.05 seconds.

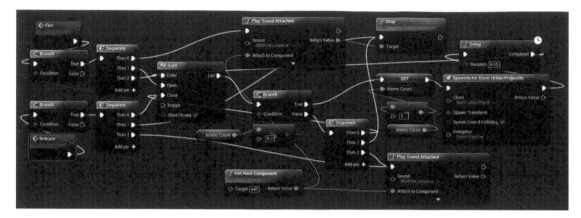

Looping Beam Weapons

Press 5 to select the [WP_SciFi_Beam].

Unlike the looping of a mechanical-based weapon, many sci-fi type weapons have loops for more of a constant beam-like quality.

For this weapon there is a startup sound, then the loop holds while the LMB is pressed, and on release there is an end fire sound.

As you can see the [WP_SciFi_Beam] Blueprint implementation is similar to the looped machine gun above.

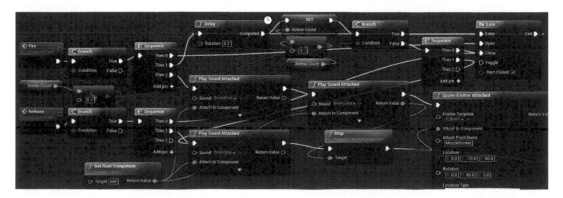

Projectiles

Press key 6 for the [WP_Grenade_Launcher].

Try it out on the barrels in the target range area (Bookmark 2).

The actual firing system in the [WP_Grenade_Launcher] Blueprint is just the same as our one-shot pistol.

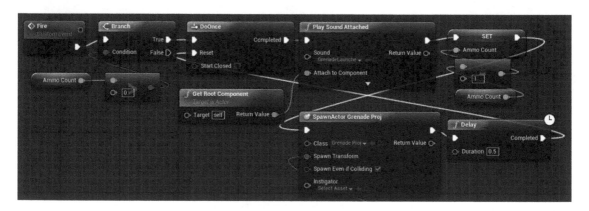

But now we need to also attach an explosion sound to the projectile itself. This takes place in the [GrenadeProj] Blueprint.

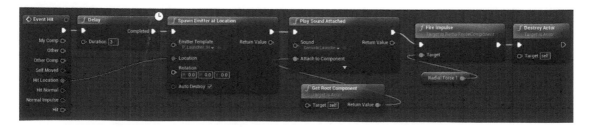

Feedback

Press key 7 for the [WP_Assault_Rifle_Feedback].

We wrote in Chapter 08 about how audio can give important feedback to the player. You can add this mechanism to any of your weapons to notify the player when they are running low on ammo.

In the [WP_Assault_Rifle_Feedback] Blueprint, you can see how we swap out the firing sound for an alternate one when the ammo count goes below 20.

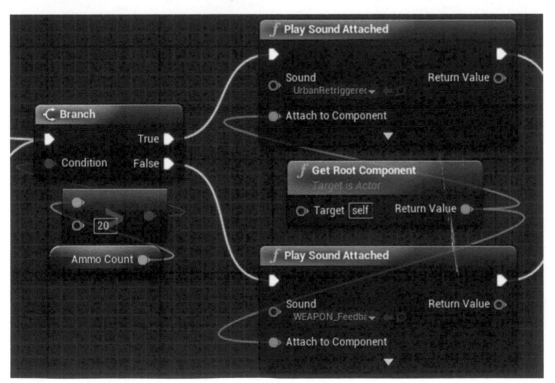

Environment and Distance Elements

Most of the sounds of the mechanics of a real weapon are actually pretty dull and repetitive. What gives them such an impact is the sound produced by the loud burst of sound energy reflecting around an environment.

Environment Layers

The reverbs you can enable in-game are often a bit of a blunt instrument and really can't match the rich quality of good recordings, so it may be that you want to exclude many weapons from this system (through their Sound Class settings) and implement your own system to add appropriate reverberant or 'reflection' layers to your weapon sound (such as indoor, urban, urban distant, forest, open field, canyon, etc.)

Press key 8 for the [**WP_Rifle**] and go to the street area of the map (Bookmark 3). (This weapon also has a scoped view -RMB and hold breath function -H that you can examine in the MyCharacter Blueprint.)

As you move from the street to inside the building and outside to the grassy area, you will hear that your weapon sounds change accordingly. We are monitoring the type of space the player is in and then swapping out different reverberant tails in the weapon fire Sound Cue.

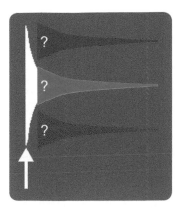

We've created our own [GAB_WeaponTailsVolume] Blueprint in order to enable this functionality. These have been placed around the level in the same way that you would place [Audio Volume]s. When the player is inside a [GAB_WeaponTailsVolume], we can get the designated name of that volume and its priority. This is set in the [GAB_WeaponTailsVolume] itself, and the priority is so that we can nest volumes like we do with reverb.

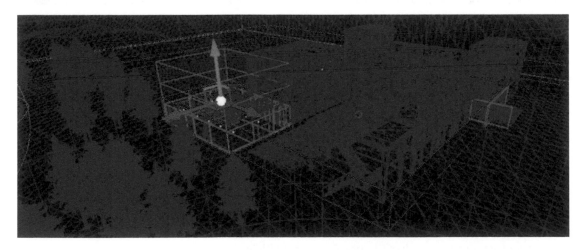

In the [WP_Rifle] Blueprint, we <Get> these values and compare the string that carries the name of the volume in order to <Set> the variable Reverb_Tails. This is used to set the -Switch- inside the Sound Cue {UrbanRifleTails}.

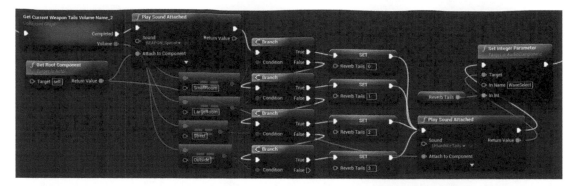

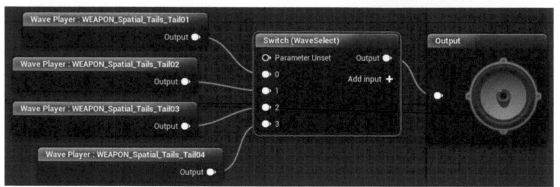

In theory we could swap out the entire weapon sound, but it's often important for gameplay that players know what weapons people are using, so it's good to keep at least one element of the weapon sound with a consistent characteristic for that weapon type. This would also be possible to do for looped weapons, although you'd need your programmer to be on the ball to manage a perfect sample level synchronization with the dry loop and the looping layers. The current mechanisms for audio timing in the Unreal Engine are not up to this yet. You could also implement the same system for the retriggered with tail or machine gun weapons so that the tails swapped out depending on the environment.

Distance Layers

We talked in Chapter 08 about how the simple implementation of low-pass filtering and attenuation curves don't really come close to the way that sound changes depending on your distance from the source. Changing the character over distance is vital for weapons sounds. The difference from the Details over Distance approach of Chapter 07 using multiple attenuations is that this time we want some elements to die away as we get closer, not just stack up.

In the *Open Field* area of the weapons map (Bookmark 4), there is a bot just randomly shooting in the air, as is their want sometimes. As you approach the bot, you can hear the different elements of the weapon sound being revealed.

In the [**Bot_DistanceFrom**] Blueprint you can see that this system derives from an idea we have come across several times—using a linear variable from the game engine to read through curves that define the volume of each element. In this case we take the distance from the player to the bot and set out our curves to represent the volume of the different elements of the weapon's sound over distance (this is just a section of the Blueprint showing two of the weapons elements).

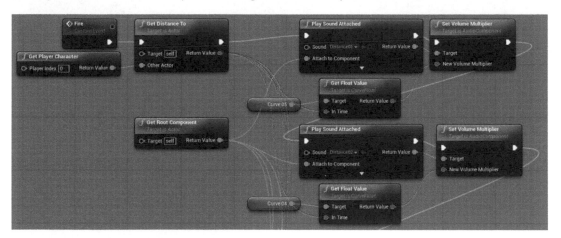

We could of course also do this within a single Sound Cue by using <Set Float Parameter> nodes that target -**Continuous Modulators**- within the cue, and we could have used the -**Crossfade by Param**- node, but using curves give us more control.

Bullets

Weapon firing sounds do not work in isolation. They are part of a system that includes the whizzbys, impacts, and ricochets.

Impacts

Press key 9 for the [WP_Assault_Rifle_Shells] weapon and go to the targets in the *Target Range* area (Bookmark 5).

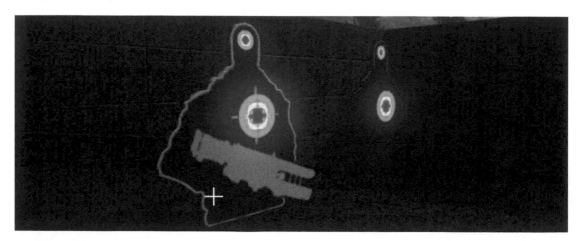

As you fire at these, you'll hear the bullet impact sounds for the wood target and ricochets for the metal target. Like we did for footsteps, we are tracing the material type that we are impacting with, only this time we're doing it for the bullet projectile.

Our weapon [WP_Assault_Rifle_Shells] references the [ImpactProjectile] Blueprint (all the others are referencing the [BasicUrbanProjectile]). The [ImpactProjectile] Blueprint gets the physical material of the surface it has impacted with, and this is used to control the <Switch on EPhysicalSurface> that then executes the appropriate <Play Sound Attached>.

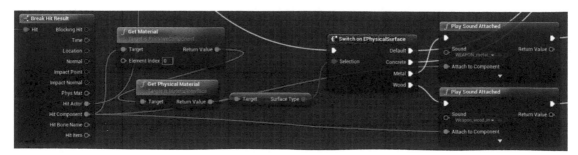

You may not always want to base the impact or ricochet sound on the physical material of an object since sometimes assets can share materials and you might not want the same impact sound for all of them, so we've also provided an alternative system where you can add tags to meshes in the game and pick up on these instead. Tags can be set in the ➡Details panel of a mesh.

The alternative system can be set up in the [ImpactProjectile] Blueprint as below.

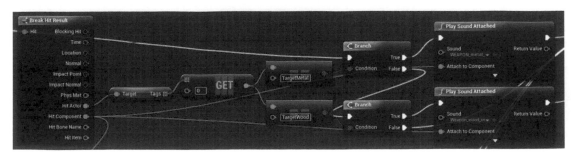

With impact sounds that are heard frequently (from a machine gun for instance), it's obviously important that you try to avoid repetition. Within your Sound Cues for impacts, you should consider applying some of the techniques covered in Chapter 02 such as modulation of pitch and volume and the randomized recombination of sounds. Bear in mind that, like footsteps, any sounds with a particularly memorable character will stand out, so you should weight them within the -Random- object to appear less often. For example you might want the frequency of a ricochet element within your Sound Cue to be significantly less for a machine gun that fires 2,000 rounds per minute than for a one-shot pistol. You may really like ricochets, but remember that, as well as perhaps getting tiresome after the 700th listening, these relatively long sounds can also contribute significantly to your voice count.

Casings

You'll also notice two different surface types on the floor in this target range and when you fire the [WP_Assault_Rifle_Shells] (9), you can hear the bullet shells rattle to the ground. You may consider this to be the product of an OCSD (obsessive compulsive sound designer), but we think it's a nice touch that these actually vary according to the surface that the player is standing on.

This works in just the same way as the targets above by getting the physical material properties of the surface and using this to control a switch for the sounds, only this time we're tracing a line directly down from the player (the Z-axis) rather than in front.

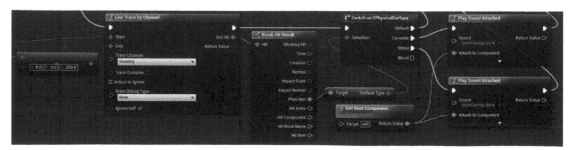

Whizzbys

Go to the final target range (Bookmark 6), and duck!

If you're hearing a bullet whizz by your head, then the good news is that you're still alive. As most bullets travel faster than the speed of sound, the usual order of things would be to be hit by the bullet first, then hear the actual shot, and in your dying moments reflect on how you really wish it were easier to get that convincing outdoor tail to the sound that you've been trying to achieve for weeks. Fortunately most games aren't that cruel and usually give you plenty of opportunity to realize that the distant twinkle you've just been admiring is the reflection off a sniper's sight.

These are handled in the [MyCharacter] Blueprint. If you look in the ➡Viewport of the Blueprint, you'll see that your character is actually carrying around the box component WhizzbyVolume.

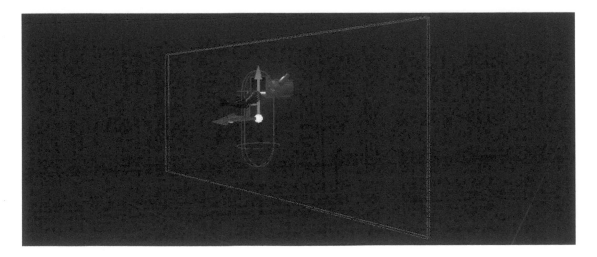

When this is hit by another Actor, it checks that it is the [BotProjectile], and if so it plays the {WEAPON_Bulletbys} Sound Cue.

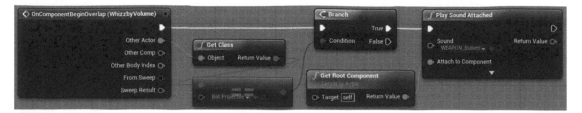

You might wonder if you can use the -Doppler- node on the whizzby sounds. Unfortunately this isn't very effective. As we noted in Chapter 07, because the whole system updates in frames, this is too slow to handle the speed at which bullets tend to move. Rather than a smooth pitch change, it would just jump immediately from high to low.

Conclusion

As with all these advanced areas, weapon sound design and implementation is a highly specialized field and we have just touched on some of the basic concepts here. Most modern engines combine the ideas above with proprietary tools that allow for material-based reflections and in sample accurate audio engines that avoid the issues you can get with drifting frame rates.

For further reading please see the up-to-date list of books and links on the book website.

Summary : Velocity to pitch, velocity crossfades, faking gears with pitch, tire layers, skids, additional layers

Project : DemoCh10Vehicles01 **Level :** FlyingSaucer01

Introduction

Simulation of vehicle sounds can be very challenging since they are hugely complex systems made of many separate sound sources, each reacting in a different way to the driver input and other physics states on the vehicle. Although we might typically associate vehicle systems with a car or motorbike, these principles are equally applicable to vehicles such as skateboards or jet skis, or indeed any other sound that has a complex relationship with in-game variables.

Simple Velocity to Pitch

Open the Level FlyingSaucer01 and Play the game. Fly the vehicle: 'W' speed up, 'S' slow down/reverse, 'A' turn left, 'D' turn right, mouse look, 'Shift' boost, 'Space'. These inputs are defined in the Edit/Project Settings/Input/Bindings menu.

If you look in the [BP_UFO_Physics] Blueprint, you can see that all the sound is handled in here. Looking first in ➡Viewport, you can see that this Blueprint Actor has three audio components embedded in it that reference the following Sound Waves: {Flying_Saucer_Engine}, {Flying_Saucer_Boost}, and {Flying_Saucer_Impact}.

In ➡**Event Graph** you can see that the engine audio component {**Flying_Saucer_Engine**} (a looping Sound Wave) is played as the level starts, and then its pitch is constantly updated by the <**Event Tick**> node.

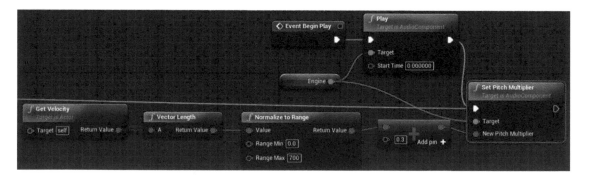

The velocity of the Actor is then scaled to produce an appropriate range for the <**Set Pitch Multiplier**>. The <**Get Velocity**> returns the direction of travel in X, Y, and Z and the magnitude of that travel (in other words, velocity in a direction as a vector). The <**Vector Length**> converts the direction as a vector into a single float that just gives you the magnitude of the vector without the direction (in other words, velocity).

It is useful to use a <**Print Screen**> node to output this variable to screen (updated by an <**Event Tick**> so that you can see the range of velocity you get from a vehicle), then you can use this information to help you decide on how to scale this into a meaningful range for a pitch multiplier. (Rather than directly applying velocity to pitch, another useful approach can be to Play/Reverse a <**Timeline**> that contains a Float Track with an appropriate pitch curve).

The impact sound for when the ship hits an obstacle is also in this graph (in the "Obstacle" section). When the Actor overlaps with another Actor, it produces an <**Event Hit**>, this triggers the impact sound, and the force of this impact is used to modulate the volume of this sound via a <**Set Volume Multiplier**>.

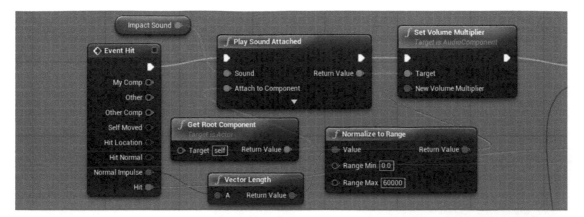

The boost sound is handled in the ➡**Movement Sequence Graph** where the Left Shift key (or gamepad button) implements a temporary speed boost in the direction that the vehicle is currently facing. This is accompanied by a <**Play Sound Attached**> that simply layers a boost sound over the top of the already playing engine sound.

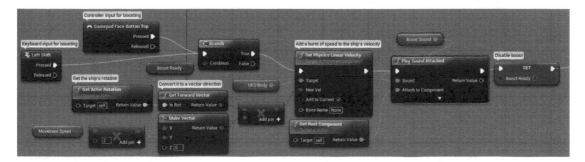

Crossfading Elements

Level: Buggy01

It is unrealistic to expect that a single sound can represent a convincing engine when taken through any significant degree of pitch shift. As car engines change speed, the timbre of the sound varies significantly so all but the most basic vehicle simulations will instead use several recordings made at a series of steady revolutions per minute intervals (typically every 500 RPM). As the RPM in the game

increases, there is often some pitch shift, but just as importantly there is a crossfade between these different recordings so that the timbre changes appropriately for the vehicle in question. In order to achieve this, we've had to create a simulated system that allows us to crossfade between samples based on the vehicle's velocity in-game.

Play the game and focus on the engine sound. You can toggle a 'solo' mix of these elements using the E key (R will reset all mixes to default). WASD keys to drive.

Open the Blueprint [Buggy_Pawn]. In the ➡ Event Graph you can see that we have three engine systems. Using the keys 1, 2, and 3, you can switch between these in-game. These are <Cast> to the [Buggy_Pawn] from the [Level Blueprint].

Looking in the ➡ Viewport of the Blueprint, you can see that again our audio is embedded in the vehicle itself. The {EngineSound} component is empty since we are swapping in the Sound Cue as the different systems are chosen in the Switching Engine Sounds section of the ➡ Event Graph.

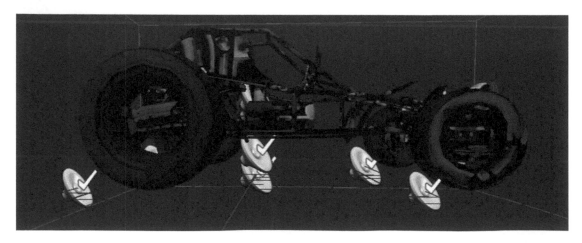

The Engine_01 variable contains a reference to the {Engine_Loop_Cue_01} Sound Cue for the first crossfade system. Here you can see that we are using the <Crossfade by Param> node to control the relative volumes of our three different RPM layers and are also varying the Pitch with a -Continuous Modulator-.

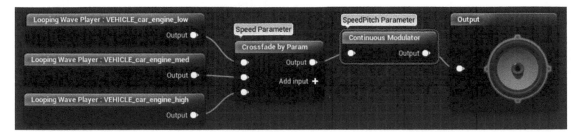

Below you can see how the -Crossfade by Param- settings are applied to the volume of the three looping layers.

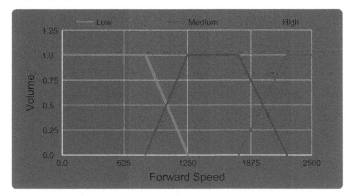

In the Engine 01 section of the ➡Event Graph, you can see the system takes the absolute value of the vehicle's forward speed. The <ABS> node gets the absolute value (i.e., converts negative numbers to positive numbers) to ensure that we still get valid values for our system if the vehicle is reversing.

This is then clamped to ensure that we don't get any sudden unexpected values. Physics systems are often very hard to deal with as they can produce occasionally extreme values (as we also saw when dealing with impacts), so the <Clamp> node helps us stop these from getting through and producing extreme audio events in response. The <Normalize to Range> node sets these values to between 0.0–1.0 for our crossfade parameter Speed, and these values are scaled within the -Continuous Modulator- node itself (to 0.7–1.2) for the pitch.

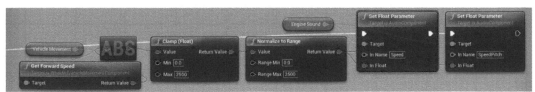

As you play try using the Console command "Stat Sounds", which shows you the currently active sounds and their volume. Press E to change the mix to solo the engine sounds, and then you can see how the different low, med, and high rev recordings change in volume in relation to the vehicle's speed.

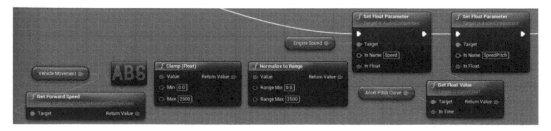

Active Sounds:
Sorting: disabled Debug: disabled
Index Path (Class) Distance
0. /Game/Audio/OLD/Starter_Background_Cue.Starter_Background_Cue (Ambient) 5081.11
 0. Wave: Starter_Birds01, Volume: 0.00, Owner: Starter_Background_Cue_2
 1. Wave: Starter_Wind06, Volume: 0.00, Owner: Starter_Background_Cue_2
 2. Wave: Starter_Wind05, Volume: 0.00, Owner: Starter_Background_Cue_2
1. /Game/Sound/WEATHER_wind_thin.WEATHER_wind_thin (Wind) 467.77
 0. Wave: WEATHER_wind_thin, Volume: 0.00, Owner: Buggy_Pawn_C_65
2. /Game/Sound/Strain.Strain (Strain) 464.55
 0. Wave: Strain, Volume: 0.00, Owner: Buggy_Pawn_C_65
3. /Game/Sound/TyreSurfaces.TyreSurfaces (Tyre_Surfaces) 526.21
 0. Wave: VEHICLE_tyre_road, Volume: 0.00, Owner: Buggy_Pawn_C_65
4. /Game/Audio/Engine/Engine_Loop_Cue1.Engine_Loop_Cue1 (Engine) 458.71
 0. Wave: VEHICLE_car_engine_med, Volume: 0.44 (FL: 0.22 FR: 0.22 FC: 0.44 LF: 0.22, LS: 0.00, RS: 0.00), Owner: Buggy_Pawn_C_65
 1. Wave: VEHICLE_car_engine_low, Volume: 0.45 (FL: 0.22 FR: 0.22 FC: 0.45 LF: 0.22, LS: 0.00, RS: 0.00), Owner: Buggy_Pawn_C_65
Total sounds: 5, sound waves: 6
Listener position: X=-4179.587 Y=-2548.878 Z=-492.285

Pitch Curves for Automatic Gears

One of the biggest challenges in vehicle audio is that we don't drive vehicles in games like we drive vehicles in the real world. If you analyze yourself while you are playing a driving game, you'll find that you have your foot on the gas almost all of the time, apart from occasional braking. Many people also use the automatic gear options. The relationships between vehicle speed, terrain, engine load, gear, and RPM are complex, and modeling realistic audio responses is made harder by the fact that we're not getting realistic controller input.

For the second vehicle system (switch to this in-game using 2), we have attempted to implement an imitation of gear changes since we are not getting them from either the player or the vehicle engine model. You can see from the illustration below (Engine 02 section of the ➡ Event Graph) that the system is exactly the same as the first vehicle, except now we are reading through a curve to set the pitch of the engine sound.

You can see the curve referred to ({Engine_Pitch_Curve_02}) by finding it in the ➡ Content Browser and double-clicking to open the ➡ Curve Editor.

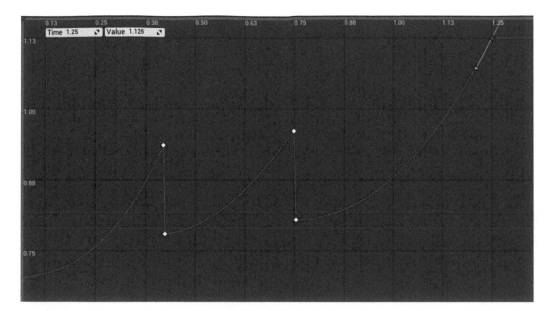

Here you can see the pitch curves that are read through by the forward speed of the vehicle and the jumps and increments in pitch that are typical of gear change events. The problem with this approach is that, as the vehicle decelerates, it will be reading backward through this graph and introducing gear change jumps where in reality we would not change gear. You will also find that, at certain velocities, the vehicle is hovering around a gear change point, leading to rapid up and down fluctuations in pitch. In order to mitigate this, we need a system that operates in one way when the player is accelerating, but in another when decelerating.

Smooth Operator

The third vehicle system (switch to this using 3) switches between two audio systems depending on whether the vehicle is accelerating or decelerating. We have also added in an <**FInterp To**> node in order to smooth out any unusual jumps in speed that we may get from bumpy terrain. At the end of the system, a variable Smoothed Speed is set, and this is linked to the Current input of the <**FInterp To**> node. This node will interpolate between this and the new speed it receives from the Return Value of the <**Get Forward Speed**>. We compare this Smoothed Speed value every tick with the Return Value of the <**FInterp To**>. If this is greater than or equal to the Smoothed Speed, then the vehicle must be accelerating, so we <**Branch**> to system A. If it is less, then the vehicle must be decelerating, so the <**Branch**> returns False and we go to system B. Phew!

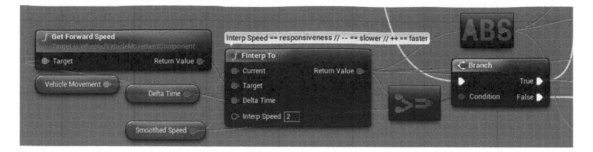

If the vehicle is accelerating (system A), then the <ABS> speed is set as the Current Speed Value and <Normalized to Range> to read through a curve with gear changes in it. The value from the curve is set as the Current Accel Curve Value and passed into the <Set Float Parameter>.

If the vehicle is decelerating, then the <ABS> speed is set from <Normalized to Range>, but we set the Range Max of the <Normalized to Range> to the Current Speed Value (set while the vehicle was accelerating). This ensures that the current speed (at the transition point between accelerating and decelerating) is always the max value (i.e., 1.0) so the curve always starts reading from its end point. The Deccel Pitch Curve ({EnginePitchCurve03}) is basically a simple curve that goes from 0.75 to 1.0. The value of the curve is then used to scale the Current Accel Curve Value (set while accelerating), and the result is passed to the <Set Float Parameter>. The result is a value that decreases (following the curve) from the current speed/pitch down to the idle value when decelerating. All pretty obvious really ;-)

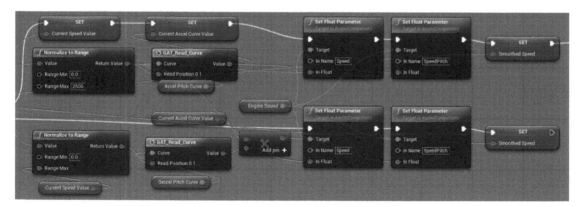

Surface/Tire Layers

In order to determine the type of sound we should play for the wheels on different surfaces, we are testing for surface types (the physical material) by sending a line trace down through the wheel of the vehicle (in this case we're using just the front left wheel, but you could set this up for all wheels individually). This surface type is used to set the variable FLWSurfaceInt.

You can toggle a soloing of the tire surfaces layer (and skids) audio by pressing Q.

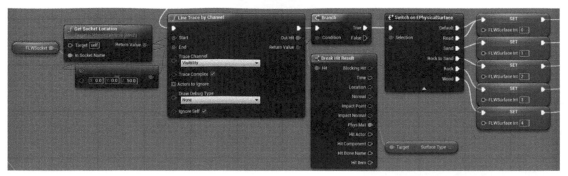

This is used (via a **<Set Integer Parameter>**) to control the switch inside the Sound Cue {**TyreSurfaces**}, which plays back the different surface type sounds. This Sound Cue is referenced by an audio component in the [**Buggy_Pawn**] vehicle Blueprint.

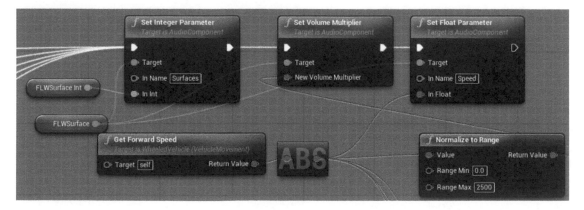

The forward speed of the vehicle is used as a **<Set Volume Multiplier>** on each (after being normalized to 0.0–1.0), and the raw forward speed goes to **<Set Float Parameter>** of the pitch of a -**Continuous Modulator**- inside the Sound Cue.

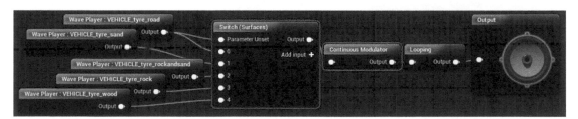

This is scaled in the -**Continuous Modulator**- itself to an appropriate range for pitch shifting, taking the possible range of speed (0.0–2500.0) to adjust the pitch between 0.8–1.2.

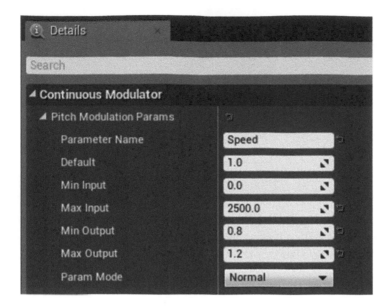

Skids

For a skid produced by braking, we take the **<InputAxis Forward>** produced by the controller or keyboard and compare it to 0.0. If it is less than 0.0 (i.e., the player is braking) and the forward speed is greater than 600, then this will produce a skid. We fade in the looping skid layer, and its volume is dependent on the forward speed (if you're going faster, then obviously the skid will be louder). Again press 'Q' to isolate the skids and surface layers.

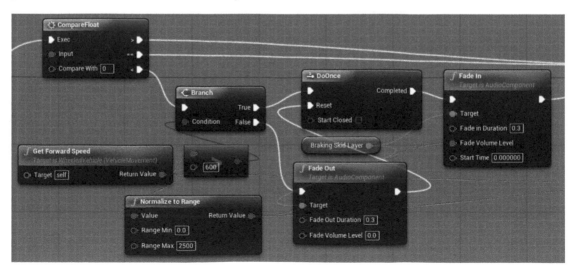

For skids produced by excessive steering, we get the forward speed of the vehicle and if it is greater than 900 and the steering angle is greater than 40, then we play the skid layer, the volume of which is also determined by a normalized version of the forward speed.

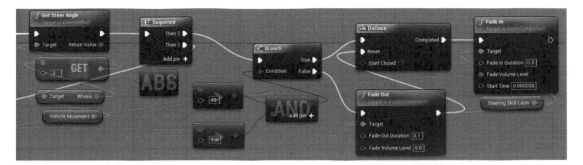

Additional Elements

You can toggle solo these additional elements by pressing F.

Engage/Disengage

This is an additional sound for when you engage or disengage the engine (i.e., you put your foot on the gas or release it). It takes the <InputAxis Forward> value and compares it to 0.0. If it is greater, then your foot is on the gas and we play the engage sound, and if 0.0, then you've come off the gas and we play the disengage sound.

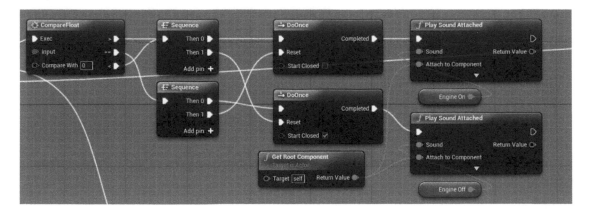

Turbo Dump

The turbo dump sounds obviously need to be related to our gear changes since it is at the moment of gear change that we should hear this sound. Based on the time of our gear change pitch events, another curve has been made ({**TurboDumpCurve**}) that outputs a value of 0.0 at these points.

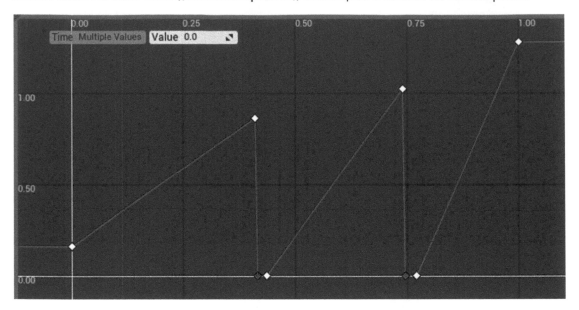

In the Turbo Dump section of the [**Buggy_Pawn**] ➡ **Event Graph**, you can see how this system compares this to 0.0, and if True it triggers the turbo dump sound. The <DoOnce> is to stop multiple retriggers and is reset once the value moves off of 0.0, ready for the next turbo dump event.

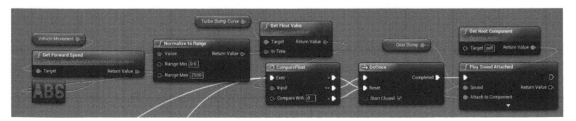

The turbo dump sound is only triggered when the vehicle is accelerating—see the Smooth Operator section earlier in this chapter.

Impact and Damage Layer

If the player damages the vehicle, then you might want to introduce an audio layer to notify them of the fact that this is affecting the vehicle. We get an event when the box component we've added to the vehicle is overlapped (see the box component in the ➡ **Viewport**). This plays an impact sound, the volume of which is modulated by the speed you were going when you collided.

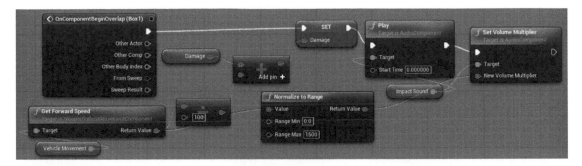

This also <Set>s a damage amount that brings up the volume of a damage layer loop.

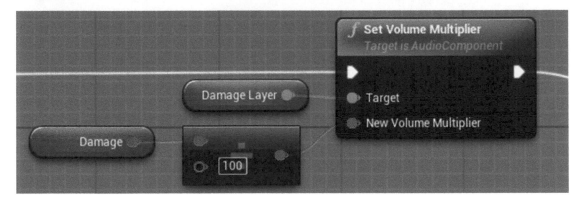

Wind Layer

If your vehicle is going fast, then we might expect some additional wind noise. This system takes the forward speed and reads through a curve to determine the volume of the wind sound, which is changed via the **<Set Volume Multiplier>**.

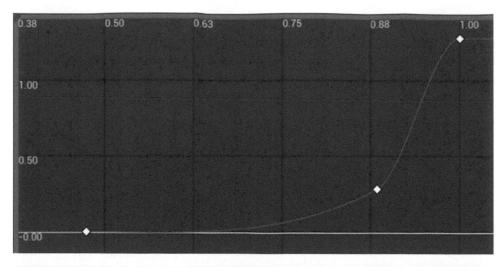

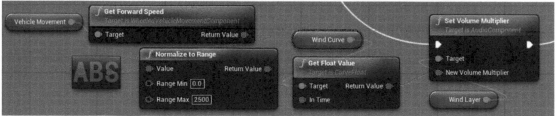

Engine Load/Stress Layer

If your vehicle is going up a steep incline, then the engine is going to be placed under greater stress, so we want to fade in a layer to represent this. By taking the vector of the vehicle, we can see if it is facing uphill and we multiply this by the forward speed so that we only hear this when the vehicle is pushing up hill (not just when the vehicle happens to be facing up hill, as it may in fact be stationary or going very slowly).

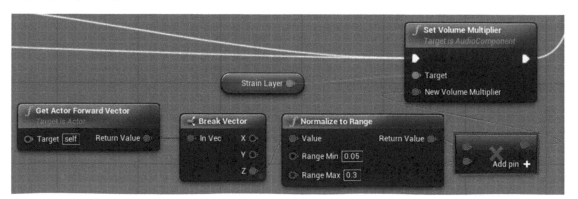

Car Body Movement or Suspension Layer

As the vehicle is thrown around the track, we'd expect some sounds from the suspension system or general creaking of the frame. In order to instigate this, we've looked at the suspension offset. If this is greater than 1.0, then we play a creaking suspension sound and modulate its volume depending on how offset the suspension is (how much it has travelled from its initial position).

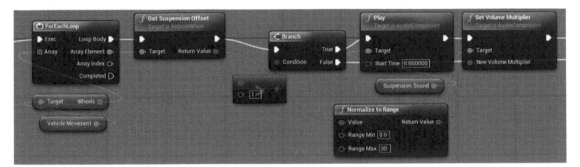

Vehicle Cameras

It is very common to give the player a choice of cameras for racing games. The different positions of the cameras bring different, and sometimes new, elements into the mix. As well as the listener position changing with camera positions, the way to achieve this is with mix changes. See Chapter 07/Cameras and the Listener and Chapter 08/Mixing sections for a discussion of these techniques.

Conclusion

Vehicle sound design and implementation is another specialist art that uses proprietary tools or specialist audio plugins that make use of granular loops and physical modeling together with effects like distortion. What we have managed to achieve in the demo levels is admittedly pretty basic, but hopefully is enough to introduce you to a few of the basic concepts.

For further reading please see the up-to-date list of books and links on the book website.

Advanced: Sports Dialogue and Crowds

11

Summary : Crowds, color commentary, play-by-play commentary, concatenation for dialogue, queuing dialogue

Project : DemoCh11Soccer01 **Level :** Soccer01A/B

Introduction

In terms of dialogue, sports games present huge challenges. Dialogue is there for authenticity, reinforcement, information, and advice, but the speech, the crowd, the camera, and graphic overlays all need to match and make sense.

Crowd Systems

Open the Level Soccer01A.

Reactive crowd systems are reasonably straightforward from an audio point of view since the nature of the crowd sounds is similar to a broadband noise, which can be effective in masking elements that come in and out. How convincing it is, to a great extent, will be determined by the accuracy of the information you can get from the game system itself as to the current play conditions. Given that we're British, we'll obviously use the game of football, which we'll refer to as soccer so as not to confuse our North American cousins. ;-)

WASD to move, mouse click or space bar to pass/shoot.

Randomized Crowd

The first thing to start with is a base randomized crowd to serve as a backdrop. Here we have a simple crowd loop with some randomized one-shots over the top (the location specific chants could be swapped out depending on the stadium using a -Switch- and <Set Int Parameter>) as seen in Chapter 06.

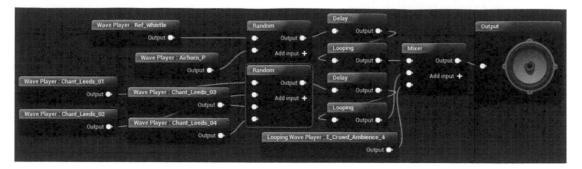

Crowd Excitement Levels

Crowd sounds don't typically start and stop immediately—they build and ebb, so they are most suited to using curve graphs to control the volume of the different elements (the principle of using a value or parameter to read through volume curves to bring crowd elements in and out could be applied to many other crowd situations, for example the panic level variable of a street crowd when shooting occurs).

The systems for the three main crowd elements, {Crowd_Ambience}, {Crowd_Excitement}, and {Crowd_Frenzy}, are governed by the player's position on the pitch (based on the premise that, as the player moves closer to the goals at either end, the corresponding supporters will get more excited by the promise of a goal being scored). This is illustrated in the following diagram, with general crowd sound represented in blue, crowd excitement in yellow, and crowd frenzy in red.

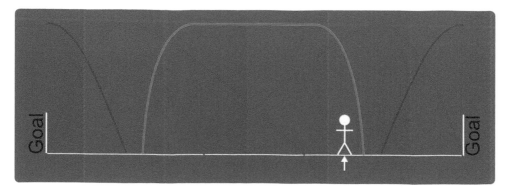

An <**Event Tick**> gets the distance between the player and a trigger box that's been placed at the right hand (red) goalmouth. This value is normalized (i.e., converted into a range between 0.0 and 1.0) and is then used to read through a set of curves that set the volume multiplier of the different elements.

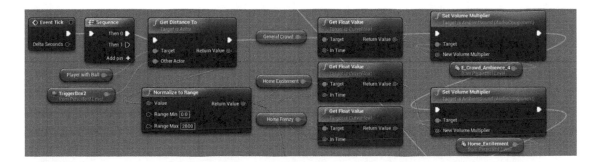

For example the away team excitement rises when the ball is in play near to their goalmouth and becomes frenzied when very close.

When a goal is attempted, we can simply play the {**Miss**} or {**Goal**} waves over the top, and the player is then reset to the middle of the pitch, bringing us back to the {**Crowd_Ambience**}.

Although the two crowd sounds for the {**Crowd_Excitment_Cue**} are relatively short (14 seconds and 11 seconds), a sense of repetition is avoided through the use of volume envelopes.

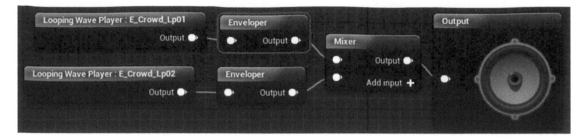

In addition to the differing lengths of the loops themselves creating new combinations through their asynchronicity these long looping volume envelopes (of 180 seconds and 145 seconds) help to further vary the resulting sound.

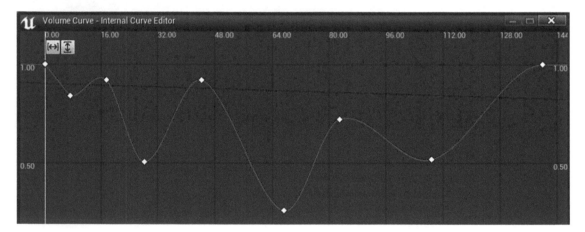

Commentary

Sports dialogue can be broadly separated into two categories: play-by-play and color commentary.

The play-by-play commentary will reflect the specific action of the game as it takes place. The color commentator will provide background, analysis, or opinion, often during pauses or lulls in the play-by-play action and often reflecting on what has just happened. Obviously some events demand immediate comment from the play-by-play commentator, so this will override the color commentary.

After an interruption a human would most likely come back to their original topic, but this time phrasing it in a slightly different way ("As I was saying . . ."). To replicate this in games, we'd have to track exactly where any interruption occurred and have an alternative take for the topic (a recovery version), but where the interruption occurred in the sentence would affect how much meaning has

already been conveyed (or not). We'd need to examine how people interrupt themselves or change topic mid-sentence and decide whether to incorporate natural mistakes and fumbles into our system. As you might appreciate, this is going to be very complex, and given that this is an area requiring further research and development even in big budget commercial games, we're not going to provide a perfect solution here. We will, however, try to propose a couple of approaches, such as ducking or queuing, to alleviate the worst offences.

Color Commentary

As a useful starting point, we've used the ambient crowd curve (that is up when the player is in the middle of the pitch) to control when the color commentary might come in since there's less likely to be any crucial action in this pitch position.

The readout of the general crowd curve is checked every tick to see if it is greater than or less than 0.5 (i.e., if the player is in the center of the field). If the player is indeed in this position, then the <Gate> is opened that allows the <Retriggerable Delay> through (the <Random Float Float In Range> gives us a random delay between 10–17 seconds). The <MultiGate> just cycles through its outputs each time it is triggered to select a different color comment type (1—Weather, 2—The team's current form, and 3—Injuries).

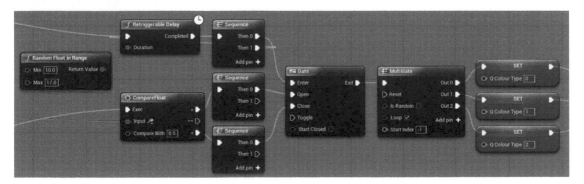

This is used to <Set Integer Parameter> to control the -Switch- for the color commentary.

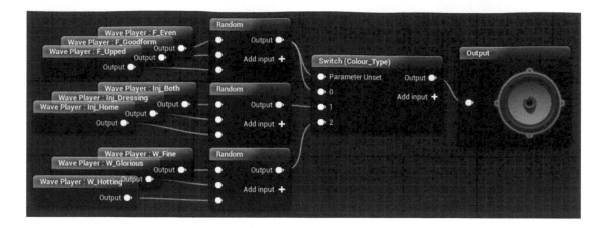

Concatenated Dialogue for Play-by-play Commentary

There are certain scenarios (and sports games are one) where simply recording all of the potential dialogue lines becomes a practical impossibility. In the English Premier League, there are 20 teams. In a season each team will play each other team twice, once at home and once away, giving them 38 games. As an example at the start of a match we might want a commentator to say:

> "Welcome to today's match with Team A playing at home/away against Team B. This promises to be an exciting game!"

In order to have this sentence stating each of the possible matches in the football / soccer season, we'd need to record this 760 times. If we now acknowledge that we have 11 players on each team (not including subs!) and each player might intercept a ball that has been passed by another player (or pass to, or tackle, or foul), then you can appreciate that the number of potential dialogue lines becomes huge.

From the sentence above, you can see that it's only actually certain words within the sentence that need replacing. We could keep the sentence structure the same each time but just swap in or out the appropriate team names and the words "home" or "away." Sentences usually comprise one or more phrases. By using a phrase-based approach, you can create a compound sentence by stitching together an opening, middle, and end phrase. This method is called concatenation or stitching. We've already come across the -**Concatenator**- node in the Sound Cue that will string together its inputs end-to-end, and this is what we want to happen to our sentence elements.

In our example there are two teams:

Team A
0 Lievsay
1 Freemantle

2 Van der Ryn

3 Boyes

Team B

0 Thom

1 Burtt

2 Murch

3 Rydstrom

The first concatenation system takes the player who has scored as a variable to control the switch inside the cue {**Soccer_Concat_A**}.

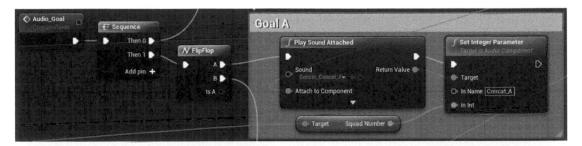

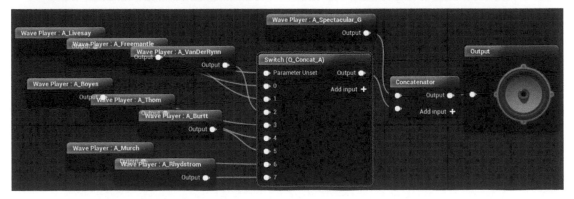

This gives us the dialogue line:

"Spectacular goal"	"from Murch"
	"from Thom"
	"from Burtt"
	etc.

Note where we have decided to split the dialogue. Rather than "Spectacular goal from…"/"Murch," etc., our stitched elements include the "from." If you say the sentence, you can feel that the word "from" and

the player name often flow into each other, so there's no natural break—making stitching hard and most likely giving a clumsy outcome. Between "goal" and "from," there's a more natural gap, although very slight, making this a better place to cut and stitch.

Our two interception cues use the same approach ({**Interception**} and {**Given_it_away**}).

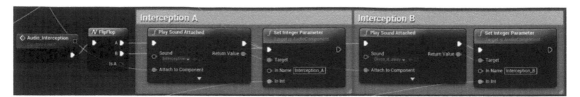

When the player loses the ball to the opposition, we have version A:

"Nice Interception"	"from Murch"
	"from Thom"
	"from Burtt"
	etc.

Version B reverses the order to give the player who lost the ball first, and there's a variation in the following line:

"Murch"	"has given it away!"/ "has given the ball away!"
"Thom"	
"Burtt"	
etc.	

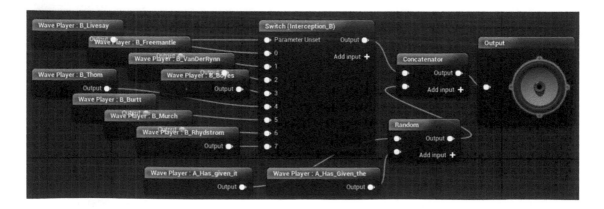

There are two randomly chosen concatenation systems for a goal score. The first operates in the same way as the interception system, adding the player name to the end of a line, and the second goal concatenation system actually inserts the player name in the middle of a phrase:

{Soccer_Concat_B}.

"It's a goal!"	"Murch"	"puts it in the
	"Thom"	back of the net!"
	"Burtt"	
	etc.	

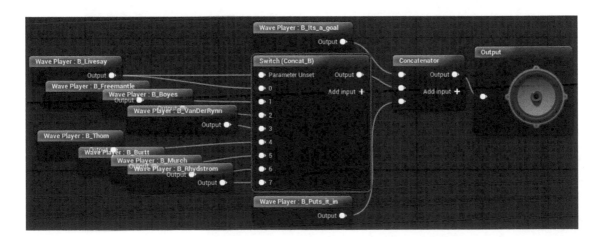

The final play-by-play system comments on the passing of the ball from one player to another, this time taking the two players involved to determine the -Switch- position within the cue {Pass}.

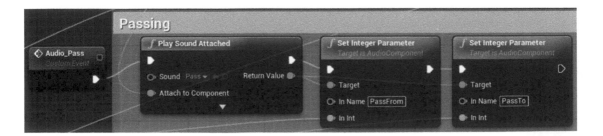

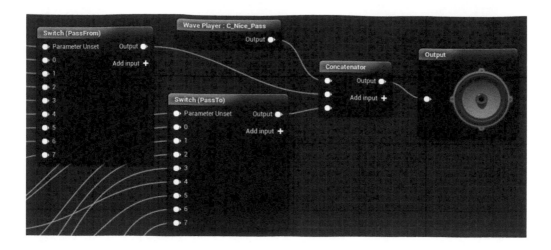

"Nice pass"	"from Murch"	"to Thom"
	"from Thom"	"to Burtt"
	"from Burtt"	"to Rydstrom"
	etc.	

As noted above, the importance of the play-by-play frequency outweighs that of the color commentary, so in this first version of the level (Soccer01A), we've implemented a passive Sound Mix that automatically ducks out any color commentary if a play-by-play line occurs.

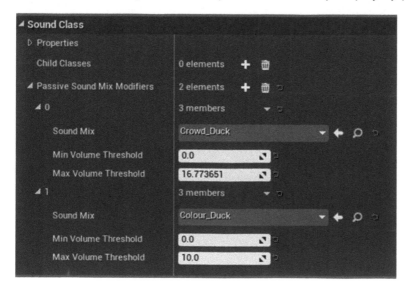

Considerations for Concatenated Dialogue

Concatenated dialogue can work well, but the challenge is to get the flow of pitch and spacing over the words feeling right across all versions. It is often the spacing of words that stops it from sounding natural and human (if you want to hear some examples of bad speech concatenation, try phoning up your local utility service or bank). You can also appreciate how a recording session for a concatenated system would differ from a normal session in that you'd want to construct a script so that you get the maximum amount of words you want in the least amount of time, but not have the chunks in such isolation as to lose the natural delivery of the words as they would be in the final context (and as you can imagine, this approach also presents a nightmare for localization where you are dealing with different languages).

Although functional, you can hear that in many cases it does not always sound very natural. In a real match these comments would also vary in inflection depending on the circumstance, for example a pass of the ball a little way down the field would be different from a pass that's occurring just in front of the goal of the opposing team with only thirty seconds left of the match. It might be that you record two or three different variations to be chosen depending on the current game intensity level. The problem with more excited speech is that we tend to speak more quickly. Even in normal speech, our words are often not actually separate but flow into each other, and this is exacerbated by speed. You recall that we discussed the importance of judging where to cut your sentences, looking out for opportunities where you can stitch seamlessly (for example on stopped consonants such as t, d, p, b, k, and g where the mouth is closed—therefore creating a silence). More seamless stitching can be achieved, but it requires a deep understanding of aspects of speech such as phonemes and prosody that are beyond the remit of this book.

Your system also needs to show an awareness of time and memory by suppressing certain elements if they repeat within certain timeframes. In natural speech we would not continually refer to the player by name but would, after the first expression, replace the name with the pronoun "he" or "she." However if we came back to that player on another occasion later on, we would reintroduce the use of their name.

All these things would be significant challenges in themselves, but are heightened by our innate sensitivity to speech and language and the huge amount of time that many players spend playing these games. They may be played regularly over a series of months or years during which players are listening to the commentator dialogue all the time. Rarely are game audio systems exposed to such scrutiny as this.

Dialogue Queues

In sports games everything tends to be much more accelerated than it would be in reality. This makes life in terms of repetition more difficult, but more importantly events happen faster than your speech system can keep up. A list of things to talk about will build up, but once they get a chance to play they

may no longer be relevant (e.g., play has continued and somebody else now has the ball). You need a system of priorities and expiry times if a second event has overtaken the first or if some things haven't been said within a certain period, then they are no longer worth saying.

In the level Soccer01B we've implemented a queuing and interrupt system so that for each cue we can define whether we want to allow it to be interrupted and can queue up the color commentary. In order to implement our system, we've integrated all of the previously discussed play-by-play and color systems into one Sound Cue {Q_Soccer_All}.

For each dialogue event, we set a series of parameters that define whether we want to allow this to interrupt any current dialogue, whether we should queue this line so that it will play back after the current dialogue, and if we do queue it, how long it should stay in the queue until dismissed because it is no longer relevant.

In this instance, only the color dialogue is queued, so all the other dialogue events go to this system.

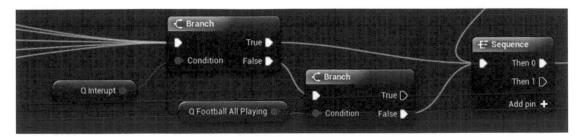

Do you want this line to be able to interrupt any currently playing line?

True—Go ahead and play it (and fade out any currently playing line).

False—Check if any line is actually currently playing (QSoccerAllPlaying Boolean), and if not then you won't be interrupting anything, so go ahead and play.

The color commentary dialogue goes to this alternative system.

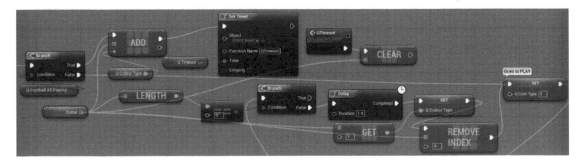

Is a line currently playing (QSoccerAllPlaying)?

False—Go ahead and play the color commentary line.

True—Add the Q Colour Type variable (that holds what kind of color comment to make) to the array Queue.

If there is already an item in the array, then this will add the new item to the end and extend the array as necessary.

387

When any currently playing dialogue line is finished, an event goes into the second <Branch> node. If the array is empty (i.e., length = 0) then it does nothing. If its length is not 0, then after a short <Delay> it <Get>s the first item from the array, removes this first item from the array, and then sets the Q Con Type variable to control the -Switch- in the Sound Cue. After this has finished playing, an event will come back into the second <Branch> node to see if there are any more lines queued up in the array (there's also a timer event that clears the array should the dialogue not get played within a given timeframe).

Conclusion

Sports commentary in particular requires complex systems and is certainly an area where games need some more development in order to match the expectations of reality over extended play sessions. Like the branching dialogue system in Chapter 06, if you're going to tackle this in some depth, then you'll probably want to explore options relating to the use of spreadsheets and data structures to manage your assets. Nobody has quite got the feel of commentators interrupting each other or themselves quite right yet—maybe you'll be the one to come up with a better solution!

For further reading please see the up-to-date list of books and links on the book website.

Summary : Musical stingers, melodic pickups, generative and sequenced approaches for variation, algorithmic / procedural music

Project : DemoCh12AdMusic01 **Level :** MusicPlatformer01

Introduction

In this section we'll be looking at some more advanced approaches to music that treat it in more of a granular way, rather than working with relatively long prerendered waves.

You can skip forward to any screen of the level by holding Ctrl and then pressing the appropriate number key. A move left, D move right, and Space Bar to jump.

Harmonically and Rhythmically Aware Stingers

Harmonically Appropriate Stingers

We've looked at stingers before in both Chapter 03 and Chapter 04. On these occasions we were writing our stingers to fit with whatever music was currently playing. This is alright if your stingers are rhythmic in nature or your music is harmonically static since there's no danger of your indeterminately placed stinger clashing with the harmony of the background music.

If we want to have music that changes chords, then we need to know what chord we're currently on, and when a stinger is called, we need to pick an appropriate stinger that we know fits with that chord. ***Screen 01*** (Bookmark 1) of the advanced music map features your stealthy ninja sneaking across the rooftops. As you do so, you can pick up some loot, indicated subtly by the large rotating gold coins.

The background music is a repeating three-bar sequence based around the chords of E Minor, F Major and A Minor. Each bar has its own stinger (actually an arpeggio figure), and so we need to set up a system that will play the correct stinger when a coin is picked up, depending on where we are in the music. In order to do this, we've set up a <Timeline> with a Float Track containing values that change at the start of each bar.

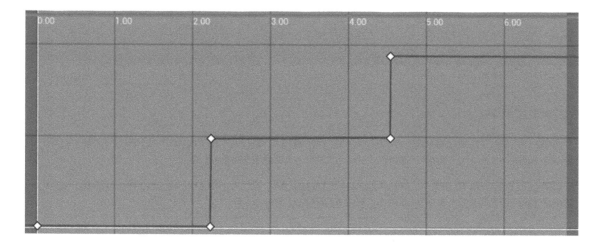

These values are rounded up to the nearest integer and then used to control the -Switch- inside our {Harm_Stinger} Sound Cue.

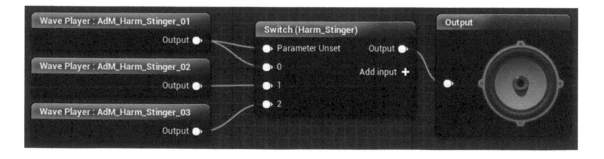

The background elements {AdM_Bassline} and {AdM_Drums_01} are looped by an Event Track in the <Timeline> as well just to keep everything in sync.

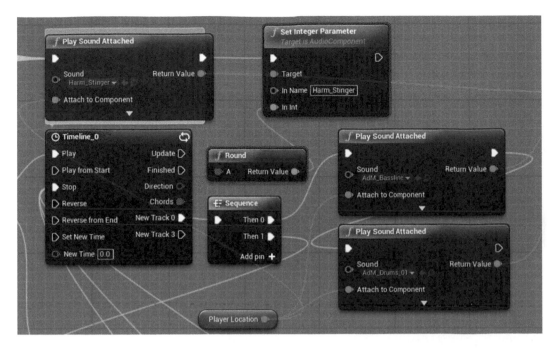

This means that when you pick up a coin the {**Harm_Stinger**} cue is triggered, but it will play a different stinger depending on what bar the music is currently in so that the stinger and underlying harmony will match.

Rhythmically-synched Stingers

As well as making your stingers fit harmonically, you might want them to actually play in time with the underlying score so that when a pickup occurs, they don't play immediately but perhaps wait until the next musical beat to do so. *Screen 02* demonstrates an example of this.

Here we continue to use the accompanying music from *Screen 01*, but if you look in the [Level Blueprint] below the <Timeline>, you'll see that we are also starting a <Timer> object. This loops around and finishes every 0.56 seconds (i.e., every beat of the music). It's also restarted every bar again to ensure sync between the <Timeline> and the <Timer>.

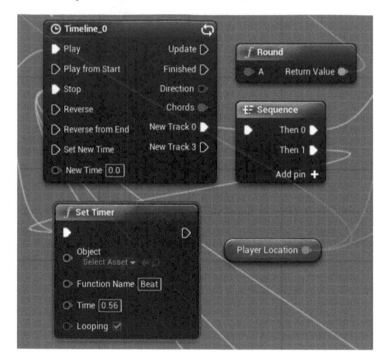

We've created a function named "Beat" for the <Timer>, and we pick this up as a <Custom Event> for our rhythmically-aligned stingers. Every time we receive a coin collected event from the coin Blueprints in the level, a <Gate> is opened to allow the next beat through. Now our stingers will play in time with the music.

Sequenced Melodies

Play for Proximity

On *Screen 03* (Bookmark 3) there is an enemy guard. To highlight the tension of being near him, we've introduced some cartoon style creeping musical footsteps. We check that we're within a given distance (Footstep Threshold) of the enemy and at the same height (i.e., on the same platform, not shown below), and if both these conditions are true (tested with an <AND>), then the <Footstep> event is allowed to <Branch> to true and play the {Walking Bass} Sound Cue (can you see what we did there?)

Chained Melodic Pickups

On *Screen 03* the walking bass notes in the Sound Cue were chosen randomly, but you may want to instill a sense of climax and reward for the player when they achieve a chain of pickups by working through a melodic phrase. For *Screen 04* if you are on a streak of pickups, the melody progresses, but if there's a gap where you miss one, it resets and you start again. You can instill a sense of progression and reward for chaining together multiple pickups.

Our melodic phrase is defined in the {Chained Pickups} Sound Cue through a sequence of -Switch- inputs.

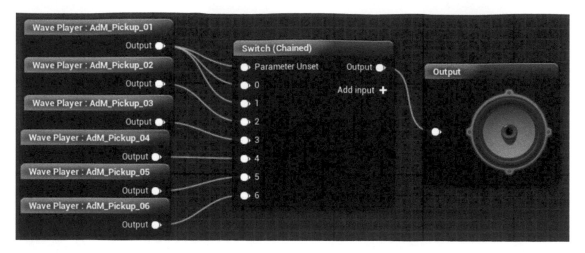

Each time a pickup is collected, the Pickup Count is incremented by one and this goes to the <Set Integer Parameter> to control the -Switch-. If the Pickup Count reaches 6 (the length of our phrase) or the player misses a pickup (i.e., hasn't picked anything up wIthIn the last two seconds), then the Pickup Count is reset, ready to start the phrase again.

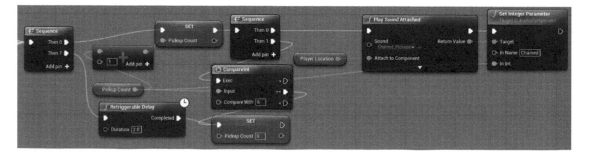

Algorithmic or Procedural Forms

There's a long history of algorithmic music (built using a systems approach) and generative music (a systems approach that includes elements of randomization) that we can learn a lot from in terms of creating music that is more variable, and potentially more reactive. If we want a finer level of control over our music, then we need to think on a more granular note level. For example you might want to represent the development of a character in an RPG or the evolution of a city in a simulation type game. Like with sound, the number of possible permutations starts to mean that prerecording them

becomes an impossibility, and so you might want to start to look at a more procedural or algorithmic approach.

Generative Combinations

Writing music that will be played back with some degree of freedom or emergent behavior requires a change in mindset from the typical linear composition that you may be used to—but it can be quite liberating!

Simple Random Combinations

A simple way to generate variation in your music tracks is to randomly recombine the different layers that make up the track. For example in *Screen 05* (Bookmark 5), the music consists of a nyatiti line {AdM_Bassline}, a low drum part {AdM_Drums_01}, a pizzicato cello part {AdM_C_Bass02_01}, and some stick percussion {AdM_C_Sticks_01}.

The Sound Cue {Combinations_01} is set up with a -Random- node and a series of -Mixers- that will combine these in different ways.

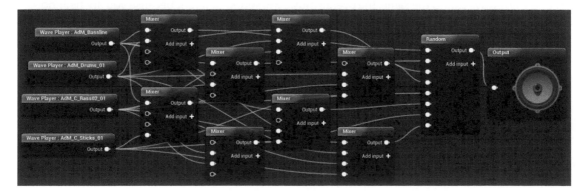

Combinations with Variations

Musicians will typically add small variations as they play, perhaps a slight change in timing or an extra note or two. By having a few versions of each part, you can maintain interest (as heard in *Screen 06* {Combinations_02}).

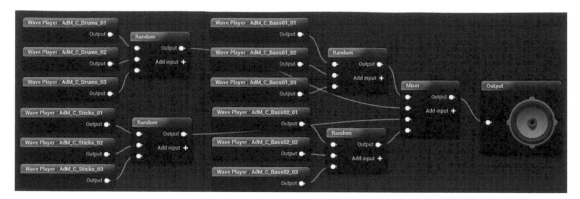

Asynchronous Loops

We looked at asynchronous or phasing loops (that is the variation that comes from combining loops of different lengths) in terms of ambience, but this can also work well for music so long as they are edited to maintain a whole number of beats. This works best with rhythmic elements, as with harmonic ones the combinations are often too complex to predictably avoid clashes.

If we had one rhythmic loop that lasted three bars and another that actually lasted 4 bars, then we would only hear the same music repeated after 12 bars. In other words what you would hear at arrow marker one in the diagram below would not occur again until arrow marker 5. Although the start of part one will always sound the same, the overall music will sound different because you are hearing this in combination with a different section of part two each time. Only after 4 bars of part one (and three bars of part two) will you hear both the start of part one and the start of part two at the same time like you did in the beginning.

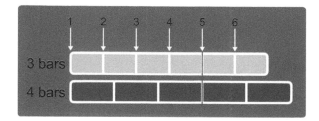

A 6-bar and 8-bar combination would only repeat every 24 bars, and 7 bars and 9 bars every 63 bars!

The music for *Screen 07* is from the Sound Cue {Phasing_Percussion} that contains a 4-bar loop (780kb), 7-bar loop (1,171kb), 9-bar loop (1,756kb), and 11-bar loop (2,146kb). By looking at the lowest common multiple between them ($7^2*7*3*11 = 2772$), we can work out that in order for them to come back in sync, and for us to be hearing exactly what we heard when they all began to play, we would have to play the 4-bar cue 693 times, the 7-bar cue 396 times, the 9-bar cue 308 times, and the 11-bar cue 252 times (the lowest common multiple is 2772). The 4-bar loop lasts 9 seconds, so that means we get over 1:44 hours of music before it repeats—not bad for 5.8MB of music (listen to it and check if you don't believe us).

Obviously although every detail will not repeat until the cycle is complete, this does not mean that it's necessarily interesting to listen to! That is up to you to make a judgment on, but it is a useful tool for producing non-repetitive textures.

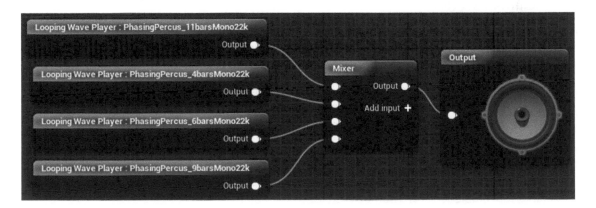

Granular Note-level Sequences

Screen 08 (Bookmark 8) is an example of how you could start to treat your game engine as a musical sequencer. The 16 outputs of the <MultiGate> act as a step sequencer. The <Beat_V02> event is being triggered every beat. The taiko (bottom right) ticks along with a randomized accompaniment while the other elements are attached to different beats. In the Sound Cues of each part, there is randomization and sometimes the inputs to the random are left blank—so sometimes that part won't play at all. Working like this not only allows a great deal of variation, but also allows the music to be very responsive since you can bring parts in and out (by muting or unmuting the parts) on the next beat (this is not to be confused with granular synthesis—we're using "granular" in the sense that we're working with note level grains rather than wave chunks).

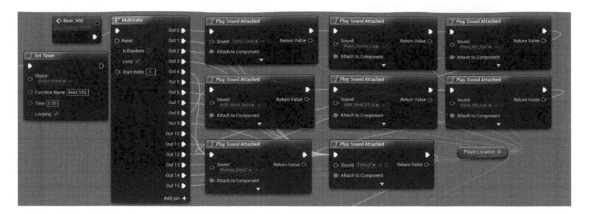

Using Random Seeds

Interestingly the nature of random numbers produced by computers is that they're not actually random at all! When writing/constructing procedural or algorithmic music systems, this can be very useful.

If we seed a random number generator, then we actually get a predictable set of outcomes. For example if we have a random seed of 234 and get a range of integers from 1–100, then we will predictably receive 37, 95, 60, 67, 4, 76, 21, etc. The system in *Screen 09* uses this characteristic to generate repeatable musical patterns. We set up a timer to output a pulse at the tempo we wanted (every 0.25 seconds = 240 BPM, but these are actually half-beats, so our tempo is our old friend 120 BPM). Every 8 half-beats we reset the random seed on this measure (or bar), and so we get a predictable, repeatable series of 8 numbers.

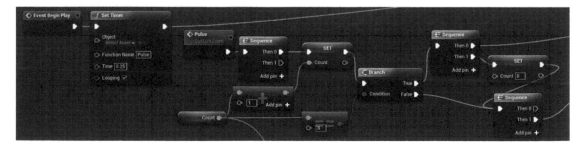

We could just send these to control the -Switch- in our Sound Cue via a <Set Integer Parameter>, but that would just give us a very repetitive 8-note (one bar) pattern. We have only actually got 5 notes in our Sound Cue, so we've restricted the output of the seeded random to give us numbers in this range.

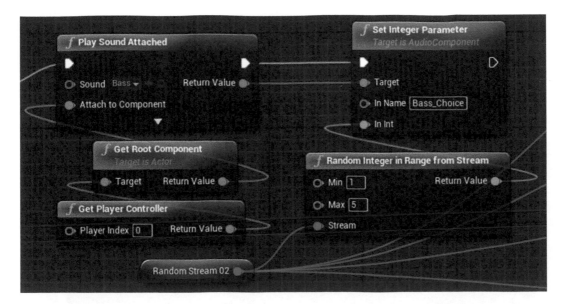

Instead we randomly weight the likelihood of each note actually being played. By doing this, we'll retain the underlying character of the pattern but will introduce variation regarding which notes will actually get played, much like a musician might sometimes add notes or miss ones out to create variety.

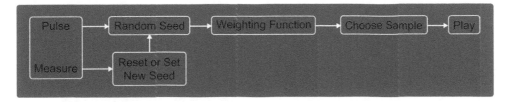

This random weighting system takes the 8-pulse note count and uses it to read through a curve. This curve is 8 seconds long since we are treating the 8-pulse count as seconds to read through time (although obviously this has nothing to do with time—it is just an easy way to read out the contents of the curve).

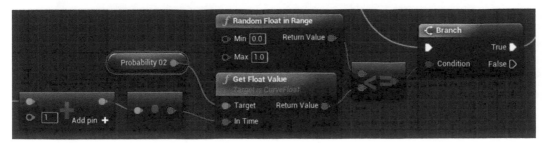

We generate another random number to compare the output of the curve to. This is a way of giving us a percent chance of the note playing. If our curve defines note one (the reading at 1 second) as being 0.5, then the chances of our **<Random Float in Range>** producing a number less than or equal to 0.5 is 50%. If our curve output is 0.25, then the chances of the random number falling within this range is 25%.

So our curve is like a probability table, defining the likelihood of each note. For example this curve would never play the first 4 notes (0% chance), but would always play the second (100% chance).

And this one would do the opposite.

Our actual curve for the bass line is a lot more interesting than this, as it introduces lots of weighted probability giving us a wide variety of possible outcomes.

You could extend this to read through arrays of notes that defined certain keys or modes or weight certain harmonically important notes for example. There are many more techniques out there associated with algorithmic composition such as Markov chains or cellular automata that also have potential applications in games that would not only allow us to produce music of great variety (within defined parameters), but also music that can be responsive to gameplay on a note, rather than track, level.

Rhythm-action

Rhythm-action games come in all kinds of guises but are united by the underlying principles that the player will gain advantage through performing actions in synchrony with musical events. Although the core approach of a performance where you play along to pre-existing music remains popular, there has also been a lot of innovation in this field in the last few years that continues to blur the lines between gameplay, performance, improvisation, and even composition.

The demo levels here are for a bit of fun (you deserve it!) and as a basis for you to develop further if you wish. Given that this is an advanced chapter, we will trust that you can make some kind of sense of them through examining the systems themselves, so we will just provide a brief overview.

Graphically Led

Project: DemoCh12Rhythm01
Level: GraphicallyLed01

The descending ships represent the notes of the bass line that you must play in time by pressing the keys A, S, and D to move the target into the correct one of the three positions. We call this a graphically led style of game since the notes are represented in a piano roll style on the screen, and you could theoretically play these with the sound turned off. Other games might be more audio led, in that you actually have to listen in order to master the game.

Two synchronized tracks are started, the {**Accompaniment**} and the {**Bassline**}. The bass line is immediately muted by the <**Set Volume Multiplier**> (set to 0.01 so as not to actually stop the track and get out of sync).

The system is controlled by note sequences in a [**Matinee**]. These are the same but offset by the amount of time it takes the ships to reach the bottom of the screen. The Note01 event in the illustration below spawns a ship that starts to move down the screen, and the PlayNote01 event opens a Window variable (<Set>s to True) for a set length, which is the time we expect the player to attempt to play this note.

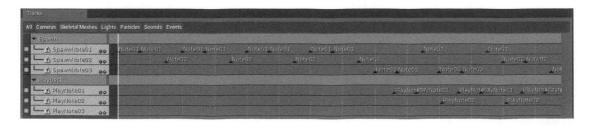

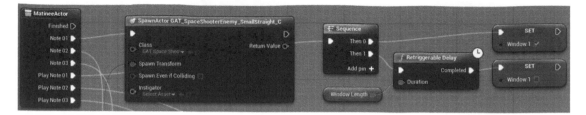

When the player presses a key, we check to see if the window is open (or True). If it is then the player has correctly timed their input with a note, and we spawn the explosion and momentarily unmute the {Bassline} track. If the window is not open (False), then we play a Duff Note sample instead.

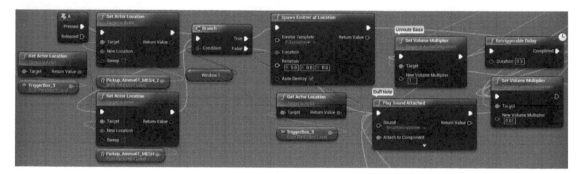

Call and Response

Project: DemoCh12Rhythm01
Level: CallandResponse01

Rather than muting and unmuting a synchronized music track or stem, call and response games tend to use repeated stingers for the particular notes you must echo. The lines at the top represent 8 musical beats, and the player must successfully respond by imitating the pattern they just heard.

Each pattern is stored in an array with 8 elements. This is read through with a <ForEachLoop> and places each element of the array (if present) at its designated spawn point (the [Target Point] Actors' positions) along the 8 beats.

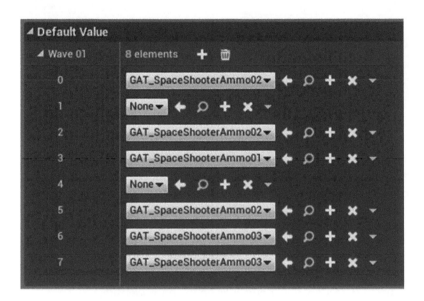

This gives us a series of pickups placed rhythmically across the screen, each of which is associated with a specific key press A, S, or D. A <FlipFlop> alternates the system between audition mode, where the player listens for the pattern, and play mode, where they attempt to recreate it.

A ship is spawned [GAB_SpaceShooterEnemy_Small] and starts to move across the screen, passing each beat marker at the correct time due to its designated speed. When it overlaps with a pickup, it sets the Boolean variable associated with that pickup (for example AOpen) to True, and when the player presses a key, we check the condition of that Boolean. If it is True, then we play the pickup sound and award some points, and if not then we subtract some points. We can set the degree of accuracy we require by changing the size of the box around the ship that gives us the overlap events.

Conclusion

There are many ways to utilize established methods of algorithmic or generative composition in games that have yet to be explored and this continues to be an exciting field of innovation. Once we are able to work on a more granular note level, the possibilities for integrating and adapting music with gameplay are huge, and make many current systems that simply rely on starting, stopping, or changing the volume of prebaked musical stems look pretty primitive. There's lots of fun to be had here!

For further reading please see the up-to-date list of books and links on the book website.

Conclusion

Phew! Well, we hope that you have enjoyed the book. We hope that through the book, demo levels, and exercise levels, you have been able to get a real feel for implementing audio in lots of different kinds of situations and game genres.

The video game industry continues to develop rapidly. The great thing about that is that new ideas and techniques come up all the time. The difficult thing, however, is that books take quite a while to make it to the shelves and so some objects and approaches in the latest version of UE4 may well have changed by the time your read this. Nevertheless, the principles remain true, so hopefully you can apply these in whatever package you happen to use. We'll tell you the best version number to use with the book and keep the website FAQ and demo levels regularly updated, but if you spot a problem before we do then just get in touch and let us know. If you make something cool, then drop us a line and we can share it with other readers.

Have fun!

Dave Raybould
Richard Stevens
www.gameaudioimplementation.com

Appendix A

Core Concepts

This section is intended to give you some quick reminders and further details about various functions, nodes, and systems and should be viewed in conjunction with the relevant sections of the book.

We have put these in the order that we might typically need to operate in a game. An input (Key and Gamepad Inputs) or event (Events and Triggers) may trigger a sound event. In order to get events we need to manipulate and place triggers (Manipulating Actors) and reference these from within the Level Blueprint (Referencing in-game Actors within Blueprints). There might be variables that influence the sound so we need to look at these (Variables, Parameters, Numbers and Arrays) and how to manipulate them (Transforming and Constraining Variables and Parameters). Depending on the variable (Evaluating Variables and Parameters) we may want to decide for certain things to happen (Routing Decisions and Events) to produce changes in our sounds (Controlling Audio Components and Sound Cue Nodes). We will also want to monitor what is happening to make sure our systems are working as intended (Console Commands).

Key and Gamepad Inputs

The Bindings menu (Edit/Project Settings/Input/Bindings) is used to map specific keys and gamepad axes and events to commands that can then be called within Blueprints.

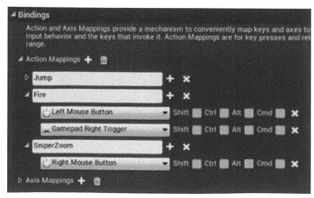

You can set these up as you like for the input methods you want to use and for any events and actions you need within your game. Action mappings are for key or button presses and releases (e.g., Spacebar for jump), while axis mappings are for inputs with a continuous range (e.g., joystick for movement). As an example, the fire action is mapped to both the LMB and the right trigger of a gamepad. This can be called within a Blueprint using the <InputAction Fire> event.

Once established in the Bindings menu, you can create events for these in Blueprints through the Blueprint ➡ Graph Action Menu. Keyboard input events are all set up by default.

Events and Triggers

You can only have one instance of an event within a Blueprint, so if you need multiple things to occur on a specific event, you will need to either chain them sequentially or use <Sequence> nodes.

As well as the input events configured within the Bindings menu, you can also make use of the following:

<Event Begin Play>

Called when the Actor or Blueprint is first initialized (in the case of the [Level Blueprint], this would be when the game starts).

<Event Tick>

Called on every frame while the game is being played. This event also returns the DeltaTime (the time between frames), which is used in conjunction with nodes such as <FInterp To>.

<Key Events>

These are assigned to a specific key and called when that key is pressed or released. By default these events are set to consume input, which means if you have the same key in multiple Blueprints (i.e., level and character), only one of them will work.

<Event Any Damage>

Called when the Actor takes any kind of damage. This event returns the amount of damage taken (Damage), the Damage Type, and the name of the Actor that caused the damage.

Depending on the type of Actor, there will be other events that are available, for example the player character has <Event On Landed> and <Event On Start Crouch>.

Trigger Touch from Overlap or Hit

With a [Trigger] Actor selected in the ➡Viewport, you can right-click in the ➡Event Graph and create the following:

<Event Actor Begin Overlap>

Called when the collision volume of an Actor overlaps with that of another Actor.

• This requires the collision property to be set to overlap.

<Event Actor End Overlap>

Called when the overlap between two Actors ends (i.e., their collision volumes no longer overlap).

• This requires the collision property to be set to overlap.

<Event Hit>

Called when collision volumes set to block collide with each other.

• This requires the collision property to be set to block.

Trigger Use

In order to trigger events from key or controller inputs anywhere in the level, we could just create a <Key Event> in the [Level Blueprint] and link it straight to a <Play Sound Attached> (or other function), however this would work globally (i.e., wherever we were in the level). Instead, we might we want this input to work only when the player is actually standing next to the relevant Actor.

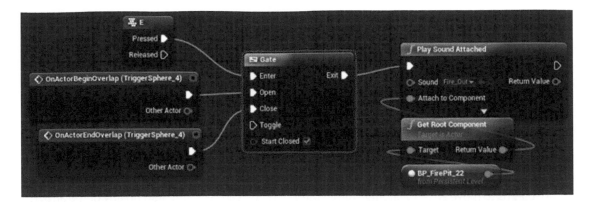

In order to do this, we use a <**Gate**> node that is opened and closed by the [**Trigger**] around the button. This way the <**Key Event**> E will not be allowed through to trigger the sound unless the player is in proximity to the button.

Find the <**Key Event**> E by searching the ➡**Graph Action Menu** for "E Key".

Trigger Use and Release

This enables us to set up the Released output of a <**Key Event**> as well as the Pressed. Again, to avoid this occurring globally we control a second <**Gate**> with the overlap events from a [**Trigger**].

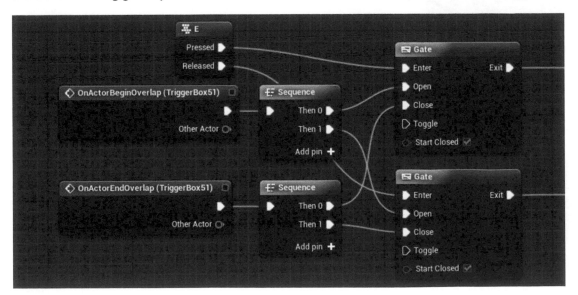

Manipulating Actors

You use the transform widgets to manipulate Actors within the editor—you can select the different widgets from the selection menu across the top of the Viewport or by pressing the Spacebar to cycle through them.

Translate Widget

This enables us to move an Actor around within the world. You can click and drag on any of the arrows to move in that axis or on the crossbeams of the arrows to move in two axes simultaneously.

Rotate Widget

This enables us to rotate an Actor around any of the three axes within the world.

Scale Widget

414

This enables us to scale an Actor along any of the three axes within the world. You can click and drag on any of the boxes to scale along that axis, on the crossbeams to scale in two axes simultaneously, or on the white box to scale along all three.

When using the transform widget, any adjustments you make will be snapped according to the snapping settings. You can change these from the selection menu across the top of the Viewport.

You can also enter transform values directly into the Actor's ➡Details panel.

Referencing In-game Actors within Blueprints

If you select an Actor in the level, and then right-click in the Blueprint, you can create a reference to that Actor that you can then use to call functions and set variables.

Handily, you can also create functions and nodes that are preconnected to this reference. For example if you have an Actor selected and then find "Get Root Component", it will automatically add a reference to the Actor hooked up the <Get Root Component> node.

This works for lots of things—for example if you have an [Ambient Sound] selected in the level and you create a <Play> node, it will create a reference to the Actor and hook it up to the <Play> node.

Variables, Parameters, Numbers, and Arrays

Variables are used within Blueprints to keep track of game states and events and to drive other systems (e.g., the volume of a music track). There are a variety of different variable types, but the most common are ints, floats, arrays, bools, and vectors. Ints are integers (whole numbers), floats are floating point numbers (with decimal points), Bools are Boolean variables (True/False), and vectors describe direction movement or locations. Remember that in the Unreal Engine (and all other code) indices start at 0, not 1 (i.e., the first output of a switch is output 0).

You can create variables from the ➡MyBlueprint panel by clicking on the + icon in the Variable section. A new variable will be created, and you can then set its Name and Type through its ➡Details panel.

If you compile the Blueprint, you can then set a default value for that variable (again, in the ➡ **Details** panel).

Once you've created your variable, you can drag into the ➡ **Graph** window and either create a <Get> or <Set> node, depending on what you want to do. Once added, you can no longer change its variable type. (You also can automatically create <Get> or <Set> by holding Ctrl or Alt as you drag into the ➡ **Event Graph**.)

This can then be connected up into your larger Blueprint systems.

Each type of variable is a different color, as are the connections that come from them when using the <Get> nodes. This makes it very easy to see what is going on within your Blueprints and what type of variables you are using.

The inputs to nodes are also color-coded in the same way.

If at any point you're not sure what type of variable to create, you can right-click an input or output port on a node and select Promote To Variable. This will automatically create a new variable of the correct type for whatever it is that you've clicked on.

You can change an existing variable node to a new one by dragging the new variable from the ➡MyBlueprint panel on to an existing variable node. Depending on whether you drag the new variable on to the left or right side of the node, you can either change the variable being read or assign the new variable to be that of the old one.

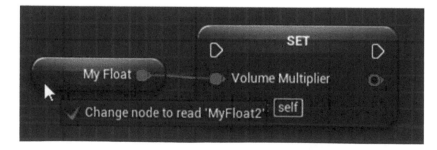

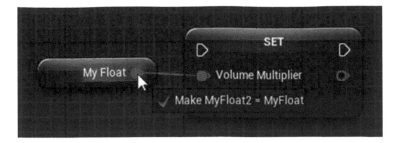

The get and set functions for arrays are slightly different. Any variable type can be turned into an array simply by clicking on the Make Array button next to the variable name.

Because an array is a collection of variables stored as a list, when we want to get or set something within the list, we have to use the index. Remember that the first item in an array has an index of 0, the second item has an index of 1, and so on.

To get an array item, we have to create a reference to the array and then get a given index from that.

To set an array element, we again have to create a reference to the array and then define the value of the item at a given index.

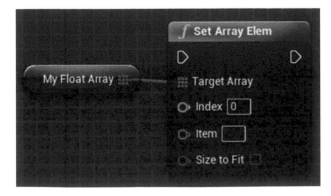

Transforming and Constraining Variables and Parameters

Variables and parameters from the game system do not always come in a range of numbers that are useful to us in terms of controlling audio (or other aspects of game systems), so there are a variety of nodes that allow us to transform these into more usable numbers. Some of these are variable type specific (i.e., only come in float varieties), but others come in different variable types.

<Normalize to Range>

This takes an incoming range of numbers and normalizes them (i.e., converts the incoming range to an outgoing range of 0.0–1.0). You have to define the Range Min and Range Max of your incoming values. If your incoming range exceeds the Range Max value, then the output will exceed 1.0 (and vice versa if the range goes below the Range Min value, so you may want to <Clamp> the values as well).

<Map Range>

This takes a defined incoming range of numbers (in range A–in range B) and maps them on to a defined outgoing range of numbers (out range A–out range B). You can also do this within a Sound Cue's -**Continuous Modulator**- using the Min/Max Input/Output settings.

<Absolute>

This returns the absolute (i.e., positive) value of the incoming number (used to convert negative numbers to positive numbers). You can also do this within a Sound Cue's -**Continuous Modulator**- by changing the Param Mode within its ➡ Details panel.

<Clamp>

This is used to ensure that a range of numbers cannot exceed a given range. The Value input is clamped between the Min and Max range values. This is a useful node when dealing with physics and impact velocities, as it can be used to constrain the occasional extreme value.

<In Range>

This node produces a Boolean output depending on whether the incoming Value input is between the Min and Max range values.

<FCeil>

This takes a float input and rounds it up to the nearest integer (e.g., 2.3 would become 3).

<Floor>

This takes a float input and rounds it down to the nearest integer (e.g., 2.8 would become 2).

<Round>

This takes a float input and rounds it to the nearest integer (e.g., 2.3 would become 2 and 2.8 would become 3).

There are also a variety of <To> nodes that will convert from one variable type into another.

- Quite often these can be created automatically if you're trying to connect one variable type to another.

If you wanted to interpolate (i.e., create a changing series of values) between one value and another (e.g., if you wanted to create a transition movement for a camera when switching between first-person and third-person views), then there are a number of nodes that can do this for you—**<FInterp To>**, **<FInterp To Constant>**, and **<Ease>**. There are also variants of these objects for colors, rotators, vectors, and transforms.

Reading through Curves

The ability to take a linear range of numbers but then transform them by using them to read through user-defined curves is very useful as we have seen in Chapter 02 for parameterized sound, Chapter 04 for layers of parallel music, Chapter 07 for impact velocities to different sounds (including footsteps speed), and Chapter 09 for weapons detail over distance.

Applying a curve to the linear parameter of volume adjustments in UE4 (0.0–1.0) is particularly useful since, unlike the volume controls in your DAW, the volume scaling does not by default reflect the logarithmic nature of loudness perception. As you can see in the rough comparison illustrated below, a 0.5 volume multiplier will indeed result in a -6dB drop and so will be perceptually at half the volume as expected, but as we get into the lower range of multipliers, smaller incremental changes have a more dramatic effect on perceived volume differences.

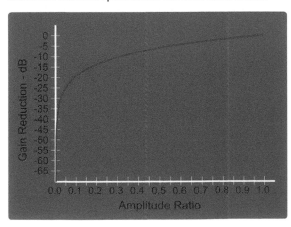

Having created a {Curve} asset in the content browser (New/Miscellaneous/Curve Float), you can double-click it to open the ➡Curve Editor. Create a new point with Shift and click, click and drag points to move, and use the mouse wheel to zoom in/out. Click and hold RMB to move the view around, and right-click on points to change the curve type.

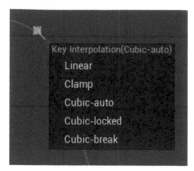

When you add your curve asset to a curve variable in the Blueprint, you can <Get> this variable and drag out from it to <Get Float Value> (compile the Blueprint first).

The In Time will make the node read and output the value of the curve at that position on its X-axis (time is just the name for this axis, but you can treat it simply as a set of values). This means that we can use curves as a kind of lookup table for values and control the response to game parameters by changing the shape of the curve.

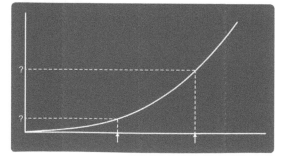

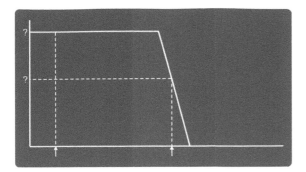

This is fine if the range of time values you are reading matches the time range of the curve, but another useful thing to do sometimes is to be able to map the time range of the curve you have created onto values between 0.0–1.0. This way the curve is acting more like a percentage scale of the input values, and you can reuse the curve for a number of different input ranges. We have created the Blueprint macro [GAB_Read_Curve] to do this. This gets the time range of the curve. This is taken from 0.0 to the position of the last defined key point. By finding the value of the end point of the curve, we can now multiply this by our read position (0.0–1.0) to map the values to a 0.0–1.0 range.

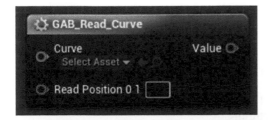

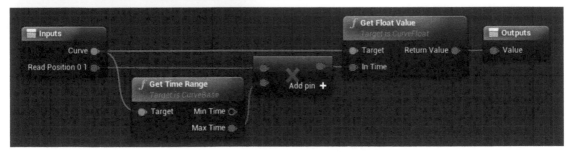

Evaluating Variables and Parameters

There are plenty of times when you need to evaluate a variable and then do something based on the result of this evaluation. The objects that are available for evaluation are (these come in a variety of variable types):

Greater Than (>)

This outputs a Boolean value depending on whether input A is greater than input B.

Greater Than or Equal To (>=)

This outputs a Boolean value depending on whether input A is greater than or equal to input B.

Less Than (<)

This outputs a Boolean value depending on whether input A is less than input B.

Less Than or Equal To (<=)

This outputs a Boolean value depending on whether input A is less than or equal to input B.

Equal To (==)

This outputs a Boolean value depending on whether input A is equal to input B.

Not Equal (!=)

This outputs a Boolean value depending on whether input A is not equal to input B.

<Nearly Equal>

This outputs a Boolean value depending on whether input A is within the Error Tolerance of input B.

You can also evaluate the results of evaluations if you want (like we did with the inventory section in Chapter 06 on dialogue). These objects only take Boolean inputs.

<AND>

This outputs True if both input values are True.

<OR>

This outputs True if either or both of the input values are True.

<XOR>

This outputs True if and only if one of the input values is True.

Routing Decisions and Events

You often may want to pass exec signals to different parts of your Blueprints based on the value of variables or the results of your evaluations.

<Branch>

This passes the exec signal to either its True or False outputs based on the value of the controlling Boolean Condition.

<Gate>

The Enter signal is only allowed to pass through to the Exit if the **<Gate>** is open. You can Open or Close the **<Gate>** using it's inputs as well as using the Toggle input to toggle it's open/close state.

<Switch>

There are a variety of these, but the most useful is probably the **<Switch On Int>**. This routes the incoming exec signal to the output defined by the Selection input (an integer).

<CompareFloat>/<CompareInt>

This is a triggerable node (i.e., it has an exec input), and it compares input A against input B to output an exec from either its >, ==, or < outputs depending on the result of the evaluation. This is actually a macro containing > and < nodes and **<Branch>**es to route the exec signal based on the evaluations.

<Select>

Unlike the other routing nodes, this one doesn't route an exec signal. Instead it routes variables. You can connect any kind of variable to its Option inputs, and the Index input selects which one gets passed through.

<Sequence>

This takes an exec signal and routes it out of multiple outputs in order.

<FlipFlop>

This takes an exec signal and alternately routes it from output A, then output B, then A, etc.

<MultiGate>

This object will pass the incoming exec signal to its output pins in order on consecutive triggers. You can also set it to be random if you want. It also has a Loop option. You can also override Start Index by connecting an integer variable to the relevant input.

<DoOnce>

This will only output an exec signal once (useful for preventing repeated retriggers). It can be reset using the Reset input.

\<ForLoop\>

This is useful for reading through or setting the entirety of an array in one go.

Custom Events

You can set up your own \<Custom Event\>s within a Blueprint—these can be used to create interactions between different Blueprints or just to reduce the number of connections within a single Blueprint. If you want to reduce the connection clutter on your screen, you can use a \<Remote Event\> to call a \<Custom Event\>—simply set them up to have the same name.

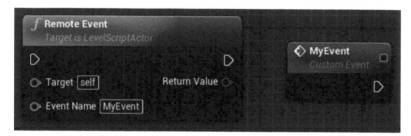

If you want to use them to create interactions between different Blueprints (say you want to call a function within your player Blueprint from the level Blueprint), then you first need to set up the \<Custom Event\>in the player Blueprint. Make sure you compile the Blueprint.

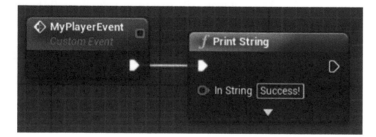

Then in the level Blueprint, you need to create a reference to the player character using \<Get Player Character\>, and then \<Cast\> this to the class of your player character (e.g., [MyCharacter]) so that you can access any events defined within its Blueprint. Then drag off the As My Character output of the \<Cast\> node and search for the name of your event. You can then use any kind of event within your level Blueprint to trigger the \<Cast\> and in turn the event within your player Blueprint.

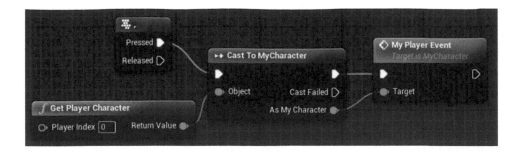

Controlling Audio Components

You can dynamically control the playback of sounds to respond to game parameters or variables with a variety of Blueprint nodes.

These can target audio components from references to in-game [**Ambient Sound**]s or from <**Play Sound Attached**> nodes. Drag out from the blue Return Values to select them from the actions palette.

The <Set Pitch Multiplier>, <Set Volume Multiplier>, <Set Sound>, and <Set UISound> apply directly, while the <Set Boolean Parameter>, <Set Float Parameter>, <Set Integer Parameter>, and <Set Wave Parameter> are given names (In Name) that correspond to names allocated in various Sound Cue nodes.

<Set Boolean Parameter>

Sets the -Branch- node for selecting sounds in response to True or False conditions.

<Set Float Parameter>

Sets the -Continuous Modulator- node for controlling volume or pitch, or a -Crossfade By Parameter- node for controlling crossfades.

<Set Integer Parameter>

Sets the -Switch- node for selecting sounds based on the value of an integer.

<Set Wave Parameter>

Sets the -**Wave Param**- node for swapping out sounds.

When an event triggers any of these **<Set>** nodes, they apply immediately to the currently playing sound, therefore you should typically trigger changes at the same time as triggering the sound itself in order to avoid the currently playing sound being interrupted.

An exception to this might be the **<Set Float Parameter>** (targeting the -**Continuous Modulator**- or -**Crossfade by Parameter**-) where you might continuously update the parameter to apply volume or pitch changes via an **<Event Tick>** or Update from a **<Timeline>**.

You might also update the parameters of a <Set Pitch Multiplier> or <Set Volume Multiplier> in a similar fashion.

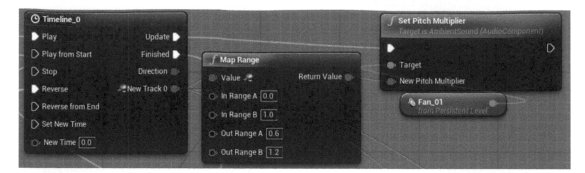

You can only have one <Event Tick> in a Blueprint, so you would either route this through several nodes until it reached your <Set> node (ideally) or use a <Sequence> node to get multiple versions directly to different places. Be aware that systems driven by an <Event Tick> can have a significant performance impact, so always consider alternatives and use only when absolutely necessary.

Sound Cue Nodes

Navigating in Sound Cues

LMB—Click to select, click and hold to drag
RMB—Click and hold to move the screen around
Ctrl + LMB—Select multiple items
Shift + LMB—Marquee select (this allows you to draw a rectangle and will select the items within it)

Click and drag wires between the inputs and outputs to connect up the systems or use Alt + click to delete connections.

-Output-

This contains the global properties of the Sound Cue itself. Here you can also set the attenuation settings for the cue, together with the overall Volume and Pitch multipliers, the Sound Class, and the playback rules (regarding how many instances of the sound can be played back simultaneously).

-Attenuation-

This node determines how the sound will attenuate over distance and spatialize. If your Sound Cue has an -Attenuation- node, then you can also access these settings from the Properties (right-click) of the Sound Cue in the ➡Content Browser.

This node allows you to set a parameter outside of the cue that will control which branch it plays depending on if the parameter is True or False (see p 428 and the Controlling Sound Cues section below).

-Concatenator-

This will chain together a series of sounds attached to its input—as soon as the first has finished playing, it will play the next input, etc.

-Continuous Modulator-

This can be used to vary the pitch and/or volume of a sound in response to game variables such as the velocity of vehicles. There are settings within the -**Continuous Modulator**- that allow some transformation of the incoming variables, such as mapping them to a given range or restricting them to absolute (positive) values (see the 'Controlling Sound Cues' section below).

-Crossfade by Distance-

Two or more sounds can have volume envelopes applied depending on their distance from the sound source

-Crossfade by Param-

You can use an external parameter to control the crossfade between two or more sounds

-Delay-

A delay will instigate a sound at a random time between its min and max settings

-Dialogue Player-

This node allows you to play certain sounds depending on which character is speaking or listening

-Doppler-

This node will apply a Doppler shift type effect to the cue

-Enveloper-

This node allows you to apply volume or pitch envelopes to your sounds

-Group Control-

This will choose a different input sound to play depending on how many instances of the first input sounds are playing

-Looping-

This will loop the system. It is not for looping sounds themselves, which is done with a looping wave player

-Mature-

This designates the sound as belonging to the mature category for reasons of age appropriateness.

-Mixer-

The volume level of two or more inputs can be set using this node

-Modulator-

This node can vary the volume or pitch of a sound with fixed or randomized settings

-Oscillator-

This oscillator can be applied to the pitch and/or volume of a sound

> Modulate Volume/Modulate Pitch: Choose to modulate either or both

> Amplitude Min/Max: The amplitude of the oscillator's modulation (following a sine wave pattern)

> The wave is centered by default around 1.0, so if this amplitude were set to 0.5, you would get a range of values from 0.5 to 1.5. There is both a min and max setting, so you can also randomize this parameter between those two values.

> Center Min/Max: You can offset the center of the modulation so that, for example, the sound does or does not drop to complete silence when at the lowest point of its cycle.

Frequency Min/Max: This value is twice the frequency of the sine wave's modulation in Hz. Min/max fields are for the randomization of this value.

Offset Min/Max: Where the sine wave starts in its cycle is referred to as phase. This offset value allows you to shift the phase of the cycle. This value is multiplied by 2*Pi. Min/max fields are for randomization.

-Random-

This will randomly choose between two or more inputs to play

-SoundClass-

This node can be used to set the Sound Class of a sound

-Switch-

You can use an external parameter to choose which input of a switch is played (see the Controlling Audio Components section above).

-WaveParam-

This parameter refers to the name of a Sound Wave and can be used to swap out the sounds played within a cue at runtime (see the Controlling Audio Components section above).

-Wave Player-

This node is the container for your Sound Waves. It can be set to loop the sound

Console Commands

¬ key (Windows) ~ key (Mac)

The quickest way to use the Console is to start typing the command you want. You will then see a list of matching commands appear. Use the up and down arrow keys to choose your command and then press the Tab key to add it to the command line. Now press Return.

If you use the up arrow key before typing anything, then you can scroll through a list of your previous Console commands.

stat audio: Gives you lots of useful information, including crucially the number of any wave instances dropped

```
Audio [STATGROUP_audio]
Cycle counters (flat)                CallCount  InclusiveAvg  InclusiveMax  ExclusiveAvg  ExclusiveMax
Finding Nearest Location                   32      0.00 ms       0.00 ms       0.00 ms       0.00 ms
Gathering WaveInstances                     1      0.05 ms       0.17 ms       0.05 ms       0.17 ms
Source Create                               0      0.00 ms       0.04 ms       0.00 ms       0.04 ms
Source Init                                 0      0.00 ms       0.05 ms       0.00 ms       0.00 ms
Processing Sources                          1      0.02 ms       0.16 ms       0.00 ms       0.08 ms
Submit Buffers                              0      0.00 ms       0.00 ms       0.00 ms       0.00 ms
Updating Sources                            6      0.02 ms       0.05 ms       0.02 ms       0.05 ms
Audio Update Time                           1      0.14 ms       0.47 ms       0.03 ms       0.06 ms
Decompress Vorbis                           0      0.03 ms       0.36 ms       0.03 ms       0.36 ms
...are Vorbis Decompression

Memory Counters                      MemUsedAv MemUsedMax%     MemPool Pool Capacity
Audio Memory Used                        4.17 MB                Physical

Counters                              Average       Max
Active Sounds                           31.60      33.00
...e Wave Instances Dropped              0.00       0.00
Audio Buffer Time                                 256.67
...uffer Time (w/ Channels)                       350.99
Audio Sources                            5.60       7.00
Wave Instances                           5.60       7.00
Wave Instances Dropped                   0.00       0.00
```

stat sounds/stat sounds off: Lists all currently playing sounds

```
Active Sounds:
  Sorting: disabled Debug: disabled
Index Path (Class) Distance
    0. /Game/Audio/Music/Music_Cue.Music_Cue (Dialogue_Music) 624.34
        0. Wave: Dialogue_3, Volume:   0.23, Owner: MyCharacter_Female_C_1
    1. /Engine/Transient.DialogueSoundWaveProxy_5 (Master) 624.34
        0. Wave: E_22_InaWorld_Princess, Volume:   1.00, Owner: MyCharacter_Female_C_1
Total sounds: 2, sound waves: 2
Listener position: X=-10.000 Y=-640.000 Z=640.000
```

You can also sort these in a variety of ways.

```
Stat SOUNDS <?> <sort=distance|class|name|waves|default> <-debug> <off> (Shows active SoundCues and SoundWaves)
> stat sounds_
```

stat sounds-debug: See the attenuation settings of ambient sounds in the game (the sound assets must have debug enabled in their ➡Details panel)

stat soundcues/stat soundcues off: Lists currently playing Sound Cues

stat soundwaves/stat soundwaves off: Lists currently playing Sound Waves

listwaves: Prints to output log (Window/Developer Tools/Output Log)

stat reverb: Lists the active reverb effect

listsounddurations: Outputs a list of all Sound Waves and their durations

listwaves: Lists all WaveInstances and whether they have a source in game

testLPF: Sets the LPF to the maximum for all sources

testLFEBleed: At the moment this does the same as TestLPF

teststereobleed: Sets stereo bleed to maximum on all audio sources for testing

stat soundmixes: Shows a list of active Sound Mixes

listsoundclasses: Shows a list of Sound Classes and the number of sounds in each class

showsoundclasshierarchy: Shows a list of all your Sound Classes and any parent/child relationships within them

setbasesoundmix: Allows you to trigger a named Sound Mix

modifysoundclass: Allows you to modify the volume of a specified Sound Class—type the name of the Sound Class, then "Vol= (***)"

isolatereverb: Isolates only the reverb

isolatedryaudio: Removes any reverb effect

Others

Matinee

After creating a [**Matinee**] Actor in the level, you can create a reference to this Actor in the [**Level Blueprint**] to control the Matinee.

In the Matinee's ➡ Details panel, you can also set it to Play on Level Load and to be Looping if you want it to start automatically.

Creating a <**Matinee Controller**> in the Blueprint allows you to get notifications of when the Matinee finishes (as defined by the red marker in the Matinee timeline) and any events that you might add to an Event Track.

When using a Matinee for cinematics, don't forget to check the options in the Cinematic section of its ➡ Details tab.

Attaching Actors to other Actors

Attaching Actors to other Actors is a useful way of ensuring that things that should move together do so. For example you might want to attach an [Ambient Sound] to a plane mesh that is moving across the level. Rather than having to set up both Actors' movements within a Matinee, we can just set up the plane and then attach the sound to the plane.

The easiest way of doing this is via the ➡World Outliner tab. Select the Actor you wish to attach (e.g., the sound), right-click and go to Attach. You can then search for the Actor you wish to attach to (e.g., the plane).

You need to make sure that both the attachee and the attacher are set to be movable Actors (via the ➡Details tab).

You can also attach Actors to each other via Blueprints, using either the <Attach To>, <Attach Actor To Actor>, or <Attach Actor To Component> nodes (which one you use will depend on how you want the attachment to work, but most likely you'd use <Attach Actor To Actor>).

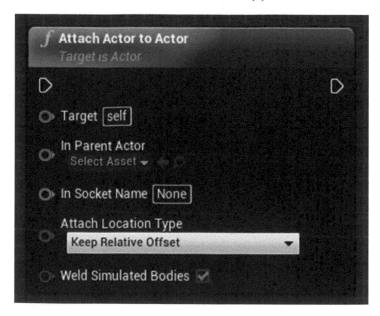

You define the Target (the Actor to be attached), the In Parent Actor (the Actor you're attaching to), the Socket Name (if you're using sockets—can be left as none), and the Attach Location Type (depending on what you're doing, the type may vary, so trial and error is best here).

Timeline

Double-click the <Timeline> node to open the ➡Timeline Editor.

Create a new track of the type you want (typically a Float Track or Event Track).

Shift and click on the line to create key points—the exact Time and Value can be set in the property boxes in the top left.

Click and drag to move key points around.

Use the middle mouse wheel to zoom in or out, or use the zoom horizontal and zoom vertical icons.

Right-click and hold to move the window around.

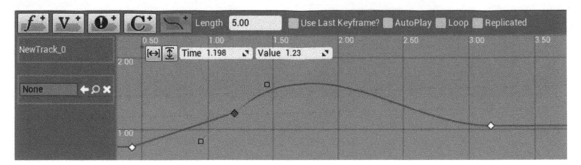

Right-click on a key point to change the settings regarding how it should interpolate between key point values.

Audio Finished

This is an event that can be obtained from an audio component within a Blueprint, either by dragging off the Return Value of a <**Play Sound Attached**> node or from a reference to an audio component variable.

Search for "Finish" and select Assign On Audio Finished. This will create the **<Bind>** function and the **<Custom Event>** that will fire when the audio has finished playing.

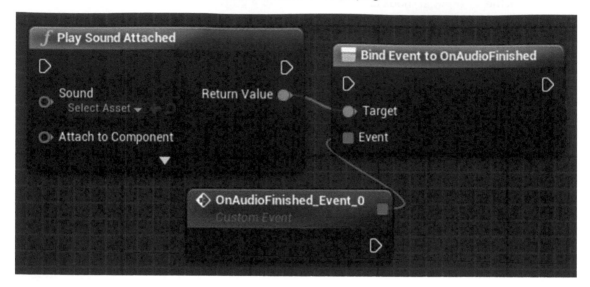

Timer

The <Set Timer> node starts a counter that counts up to the time specified by the Time input. Once the count is reached, the timer calls a remote event with the name specified by the Function Name. You can also set the timer to be Looping.

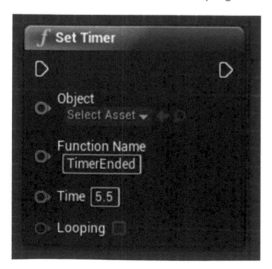

Appendix B

Blueprint Primer

Navigating, Creating and Connecting

RMB Click, hold and drag: Move the graph
Mouse Wheel: Zoom in / out
LMB Click on node: Select node
LMB Click, hold and drag in empty space: Marquee selection
LMB Click on selected node(s), hold and drag: Move Selected item(s)

RMB click in empty space: Open the -Graph Action Menu
LMB Click on node pin, hold and drag out to empty space: Open the Graph Action Menu

LMB click on node pin, hold and drag out to other pin: Make new connections
Ctrl + LMB click on node pin with existing connection, hold and drag top new node pin: Move an existing connection.
Alt + LMB click on node pin to break connections.
Double-click on a wire to insert a reroute node (for keeping things tidy).

You can select multiple nodes and then right-click to choose Collapse Nodes. This will package the selection into a sublevel of the graph (useful for tidying sequences up). If you change your mind, you can right-click a collapsed node and choose Expand Node to unpackage it. To move into a collapsed node's graph, double-click the node. Use the arrows in the top left of the graph to navigate back up to the main graph again.

Events and the Programming Paradigm

Blueprints are the implementation of a visual scripting system, and this follows normal programming methodology in terms of its sequential nature. You can only have one instance of an event in each Blueprint (i.e., only one <**Event Begin Play**>). You also can't connect an exec output from one node to multiple nodes.

If you want to use an exec signal from either a node or an event in multiple places, you need to either connect them sequentially or make use of the <**Sequence**> node.

As an example, if you wanted a <**Key Press**> E to play a sound, turn a light off, and spawn an explosion, you could do it sequentially like this:

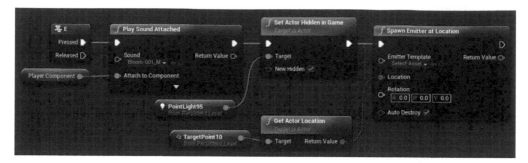

Or by making use of the <**Sequence**> node, like this:

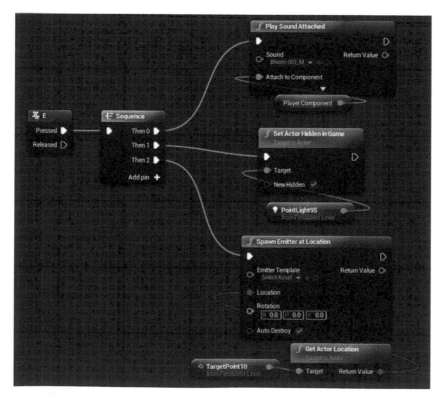

Best practice is to avoid using the <**Sequence**> node whenever possible.

Compiling Blueprints

When you've created your Blueprint system, you need to compile (either using the button in the top left of the screen, or the F7 shortcut).

Hopefully, it will compile fine and you'll get the green checkmark of success!

However, sometimes there may be problems with your Blueprint, and it will not compile correctly, shown by a red sign.

If this happens, you can use the compile results to identify and locate the problem.

You can click on the linked object or connection (in the image above, the Target) to jump to the offending object and then resolve the issue (in this case, no valid reference provided to the Target input of a <Bind> node.

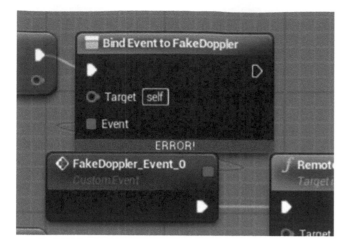

Actor Blueprints

Actor Blueprints function in exactly the same way as the [**Level Blueprint**], but they also have Components that you can add to the Actor such as collision boxes, sounds, meshes, etc. Adding components is easy—simply use the +Add Component menu (in the ➡Viewport panel), then choose from the available types. Once added, you can set the component up in the ➡Details panel (i.e., add your Sound Cue, static mesh, etc.)

You can get references to any components within an Actor in the ➡Event Graph by simply dragging the reference variable into the ➡Event Graph, and you can then drag off the reference to create function nodes and/or set variables within that component.

Below is an example of this using the Explosion_Core sound component within the [**ExplosionMovingSound**] (from the urban warfare level).

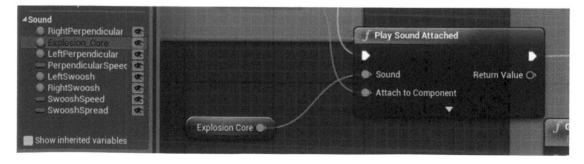

Structures

Structure (or struct) variables contain a series of different variable types (a bit like an array, but with different variable types). These are useful ways of storing a variety of different information for reuse within your Blueprints. These can then be broken to enable you to get at the different variables contained within the struct.

An example of a struct variable is the Out Hit result obtained from a line trace (we used this when looking at footsteps and surfaces in Chapter 07).

The Graph Action Menu

When you right-click in a Blueprint to create a new node, you are using the ➡Graph Action Menu. You can navigate through the different categories, or just search for nodes by name. If you have an Actor selected within the level and the Context Sensitive option ticked, you can search for functions and nodes that relate to that specific type of Actor.

However, sometimes you may need to turn Context Sensitive off to find the node, function, or event that you are looking for. An example of this is the <**Set Audio Listener Override**>. With context sensitive enabled, you can't see it.

With context sensitive disabled, you can see it.

Creating Nodes between Existing Connections

A useful little time saving device is that you can create nodes between existing connections simply by dragging off an output that already has a connection and creating a new node. The engine automatically creates the new node and makes the necessary connections to place it in-line.

Finding Things in Blueprints

It's likely that you'll be producing some fairly complex Blueprint systems and so may struggle to remember where you put a specific node or variable. If this happens, you can use the Find feature within a Blueprint.

Use Ctrl + F to open the Find dialogue and type the name of the node you want to find.

You can then double-click on the result and jump straight to it within the Blueprint.

Communicating between Blueprints

Casting

Casting is an extremely useful feature within the Blueprint system—it is where you take a reference to an object or Actor and then cast it to its parent class so that you can access variables within it (either get or set) and call functions and events within it.

A good example of this is the player character. In the [Level Blueprint] you might want to change a variable within the player character Blueprint in response to an in-game event, so you can create a reference to the player character using <Get Player Character> and then <Cast> this to its parent class (e.g., [MyCharacter]).

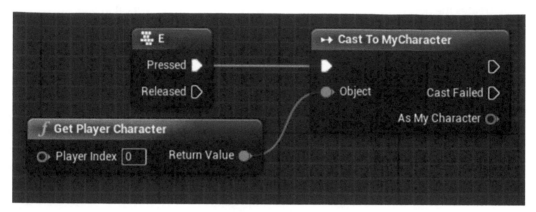

You can then drag off the AsMyCharacter output and call any events that have been set up in the Blueprint.

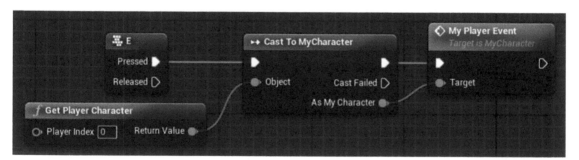

You can also access any variables within that Blueprint as either a get or a set.

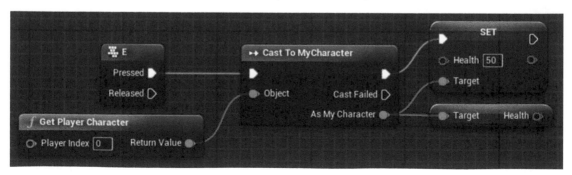

Event Dispatcher

The Event Dispatcher system enables you to call functions and events with the [Level Blueprint] from an Actor Blueprint or other Blueprints (e.g., the HUD). An example of this would be to call an event within the [Level Blueprint] when the player character takes some damage.

First you need to create the Event Dispatcher within the Actor's Blueprint (from the ➡MyBlueprint panel) and give it a name. Then within the ➡Event Graph, you <Call> the Event Dispatcher when the thing you want to trigger the dispatcher occurs (in this example, a Take Damage event).

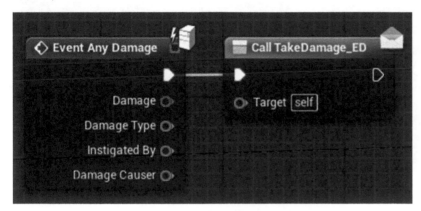

You then need to set up the receiver for this within your [Level Blueprint]. The best approach is to do this when the level starts (i.e., on begin play)—this way the receiver is always ready and waiting for the dispatcher to be called. Create a reference to your Actor, then <Cast> this to its parent class, and finally drag from this to <Bind> the receiver.

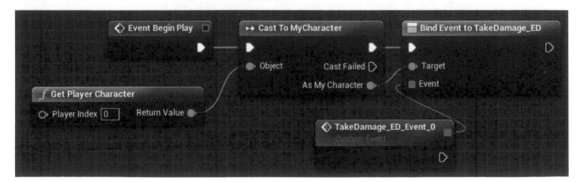

Anytime the <Event Any Damage> is triggered within the player character Blueprint, the <Call TakeDamage_ED> Event Dispatcher will be called, and this will cause the <TakeDamage_ED_Event_0> event to be triggered within the [Level Blueprint].

Getting References to Spawned Actors

So far we've looked at getting references to Actors that are placed within the level and so already exist (or the player character). But what if we want to get a reference to an Actor that doesn't yet exist in the level and is spawned at some point as a result of an event occurring? All of the <Spawn> nodes provide a Return Value output that returns a reference to the Actor that was spawned. You can drag off this and get access to any event, function, or variable that is contained within that Actor's Blueprint.

Below is an example of this using the [ExplosionMovingSound] Actor (from the urban warfare level) that demonstrates that we can access a variable contained within the Actor's Blueprint and are able to <Set> it as the Actor is spawned.

Appendix C

Testing, Troubleshooting, and Good Practice

See also the Compiling Blueprints section above.

Watching Blueprints

While playing the game, you can press Shift + F1 to regain the mouse without having to exit the game. If you then switch to one of your Blueprints, you can see when events are triggered.

You can also right-click on variables, inputs, and outputs and watch variables while the game is running.

Print String

The <Print String> is a very useful node for debugging your Blueprint systems. You can use it to print text or variables to the screen as you play the game in order to check your systems are working correctly or that variables are in the ranges that you are expecting. In this example, the <Print String> is printing the physical material that is obtained from a line trace within a footstep system (the name of the physical material has been converted into a string by the <To String (Object)> node.

This enables us to monitor and check the physical materials that are called as the player walks around the level.

If you have multiple <Print String> nodes running simultaneously, it can sometimes be difficult to keep track of which values are being printed to the screen. A useful solution to this is the <**Format Text**> node.

This allows you to build a string (as text, so will need to be converted to a string using a <**To String (Text)**> node), using specifiers.

In the example above, the specifier is health ({**Health**}). This creates a second input to the node (Health), and so the final output to the <Print String> node in the example below would be "Player Health = 100" (if the player's health were 100).

Auto-Save Recovery

As you can get absorbed in work and forget to save regularly, the Unreal Engine has an auto-save feature. The default setting is to auto-save your maps and content every 10 minutes, but you can change these settings via the Edit/Editor Preferences/Loading and Saving menu.

The files are saved here:

PC: C:\Users\UserName\Documents\Unreal Projects\Project Name\Saved\Autosaves
Mac: /Users/UserName/Documents/Unreal Projects/Project Name/Saved/Autosaves

If the worst does happen, then you can copy the auto-saved map back into your project maps folder:

Projects\Project Name\Content\Maps

Although this can be useful in an emergency, we would not advise relying on this too much, so get into the habit of making your own regular saves—don't forget to use incremental file names!

Organizing and Commenting

We talked quite a lot in Chapter 00 about the importance of establishing folder structures and naming conventions for your assets early on in a project to help you keep track. This will enable you to find and recognize assets quickly and make your work a lot more efficient.

In addition to using folders and sub-folders in the ➡**Content Browser** to manage your assets you can also use them within the ➡**World Outliner** to organize your in-game Actors. For example you might use named folders for each location in the level to group the Ambient Sound Actors in that area.

As your system become more complex, it becomes harder to remember what different sections are for or do. It makes sense to add comments to your sections to remind you when you come back to them. For in-game systems and areas, you can add a <**Note**> Actor to your level, and then within its ➡**Details** panel you can add text to the Note/Text property. If you change the name of these notes as well, you can search for them in the ➡**World Outliner**.

Within your Blueprints, you can add comments directly to individual nodes by right-clicking them and typing into the Node Comment box.

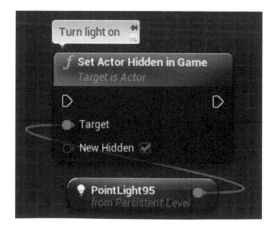

You can also select multiple nodes and press C to create a comment that encompasses them all. This is useful for separating out your different subsystems and marking up sections so you know what they do.

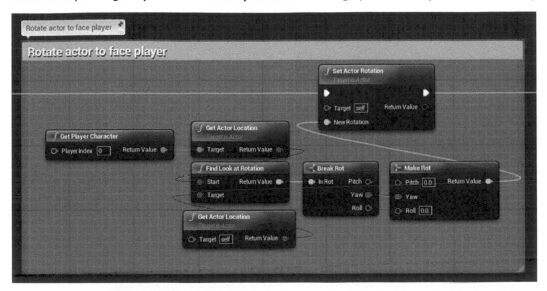

Working in Separate Audio-only Levels

When working on larger levels or projects or within teams, implementing your audio in your own audio levels is a good working practice to get into, as it means that you can be working on your audio systems separately from the level designers.

It is pretty easy to set up multiple levels within a single project in UE4. Simply open the Levels window (Window/Levels), and then from within this window, use the Levels menu and Add Existing or Create New, depending on your needs to either add your existing audio level or create a new empty level within the project.

All available levels within the project (i.e., ones that have been added) will be displayed within the Levels window.

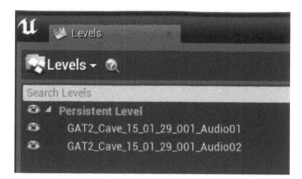

The next step is to set up your [Level Blueprint] to stream your levels (i.e., load them in) as and when necessary.

The image below shows how you would use the <Load Stream Level> node to load in an additional level as the main level starts.

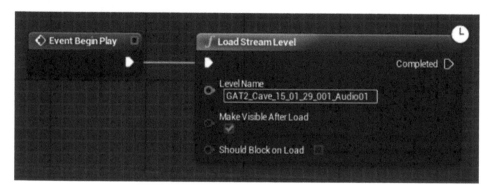

The next image shows how you might use an in-game event to unload one level (using the <Unload Stream Level> node) and then load in another one. This technique can help to free up memory resources in larger levels, as you only stream in the audio assets as you need them.

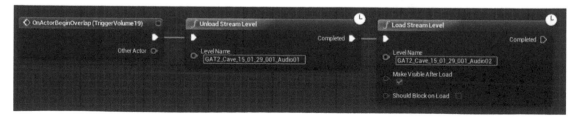

Unfortunately there isn't really a direct way of passing variables and events between the persistent level and those that are being streamed in and out. The best approach is to use either an external Blueprint (e.g., the [Game Mode] Blueprint) as a way of storing global variables or calling events within the different level Blueprints.

Here is an example of how this might be done.

In the main persistent level, an in-game event gets a reference to the game mode and <Cast>s it to its parent class and then calls an event within the [Game Mode] Blueprint.

In the [Game Mode] Blueprint, the <Custom Event> then <Calls> an Event Dispatcher.

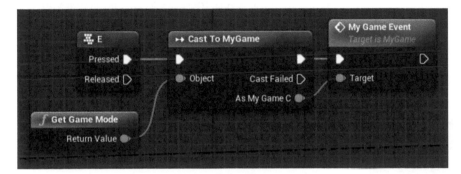

In the streamed level, an <Event Begin Play> <Casts> the game mode to its parent class and <Bind>s an event to the Event Dispatcher, which is triggered by the in-game event from the persistent level.

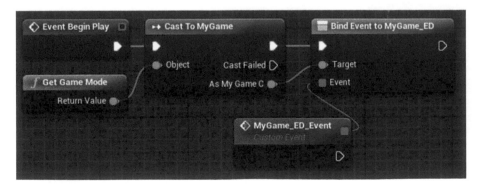

This seems quite complex but is actually the same process discussed above in Appendix B/ Communicating between Blueprints/Casting and Appendix B/Event Dispatcher. It's just that we're doing it between three Blueprints rather than the usual two. In summary, the in-game event triggers something in the persistent level, which in turn triggers something in the [**Game Mode**] Blueprint, which then triggers something in the streamed level.

Tips for Slow Running

If you find that UE4 is running slow while you're editing your levels, there are a few things that you can do.

Disable Realtime Rendering

From the Viewport Options, disable the realtime options. This will prevent the engine from trying to constantly update the Viewport display (Ctrl + R will toggle this on or off).

Far View Plane

Also in the Viewport Options, this is set to 0.0 by default and means that there is an infinite far view plane so all objects are rendered no matter how far away they are. You can set a different value to reduce the rendering load as fewer objects are rendered.

Build Lighting

Ensuring that the lighting build is kept up to date can help reduce the load on the CPU as you edit your level, as it does not have to generate temporary textures.

Engine Scalability Settings

From the Settings icon across the top toolbar, access the Engine Scalability Settings, and from here you can scale down some of the video settings to make things a bit more responsive.

Index

Page numbers for images are shown in italic type.

Actors 6–7, 44–6, 414–17, 442, 448
Adjust Volume node 158–60
advice, dialogue for 201–4
algorithmic forms *132*, 396–403
aligned transitions 190–2
always play 308
ambience and environment 23–56; area loops
 26–31; embedding sounds 44–6; occlusion issues
 46–51; player-oriented one-shots 41–4; reverb
 51–3; sound cues 35–7; source loops 31–5;
 source one-shots 37–41; sourcing and masking
 one-shots 44; trigger sounds 53–6; types of
 sound 25–6
ambient/incidental/chatter/grunts dialogue
 198
Ambient Sound actors 6, 7, 10, 133
Ambient Zones 250–6
Animation Editor (Persona Editor) 280
animations 279–89
Anim Notifies 280–1
apply effects 308
area loops 26–31, 33–4
arrangements 131, 156, 190, 302
arrays 176–7, 212–15, 222, 387, 407, 417–20
assets: browsing for 7–9; checking 121; importing
 16–20; preparing for import 11–16
asynchronous loops 66–7, 398–9
attenuation 27–31, 240–3
Attenuation node *245,* 430
attraction 327

audio: components 160–1, 427–30; files compression
 64–5, levels 453–6
audio, role and function of 301–33; background
 301–2, 309; concepting 332–3; feedback 323–5;
 I.N.F.O.R.M. Model 310; instruction 310–20;
 mechanic 327–30; mixing 302–9; notification
 320–3; orientation 326–7; rhythm-action 327;
 testing 331–2
Audio Finished 436–7
audio physics 266–78; collisions 269–78; Doppler
 267–9; speed of sound 266–7
Audio Volumes 52, 227–33
auto-attenuation 316–17
automation, mix for parallel layers 166–71
auto-saves 3–4, 451

backing up 3
Bajakian, Clint 130
bit depth 12
Blueprints 10–11, 42, 44–6, 133, 439–49, *449*
bookmarks 5
Boolean variable 108, 209–10
Box *29*
Branch 106–10, 206, 209, 210, 215, 216, 276, 286, 365,
 395, 426
branching dialogue 217–21
branching forms *132*
breaths 198
bullets 352–6
buses 305

call and response 406–8
cameras: and cutscenes 289–92; and listeners 292–9; vehicle 372
Capsule 29
cascading physics system 276–8
casings 354
casting 445–6
cellular automata 403
chain of events, concatenation for 76–8
character dialogue 197
character state 321
choices, dialogue 208–12, 221–3
chords 391–2
clicks and pops 198
clunky transitions 173–8
clusters of activity 70
cocktail party effect 301
collisions 269–78
color commentary 378–80
combinations, generative 397–9
commenting 378–85, 452
compiling Blueprints 441–2
compression/limiting 302
Compression/Ogg Size 121
Compression Quality 64–6
concatenate node 74, 79, 381–4
concatenation 71–9, 380–5
Concatenator 70, 74–5, 133–4, 138, 380
concepts 332–3
cone 30
confirmation sound 324
console commands 433–5
Content Browser 5, 7–9, 17
Continuous Modulator node 118–19, 162–3
controller input 53–5, 336–8, 410
counts to dialogue choices 210–11
creep/walk/run 285–6
crossfades 112–16, 175–7, 361–3
crossfade by param node 112–16, 431
crowds, sports dialogue and 375–89; commentary 378–85; dialogue queues 385–8; systems 375–8
culling 316–17
curves 422–4; pitch 364–5; user-defined 116–20; velocity reading through 273; to volume 164–6
Custom Event 153, 191, 438
cutscenes and cameras 289–92

damage layers 370
debug tools 122, 433, 449
decay tails 136–7, 182–3
deconstructing sounds 85–8
decoy 328–30
de-essing 198
delay node 38–40
demo projects, setting up 1
detail over distance 245–6, 350
Details panel 28
dialogue 197–225, 372; for advice 201–4; branching 217–20; characters, contexts and choices 221–4; conditions and choices 208–16; crowds and sports 375–89; discussed 197–8; interrupts 204–8; languages 224–5; randomization 198–201; scenes 290
directional sources 234–8
distance attenuation 240–5
Distance Algorithm 33, 241–3
DoOnce node 151
Doppler 267–9
drag and drop 17
dry sound 227
ducking 310–13
Duff Note 406
dynamic occlusion 254–5
dynamic range 315

earcons 324
editing 12
embedding source sounds 44–6
engine sounds 359–67
Enveloper node 96, 99, 138
envelopes 92–100
environment (listening) 305
Epic Games launcher 2
EQ 303, 312–13
equal volume 304
Event Dispatcher 447
Event Graph 10
events and triggers 411–13
excitement levels of crowds 376–8
exclusions and obstructions 253–4
Extents settings 27–30

fades (editing) 15
fadein node 49–50

fadeout node 49–50, 156
Falloff Distance 29–30; *see also* attenuation
feedback 310, 323–6; weapons 346–7
files 3, 12–13
filters: audio 32–3, 198; files 8–9
Find feature 445
FlipFlop node 49
folders: project 1; searching 8; structures *7*, 17–18
Foley system 287–8
footsteps 280–9
forms: algorithmic 396–403; musical 130–3; parallel
 131, 143–4, 156–66

Game Actor Blueprints 45–6
game editor 4–5
gamepad inputs 410–11; *see also* controller input
Gate node 54, 186–7
gears, automatic 364–5
Generic Asset Editor 64
Get Distance System 161–4
Get Float Value node 119
global interrupt 207–8
good practices 449–57
Graph Action Menu 443–4
graphically led style 404–6
Group Control node 277
groups (mix) 305

headphones 64
hearing 301
help advice 201–2
high-pass filter 198
horizontal resequencing *132*
HUD interactions 324–6

icons 6–7, 27
impacts 352–4, 370
importing assets 16–20
inflection 385
informational dialogue 197
I.N.F.O.R.M. Model 310
in-game Actors 6–7, 414–17
input 53–5; *see also* controller inputs
instruction 310–21
interactivity *see* parameterization
interrupts, dialogue 204–8

inventory 212–15
inverse attenuation 242
IsMusic 308
IsUisSound 308

key input 53–5, 410–11

languages 224–5
layered concatenation 75–6
layered variation 81–90
layers: distance 350–1; environment 348–50; impact
 and damage 370; parallel 166–71; stress 371–2;
 suspension 372; switching or fading 157–9; wind
 371–2
Level Blueprint *10*
levels: dialogue 198; editors 2, 6; excitement 376–8;
 streaming 123–5
LFE bleed 307
linear attenuation 241
linear variables 160–6
listeners and cameras 292–9
listening 301
location-based switching 174
logarithmic attenuation 242
log reverse attenuation 243
longer music pieces 185–90
looking and moving 4–6
looping 13–16, 135–41, 344–5
looping node 38–9, 133
loops: asynchronous 66–71, 398–9; for moving
 objects 262–3; for weapons with tail 343–4
lossy format 64
loudness 304

macros 42, 424
MakeNoise node 329
manual looping 139–40
Markov chains 403
masking 44, 177–8, 330
Matinee 256–8, 263–6, 435
Matinee Controller 260–1, 264
Max Volume *29–30,* 315
measure-based transitions 181–93
mechanic 310, 327–30
mechanical systems, Matinee events for 263–6
melodic pickups 395–6

memory *60–1,* 121–6
midi files 137
Min Volume Threshold 315–16
mix: automation for parallel layers 166–71; changes 314–20; principles 302–9; testing the 331
Mixer node *40–1*
mockups 332–3
modes 5
modifiers *195*
modulation/modifiers for variation 90–105; oscillation 100–3; pitch 90–5; volume 96–100; wavetables 103–5
Modulator node 39
monophonic (one voice) system 40
mono sound source 234
mouse moves 5–6
movement, creating 258–9
moving/looking 4–6
MP3 64
multichannel sound source 234
multigate node 81, 206, 379, 399, 426
music, advanced 391–458; forms 396–403; melodles 395–6; rhythm-action 403–8; stingers 391–5
music, introduction to 129–47; interactive principals 130–3; loops and decay tails 135–41; parallel forms 143–4; playlists 133–5; stingers/ornaments 141–3; transitional forms 144–6
music, parallel forms and basics 149–71; basics 149–56; mix automation 166–71; parallel forms 156–66
music, transitional forms 173–95; clunky transitions 173–7; musical transitions 178–94; options 194–5

naming conventions 17–18
nasty transitions 173–4
natural sound attenuation 243
navigation 326–7; Blueprints 10–11, 439; browser 7–9; game world 2–7
nested reverbs 229–33
nodes 426–7, 445
Non-Spatialized Radius 33
normalization 304
notification 310, 320–3
NPC Footsteps 288–9
NPC state 321
number of voices control 278–9

numbers 417–20
NumChannels 121
Nyquist-Shannon theorem 12, 62

objects, moving 260–6
object state 322–3
obstructions and exclusions 253–4
occlusion 46–51, 246–50, 254–5
Ogg Size 65
one-shots: music 150–2; sounds 40–4, 69; source 37–40; volume envelopes 96–8; weapons 338–40
organization, dialogue 198
orientation 310, 326–7
ornamental forms/stingers 131, 141–3, 154–6
oscillation 100–3
Oscillator node *100*

panning 302
parallel forms *131,* 143–4, 156–66
parameterization 106–21; with Crossfade 112–16; monitoring approaches 121–6; with Set Pitch Multiplier 110–12; swapping out sounds 106–10; and user-defined curves 116–21
parameters 417–25
passive sound mixes 314–15
pawns 329
Perforce version control 3
Persona Editor (Animation Editor) 280
physics *see* audio physics
pickups 323–4, 395–6
pitch 90–5, 110–12, 307; oscillation *101–2*; velocity to 359–61
playback medium 64
play-by-play commentary 380–4
Play Cue 3
Player Component 151
player-oriented sounds (POS) 26
playlists 133–4
Play Sound Attached node 10, 150–1
play then loop 137–8
polyphonic one-shots 40–1
POS (player-oriented sounds) 26
prebake 233
preduck strategy 316
Preselect at Level Load option *88–9*
pre-syncs 187–90

principles, interactive music 130–3
Print String node 450–1
prioritization 278–9
procedural forms 396–403
procedural sound design 59–127; background
 59–65; layered variation 81–90; modulation/
 modifiers for variation 90–105; monitoring
 memory 121–6; parameterization 106–21;
 sample rates and audio compression 62–5;
 sequenced variation 65–81
programming 439–41
project folder 1
projectiles 345–6
proximity 395
Proximity Component 161–2
punishment 323

queues, dialogue 385–8

radio filter volume 308
RAM (restricted memory) 60
ramps 187–90
random combinations 81–5, 397–9
randomization 198–201, 200–1, 376
Random node 37–9, 200–1
realism 227–99; animations 279–89; cutscenes,
 cameras and 289–92; listeners, cameras and 292–9;
 moving objects and sounds 256–66; number
 of voices control 278; physics 266–78; sound
 propagation 227–55
Real Time Audio 5
REAPER 12
recall 328
reference levels 305
repelling 327
repetition 37, 59, 66, 76, 106, 137, 281, 323–4
restricted memory (RAM) 60
retriggering 340–3
reuse 90–2
reverb 51–3, 227–33, 303, 308, 348–9
Reverb Effects 227–8
rewards 131–2, 142, 323
rhythm-action 310, 403–8
ricochets 352
rolling 274–5

rotating doors 260–1
routing 425–6
running slow tips 456–7

Sample Rate 121
sample rates 12–13; and audio compression 62–5;
 concatenate 78–9
scalability 88–9
Schmidt, Brian 59
scraping 274–5
searching 8–10
seeds, random 400–3
Sequence node 42, 50, 426, 440
sequences 64–81; concatenation 71–9; note-level
 399–400; start points 80–1; time-based variation
 66–71
Set Boolean Parameter node 54
Set Float Parameter node *429*
Set Int Parameter node 184
Set Pitch Multiplier node 110–12, *429*
shapes attenuation *29–30*
shortcut keys 335–6
Show menu 27
simple collisions 269–71
skids 367–8
sliding 274–5
Sound Class 51, 207, 251, 305–9
Sound Cue 36, 74, 169, 430–3
Sound Cue Editor *36–7*
Sound Mixes 310–20, 331
sound propagation 227–56; distance attenuation and
 detail 240–5; occlusion, obstruction, and exclusion
 246–56; reverb 227–33; spatialization 233–40
sound tracks, Matinee 265–7
Sound Waves 8, 9, 36–7, 359
sources: diffuse 239–40; directional 234–8; loops 26,
 31–5; music 149–50; one-shots 26, 37–40, 44
spatialization 233–40
spawn 43
speakers 64
speed, walking 285–6
speed of sound 266–7
Sphere *29*
split and crossfade 15–16
sports dialogue *see* crowds, sports dialogue and

Start menu *122*
start points, multiple 80–1
stealth 174
stereo bleed 307
stereo sound source 234
stingers: harmonically appropriate 391–3; ornamental
 forms 131, 141–6, 154–6; rhythmically-synched
 393–5
streaming 121–6
stress layer 371–2
structures 443
surfaces 281–5
surface/tire layers 366–8
suspension layer 372
swapping out sounds 106–10
switch, controlling 183–5
switching ambience 46–51
Switch on Int node 183–4
systems, crowd 375–9

tail 341–4
testing 449–57
time-based variation 66–71
timed events, music for 152–4
TimeLine 104, 110–12, 436
timer node 437
tire layers 366–8
toggle for occlusion 249–50
toolbar 5
tracking 212–15
transitions 178–93; forms *132,* 144–6; junctures
 179–81; masking 177–8; matrix *181, 193*
triggered advice 202–3
Triggers 35, 40, 42, 46–51, 53–5, 310–13, 411–13
troubleshooting 449–57
turbo dump 369–70
turrets 8–9, 10, 321

Unreal Unit (UU) 27
utilities 8

variables 159–66, 417–25
variations 81–90, 398
vehicles 359–73; automatic gears 364–5; cameras 372;
 elements 361–3, 368–72; smooth operator 365–6;
 surface/tile layers 366–8; velocity to pitch 359–61
velocity 271–4, 359–61
version control 3–4
vertical re-orchestration *131*
View Options menu 8
Viewport panel *5*
views 4–5
voice center channel volume 308
voices control 278–9
volume 96–100, 302, 307; curves to 164–6;
 determining 159–66; equal 304; oscillation *100–2;*
 velocity to 272

walking speeds 285–6
Wave Param node *429*
wavetables 103–5
weapons 287–8, 335–56; background 335–6; bullets
 351–6; environment and distance elements
 348–51; feedback 346–8; one-shot, retriggered, or
 loop 338–45; projectiles 345–6; system 336–8
wet sound 227
whizzbys 352, 355–6
widgets *414–15*
wind layers 371–2
wind sounds 68
words, spacing 385
World Outliner 5, 6–7, 9

zero crossings 15, 135
zones, prioritizing 252–4